Pioneering Modern Painting: Cézanne & Pissarro 1865-1885

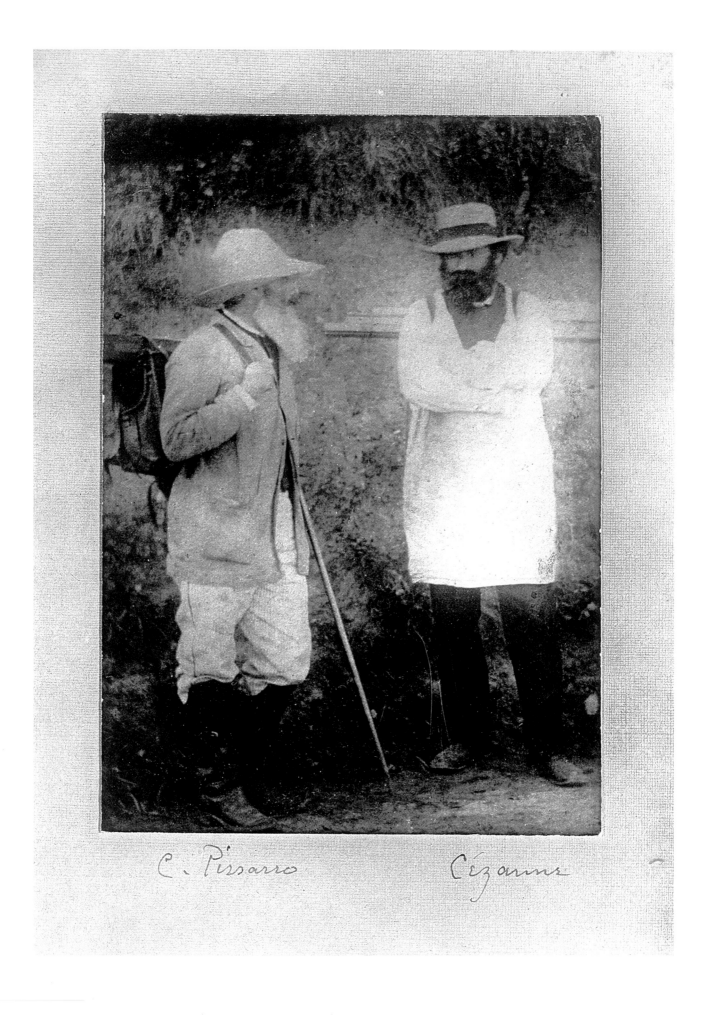

C. Pissarro Cézanne

PIONEERING MODERN PAINTING

Cézanne & Pissarro 1865-1885

Joachim Pissarro

The Museum of Modern Art, New York

Published in conjunction with the exhibition *Pioneering Modern Painting: Cézanne and Pissarro 1865–1885*, at The Museum of Modern Art, New York, June 26–September 12, 2005, organized by Joachim Pissarro, Curator, Department of Painting and Sculpture, The Museum of Modern Art

This exhibition travels to the Los Angeles County Museum of Art, October 20, 2005–January 16, 2006, and to the Musée d'Orsay, Paris, February 27–May 28, 2006.

The exhibition is made possible by The Starr Foundation.

Major support is generously provided by Joan and Preston Robert Tisch.

An indemnity has been granted by the Federal Council on the Arts and the Humanities.

Additional funding is provided by IXIS^SM Capital Markets.

This publication is made possible by the Blanchette Hooker Rockefeller Fund.

Produced by the Department of Publications
The Museum of Modern Art, New York

Edited by Joanne Greenspun
Designed by Steven Schoenfelder
Production by Christina Grillo
Chronology translated by Jeanine Herman

Printed in Verona, Italy, by Stamperia Valdonega
on 150 gsm Larius Matte
Bound by Legatoria Zanardi, Padua

Library of Congress Control Number: 2005925252
ISBN: 0-87070-184-3 (cloth)
ISBN: 0-87070-185-1 (paper)

Published by The Museum of Modern Art
11 West 53 Street, New York, N. Y. 10019-5497
(www.moma.org)

Clothbound edition distributed in the United States and Canada by D.A.P., Distributed Art Publishers, Inc., New York
(www.artbook.com)
Clothbound edition distributed outside the United States and Canada by Thames & Hudson Ltd., London
(www.thameshudson.com.uk)

Printed in Italy

FRONT COVER (top left): Paul Cézanne, *The House of the Hanged Man, Auvers-sur-Oise.* Musée d'Orsay, Paris; (top right): Camille Pissarro, *The Conversation, chemin du chou, Pontoise*, Private collection; (center left): Paul Cézanne, *Landscape, Auvers-sur Oise*, Philadelphia Museum of Art; (center right): Camille Pissarro, *The Climbing Path, L'Hermitage*, Brooklyn Museum; (bottom left): Paul Cézanne, *Oise Valley*, Private collection; (bottom right): Camille Pissarro, *Gisors, New Quarter*, Private collection

BACK COVER Paul Cézanne, *Self-Portrait*, Musée d'Orsay, Paris; Camille Pissarro, *Self-Portrait*, Musée d'Orsay, Paris

ENDPAPERS Paul Cézanne and Camille Pissarro. Photograph (detail). National Gallery of Art, Washington, D.C.; Camille Pissarro and Paul Cézanne. Photograph (detail). L&S Pissarro Archives

FRONTISPIECE Camille Pissarro and Paul Cézanne. Photograph. L&S Pissarro Archives

DETAILS OF PAINTINGS Page 76: Camille Pissarro, *Still Life (Nature morte)*, detail of plate 5; page 77: Paul Cézanne, *Dominique Aubert, the Artist's Uncle (Homme au bonnet de coton [L'Oncle Dominique])*, detail of plate 7; page 88: Camille Pissarro, *Self-Portrait (Portrait de l'artiste)*, detail of plate 14; page 89: Paul Cézanne, *Self-Portrait (Portrait de l'artiste)*, detail of plate 13; page 104: Camille Pissarro, *Louveciennes*, detail of plate 22; page 105: Paul Cézanne, *Louveciennes*, detail of plate 23; page 110: Camille Pissarro, *Still Life with Apples and Pitcher (Nature morte: pommes et chataigniers et faience sur une table)*, detail of plate 26; page 111: Paul Cézanne, *Still Life: Flask, Glass, and Jug (Fiasque, verre et poterie)*, detail of plate 27; page 124: Camille Pissarro, *The Potato Harvest (La Récolte des pommes de terre)*, detail of plate 43; page 125: Paul Cézanne, *Small Houses near Pontoise (Petites Maisons près de Pontoise)*, detail of plate 44; page 146: Camille Pissarro, *Small Bridge, Pontoise (Le Petit Pont, Pontoise)*, detail of plate 64; page 147: Paul Cézanne, *The Bridge at Maincy, near Melun (Le Pont de Maincy, près de Melun)*, detail of plate 65; page 164: Camille Pissarro, *Kitchen Garden, Trees in Flower, Spring, Pontoise (Potager, arbres en fleurs, printemps, Pontoise)*, detail of plate 68; page 165: Paul Cézanne, *The Garden of Maubuisson, Pontoise (Le Jardin de Maubuisson, Pontoise)*, detail of plate 69; page 188: Paul Cézanne, *Bridge and Dam, Pontoise (Le Pont et le barrage, Pontoise)*, detail of plate 87; page 189: Camille Pissarro, *Railroad Bridge, Pontoise (Le Pont du chemin de fer, Pontoise)*, detail of plate 86; page 204: Paul Cézanne, *Oise Valley (La Vallée de l'Oise)*, detail of plate 103; page 205: Camille Pissarro, *Gisors, New Quarter (Gisors, Quartier neuf)*, detail of plate 104.

Contents

Foreword

Pioneering Modern Painting: Cézanne and Pissarro 1865–1885 presents a detailed look at the work of two of the most important artists of the late nineteenth century. In doing so it asks a simple but important question about how modern art came to be formulated and understood, first among a small circle of artists and critics, and later an expanding public. By focusing on the roughly twenty years, from the mid-1860s to the mid-1880s, when Cézanne and Pissarro were in close contact with each other, often working side by side, *Pioneering Modern Painting* explores their mutual interests and, more importantly, their individual differences. What emerges is a finely wrought look at how these two artists influenced each other, while developing distinctly independent ideas and perceptions. The rich dialogue between the two—both in terms of the many paintings and drawings they produced during this period and their written comments—allows us a rare glimpse into the way Cézanne and Pissarro worked to create a distinctly modern art, self-critical and self-reliant.

At a time when The Museum of Modern Art has put a great deal of emphasis on the new, having just completed a major expansion and renovation of the Museum and embarked on a series of contemporary exhibitions, *Pioneering Modern Painting* reminds us of the importance and vitality of the early years of a tradition that now spans well over a hundred years. In 1929, when The Museum of Modern Art first opened its doors to the public, it did so with an exhibition of the work of Cézanne, Gauguin, van Gogh, and Seurat, four of the founding figures of modern art as the Museum understood it. Over the succeeding decades the Museum presented numerous exhibitions that endeavored to trace the origins of modern art while periodically examining in greater detail the work of the early practitioners of modern art. It has been, however, almost thirty years since the Museum's last exhibition devoted to Cézanne, which dealt exclusively with his late work, and the Museum has never had a monographic exhibition of the work of Pissarro. *Pioneering Modern Painting* thus provides an opportunity to examine these artists at a critical moment in their careers, when they were struggling to define themselves and modern art.

This project would not have been possible without the efforts of Joachim Pissarro, Curator in the Department of Painting and Sculpture at The Museum of Modern Art, and Camille Pissarro's great-grandson. Mr. Pissarro's lucid text and thoughtful study of Cézanne and Pissarro provide a fascinating window into the ways in which modern art was conceived and practiced at the end of the nineteenth century. Thanks also are due to the following for their support of the exhibition and its publication: The Starr Foundation, Joan and Preston Robert Tisch, the Federal Council on the Arts and the Humanities, IXIS℠ Capital Markets, and the Blanchette Hooker Rockefeller Fund.

Glenn Lowry
Director, The Museum of Modern Art

Acknowledgments

It is a well-known fact in the museum world that it has become increasingly complex and challenging to put together international loan exhibitions, and *Pioneering Modern Painting: Cézanne and Pissarro 1865–1885* is no exception to this trend. In fact, the concept of this show—bringing together specific groups of works by Cézanne and Pissarro that had been executed in relation to each other—made that challenge all the more acute, as each specific painting could not be substituted by another loan. An extraordinary team of people, all of whom have vastly contributed to the realization of this exhibition and its catalogue, was assembled for this undertaking, and huge thanks are owed to every one of them.

Our deep gratitude goes to those who consented to loan works of art in their collections. They are listed on page 255. The museums and private collectors who have graciously participated in this exhibition have allowed us to unite many works of art that have not been seen together since their creation. Without their generosity, there simply would be no show.

The research that made this exhibition possible often felt like living through a Sherlock Holmes story. So many colleagues and friends patiently answered our questions, and thus helped us to secure major loans to this show. Our sincere thanks is extended to the following, and to countless others who donated their time and knowledge to making this project possible: William Acquavella, Joel Anderson, Kathleen Antion, Irina Antonova, Alex Apsis, Janet Atkins, Kate Austin, Don Bacigalupi, Joseph Baillio, Tim Bathhurst, Hans Becker, Loïc Bégard, Sylvain Bellenger, Alberto Bellucci, Sergio Benedetti, Guy Bennett, Marc Blondeau, Bénédicte Boissonnas, Martine Bozon, Sylvaine Brans, Richard Brettell, Christopher Brown, Bernhard Mendes Bürgi, Françoise Cachin, Anthea Callen, Chris Campbell, Bettina della Casa, Paula Casajús, Michael Christides, Ernst Vegelin van Claerbergen, T. J. Clark, Jean-Paul Claverie, Melanie Clore, Philip Conisbee, Stephane Cosman Connery, Harry Cooper, Desmond Corcoran, David Aguilella Cueco, James Cuno, Vincent David, Annabel Daou, Susan Davidson, Jessica Burne Davis, Jim Dimond, Alain Disch, Anne Distel, Benjamin Doller, Douglas Druick, Katherine M. Dugdale, Ian Dunlop, John Earle-Drax, Elizabeth Easton, Bernd Ebert, Jean Edmonson, Carol Epstein, Catherine Evans, Sabine Fehlemann, Walter Feilchenfeldt, Evelyne Ferlay, Christiane Filloles, Michael Findlay, Hartwig Fischer, Jack Flam, Holly Forrester, Marco Franciolli, Hugh Gibson, Thomas Gibson, Susan Ginsburg, Franck Giraud, Elizabeth Gorayeb, Louis Grachos, Jonathan Green, Gloria Groom, Robert Grosman, Jennifer Gross, Doris Grunchec, Torsten Gunnarsson, Jennifer Hardin, Anne d'Harnoncourt, Colin Harrison, Chieko Hasegawa, Tokushichi Hasegawa, Annette Haudiquet, Ernst Haug, Jeanine Herman, John House, Ay-Whang Hsia, David Jaffé, Ryan Jensen, Catherine Johnston, Frédérique Kartouby, Sadao Kato, Raymond Keaveney, Gwendoline Keywood, Shireen Khalil, Gilly Kinloch, Milan Knizak, Albert Kostenevich, Thomas Krens, Jan Krugier, Rolf Lauter, Geraldine Lefevre, Arnold Lehman, Serge Lemoine, Thomas W. Lentz, Brett Littman,

John Lumley, Mario-Andreas von Lüttichau, Nannette V. Maciejuens, Peter MacGill, Nicholas Maclean, Jean-Patrice Marandel, Philippe Mariot, Catherine Marquet, Caroline Mathieu, Marie-Christine Maufus, Marc Mayer, Maureen McCormick, Charles S. Moffett, Jean-Pierre Mohen, Philippe de Montebello, Alain Mothe, Christian Müller, Kimio Nakayama, David Nash, Peter Nathan, Lawrence W. Nichols, Linda Nochlin, David Norman, Inna Orn, Sylvie Patin, Charles E. Pierce, Jr., Marnie Pillsbury, Mikhail Piotrovsky, Lionel and Sandrine Pissarro, Steven Platzman, Earl A. Powell III, Eva-Maria Preiswerk, Xenia Pushnitskaya, Tara Reddi, Susan Reed, Katharine Lee Reid, Daniel Rentzsch, Jock Reynolds, Andrea Rich, Christopher Riopelle, Joseph J. Rishel, Anne Robbins, Malcolm Rogers, Ali Rosenbaum, Nan Rosenthal, Timothy Rub, John E. Schloeder, Manuel Schmit, Peter-Klaus Schuster, Philippe Segalot, Sato Seiko, George Shackelford, Barbara Shapiro, Alex Shedrinsky, Richard Shiff, Charles Saumarez Smith, Paul Smith, Claire Durand-Ruel Snollaerts, Susan Stein, Michel Strauss, Deborah Swallow, John Tancock, Vérane Tasseau, Pierre Théberge, Gary Tinterow, Aleksandra Todorovic, Araxie Toutghalian, Kathryn Tuma, Olga Uhrova, Charles L. Venable, Tonya Vernooy, Tomas Vlcek, Jim Voorhies, Jayne Warman, John Warner, Kenneth Wayne, Rosemarie Weber, Angelika Wesenberg, Alice Whelihan, Barbara Ehrlich White, Virginia White, Cathy Whitehouse, Elizabeth Wieseman, Guy Wildenstein, Ully Wille, James N. Wood, Kazuko Yamaguchi, and Stoney Yeung. Special thanks also go to the many administrators and registrars of lending institutions, as well as photographers who provided images for the catalogue. Without their expertise, this project would not have been possible.

Additionally, certain Trustees of The Museum of Modern Art were especially helpful in securing key loans. Warmest thanks go to Leon D. and Debra Black, Gustavo and Patricia Phelps de Cisneros, Henry and Marie-Josée Kravis, Ronald S. and Jo Carole Lauder, David Rockefeller, and Sharon Percy Rockefeller.

At The Museum of Modern Art, many colleagues made critical contributions. Most important was Glenn D. Lowry, Director, who gave this project his personal, moral, and institutional support. His personal intervention made a number of loans possible, for which I am especially grateful. Jennifer Russell, Senior Deputy Director for Exhibitions and Collection, also deserves a special mention; her patience and flair throughout the (often taxing) process of this show was only matched by her flawless rapidity of action. I am personally deeply indebted to John Elderfield, The Marie-Josée and Henry Kravis Chief Curator of the Department of Painting and Sculpture, who participated in every curatorial and conceptual step of this show. My colleagues Ann Temkin and Anne Umland, Curators in the Department of Painting and Sculpture, gave this project their support and made critical and constructive suggestions. Fereshteh Daftari, Assistant Curator, edited Alain Mothe's chronology and offered insightful suggestions regarding the content of this exhibition. Jennifer Field, Curatorial Assistant, flawlessly tended to every aspect of the fabrication of this exhibition and has earned all her colleagues' admiration. Claire Henry, Administrative Assistant, applied her exceptional organiza-

tional skills and resourcefulness to this project at its inception at MoMA; and Marika Knowles, Holly Solomon Twelve-Month Intern, conducted invaluable research and compiled helpful reference materials throughout the unfolding of this project.

My gratitude also extends to all of the following for their ongoing dedication to this exhibition and the accompanying publication: Nancy Adelson, Associate General Counsel; Lawrence Allen, Publications Manager; Anny Aviram, Paintings Conservator; Maria DeMarco Beardsley, Coordinator of Exhibitions; Laura Beiles, Assistant Educator, Public Programs; Sara Bodinson, Assistant Educator, Interns and Audio Tours; Stephen Clark, Deputy General Counsel; James Coddington, Agnes Gund Chief Conservator; Sharon Dec, Administrative Assistant to the Chief Curator, Department of Painting and Sculpture; David Frankel, Managing Editor; Joanne Greenspun, Senior Editor; Christina Grillo, Associate Production Manager; Christel Hollevoet-Force, Provenance Research Project, Office of the Senior Deputy Director for Exhibitions, Programs and Collection Support; Robert Jung, Assistant Manager, Art Handling and Preparation; Beatrice Kernan, Assistant Deputy Director for Exhibitions and Collection Support; David Little, Director, Adult and Academic Programs; Jennifer Manno, Assistant to the Exhibition Coordinator; Michael Margitich, Senior Deputy Director for External Affairs; Kerry McGinnity, Senior Registrar Assistant; Jerome Neuner, Director of Exhibition Design and Production; Philip Omlor, Manager, Art Handling and Preparation; Susan Palamara, Associate Registrar for Exhibitions; Avril Peck, Curatorial Assistant, Department of Painting and Sculpture; Cora Rosevear, Associate Curator, Department of Painting and Sculpture; Marc Sapir, Production Director; Jenny Tobias, Librarian, Collection Development; and Carlos Yepes, Associate Coordinator of Exhibitions. In addition, thanks are due to all library staff and art handlers and technicians assigned to this show. I would also like to thank Steven Schoenfelder for his sensitive design of this catalogue.

Joachim Pissarro
Curator, Department of Painting and Sculpture

Pioneering Modern Painting

By Joachim Pissarro

Still Modern?

I sense that I can be neither a master nor a disciple.

GEORGE SAND[1]

AT THE TURN of the twenty-first century, after more than 150 years of the modern tradition, the questions raised by Paul Gauguin in his monumental painting of 1897-98, *Where Do We Come From? What Are We? Where Are We Going?* assumed new relevance (fig. 1). As the modern era defines our own history, it seemed legitimate to ask what the outcome of a century and a half of this modern tradition had brought. Could we still claim to be "modern" or had several decades of POSTmodernISM[2] reduced all past modern claims to naught? Indeed, where were we—and where are we—going?

Analogous questions had emerged with the same urgency in Europe throughout the second half of the nineteenth century, culminating with Gauguin's testament. What was this new "modern" phenomenon about? Against what did it define itself? Where was it taking us?

These questions, which received numerous and diverse answers, coincided roughly with the rise of Impressionism in the 1870s. During the Impressionist decades, two individuals were particularly strident in their opposition to academic tradition and the artistic institutions that supported and embodied that tradition: Paul Cézanne (1839-1906) and Camille Pissarro (1830-1903). These artists met at art school in Paris in the 1860s and quickly developed an intense friendship that lasted almost a quarter of a century. This unlikely bond—between a Jew born in the Caribbean who gave free rein to his passion for art in Caracas, and a Provençal born to a banking family and destined by his father to study law—resulted in one of the most fascinating artistic exchanges of the nineteenth century. In fact, these two artists' works are occasionally so

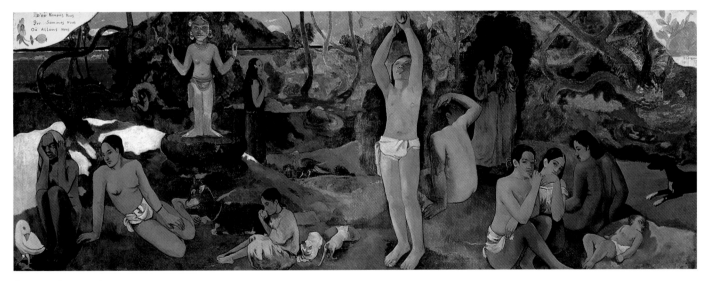

fig. 1. Paul Gauguin
Where Do We Come From? What Are We? Where Are We Going? (*D'où venons nous? Que sommes nous? Où allons nous?*). 1897-98
Oil on canvas, 54¾" × 12' 3¼" (139.1 × 374.6 cm). Museum of Fine Arts, Boston. Tompkins Collection

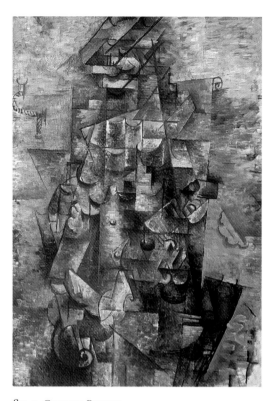

fig. 2. Georges Braque
Man with a Guitar (Homme à la guitare). 1911–12
Oil on canvas, 45¾ × 31⅞" (116.2 × 80.9 cm)
The Museum of Modern Art, New York
Acquired through the Lillie P. Bliss Bequest

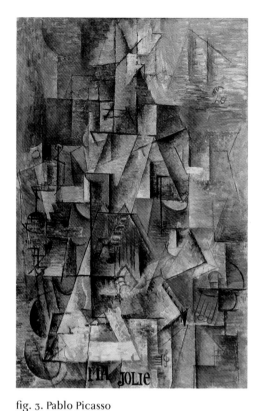

fig. 3. Pablo Picasso
"Ma Jolie." 1911–12
Oil on canvas, 39⅜ × 25¾" (100 × 64.5 cm)
The Museum of Modern Art, New York
Acquired through the Lillie P. Bliss Bequest

similar that it is difficult to tell them apart. Their reciprocity anticipated other modern exchanges, between Vincent van Gogh and Gauguin, André Derain and Henri Matisse, Georges Braque and Pablo Picasso (figs. 2, 3), Mikhail Larianov and Natalia Goncharova, Sonia Delaunay-Terk and Robert Delaunay (figs. 4, 5), Piet Mondrian and Theo van Doesburg, or indeed closer to our time, Jasper Johns and Robert Rauschenberg. With the exception of the latter two artists, most of these examples were defined by a paroxysmal exchange that lasted barely more than a couple of years.

The Cézanne/Pissarro artistic exchange lasted longer than any of the examples just cited: the two nineteenth-century artists worked closely at intermittent intervals from the early 1860s to the mid-1880s. In this sense, they would appear to have more in common with recent examples of collaborative efforts—Bernd and Hilla Becher, the Chapman brothers, the

Wilson sisters—in that their relationship lasted the span of a generation. However, unlike these contemporary examples, they never collaborated on the same project or the same work of art. While painting or sketching side by side outdoors or in each other's studio, Pissarro and Cézanne retained their own individuality, at the same time coming very close to assuming each other's persona. Their time together, however, was regularly interrupted. Cézanne went back and forth between Provence and the north of France, and Pissarro regularly spent prolonged stays in Brittany at the farm of his friend, Ludovic Piette. Their relationship was not exclusive of other relationships, either: during the 1860s especially, they both shared the friendships of other radical artists (Armand Guillaumin, Antoine Guillemet, and Francisco Oller, among others) and toward the end of their association, in 1881, they spent a good deal of time with a younger artist whom Pissarro had tutored: Paul Gauguin.

The artistic relationship between Cézanne and Pissarro takes us from the early 1860s, with the emergence of a modern language in art at the time of the Salon des Refusés and of Édouard Manet's *Olympia* (fig. 6), to the mid-1880s, when Cézanne decides to return to Provence for good, turning his back on the Paris art world and on Pissarro, Émile Zola, and his other early rebellious companions. The narrative that unfolds through this exhibition and its catalogue thus begins with the inception of modern art and concludes with the advent of modernism, with the aging Cézanne at its helm.

There is a paradox here, however: the tradition that had defined a century and a half of modernity was rooted in the idea that no tradition should be above criticism. One of the central tenets of the practice of modern art was its capacity to question itself, as well as any and all paradigms inherited from tradition. As Clement Greenberg himself insisted, being modern has meant, first and foremost, being critical, and especially self-critical.[3] Was the modern tradition, then, in the end, forced to annihilate itself in order to live up to its critical mandate?

There were, broadly speaking, two ways of addressing this dilemma. The first (fairly pessimistic) scenario suggested that

the dynamics of postmodernism (a.k.a. "postism") had brought modernity to its knees. Nothing was left but the raving forces of novelty, creating a ceaseless buzz that carried neither rhyme nor reason. Not much was left to the postmoderns but to celebrate "the multiplicity of language games."[4] The second scenario (far less pessimistic) suggested that the postmodern spectrum, even in its most menacing forms, was but living proof that the critical dynamics of modernity were still able to generate new modes of creation—even if these were turning against the whole modern phenomenon. Based on the principle that "out of the ashes a phoenix shall rise," the "postmodern condition" could then be diagnosed as a symptom that the "modern" was still alive.

No matter what one's position might be on the question of the relevance of "modern" to our present-day situation, it generated a whole industry of critical reflection that attempted to clarify the issues. What should this problem mean to our budding century? This daunting question still looms large and both challenges and encourages the continuation of a reflection on what "modern" means to the present. This reflection essentially took two directions: one focusing on our immediate present in

fig. 4. Sonia Delaunay-Terk
Portuguese Market (*Marché portugais*). 1915
Oil and wax on canvas, 35⅝ × 35⅝" (90.5 × 90.5 cm)
The Museum of Modern Art, New York
Gift of Theodore R. Racoosin

fig. 5. Robert Delaunay
Simultaneous Contrasts: Sun and Moon (*Soleil, lune, simultané 2*). 1913 (dated on painting 1912)
Oil on canvas, diam. 53" (134.5 cm)
The Museum of Modern Art, New York
Mrs. Simon Guggenheim Fund

light of what the modern phenomenon could *still* mean; the other addressing modernity not from our perspective but from its own origins. Out of the plethora of diverse publications in the field of cultural studies and theory devoted to this question, two titles are indicative of these two directions: Albrecht Wellmer's *The Persistence of Modernity* and William R. Everdell's *The First Moderns*.[5]

The Museum of Modern Art took the lead in this effort of reflection. To reexamine the origins and destiny of its mandate as a museum of modern art at this juncture in history was an opportunity not to be missed. In a cycle of exhibitions titled *MoMA 2000*, the Museum began addressing the vital question of what binds the origins of modern art to our present and vice versa. This question naturally implied a two-way critical gaze at both the origins and the present-day sense of what "modern" has meant. The curators of Modern*Starts* clearly stated their intention, and it is useful here to recount their argument for the purpose of the present exhibition: "Our title [Modern*Starts*] is intended to convey two meanings: first, that the period 1880 to 1920, to which this project is devoted, is when the 'modern' starts, when modern art starts; and, second, that there is not just one modern art start but many modern starts, therefore many different versions of modern art. Our project is devoted to something that is at once singular and plural: to one period and to many parts of that period; to one movement and to the disparate strands that compose it; to one journey and to its branches and diversions; to one subject and to its multiple histories."[6]

In many ways, this exhibition and its catalogue follow up on the premises and questions established by Modern*Starts*. If indeed the 1999 exhibition catalogue explored "when the 'modern' starts," the present exhibition's task is to explore a particular segment of this vast question: How did the so-called father of modernism begin? Insofar as it is usually accepted that the modern phenomenon was largely launched by Cézanne in the 1880s, exploring the path that led the artist to this "modern start" was only too tempting.

The present book traces the steps that led Cézanne from his early days, when he decided to leave his native Provence, to the point when, then in his forties, he returned for good to Provence, bidding farewell to the Paris art world. Throughout almost a quarter of a century, with intermittent trips to the south, Cézanne attempted to leave his mark on the indomitably chic–and exclusive–Paris art world. During this period, Cézanne's unyielding efforts were met with stubborn ignorance from the public, and even from many of the more adventurous art dealers. It is the artists themselves who were Cézanne's most fervent admirers and supporters. Pissarro, chief among them, stood by Cézanne from the moment they met in the early 1860s until 1885,[7] the last time they responded to each other's work.

The path that leads us to this particular "modern start" took the form of an artistic and essentially pictorial dialogue that was indeed "at once singular and plural." Cézanne and Pissarro met approximately at a time when the foundations of modern art were being laid historically, through the seminal Salon des Refusés of 1863, and they decided to determine their own destinies: an essentially modern gesture. Each artist formed his own artistic personality, not so much in isolation but in constant contact with others. Recognizing each other as artists who could push the envelope of the modern game further, Cézanne and Pissarro became almost inseparable.

This exhibition and its catalogue offer an opportunity to examine afresh the nature of this artistic exchange. The story of the friendship between the two artists is familiar not only to Cézanne and Pissarro scholars, but also to anyone conversant with Impressionist studies in general. The exhibition distances itself from the traditional accounts of this friendship in that it proposes to look at this intense artistic interaction more as an event symptomatic of the modern age than as a springboard for modernism itself. The terms "modern" and "modernism" need to be distinguished here. I see "modern" as pointing to a set of attitudes, choices, or ideological positions that essentially challenges the contextual establishment and confronts these issues constantly. "Modern," in this sense, means being radically critical of the traditions inherited by the present, critical of the surrounding established values, and critical of itself, too. "Modernism," by contrast, is a system of explanation that attempts to bring order to such critical gestures by proposing (and, in the end, imposing) a given sense to all these attitudes. The greatest difference lies in the fact that "modern" designates attitudes, while "modernism" denotes a mode of understanding that attempts to make univocal sense out of

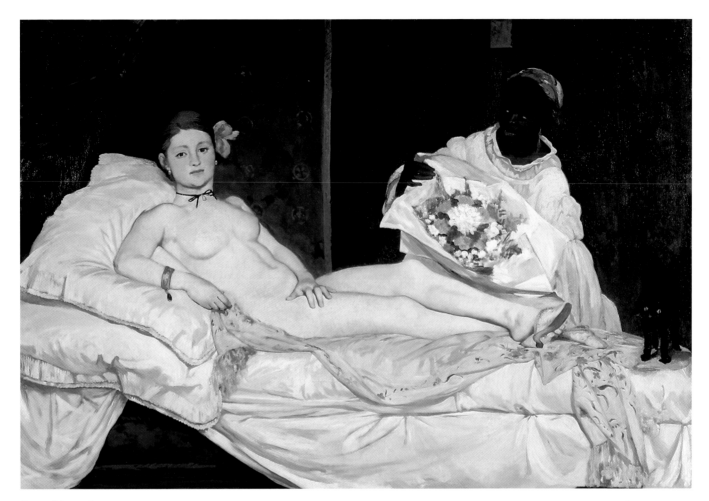

fig. 6. Édouard Manet
Olympia. 1863–65
Oil on canvas, 51⅜" × 6' 2⅞" (130.5 × 190 cm)
Musée d'Orsay, Paris

these sets of disparate gestures. The position taken throughout this catalogue is that the concept of "pioneering modern painting" is best looked at as a spectacular chess game—each move coming as a surprise, a drama—rather than as the first step toward modernism.

According to the latter system, everything that Cézanne focused on led to his eventual role as a pioneer of modernism. Therefore, the role assigned to Pissarro in this scenario was predictably that of a catalyst who prompted Cézanne toward his predestined goal as a founder of modernism. Roger Fry, in 1927, was the first to codify the narrative of the Cézanne/ Pissarro relationship in this way.[8] Essentially, according to

Fry, the older artist, Pissarro, would have cured the younger Provençal artist of his early artistic madness, or of what Alfred H. Barr, Jr., only two years after Fry, called Cézanne's abnormal sensitivity.[9] Then, Pissarro, having helped Cézanne to hone in on his own talent by introducing him to landscape painting, would have set him on the road that eventually released him from his early folly and allowed him to realize his own truth. In the 1870s, Cézanne, as Barr put it, turned himself "resolutely to the problem of Impressionism under the guidance of Pissarro."[10] He had just begun to see the danger of pursuing an art that risked "[arriving] at that degree of unbridled romanticism where nature is merely a pretext for dreams and where

the imagination becomes powerless to formulate anything but personal, subjective fantasies without any echo in general reason," as stated by Jules-Antoine Castagnary.[11] Thus, through contact with Pissarro, Cézanne's art gained distance from his initial dreams and folly. As Judith Wechsler summarized, through Pissarro, Cézanne "recognized the danger forecast by Castagnary. The painter's contact with Pissarro . . . was his way out of subjectivism and projected fantasy."[12]

The modernist tradition saw in Pissarro what Barr (referring to Impressionism) called a "point of departure."[13] After having worked with Pissarro in a "quasi-impressionist" style, Cézanne "saw his path lying clear before him."[14] Pissarro thus performed the function of a therapist for Cézanne, curing him and luring him away from his early fantasies and obsessions and allowing him eventually to realize his true historical destiny: that of a classical pioneer of modernism. As Barr summed up in a wonderful formulation, this was Cézanne's litmus test: "To remain faithful to both Poussin and Pissarro! A task of incredible difficulty."[15]

Although this is a slightly simplistic dramatic scenario proposed by the modernist tradition, it led both Fry and Barr to pay attention to Cézanne's early imagery, which was a definite gain. Fry, first among them, saw in the artist's "early visions" "indeed extraordinary dramatic force, a reckless daring born of intense inner conviction and above all a strangeness and unfamiliarity, which suggests something like hallucination."[16] Fry goes on listing Cézanne's inner ailments: "romantic exaltations," "intoxication," "inner fermentation of spirit," or "bewildering dreams."[17] Finally, Cézanne meets the artist who pulls the veil and reveals him gradually to himself: "At Auvers Cézanne became in effect apprentice to Pissarro."[18]

The problem I see with this interpretation is that it implies that the two artists are never equals—their relationship is couched in terms of a master/disciple exchange or of a doctor/patient exchange. In contradistinction to this traditional model of interpretation of the Cézanne/Pissarro hierarchical model, the present exhibition and its catalogue offer the viewer/reader the possibility of following the more complex, reciprocal interchange in which both artists appeared to have a lot to gain and lose each day of their artistic interactions. The present scenario takes us through the common formation of a new language (a modern language) to which both artists constantly contribute. The dynamics of this common project do not confine each artist to one role. Indeed, each in turn gives and takes; each learns from and teaches the other so that, in the end, neither plays just one part, and, certainly, neither can be seen as either a "master" or a "disciple."

Over a period of twenty years, the exchange of ideas, artistic methods, and ideological issues between these artists crystallized into an extraordinary panoply of works executed as they were either working side by side or with each other in mind. In the end, the concluding words Barr used in 1929 to describe Cézanne seem fittingly to apply to each artist individually. They both arrived "by infinitely patient trial and error at conclusions which have changed the direction of the history of art."[19]

Origins: Two Foreigners–The Formation of a New Language in Painting

Analogous Backgrounds

CAMILLE PISSARRO WAS BORN in 1830 in Charlotte Amalie, the harbor capital of St. Thomas in the West Indies, to a French Jewish father from Bordeaux and a mother with Creole origins from Santo Domingo. His father, Frédéric Pissarro, was sent to St. Thomas after the sudden death of his uncle, Isaac Petit (his mother's brother), who left behind a wife and three daughters. Frédéric was charged with helping his uncle's wife, Rachel, manage the family business.[20] The young man arrived in St. Thomas, fell in love with his aunt, and soon made her pregnant.

The couple decided to get married, but their union was deemed unacceptable by the rulers and wardens of the synagogue of St. Thomas because a Levitic law prohibits any man from marrying his uncle's widow.[21] What followed was a legal and theological battle between the couple and the religious authorities of St. Thomas, which ended in 1832, when the King of Denmark[22] intervened in person, and their union was declared valid and legal. At that point, Frédéric and Rachel were the parents of three boys: Joseph (born in 1826), Alfred (born in 1829), and Camille (born in 1830). A fourth son, Aaron, was born to the couple in 1833.

This biographical anecdote indicates that the young Pissarro was brought up in a very unorthodox (in every sense of the word) environment in which religious authority was not only questioned but challenged.[23] Paradoxically, Pissarro's parents were fighting the decisions of the rulers and wardens of the synagogue from a conservative stance: they wanted to be recognized and accepted by them. This refusal to have one's status in society prescribed by a heteronomous system was an essentially modern position, which consisted of claiming the right to question the validity of certain laws, customs, or conventions. Later on, the young Pissarro, together with Cézanne and several of their colleagues, would take on the French art establishment, questioning the very validity of its exclusive jury-based selection system. Their fight concerned a system of artistic conventions and traditions, as opposed to a system of religious dogmas and rules; it was fought from a radical perspective, as opposed to a conservative one. But what the young Pissarro may have learned from his parents' example was that the efforts to have one's claims and rights validated by others may take time but eventually pay off. This was a radical idea, whether motivated by conservative interests (as in his parents' case) or by progressive ideals (as in his case).

While Pissarro was born in the Caribbean, he was educated in France and returned to his parents' home with the understanding that he would work in the family business. Having no interest in doing this, he eventually broke off with his family, escaping to Caracas with a Danish friend, Fritz Melbye. There Pissarro decided to become an artist (see fig. 7). It is not excessive to say that Venezuela, where he stayed for two years (1852–54), revealed Pissarro to himself. He was twenty-four when he returned briefly to St. Thomas to tell his family that he had made a career decision. He left St. Thomas for Paris in 1855, never to return to the New World.

Pissarro arrived in the French capital on a Danish passport. In 1858 the Puerto-Rican artist Francisco Oller y Cestero (fig. 8) came to Paris and became a friend of his owing to their common Caribbean backgrounds.[24] Three years later, another young artist, Paul Cézanne, arrived from Provence, and Pissarro was introduced to him by Oller. Oller had enrolled in several studios, including the Académie Suisse, and by the time Cézanne arrived in Paris and enrolled at the same academy, Oller had acquired some artistic experience and apparently became Cézanne's instructor.[25] Pissarro never forgot his first meeting with Cézanne, and more than thirty years later, he proudly shared his recollection with his eldest son, Lucien: "Was I seeing right in 1861[26] when Oller and I went to see that

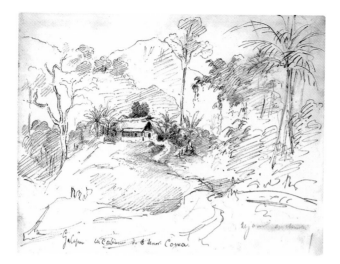

fig. 7. Camille Pissarro
Señor Correa's Hut in the Forest, Galipan (La Cabane de Señor Correa, Galipan). 1855
Black lead, pen, and brown ink, 8 × 10¼" (20.3 × 26 cm)
Private collection

fig. 8. Francisco Oller y Cestero
The Student (L'Étudiante). c. 1875-78
Oil on canvas, 25⅝ × 21⅜" (65.2 × 54.2 cm)
Musée d'Orsay, Paris

peculiar Provençal at the Académie Suisse, where Cézanne was doing life studies that provoked roars of laughter from all the impotents of the school—among others the famous Jacquet, who had long been buried in prettiness and whose works fetched unheard-of prices!!"[27]

In Paris, Cézanne was looked upon as a foreigner and sounded every bit like one due to his very pronounced Provençal accent. In fact, Cézanne's accent was so intense that many of his friends who recounted conversations with him would insist on transcribing the speech sounds by means of phonetic symbols. In an unpublished sketchbook, Lucien Pissarro noted down in telegraphic fashion a brief and characteristically crude exchange that took place between Cézanne and an unnamed artist. Cézanne asked the artist what color he should paint a barge passing on a river. When the artist told Cézanne to paint it pink or pure vermilion, Cézanne burst out with one of his favorite curses: "Go fuck yourself!" The point, however, is that Lucien, with the same care as a stage director annotating a script, added, "The whole thing must be heard with a strong Marseille accent."[28]

Pissarro was born on an island where little French was ever spoken, but he had been schooled in Paris and, therefore, had a much less noticeable accent than Cézanne. Émile Zola, who became Cézanne's school friend, had begun his education in Paris. He arrived, as a child, in Aix-en-Provence with a distinct Parisian accent, which made him a constant subject of derision and humiliation. Cézanne came to Zola's defense, which is how their close childhood friendship began.[29] As for Pissarro and Cézanne, when they met in Paris in the early 1860s, they obviously saw in each other an outsider. Another point in their backgrounds—seldom mentioned—that probably brought them closer to each other is that both of their mothers were supposed to be of "Creole" origins.[30]

Both artists came from bourgeois backgrounds. Cézanne's father, Louis-Auguste (fig. 9), of relatively modest Italian origins, was a self-made man who had established a successful hat trade. He had greater aspirations, however, and ultimately founded a local bank: MM. Césanne [*sic*] et Cabassol.[31] Cézanne's father's ambitions would have been totally fulfilled had his son become a notary or a prominent lawyer in Aix-en-Provence. To this end, Louis-Auguste pressured the young Paul to study law for two

years (from 1858 to 1860). This experience proved to be as utterly useless as it had been counterproductive for Frédéric Pissarro to force his son to enter the family business. Both situations generated a sense of rebellion in each young man, and, if anything, strengthened their determination to become artists.

Their mothers, however, were much more lenient, understanding, and even supportive of their sons' wild aspirations. Pissarro's mother offered him financial support until he was forty-two years old (even though she never accepted the fact that her son had fallen in love with her own cook's help and had had three children with her before deciding to marry her). As for Cézanne's mother, she tried to counter her husband's materialistic concerns with some quasi-cabalistic reasoning: their son's artistic destiny had been sealed when he was baptized and given the name Paul. "What do you expect?" she chided her husband, "His name is Paul, just like Veronese and Rubens."[32] What could one say to such an argument? After all, who had chosen the child's name—and, in so doing, sealed his fate?

Ultimately, Pissarro and Cézanne obtained permission from their fathers to go to Paris.[33] Both fathers made reluctant commitments to support their sons financially. The paternal authorizations they painstakingly obtained were, in each case, contingent on them reaching *success* in their enterprises. The only gauge of success known to Frédéric Pissarro and Louis-Auguste Cézanne was the Salon. If their sons were to win medals, or be awarded some official recognition through the Salon, it should be enough to ensure their success. However, neither son had any intention of succeeding through the conventional path offered by the Salon. In fact, both Camille and Paul wanted to prove to their fathers that it was possible to attain success not only outside of the Salon, but even in opposition to it.

Pissarro and Cézanne shared the sense of being from another place, especially when they came to paint the landscape of the Pontoise region, in northern France, and they remained outsiders all their lives. This alien quality, called exotopy, is defined by the Russian literary critic Mikhail Bakhtin in this way: "To enter in some measure into an alien culture and look at the world through its eyes is a necessary moment in the process of its understanding; but if understanding were exhausted in this moment, it would have been no more than

fig. 9. Paul Cézanne
The Painter's Father, Louis-Auguste Cézanne
(*Père de l'artiste, Louis-Auguste Cézanne*). c. 1865
Oil on house paint on plaster, 66 × 45" (167.6 × 114.3 cm)
The National Gallery, London

a single duplication, and would have brought nothing new or enriching. *Creative understanding* does not renounce its self, its place in time, its culture; it does not forget anything. The chief matter of understanding is the *exotopy* of the one who does the understanding—in time, space, and culture—in relation to that which he wants to understand creatively. . . . In the realm of culture, exotopy is the most powerful lever of understanding. It is only to the eyes of an *other* culture that the alien culture reveals itself more completely and more deeply."[34]

This principle of exotopy is a particularly useful conceptual tool in tackling the complex dialogue that went on between

Cézanne and Pissarro while painting their natural surroundings in northern France. First, their "alien" origins offered them a privileged vantage point from which to look at every detail without taking anything for granted: everything was potentially unused and subject to pictorial curiosity. Both artists certainly looked at the *patrie française* with different eyes from those of their colleagues.[35] On so many occasions (e.g., Pissarro's *The Climbing Path, L'Hermitage, Pontoise*, or Cézanne's *Turn in the Road*; plates 57, 59), these artists seemed to be set on revealing, through their visual perception and their painting, the awkwardness of the particular spot they decided to grapple with. Despite the ordinariness (to a local's vantage point) of the landscape that surrounded them, there is almost nothing ordinary about the way they painted it: the *otherness* of the land they saw came through in every square inch of the paintings they produced there.

The second point to make here is that Cézanne and Pissarro decided to paint nature together as they retained and cultivated their mutual *otherness* toward each other. What fascinated them was the extraordinary difference that each of them embodied. They sought out an excess of vision in each other and learned from each other's excesses. One finds a perfect illustration of this point in the exquisitely excessive *Portrait of Cézanne* by Pissarro (plate 12).

This radical exotopy also reveals itself when one compares the two artists' techniques. Thanks to Jim Coddington, chief conservator at The Museum of Modern Art, who analyzed a substantial number of works by both artists, it is possible to see that neither artist ever followed a particularly set technical formula. In fact—and this is especially true for Cézanne—one could almost claim that the two artists were engaged in a systematic quest for *otherness*: they kept trying new tricks. Even when they came closest to painting the same motif, their technical methods differ radically from one another. A case in point is *Orchard, Côte Saint-Denis, at Pontoise* (plates 76, 77). While the vantage point is virtually the same for both works, the two artists seem to have been intent on using almost diametrically opposed techniques. Pissarro's work is thickly encrusted with paint, applied with a dry and hard brush; the volumes of paint create a crunchy and appetizing surface, which, seen under raking light, is not unlike that of a baguette.[36] There is no trace of a

knife having been used. Cézanne's work of the same motif is painted almost entirely with a palette knife. Long, soft brushes were used to draw out the branches of the trees in purple-blue. The paint was otherwise applied wet on wet, its structure appearing to have been created quasi-geologically, strata upon strata. This unusual effect gives the painting a sense of the lopsided curves of the terrain, and, at the same time, gently scans the entire surface of the painting diagonally, thus anticipating Cézanne's late Provençal landscapes. Contrary to the Pissarro, the Cézanne, of smaller dimensions, appears to have been done on the spot, very quickly painted, with almost no preparation.

What Did "Modern" Mean to Pissarro and Cézanne?

To be "modern" in the nineteenth century implied a certain view of history and of one's place in it. Few artists at that time thought much about what Pissarro called a *"tradition d'art moderne"* (modern art tradition).[37] He attempted to give this modern tradition its point of origin, which he saw in what he called *"l'art 1830,"*[38] i.e., Camille Corot, Gustave Courbet, Eugène Delacroix, and Jean-Auguste-Dominique Ingres (figs. 10-13). Later in their lives, both Pissarro and Cézanne

fig. 10. Jean-Baptiste-Camille Corot
Passing the Ford in the Evening (Le Passage du gue, le soir). 1868
Oil on canvas, 39 × 53⅛" (99 × 135 cm)
Musée des Beaux-Arts, Rennes, France

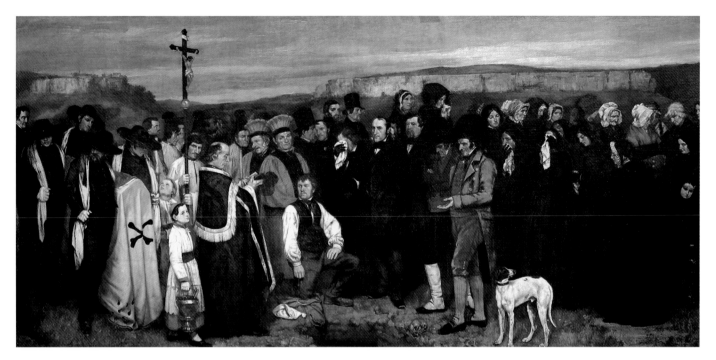

fig. 11. Gustave Courbet
Funeral at Ornans (Enterrement à Ornans). 1849
Oil on canvas, 10′ 4″ × 21′ 11″ (315 × 668 cm)
Musée d'Orsay, Paris

were deeply and personally concerned with the impact of the speedy development of modern art on their own careers. In order to measure each artist's concern, we should review the end of their careers, when the general movement of modern art, with its challenges and promises, was becoming increasingly clear. Indeed, both artists assessed the results of nearly half a century of modern art at the end of their lives. At that point, oddly enough, their views of the course of modern art were fairly pessimistic, though each approached it from a different perspective. Pissarro's take was more historically minded; Cézanne's more individualistic and self-motivated.

Pissarro's approach was even historicist. He saw the history of modern art as having its own set of laws and inner progression and logic that governed its orientation and propelled it in a particular direction. Pissarro pointed to what he called "a general idea of the movement which drives our modern society toward new ideas."[39] This is an early form of historicism (or a vision of history as automated by its own internal engine). Many of Pissarro's letters take on a slightly predicatory, even a kind of messianic tone of voice: "We are on the right track, be faithful to your sensations."[40] He saw early modern art (when he and

Cézanne were working in tandem, and when Impressionism was making its own impact on the Parisian art scene) as an art that was honest, simple, natural, and reflected the *sensations* of an individual who was free.[41] That individual (himself, Cézanne, and each of their close friends) had broken the shackles of bourgeois society and was governed only by his own self-imposed rules. The modern individual artist was, therefore, autonomous—or aspiring to be so: his law came from within. He knew—as Pissarro would have it—no god, no master, and no school.

In the artistic realm, this individual was an Impressionist; in the political realm, he was an anarchist. Pissarro saw absolutely no contradiction between the two. In fact, he conceived of both options (one governing the new art world, and one ruling the ideal society of the future) as being two sides of a coin. This fear of imitating a master became a shibboleth of modernism. In 1950 Henri Matisse absorbed it as one of his principles of creation: "WHEN ONE IMITATES A MASTER," he wrote in capital letters, "THE TECHNIQUE OF THE MASTER STRANGLES THE IMITATOR AND FORMS ABOUT HIM A BARRIER WHICH PARALYSES HIM. I COULD NOT REPEAT THIS TOO OFTEN."[42]

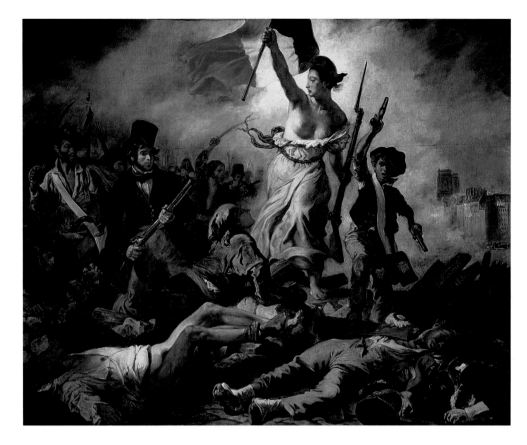

vidual (upon which the modern ideology was largely founded) was threatened by the coercive push of the Church—in politics— and the return of metaphysics—in art. The efforts that he, Cézanne, and others had put forth to promote each artist's individual sensation in his art were inseparable from the larger question of the rights of each individual in society. He saw the latter in great danger of dying out due to the political pressures of a conservative reaction in France. Things would get worse before they could get better—with the Dreyfus Affair, in particular. This affair

fig. 12. Eugène Delacroix
Liberty Leading the People (*La Liberté guidant le peuple*). 1830
Oil on canvas, 8′ 6⅜″ × 10′ 8″ (260 × 325 cm)
Musée du Louvre, Paris

Pissarro saw his utopian program put to task in the 1890s, and, as he was growing older, doubted increasingly that he would ever see the promises of a utopian (and quasi-messianic), bright, anarchist future become real. Worse, the combined forces of political and artistic reaction (the two going hand in hand, according to Pissarro) appeared to put a brake on the "way of truth"[43]—the progressive ideology set in motion by the Impressionists at the onset of the modern tradition. Pissarro feared that the clerical and conservative forces had joined ranks in the 1890s to counteract the democratic process put in place by the Third Republic, and to muzzle the new taste in art introduced by the Impressionist generation.[44]

From Pissarro's perspective, there was a direct correlation between the clerical reaction in politics and the Symbolist movement in art, in which he saw signs of a dangerous return of religiosity and sentimentality (figs. 14, 15). From both a political and an artistic perspective, things were not going well at the end of the century, in Pissarro's eyes: the thrust of the indi-

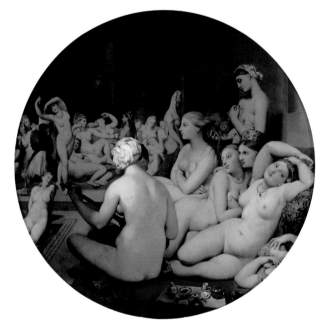

fig. 13. Jean-Auguste-Dominique Ingres
The Turkish Bath (*Le Bain Turc*). 1862
Oil on canvas laid down on wood, diam. 43¼″ (110 cm)
Musée du Louvre, Paris

fig. 14. Paul Gauguin
The Vision after the Sermon: Jacob Wrestling with the Angel
(*Le Vision après le sermon: La Lutte de Jacob avec l'ange*). 1888
Oil on canvas, 28¾ × 36¼" (73 × 92 cm)
National Gallery of Scotland, Edinburgh

fig. 15. Maurice Denis
The Women Find Jesus' Tomb Empty
(*Saintes femmes au tombeau*). 1894
Oil on canvas, 29⅛ × 39⅜" (74 × 100 cm)
Musée du Prieure, Saint-Germain-en-Laye, France

raged through French society and split it into two irreconcilable halves: those who supported the State and were ready to ignore the fact that Captain Alfred Dreyfus had been convicted of treason on forged evidence versus those who advocated individual rights and vocally protested against the State's decision to let an innocent man be convicted to save the State's face. Pissarro associated with like-minded supporters of individual rights (Bernard Lazare, Zola) who fought to no end to protect an individual against the ignominious attacks of the State. This brought the realization that the modern world—whether in the realm of art or politics—did not follow a happy linear progression toward a bright utopian future, but was inherently uncertain, and that no guarantees could be taken for granted.

If Pissarro chose to adopt the perspective of history to gauge the demise of his early ideology, Cézanne came to equally pessimistic conclusions from his own perspective and his individual *sensation*. Cézanne did not care much about the history of modern art (or about politics, in fact). But he did see its impact on an increasingly large number of younger artists, who made pilgrimages to Aix to pay homage to the Maître d'Aix, many of them shamelessly working in a Cézannian style and heralding him as the father of modern art. Cézanne

responded with a mixture of characteristic paranoia (fearing to be copied) and understandable pride. His last letter written to his son, Paul, a week before his death, in 1906, is both moving and sad: "I am continuing to work with difficulty, but anyway, there is something there. This is what matters, I believe. Sensations are the bedrock of my business, and so, I believe to be impenetrable. Incidentally, I am happy to let that miserable guy you know go on plagiarizing me as much as he likes: there's not much danger there."[45]

The letter ends with some personal health considerations that take on a deeper meaning, since this was his last letter to his son: "My dear Paul, in order to give you the satisfactory news that you are asking for, I should be twenty years younger. I am telling you again that I eat well, and some moral satisfaction would go a long way with me—but only work can deliver this to me. All my compatriots are assholes compared to me."[46]

Wanting to qualify somewhat the universal extension of the latter statement, Cézanne explained his thoughts further. He felt that the younger generation of painters was "much more intelligent than the others." As for "the others"—"the old guys"[47] as he called them—there was not much hope left: "[They] can only see a disastrous rival in me."[48]

At the end of his life, Cézanne distinguished between two groups of living artists: those who adulated him versus those who competed with him. In either case, he sensed that he had been misunderstood. The absolute irony is that this artist, hailed by most as the father of modern art, felt as isolated and lost within the complex machinery of production and evaluation of modern art at the end of his life as he did at the very beginning, when, painting alongside Pissarro, his work was systematically rejected from each Salon. His very last words to his son echo his penultimate letter to Zola in 1885 in which, out of frustration and delusion, he declares desiring nothing more than "the most complete isolation," interrupted, as he qualified his wishes, by a visit now and then to the brothel, but "otherwise nothing else."[49]

The year 1885 marked the last link between Cézanne and Pissarro, although they saw each other briefly in 1895. (See Chronology.) Pissarro heard of Cézanne's final departure to the south through somebody else—Cézanne having not deigned to come and say good-bye. But Pissarro knew his old friend only too well to be surprised. More than twenty years of an intense artistic friendship were to result in a wall of silence—the necessary condition for Cézanne to return to work and continue to develop the premises of what he and Pissarro had discovered, to go on "realizing his sensation" and facing, on his own, the challenges of modern art in the making.

A Yardstick of Modernity: The Importance of Émile Zola

In their twenties and early thirties, both Cézanne and Pissarro wholeheartedly embraced the new ideology of modern art, and they found in Émile Zola (1840-1902) an eloquent and notable exponent of these ideas. Zola first championed Édouard Manet (1832-1883), whom he believed embodied a radical departure in art, and he defended his belief that there is no longer any standard (or canon) that can be referred to as absolute beauty (fig. 17).[50] The huge leap that Zola accomplished was to suggest that beauty did not reside in the outside world but inside ourselves: [51] "It is in us that beauty exists and not outside us."[52]

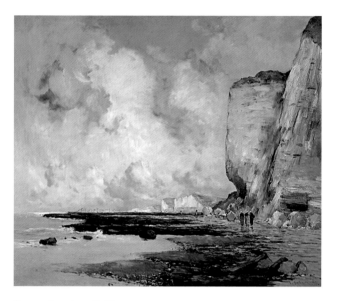

fig. 16. Antoine Guillemet
Cliffs of Puys, Low Tide (*Falaises de Puys, marée basse*). 1877
Oil on canvas, 34¼ × 41⅜" (87 × 105 cm)
Musée du Château, Dieppe, France

Zola, characteristically diligent in laying the groundwork for his research, spent hours discussing with his close friends the stakes in this new form of aesthetics that was bringing a radical redefinition of beauty. These friends included Cézanne, Pissarro, and their group of friends—Jean-Baptistin Baille and Philippe Solari, whom Cézanne and Zola had known since their childhood, and Guillemet (fig. 16) and Oller, whom Cézanne and Pissarro had met in Paris. Zola soon began to articulate a critical language that reflected a consensual platform of agreement between all these artists. By the same token, it described the ideological ground on which they met, and virulently expressed their views.

Cézanne, Pissarro, and Zola tended to use the very same terms throughout their correspondence or writings. The prolonged and emotional dedication to Cézanne that Zola published in his "Salon" of 1866 [53] must be taken seriously. Its tone is evident from the first paragraph: "A deep joy fills me, my friend, when I can converse with you, one on one. You have no idea how much suffering I have endured lately from this quarrel I have just had with the crowd, with people I didn't know. I felt so little understood. I could sense so much hatred around me that I felt discouraged to the point where my pen fell from

my hand."[54] In fact, the theme of a "conversation" or a "chat" recurs throughout this dedication. Zola admits openly and proudly that his art criticism is the result of serious ongoing discussions. He refers to the "voluptuous intimacy" of those good "chats." And it goes on: "Imagine that we are alone . . . far from any struggle and that we are chatting as old friends . . . who understand each other just at a glance." "It has been ten years that you and I have been speaking about art and literature." "As we were flat mates, the light of dawn would catch us by surprise as we were still talking." "Do you remember our long conversations? We used to say the slightest new truth was enough to ignite wrath and clamors. And now I am being hissed and insulted."[55]

Zola's art criticism has often been simplified in light of his own literary program, misunderstood as an interpretation of reality as close to facts as photography.[56] This interpretation needs correction. Zola indeed researched his facts with the scrupulous zeal of Sherlock Holmes, but this method of inquiry only served him better to reveal what was essential in art (to him): a man with flesh and nerves, as he was wont to say. Because of the emphasis traditionally placed on Zola's "photographic" realism, and his intense attachment to describe reality as it is, art historians have privileged the novelist's attachment to truth and honesty when he was studying the works of his artist friends. Zola's position is more complex, and, by the same token, closer to his Impressionist friends' own position.

The term "truth" indeed recurs frequently in Zola's criticism, as it colors Pissarro's and Cézanne's artistic ideas throughout their correspondence or dialogues,[57] but "truth" actually refers to a work of art that adequately reflects the temperament, the feelings, and the individuality of an artist. This is a critical idea that Pissarro and Cézanne explored until their deaths. They called this notion of truth to one's own individuality their "sensation." The term "sincerity" is also central to their vocabulary in that it designates a work of art that is "truthful" to the sensations of its authors. Zola's truth is, therefore, at the antipode of the photographic notion of truth, which he in fact despises in painting. "I said that I cared about truth. All in all,

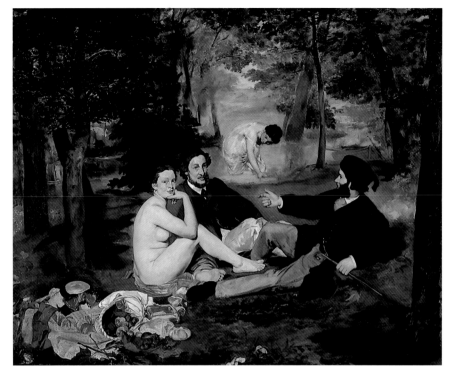

fig. 17. Édouard Manet
Luncheon on the Grass (*Le Déjeuner sur l'herbe*). 1863
Oil on canvas, 6' 9⅞" × 8' 8⅛" (208 × 264.5 cm)
Musée d'Orsay, Paris

I care even more about personality and life. I am, in art, someone who is curious, doesn't have many big principles, and is readily inclined toward any work of art provided it is the forceful expression of an individual."[58]

Consequently, one is not surprised to see Zola himself attack the traditional concept of truth when applied to art. This is also central for both Cézanne and Pissarro: "One feels the need for truth, and, as the whole truth cannot be found anywhere, one makes it up for one's own particular purpose out of selected bits and pieces. . . . Truth, therefore, doesn't belong to this world, since it is not universal or absolute."[59] He explains that, more than the truth, what is important is to find an artist who reveals himself in his paintings."[60] This is the critique that Zola addresses to Hippolyte Taine—a man of a cold, pseudoscientific system, who interprets works of art as the mere reflection of a particular historical and geographical context. Zola objects to this positivist understanding of art that the temperament of an individual resists such determinations and cannot be fully accountable in terms of raw facts and statistics.

It is in this important early (and seldom quoted) text that one finds Zola's first iteration of his famous motto: "I will express my mind totally in saying that a work of art is a corner of the creation seen through a temperament."[61] Drawing on this motto (that will, incidentally, orient Pissarro's and Cézanne's careers for the rest of their lives), Zola then insists that a proper definition of the modern artist must respect his independence. The real artist cannot abide by the constraining laws of any canon[62] that would be contrary to the essential freedom that is inherent in any human enterprise.[63] Zola thus concludes: "It is understood that the artist places himself in front of nature; he copies it while interpreting it; he is more or less a realist according to his eyes; in a word, his mandate is to render objects as he sees them, stressing such and such detail and creating anew."[64]

The logic of Zola's system is flawless and constitutes the thrust of Pissarro's and Cézanne's art production. Given the fundamental need for an artist to be independent and wholly individual, two factors could be a real threat: the influence of a *master* (dictating to him the way he should paint) and the impact of a school system (passing on to students the codes and conventions of a preestablished tradition). One finds in Zola's essay on Taine the premises of a deep-seated anti-school position (to which Pissarro and Cézanne will subscribe wholeheartedly): "Let the schools die, if all they leave behind are masters. . . . Every great artist gathers around himself a whole generation of imitators, and of like-minded temperaments–just somewhat weaker. [The great artist] is born a dictator of the mind."[65] Cézanne and Pissarro echoed this distaste for the art-school system of their time with virulent passion: "[I]nstitutions, stipends, and honors are made only for idiots, pranksters, and rogues. . . . Let them go to the École, let them have a raft of professors. I don't give a damn."[66] And Cézanne stated to Ambroise Vollard: "Teachers are all castrated bastards and assholes. They have no guts! . . . See, M. Vollard, the whole thing is to get out of school, of any school."[67]

Both artists were equally weary of the insidious impact of "masters" who could corrupt their in-depth search for their artistic selves. The irony, of course, is that at the end of their lives, they both attained the status of masters themselves,[68] but they became modern masters, i.e., masters who kept at

heart the paradox of modernity: How is it possible to learn while retaining one's freedom? It is exactly in those terms that Pissarro couched this problem when he defended his son, Georges, who had been obstinate and rude in expressing his artistic opinions to his cousin. Camille justified his son's behavior by saying that he was animated by an "instinctive distrust toward what could be fatal to him."[69] By this Pissarro meant any kind of school-derived system of values. Georges Pissarro's position was that works of art he could not understand were not worth his time. Camille warned his niece against the danger of imitation, which threatens most artists who become the prey of some kind of influence without even noticing it. Georges, according to his father, is above that threat. Pissarro concludes by briefly expressing his philosophy of education, which reflects his and Cézanne's shared position: "You know, ultimately, he [Georges] is built this way because of his genes. . . . This question of education is of the utmost complication. You cannot set up principles, because each personality experiences different *sensations*. One goes to all those schools to study art. Well, that's a big illusion. One learns a craft, but art? Never!"[70]

Note the ironic suggestion on Pissarro's part that his son was determined *genetically* to rebel against any kind of education system. The main point is that Pissarro and Cézanne felt exactly the same way about schools, although they expressed it in different terms. One of them cursed and swore against schools and teachers; the other tried to articulate his reasoning in his somewhat convoluted prose. However, both of them echoed what their shared "master," Courbet, stood for (fig. 18): to be a master–a modern master–meant, first and foremost, to give up on the idea of being a master. Courbet expressed this most clearly in the form of a performative contradiction, to his own students in 1861: "I do not have and cannot have any students. I, who believe that any artist must be his own master, cannot think of establishing myself as a professor. I cannot teach my art, nor the art of any school, given that I refute art teaching: I claim, in other terms, that art is all about the individual."[71]

Courbet did not use the term "sensation" that Pissarro and Cézanne used all their lives. Essentially, "sensation" to them is the indexical trace of the individual in art: it is what escapes rules and principles in schools. This opposition is the same as that expressed by Pissarro between producing an aesthetic

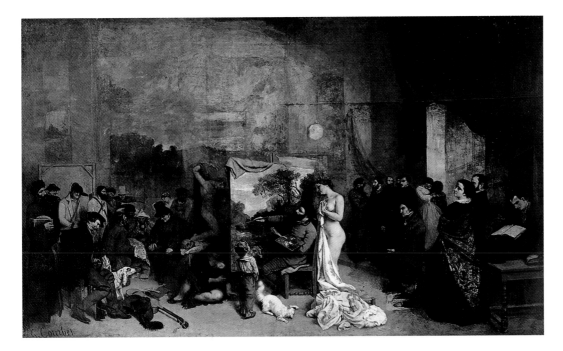

fig. 18. Gustave Courbet
*The Painter's Studio: An
Allegory* (*L'Atelier du peintre*).
1854-55. Oil on canvas,
11′ 10⅛″ × 19′ 7⅜″ (361 × 598 cm)
Musée d'Orsay, Paris

object according to a particular craft (what Pissarro calls "*exécuter*") and creating art, properly speaking, which draws upon the individual's unique imprint (his "sensation"). As we saw above, Zola reiterates the same opposition but inverts the term used by Cézanne and Pissarro. Zola calls "art" what Cézanne and Pissarro call "production" ("*exécution*") or "craft" or "skill." And what Cézanne and Pissarro call "art" (what can only develop in contact with nature), he calls "life." This same opposition has continued to define the central paradox of art schools to this day.[72]

One of the facts of Pissarro's early biography that Cézanne most admired and envied was that he was born in the West Indies and was able to learn to draw there *without a master*.[73] The expression "without a master" constitutes the etymological definition of the term "anarchy"–*an-archos,* meaning, in Greek literally, "without a master." (This would have been plainly obvious to a classicist such as Cézanne.[74]) In other words, according to Cézanne, Pissarro, growing up away from any art schooling, was almost born an anarchist (in art), one who had to invent his own ways of working as he went along. Autonomy (or "independence"–the term preferred by Zola) remained one of the key aspirations of both artists.

Defining anarchy in his text on Cézanne, Maurice Denis (using a quote from André Suarès) expresses pithily the aesthetic program shared by Pissarro and Cézanne. The main thrust is the concept of autonomy: "In times of decadence, everyone is an anarchist, both those who are and those who pride themselves on not being anarchists. Because each one

takes the law unto himself. . . . We love order passionately, but the order that we create, not the order that we receive." [75] This, in turn, explains one of the most sibylline pronouncements ever made by Cézanne in a letter to Émile Bernard: "Studying modifies our vision to such a degree that the humble and colossal Pissarro has proved to be justified in his anarchistic theories."[76] What could "studying" nature and honing one's artistic vision have to do with anarchistic theories? The answer is: autonomy. Autonomy (or self-reliance and self-discipline) constitutes the hinge concept between the political program defined by anarchy and the artistic sphere inhabited by Pissarro and Cézanne. Indeed, Cézanne confirms this in the same letter to Bernard by delineating in a very clear way their common artistic program, the goal of which was the full realization of one's autonomous sensation, attained from within oneself and expressing oneself.

Here are the various steps that Cézanne prescribes: 1. go to the Louvre (where one learns the vocabulary of painting); 2. be careful, however, to stay away from the Louvre's lessons, the mechanisms of traditional technique and learned formulas. After the Louvre, one must exit the museum and the tradition it encompasses and go *study* nature; 3. in this process, one obtains two benefits: one extracts "the spirit" (or the essence) of nature at the same time as one manages gradually to "express [oneself] according to personal temperament";[77] 4. after time and reflection, our vision becomes transformed and finally one understands it: "Comprehension comes to us." Our self

is finally revealed through this time-consuming, painstaking research before nature. This is the point of "realization" (a term much liked by Cézanne) of this new, modern aesthetic and artistic program–defined by Zola in the 1860s–which will anchor the artistic pursuit and production of both artists for nearly half a century. This program of autonomy of one's individual sensation found its parallel and analogy in politics, in the program that advocated the total autonomy of the individual from the authority of the state.

Zola was the first to understand that parallel link between anarchy, on the one hand, and an ideological artistic program that refused the impact of any schools or traditions, on the other. Opposing "dictatorial" influence from any "great artist,"[78] Zola advocates cultivating one's own sensation:

We are on a full-throttle push toward anarchy, and, for me, this anarchy is a peculiar and interesting spectacle. Of course, I regret the fact that any great man–a dictator–is now gone; but then, I rather enjoy the spectacle of all these kings warring among themselves, of this kind of republic where every citizen is his own master at home. All around one are vast amounts of energy turned into action, feverish and ecstatic forms of life. One doesn't admire enough this sustained and obstinate fecundity within our own time: every day signals a new enterprise, a new creation. . . . Artists lock themselves up, each in his corner, and appear to work in isolation on their chef d'œuvre that will launch the next school; but there is no school: every one can and will become the master.[79]

With this premise, Zola sums up perfectly the new ideological program to which Cézanne and Pissarro wholly subscribed throughout their careers.[80] There is a paradox, however: if indeed this program emphasizes each artist's individuality (and his sensation), if, as Zola put it, each artist works in isolation trying to create his chef d'œuvre, why then did Cézanne and Pissarro need to work together?

"Serious Workers" of the Art World, Unite!

This paradox can be answered in two ways. The first is that an individual alone cannot demand his or her own rights without the support of others. The year 1863, with the famous Salon des Refusés, became the historical launching pad for such rights and saw the formation of groups with similar aims and ideologies. The Cézanne/Pissarro relationship started around this time and was considerably nurtured by this movement, which became known as Impressionism. The second answer to this paradox is that artists could no longer find proof of the validity of their works through an educational system which they rejected, or through masters whom they ignored. Each artist, therefore, had no other choice but to face the world alone, or to turn to his or her peers in order to find confirmation of what she or he is doing. Hence a new system of interaction develops: between peer and peer, as opposed to the traditional link between master and student in which the master passed the secrets of a time-honored artistic tradition to the novices. The Cézanne/Pissarro relationship was based on a peer-to-peer exchange.

Two phases marked the development of the new movement of Impressionism, the first being the "militant" and the second the "interchange." The two are not incompatible, and can even overlap to a degree. For instance, artists did share studios and exchanged ideas about work while also joining forces to assert their rights. However, it is fair to say that the militant phase was dominant during the first decade of these artists' collaboration. Once they attained a more public presence in the 1870s, they were more at ease in turning to each other for the sake of dialogues or interchanges. The Cézanne/Pissarro relationship was traditionally described as belonging to the second phase, since art historians have not focused much attention on the first decade of their relationship.[81] Eventually, in the 1880s, these artists acquired some public recognition and began to pursue their research more and more independently. We can call this phase the individualist phase. The Cézanne/Pissarro relationship is unique in that it spans three decades and moves from the militant phase to the interchange phase, and then to a point when each artist draws a lesson from the past and retains, from these years of rich exchange, what each needed to further develop his career.

The manner in which the group of artists, referred to as "notre communauté artistique" by Pissarro[82] and later known as the Impressionists, became acquainted conjures up the formation of a small private army of combatants who decided to impose,

not just a new form of art, but a new kind of art world. Even those artists who later in life became politically conservative (such as Pierre-Auguste Renoir) were at the forefront of a struggle against the prevailing powers and were intent on reforming, if not revolutionizing, the present institutions. Pissarro and Cézanne already knew each other in 1863 when they met other members of the group of rebellious artists. They both soon appeared to be the most radical and intransigent in their demands and complaints against the existing system.[83] Here is how Renoir describes his initial meeting with Pissarro and Cézanne:

That year [1863] I became acquainted with Cézanne. I then had a small artist's studio on the rue de la Condamine, in the Batignolles district. [Frédéric] Bazille [see fig. 19] and I shared that studio. Bazille was returning one day and was accompanied by two young men: "I am bringing you two great new recruits!" They were Cézanne and Pissarro.

I eventually got to know them both intimately, but I have an especially acute recollection of Cézanne. I don't think that you can find any artist who compares with Cézanne in the whole history of painting. When you think that he lived until the age of seventy, and from the day he held a brush he became as lonesome as if he was living on a desert island! Add the fact that he was passionately enthralled by his art, and yet he felt such indifference to his work once it had been completed.[84]

The term used by Bazille to introduce Cézanne and Pissarro ("recruits") is borrowed from military vocabulary and clearly alludes to the confrontational art scene in Paris at the time. Out of all these recruits, there is little doubt that Cézanne, with Pissarro's sustained encouragement and catalyzed by Zola's writings,[85] was the most vociferous and virulent opponent of the system. His letter to the Count de Nieuwerkerke, Minister of Fine Arts in the administration of the emperor Napoléon III, marks a cornerstone in the history of modern art in its opposition to the dominating institutions.[86] Cézanne had had two paintings rejected by the jury of the Salon of 1866.[87] He wrote a first (and lost) letter to the Minister of Fine Arts, which remained unanswered. The letter that survived is the second, insistent letter that almost reads like a manifesto. What is fascinating is that in his letter, Cézanne does not beg the minister to overrule the decision of the jury; instead, he simply declares that the decision of the jury is null and void, given the fact that

he–Cézanne–had not conferred upon the jury the "mandate" to judge his work: "I cannot accept the *illegitimate judgment* of colleagues to whom I have not given a mandate to evaluate me [emphasis mine]."[88]

Cézanne asks the minister not so much to amend the present system as to strike it altogether. He does not speak about reforms, but calls for a revolution, demanding that the members of the jury be replaced by the public at large (or "the crowd"): "I wish to refer the matter to the public and be exhibited regardless."[89] This individual claim would remain utterly naïve and meaningless–not to say puerile–on its own. Cézanne knew this. The reason why the tone of his letter is so virulent is that he speaks, not in his own name, but in the name of "all the artists who find themselves in [his] position."[90] In this sense, he adopts a position close to that of Karl Marx in the *Communist Manifesto*, in which he advocates the formation of a coalition

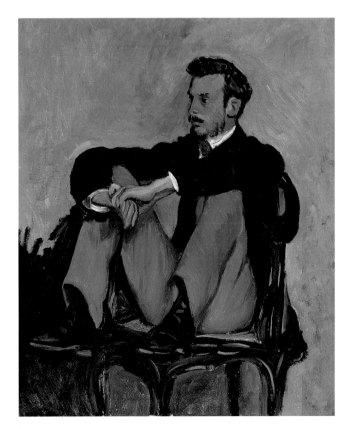

fig. 19. Frédéric Bazille
Portrait of Pierre-Auguste Renoir, Painter (*Portrait de Renoir*). 1867
Oil on canvas, 24⅜ × 20" (62 × 51 cm)
Musée d'Orsay, Paris

that will then have sufficient strength and power to reverse the existing social structures.[91]

Cézanne's letter is legalistic in tone and content, and threatening. It exposes two claims: one negative, one positive. The former is that the jury has lost its authority because all the artists in his position have refused to acknowledge the jury's members.[92] The latter is that they all demand to have their work shown in an exhibition "that must unconditionally be open to *all serious workers* [emphasis mine]."[93] The underlying assumption beneath these demands is that the artists—not the jury, or the emperor's own administration, or his ministers—are in control and have the ultimate power and authority to decide their own public destiny. Obviously perceived as an expression of wishful thinking on the part of a wild and cantankerous artist, Cézanne's letter was never answered by the minister, but was annotated by a clerk with this observation: *"Ce qu'il demande est impossible."* (What he's asking is impossible.) Eight years later, in 1874, the situation had evolved considerably, and the group of artists whose voice Cézanne represented had now given themselves the means and platform to exhibit their works publicly, without the assent of any jury. The legal charter binding these artists had been written—not by Cézanne, despite his two brief years in law school—but by Pissarro, who drafted the document defining the Société des artistes peintres, dessinateurs, graveurs, etc. de Paris,[94] i.e., the group of artists who were soon going to be called "Impressionists."[95]

Cézanne and Pissarro had played major roles in taking control of a situation that was radically transformed through their efforts and would never be the same again. The Salons continued to exist until well into the twentieth century, but they had lost their supremacy. Their unchallenged control over who could exhibit and sell one's works was fast becoming history, and Cézanne's threats (and his "impossible demands") were becoming reality. However, by deferring the rights to judge their works to "the public" (as the Impressionists did), they suddenly faced a completely different kind of challenge from the type of problems posed by the jury system. The public could not turn down their works, but they voiced their dismay, shock, and incomprehension. But a negative or critical public reception is better than no reception at all: this is the point Cézanne was trying to make in his momentous letter of

1866 to the Minister of Fine Arts, the Count de Nieuwerkerke.

The transition from an exclusive system in which artists were selected by a jury whose members were co-opted by each other to a system in which "every serious worker" was to be accepted—attractive as it may have sounded—also raised considerable problems. The first major question, inherent in the dynamics of modern art, was: What criteria of quality would be used to select these artists? Obviously sensitive to this question, Cézanne had first written in his letter that the jury-free exhibition he and his colleagues had conceived would be "open to everybody."[96] He then changed his mind and wrote instead: "open to every serious worker." Thus, Cézanne, who was holding regular discussions with Zola and Pissarro on these very concerns, introduced two criteria of selection: work and seriousness. Realizing that the anarchist-inspired conception of a show that would be open to "everybody"—regardless of their commitment or competence—would create a huge set of problems, Cézanne felt compelled to edit himself and introduce subtle criteria of acceptability.

It is noteworthy that the criteria Cézanne retained was the degree of an artist's commitment to his work rather than the quality of the works submitted. The notion of *work* became absolutely paramount to both Cézanne and Pissarro. Interestingly, Cézanne credited Pissarro on several occasions with having introduced him to the taste of *serious work*: "Until the age of forty I lived as a Bohemian: I wasted my life. It is only later when I got to know Pissarro, who was indefatigable, that I developed a taste for work."[97] Interestingly enough, Pissarro, too, in late autobiographical statements seemed to consider that his artistic career began around the age of forty: "I began to *understand my sensations*, to know what I wanted toward the age of forty, but only vaguely. When I was fifty—that is in 1880—I formulated the idea of unity, but was unable to turn it into practice. Now that I am sixty years old, I am beginning to see the possibility of turning this into practice [emphasis mine]."[98]

Both artists felt that coming of age artistically comes from hard work, which eventually delivers one's own "sensations." Pissarro tried to communicate his lifelong passion for work to any artist close to him, including his own children. To Lucien, an aspiring artist who was visiting London and having fun, his father tried to convince him that if he could develop a passion

fig. 20. Henri Matisse
Joy of Life (*Le Bonheur de vivre*).
1905-06. Oil on canvas, 69⅛" × 7' 10⅞" (175 × 241 cm)
© 2005 The Barnes Foundation, Merion, Pa.

properly. He's a painter just like me: your boy knows him. . . . He was a fanatic. A compulsive love of work got hold of me then. I don't mean to say that I hadn't worked before—I always worked."[102]

Cézanne always worked, but Pissarro turned him into a workaholic. Oddly enough, Pissarro used the very same words that Cézanne used—*"travail acharné"* (compulsive work)—to describe Gauguin's approach to work. Gauguin, after spending several years studying art with Pissarro, decided to abandon his family and his job in order to dedicate himself solely to art. With a touch of cynicism, Pissarro concludes that Gauguin "hopes to conquer his place in the art world through compulsive work."[103] But this compulsive taste for work came from Pissarro himself.

Pissarro's notion of work left no room for holidays, breaks, or moments of idleness. Work for him was a regulator of life and health: "Painting, art in general, enchants me: this is my life. The rest doesn't matter."[104] One can even assert that Pissarro approached work almost as a means of redemption. At one point he wished he could be a monk, who has the luxury of dedicating himself solely to his work: "I have to withdraw into myself just like the monks in the past, and then, quietly, patiently, I have to build up my œuvre. . . . I work a lot mentally: I now need to execute." [105] The obsessive need to work and to return to it over and over is also one of the defining characteristics of Cézanne, which he learned from Pissarro. To his mother, he wrote (as early as 1874, when he sees Pissarro very regularly): "I have to work always—but not in order to reach a finished state (which the idiots cherish)."[106] Almost word for word, Pissarro addressed the same complaint to Claude Monet, when, even as late as 1890, he described himself as overwhelmed with work, and complained that despite all the energy that he pours into his paintings, "We hear the reproach that we never finish anything."[107]

Shortly before his death in 1906—his mother, by then, long dead—Cézanne repeated virtually the same words to a friend: "I

for his art, it would be "perfection" because all his Sundays and holidays would become workdays and this would be so much fun! There would be "days of pure happiness and you just couldn't wait."[99] Doubtful as it is that Pissarro managed to convince his son of the veracity of this idea, he certainly managed to give Cézanne the same infectious and chronic obsession with work. Matisse, too, a late starter, like Cézanne and Pissarro, conceived of his oeuvre as an obsessive, single-minded pursuit: "From *Le bonheur de vivre* [fig. 20]—I was thirty-five then—to this cutout—I am eighty-two!—I have not changed . . . because all this time I have looked for the same things, which I have perhaps realized by different means."[100]

The same idea is further developed and phrased differently in Cézanne's conversations with Joachim Gasquet: "I must stay home, see nobody, work. . . . My business, my business! . . . it would be to reach satisfaction with myself. But I cannot. I never will. I cannot be satisfied. Until the war,[101] you know, my life was bogged down: I wasted it. It is only when I returned to L'Estaque, when I think of it, that I got to understand Pissarro

fig. 21. Jules Bastien-Lepage
Joan of Arc (Jeanne d'arc). 1879
Oil on canvas, 8' 4" × 9' 2" (254 × 279.4 cm)
The Metropolitan Museum of Art, New York
Gift of Erwin Davis, 1889 (89.21.1)

believed that art should be judged by taking into account the artist's self (his sensation, in Pissarro's and Cézanne's vocabulary; his temperament or personality in Zola's).[111] This idea of remaining faithful to oneself constitutes a defining thread of modern art. Pissarro couched the problem very bluntly, by opposing people who produced quality works as defined by the rules of the academy versus what he calls "art": "I remember at the Academy, there were some who were pretty skillful: they would draw with amazing assurance. Later in life I saw these artists again at their work: it was still the same skill, and nothing more. You remember [Jules] Bastien-Lepage [fig. 21]! And [Charles-Émile] Carolus-Duran [fig. 22]! Well, no, this isn't art!"[112]

The distinction between those artists who are technically skilled and those who produce true art oriented the practice of modern painting up to the late twentieth century. This radical rethinking of what constitutes a work of art represents one of the first major modern shifts that reoriented the value system of the art world. For instance, close to a century later, Sol LeWitt echoed Pissarro

always work, and I don't let the reviews and the critics worry me: just what a true artist should do. Work will eventually prove me right."[108] In a letter to Zola, he stated that it was only through work that one could reach true self-satisfaction,[109] and in his last letter to his son, a week before his death, he referred to work as providing "moral satisfaction."[110]

Both Pissarro and Cézanne developed an understanding of work that far exceeds its usual definition. For them, work attained an ontological dimension in that it became a way to "realize" one's self. To put it in negative terms, without work one could not become oneself. Thus, one understands why Cézanne and Pissarro placed such critical emphasis on *work* per se. They rejected the notion that a work of art must be created according to certain conventions and formulas, and

fig. 22. Charles-Émile Carolus-Duran
The Assassinated Man (L'Homme assassiné). 1865
Oil on canvas, 9' 2¼" × 13' 9⅜" (280 × 420 cm)
Musée des Beaux-Arts, Lille, France

and Cézanne almost word for word in one of his "Sentences on Conceptual Art" when he wrote: "When an artist learns his craft too well he makes slick art."[113] Pissarro would have basically agreed with LeWitt, although he probably would have been even more terse: to him, this "slick craft" did not even deserve the name "art."[114]

Indeed, Pissarro does run into a contradiction by refusing to call "art" what skilled artists produced. They are skillful artists, but they don't produce art: they only produce crafty objects. Zola faces the very same predicament and solves it by inverting the meaning of the terms used by Pissarro. For Zola, "art" is actually what skilled artists are producing: it is (the etymology of the word is *ars* in Latin) mere technique, pure craft, knowledge of tools and materials. What these "artists" produce is artful rather than artistic. But what Zola is looking for is not art in the sense of a technical craft but "life"! So Zola, responding to Pissarro's characterization of Bastien-Lepage and Carolus Duran, would have said: "You're wrong. These men are producing art—but it is art and nothing more. It is dead art. I want artists who produce life!"

While both Zola and Pissarro use the same term, "art," each gives it an opposite spin. Zola claims that the word displeases him for it contains the idea of some artificial arrangement. He sees the word "artifice" in "art": he sees art at the other end of what "man," "nature," and "beauty" stand for.[115] Pissarro understands the word "art" as precisely encompassing both man and nature. Both fundamentally agree about what they are looking for in a work of "art." Zola wrote: "I am in support of no school because I support human truth and this excludes any clan or system. . . . I want [artists] to produce life; I want them to be alive, I want them to create afresh, outside everything, according to their own eyes and temperament."[116]

Pissarro would have agreed, but would have used different terms. In the end, despite a few semantic nuances, they both wanted to change the art world from one dominated by cliques and controlled by jury members to one where "truth and life" (Zola's shibboleth) would become the main focus of artists. Later in life, Cézanne, further echoing Pissarro's distinction between true art and skill, bemoaned the fact that one of his good friends, Achille Emperaire (figs. 35, 36), had never been recognized by the academicians: "I still have a good old friend from the old days. Well, he never made it. With all this, he is a hell of a good painter, much better than all those frauds with medals and honors. It makes me want to puke."[117]

Ultimately, for all three artists, work—"serious work"—is paramount to a modern artist. It is not just any kind of artistic activity entered into with attentive zeal and dedicated industriousness. "Serious workers" (as defined by Zola, Cézanne, and Pissarro) are those who bring *life* into their work, and come to life through their work. Serious work is a kind of self-generating process in which artists take part in their own creation as artists. "Serious workers" are those "free artists who live outside, who seek elsewhere and further away the rough and strong realities of nature."[118] It was in *L'Événement*, in a series of articles published from February to May 1866, that Zola advocated the rights of those serious workers, as opposed to the complacent values of the members of the self-promoting academic system.

In 1866 Cézanne painted a picture of his father reading a copy of *L'Événement* (fig. 23). Here is an odd scene: this conservative, established banker and businessman is portrayed by his own son reading a radical, liberal newspaper from Paris. This monumental and profoundly moving work has a threefold dimension. Cézanne, by painting the portrait, is conjuring the presence of his father, who, as we saw above, had been reluctant, even firmly opposed to his son's undertaking a career as a painter. On the wall hangs one of Cézanne's still lifes with pears, which is rendered, in reality, with a thick, sensuous, and lush impasto (fig. 24). Cézanne manages to juxtapose quietly his own work with his father's presence. Louis-Auguste does not acknowledge the painting but seems serenely to accept its existence. Cézanne's father is absorbed in reading the issue of *L'Événement* in which appeared Zola's litigious attack on the biased jury and his precise and legalistic defense of those who place all their energy and hopes in serious work. Here then is a remarkable, logical, and transitive circle of progression: from Cézanne's acknowledging (in paint) the presence of his father; to Louis-Auguste Cézanne acknowledging (in reading) the presence of Zola; to Zola acknowledging and defending (in his article) the legitimate rights of Manet, Pissarro, and Cézanne. Cézanne knew full well that the notion of "serious workmanship," despite the radical edge that it assumed in Zola's writings, would speak volumes to the self-made businessman,

Louis-Auguste Cézanne. Ultimately, there is no more profound way to understand the content of this monumental painting than to recite a few lines by Wallace Stevens (quoted by T. J. Clark):

Farewell to an idea . . . The cancellings,
The negations are never final. The father sits
In space, wherever he sits, of bleak regard,

As one that is strong in the bushes of his eyes,
He says no to no and yes to yes. He says yes
To no; and in saying yes he says farewell.[119]

fig. 24. Paul Cézanne
Still Life: Sugar Bowl, Pears, and Blue Cup
(*Sucrier, poires et tasse bleue*). 1865-66
Oil on canvas, 11⅞ × 16⅛" (30 × 41 cm)
Musée Granet, Aix-en-Provence, France

If indeed Cézanne's father said "no" to his son's "no"—if he refused to acknowledge the "seriousness" of his son's opposing voice—then he was unwillingly contributing to the rebelliousness of his son. But, ultimately, Louis-Auguste seems to be saying "yes" to his son's "no," quietly acknowledging that these were the virtues that he (the father) had upheld the most that had given his son the strength to say "no" and turn his back on the system.

In the end, one can also place the narrative of this exhibition within the larger narrative described by Thomas Crow. At the onset of modern art, there was "a history of missing fathers, of sons left fatherless, and of the substitutes they sought. The sons in question were painters, and together they made a great project in art."[120]

From "Painting with a Knife" to "Painting with a Gun"

What constituted this "serious work" that Cézanne, Pissarro, and Zola spoke about? In the first known letter from Cézanne to Pissarro, dated 1865, he announced to his friend that he and Oller would bring canvases to the Salon jury that would "send [the members of] the Institute up the wall with rage and despair,"[121] and concluded his letter by saying, "I hope that you will have made some *beautiful* landscape [emphasis mine]."[122] Obviously, the notion of "beauty" to which Cézanne is here referring has very little to do with the notion of "beauty" under-

fig. 23. Paul Cézanne
The Artist's Father (*Père de l'artiste*). 1866
Oil on canvas, 6' 6⅛" × 47" (198.5 × 119.3 cm)
National Gallery of Art, Washington, D.C.
Collection Mr. and Mrs. Paul Mellon

stood by Alexandre Cabanel, William Bouguereau, and most of the academic tradition they incarnated. The academic definition of what was beautiful did not pose any question: "A work is said to have a beautiful 'effect' . . . when, after careful finishing, it remains imbued with, and, so to speak, radiates the inspiration and genius of its conception."[123]

The story is well known: the canon of such beauty was held to have been cultivated to its highest degree in Italy, and the function of the Academy was therefore to form students (or even to "mold" them) according to the noble Italian tradition. As per the Baron Gros's own admission, "My job is to mold artists and send them to Italy at the government's expense [through the Prix de Rome]."[124]

To a large extent, Cézanne's and Pissarro's conceptions of beauty turned the academic approach on its head. The very same term, *"beau,"* took on a completely different connotation with these artists. It is Pissarro's turn to mention the term when he writes to Oller and refers to what he, Cézanne, and Guillemet are expecting of Oller: "All three of us are counting on receiving a *beautiful* picture from you, and, please, nothing Jesuitical [emphasis mine]."[125] "Something beautiful," in their language, means something up to shocking the system. In fact, a *beautiful* work—or its superlative "superb"—can be evaluated in terms of its audacity, another term very much favored among this small avant-garde group. An important letter to Oller from Guillemet (and never published in English), dated September 12, 1866, gives us a firsthand account of the terms of reference shared by these artists. In a facetious and somewhat cynical tone, he describes the general art scene in France and then notes what Pissarro and Cézanne are about to send to the Salon:

My dear Oller,
Art is undergoing a profound crisis: buying paints has become prohibitively expensive. People no longer accept credit—it's all the artists' fault! Private commissions obstinately refuse to fall into our laps. And the jury—those felons!—keep rejecting us from the sanctuary!!! Times are terrible. Nature is littered with drunken artists' puke.[126] Pissarro alone continues to produce masterpieces. He is submitting something *superb* to the salon this year.[127] He even had the *audacity* to send a realist slice of paint to the universal exhibition. How naïve of him: he does not seem to know that France only wants to expose its foreign visitors to its least ugly productions. Cézanne is in Aix and has made a good picture.

He says so, and he is very tough on himself. He has also produced sketches that are *superb* in *audacity*: it makes Manet look like Ingres in comparison. Your student [Cézanne] has come a long way: you won't recognize him [emphasis mine].[128]

What unites Cézanne and Pissarro in Guillemet's letter to Oller is the "superb audacity"—and, therefore, the "beauty" in a modern sense—of the works they are producing. The term Guillemet uses to describe Pissarro's painting (plate 5) is the slang *"tartine."* A *"tartine,"* which is a slice of bread spread with butter or jam, suggests a surface that has been coated with thick layers of soft, creamy matter—any kind of paste (cream, jam, peanut butter). This term obviously emphasized the sheer physical thickness of layer over layer of paint, applied with a palette knife. The impact of thick layers of colored paste left a strong impression on a generation of early critics who looked at either artist's work.

The early works of Cézanne were almost forgotten until 1988, when an exhibition, curated by the late Sir Lawrence Gowing, brought these fascinating, awe-inspiring works to our attention.[129] In an article published almost a century before Gowing's exhibition, one of the first female critics of modern art, Cecilia Waern, wrote about Cézanne's "thick canvases" that she saw at Père Tanguy's shop. According to her, one could have sworn they were painted with "mud," even though there were some fortunate passages in the treatment of his figures.[130]

The letter from Guillemet, written as Pissarro sat beside him after a good lunch, reveals these artists' innermost beliefs toward the end of the 1860s. One sentence in particular sounds as a core principle or an axiom of this small group of artists: "Your eyes should see patches [*taches*]; your craft [*métier*] means nothing: impasto and a perfect pitch—this is the only goal you should strive for."[131] "*Pâte*" (impasto), "*justesse*" (perfect pitch), and "*voir par taches*" (seeing by patches):[132] these are the bare essentials of the new language that Pissarro and Cézanne, along with Guillemet, Oller, and a few others, were forging together. It is important to emphasize how the pictorial language these two artists had put in place, with the help of others such as Guillemet and Oller, was going to orient the rest of their œuvre. Cézanne remained attached all his life to this particular theme of "seeing by patches of color."

In 1903, in the last published interview that Pissarro gave,

he repeated Cézanne's theme when he told a journalist: "I can only see patches."[133] The artist's statement offers poignant and compelling evidence that the formation of Cézanne's and Pissarro's artistic careers in the 1860s was not—as so often claimed—just an experimental phase out of which they eventually both moved. The "patch" (*tache*) and the "touch" (*touche*) remained two fundamental building units in the pictorial language established by these artists throughout their lives. When one compares Cézanne's early portraits of Uncle Dominique (plates 7-9) with a later landscape of L'Estaque (plate 83), what is extraordinary is the fact that the early pictures are composed of so many "touches" of thickly layered, even plastered, chalk-hued oil colors slapped on the canvas with a palette knife. Although Cézanne, in his later works, did not (always) retain the inch-thick buttered surfaces, his procedure of building up the canvas, "touch after touch," had not changed much.[134]

Throughout their careers, a principal tension characterized the novel conception these artists gave to their métier. The axis of this tension centered around the opposition between *tache* and *touche*. Both artists used these terms often, and for this reason they need clarification, especially since each term has been translated in a variety of ways, depending on the translator. *Tache* has been translated as stain, patch, and even stroke. To add to the confusion, *touche* has also been translated as stroke (as in brushstroke) and as touch. For the sake of clarity, I have chosen to translate *tache* to mean "patch" and *touche* to mean "touch."

The term *tache* in everyday French refers to an area of color that is distinct from its support or background, for instance, a spot of color that is bleeding out on a surface, as in *une tache de vin sur une serviette* (a stain of wine on a napkin). The term *touche* (unlike *tache*) implies a certain action and control and suggests a small area of color applied by means of a device or a tool (a brush or a knife). Briefly stated, *tache* suggests a passive state while *touche* suggests an active one of control. Additionally, *tache* (especially in Cézanne's and Pissarro's vocabularies) refers to the presence of color that is there, beyond one's will. A "patch" of color calls for an act of vision to observe it. A "touch" of color, on the other hand, refers to a willful action and an act of construction. One thus understands differently the passage quoted above: "Your eyes should see patches [*taches*]; your craft

[*métier*] means nothing: impasto and a perfect pitch—this is the only goal you should strive for."

The artists' eyes have no control over the patches of color they see; their craft (i.e., the traditional technical skill learned at school) is unable to "transliterate" those patches. The artist needs a new language that will resort to impasto (the physical, creamy matter that comes out of the tubes of color) and a perfect pitch. This targeted act of control to pick up whatever amount of paint the artist needs out of his small mounds of color, laid on his palette, before transferring it on the canvas, is called a touch. At each instant, everything can go wrong: the touch (*touche*) is the act of objectivation of the patch (*tache*). Maurice Merleau-Ponty has best analyzed and expressed the nature of this paradoxical tension: "Quality, light, color, depth, which are out there before us [that is, patches] are so only because they awaken an echo in our body [that is, touches], because it makes them welcome." From this inner stimulus—what Merleau-Ponty calls "this fleshy formula of their presence that things evoke in me"—comes the act of construction (building up the canvas "touch after touch"): "a trace, visible in its turn, where every other eye will rediscover the motives which support its inspection of the world."[135]

Both Pissarro and Cézanne established a system of research—striving to build up a harmonic network of chromatic relations that would allow them to catch what they found (patches) before their eyes. The difference between the two artists is that Cézanne brought his viewer more openly into the process of building up his surfaces. He announced on his canvas how he worked. Pissarro, while following the same premise, was probably more concerned to reach an effect of smooth unity than Cézanne was. If, to resume Merleau-Ponty's language, a painting is " visible to the second power,"[136] one could say that the difference between Cézanne and Pissarro is that the gap between "the visible" and "the visible to the second power" was more extreme in Cézanne's work than in Pissarro's. However, in the formula they both sought, the terms they chose to express, their research was identical.

In the 1860s, both artists took this new language and pushed it to the furthest limits they could. To use Greenberg's famous expression, Pissarro and Cézanne went out *with a vengeance*, spreading layers upon layers of paint on their canvas. The notion

fig. 25. Paul Cézanne
Antony Valabrègue (Portrait d'Antony Valabrègue). 1866
Oil on canvas, 45¾ × 38¾" (116.3 × 98.4 cm)
National Gallery of Art, Washington, D.C.
Collection Mr. and Mrs. Paul Mellon

of "*pâte*" (impasto, or simply paste) is paramount to what they were trying to achieve during the 1860s. This way of painting—so visible in the *Still Life* or in *Uncle Dominique* (plates 5, 7–9)—was a synecdoche for a manifesto in and of itself. In a letter written by a friend of Cézanne's, Antony Valabrègue, there is a discussion of his portrait by Cézanne (fig. 25), in which he states the reason why this painting has no chance of being accepted by the Salon jury: "Paul will without doubt be rejected at the exhibition. A philistine in the jury exclaimed on seeing my portrait that it was painted not only with a knife but even with a *gun*. Many discussions already have arisen. [Charles-François] Daubigny said a few words in [its] defense. He stated that he would rather have pictures brimming over with audacity than the nullities that appear at every Salon. He didn't succeed in convincing them [emphasis mine]."[137] This ballistic metaphor was recurrently applied to Cézanne's work. Vollard mentions that an opinion among reviewers of the time was that Cézanne executed his painting by shooting a blank canvas with a gun filled to the brim with colors. This was known as "gun painting."[138]

This metaphor could apply to both artists in the 1860s. Painting with thick paste—couching coarse, leathery layers of

paint one on top of the other—became a language that affirmed its radical difference. They thus imposed their position in history by signaling a new departure, a revolution in painting. Guillemet describes, in colorful and student-like slang, this revolution:

We are painting on a volcano: the *1793*[139] of painting will soon announce its funerary march: The Louvre will be burned; museums and antiquities will disappear, and as [Pierre-Joseph] Proudhon said, from the ashes of the old civilization a new art will rise. Fever is burning in us. The gap between today and tomorrow is a whole century long. Today's gods are not tomorrow's: let's seize our weapons, and, with a feverish hand, get hold of the insurrection *knife*. Let us destroy and build again (*et monumentum exegi aere perennius*). Courage, brother. Let's keep tight ranks between us: there are too few of us not to share our common cause. They are throwing us out; we will shut the fucking door behind us. The classics are falling apart. Nieu[wer]kerke is slipping off his pedestal. Let us launch an assault and overtake that treacherous creature. . . . Let us only trust ourselves: Let's all build up paint with full impasto and dance on the bellies of those horrified bourgeois. . . . Work, old woman, keep up the courage: impasto, and just the right patches ["*taches*"] of color—and we will prevail in the end. Pissarro is sending his warmest greetings, and we all, including Cézanne, are hoping to see you soon.[140]

The "knife" refers both to a weapon and to a palette knife. Paint—or, more specifically, "paste"—is metaphorically described as a weapon of insurrection. Pissarro's still life and Cézanne's portraits of Uncle Dominique may not have much in common in terms of subject matter, but a phenomenal force and power emanate from these works. This force, or impact—almost in a military sense—did not fail to impress Barnett Newman a century later. Describing Cézanne's apples in an interview with Emile de Antonio, Newman said: "For a long time I was very antagonistic to those apples, because they were like superapples. They were like cannonballs. I saw them as cannonballs."[141] At the same time, the directness, frontality, and forthright power of the surface, packed with condensed pigments ("paste") that emanate from the still life, would have been enough to win Newman over to Pissarro: "Fantastic. Absolute totality," Newman said: "I suppose this is so because the light is even from corner to corner. No spotlights—Courbet and Pissarro are like that."[142]

Dialogues in Word and Paint

Truly speaking, it is not instruction, but
provocation that I can receive from another soul.

RALPH WALDO EMERSON[143]

Cézanne and Pissarro's Common Search for Simplicity: The Terms of Their Early Correspondence

As WE HAVE SEEN, during the 1860s Cézanne and Pissarro, with the help of others such as Oller, Guillemet, Guillaumin, and Zola, established the basis for a new artistic language that would afford them a variety of future opportunities. Not only did they claim complete autonomy from the formal artistic code that regulated the official system, but they also began to launch an attack against that system in a series of cogent exhibitions.

The bond between Pissarro and Cézanne was initially based on what they opposed rather than what they tried to impose. In the late 1860s and into the 1870s, with the formation of Impressionism, their cooperation took a different form. The dialogue that evolved became more closely focused on themselves as individuals, and on what they were actively attempting to achieve in painting, together or separately. A number of works executed during those years have a sustaining power that remains today.

Philosopher and sociologist Jürgen Habermas, who has extensively studied and written about the process of individualization through others, defines precisely the point that Pissarro and Cézanne had reached at the end of what we could call their militant period: "Standing within an intersubjectively shared lifeworld horizon, the individual projects himself as someone who *vouches* for the more or less clearly established continuity of a more or less consciously appropriated life

history; in light of the individuality he has attained, he would like to be identified, even in the future, as the one into whom he has made himself. In short, the meaning of 'individuality' should be explicated in terms of the ethical self-understanding of a first person in relation to a second person. A concept of individuality that points beyond mere singularity can only be possessed by one who knows, before himself and others, who he wants to be."[144]

Nothing could better symbolize the particularly rich moment that Pissarro and Cézanne had reached in the early 1870s than the pair of paintings with the identical motif of Louveciennes (plates 22, 23). Cézanne executed his canvas *after* Pissarro's own painting. These extraordinary works reveal a great proximity between the two artists; at the same time, each of them is allowed to preserve his own distinct identity. At the beginning of the 1870s, through several years of interaction, each artist knew who he wanted to be and how he wanted to appear before a special other. The artistic dialogue between the two took a new turn in the mid-1870s, although the basic language that they had elaborated together continued to be the language they would use until their deaths.

The ultimate paradox of what Cézanne and Pissarro strove for in the Impressionist decade was couched pithily by a critic who reviewed Pissarro's painting *The Banks of the Marne in Winter* (plate 1), sent to the 1866 Salon. As he put it, "Surely, nothing is more vulgar than this site, and yet I challenge you to walk in front of it without noticing it. It becomes original by the brusque energy of the execution, in some way underlining ugliness rather than attempting to conceal it. One can see that M. Pissarro is not banal because he is lacking in the picturesque. On the contrary, he uses his strong and exuberant talent to emphasize the crudeness of the contemporary world, in the manner of a satirical poet, all the more eloquent as he is telling the raw and unaltered truth."[145] This "raw and unaltered truth"

fig. 26. Camille Pissarro
L'Hermitage at Pontoise (L'Hermitage à Pontoise). 1867.
Oil on canvas, 35⅜ × 59" (90 × 150 cm). Wallraf-Richartz-Museum, Cologne

was enough to seduce Cézanne. If Pissarro was the first critic to point out the relevance of Cézanne's early works to his late works, Cézanne was the first critic who was in awe of Pissarro's works of the late 1860s. John Rewald quotes a painter, Louis Le Bail,[146] who had worked with Cézanne and who claimed that the latter used to say, "If Pissarro had always painted as he did in 1870, he would have been the strongest among us."[147] Later on, in a conversation with Gasquet, Cézanne seemed to be echoing this very expression, now using it to describe himself: "All the while being the first in my profession, I want to be simple. Those in the know stay simple."[148]

In his statement to Le Bail, Cézanne was referring to what Pissarro was doing around the time of the Franco-Prussian War (1870–71). He was also familiar with works executed by Pissarro two or three years earlier, which left a strong impression on him (see fig. 26 and plates 90, 92, and 94).

Cézanne's admiration for his friend's early work culminated in his borrowing a large-scale landscape by Pissarro done in

1871 (plate 22). Cézanne executed his own painting, not quite as large as the Pissarro, after the borrowed work (plate 23). This is one of the most compelling examples of a close artistic interaction between two early modern artists and is unique in the history of Impressionism. We have to wait until Derain and Matisse, who worked together in Collioure in 1905, or Braque and Picasso, who worked in close interaction with each other during the years preceding World War I, to find other examples of such intimate artistic relationships.

The same basic principles of invention were shared by both artists: "Don't bother trying to look for something *new*: you won't find novelty in the subject matter, but in the way you express it."[149] This principle may be one of the most important legacies that Pissarro passed on to Cézanne. However, at the base of it lies a paradox: In order to express the strength of your sensations, you needed a subject that was as neutral and inconspicuous as possible. In other words, a village street yields a far greater aesthetic return than a murder scene (fig. 27) as a

fig. 27. Paul Cézanne
The Murder (*Le Meurtre*). c. 1870
Oil on canvas, 25⅝ × 31¼" (65 × 80 cm)
National Museums Liverpool (Walker Art Gallery)

support to reflect an artist's sensations. What Pissarro had understood is that a subject that presents *too much* interest (great "novelty," sentimentality, horror, prettiness) risks overstepping the artist's own sensations.

The immediate and radical importance of this particular principle for Cézanne was that it allowed him to transfer the energy of his earliest subjects into a manner of painting that retained the original force of these subjects, while internalizing that particular force and transforming it into a new way of painting. It is obvious when we compare the two Louveciennes paintings by each artist that Cézanne took his cue from Pissarro, but went further in simplifying the overall composition, paying less attention to the atmospheric envelope that wraps everything in the Pissarro landscape (plates 22, 23). Finally, Cézanne can already be seen breaking away from the subtle scale of harmonious grays that characterize the Pissarro painting, while he begins to emphasize individual tones of color (red vermilions, oranges, yellows) that become more pronounced in his paint-

ing and distance his work ever so slightly from his older friend's work.

Paralleling this important transition in the communication they established through their art is the passage from their earliest thinking together to their more mature careers as noted in their correspondence. What is left of the original correspondence, however, is sadly sparse and incomplete. The largest bulk of the existing letters covers principally the Impressionist decade. We hear only one voice: all of Pissarro's letters were lost, but seven letters from Cézanne to Pissarro survived.[150] These documents, however, are essential and give us an irreplaceable sense of the tenor of their exchanges. These letters of the 1870s greatly contrast with the earlier correspondence between the two artists.

The first known letter by Cézanne to Pissarro, dated March 15, 1865 (mentioned above), started with the rather formal expression: "Monsieur Pissarro."[151] The tone of the letter was solicitous, Cézanne being uncharacteristically polite. He explained to Pissarro that he offered to help Oller "carry" his huge canvases to the Salon and that he would make a special effort to be at the Académie Suisse as soon as Pissarro tells him when he will be there. The letter ended with this loaded double entendre: "I hope that you will have made some *beautiful* landscape [emphasis mine]."[152] A year later, the formal address, "Monsieur Pissarro," had become the much more cordial and familiar address: "Mon cher ami."[153] This shows that even if Pissarro and Cézanne met around 1861, it was not until several years later that they actually became close friends. In this second letter, one of Cézanne's lifelong characteristics is revealed: his inclination to use scurrilous expressions and, on occasion, extreme curses.[154] He refers to his family as *"emmerdants par-dessus tout"* (they are bugging me beyond everything), and as *"les plus sales êtres du monde"* (the most disgusting people on earth).[155] The letter is written from Aix, and Cézanne tries to lure Pissarro to the south, telling him that Guillemet has completed a landscape, in gray weather, which he found very beautiful.[156] The implication is obvious: if Guillemet can do it, can

we imagine what you, Pissarro, would be able to do here! The letter was written in 1866 (the same year as Cézanne's famous letter to Nieuwerkerke); he, like Pissarro, refuses to send any of his works to the Salon of Marseille and uses the occasion to say "shit to the jury."[157]

Guillemet writes a note to Pissarro on the back of the letter sent by Cézanne, describing the latter's paintings: "He uses light golden tones again, and I am sure that you will be happy with three or four canvases that he will bring back."[158] Guillemet's expression is untranslatable: *refait blond* means using tonalities (again) that suggest the color of blond hair or straw. Such a color metaphor, *faire blond*, was not unfamiliar to Pissarro, as his erstwhile mentor, Corot, had recommended the tonality to him. Corot gave Pissarro what perhaps amounted to one of the first bits of artistic advice related to the color theory that he and Cézanne—as well as Georges-Pierre Seurat and Matisse—would put into practice all through their careers. Corot insisted that Pissarro should pay attention to color values: "Since you're an artist, you don't need advice. Except for this: above all one must study values. We don't see in the same way: you see green and I see gray and 'blond'! But that is no reason for you not to work at values, for they are the basis and the background of painting."[159]

"To see gray and blond" indicates more a modeling relationship between tonal values than a dominating color, or ultimately what Cézanne would call one's "coloring sensations"—one could almost speak about the color of a particular personality. Even when Pissarro himself used the same expression as Corot to describe the works of his first series in Rouen, in 1883 ("I have just unpacked my studies, my paintings: everything looks so *blond* to me [emphasis mine]"),[160] he, too, meant to designate the color that structured his sensations. Color appears to both artists as the medium (here in the sense of a mediation) between nature and the artist's own sensation. Upon examining a large corpus of their works through the decades, the surest thing is that, from year to year, their coloring vision changed greatly. In 1875, for instance, at the climax of their interchange, both artists seemed to be intent on "*faire vert*" (painting in "green" values) almost with a vengeance (see plates 64, 65).

Pissarro, Cézanne, and Impressionism

The decade and a half (1870-85) when Pissarro's and Cézanne's friendship matured coincided with the Impressionist era. By the early 1870s, the dream and threat to secede from the Salon and organize a group of independent artists had become a reality. Monet and Pissarro were leading forces in making this happen.[161] An explosive article by Paul Alexis, a friend of Zola's, published in 1873, gave that group of artists a final cue. The Salon jury was innocent, the journalist claimed, "because in art matters no jury can be other than ignorant and blind. Instead of attacking it—which doesn't help—let's be practical and abolish it."[162] What is noteworthy is that the same ideological vocabulary that had inspired Cézanne and Pissarro in their imprecations against the system some six or seven years earlier now found a public arena and a practical point of application. The broad democratic appeal of Cézanne's claim[163] found an echo in Alexis's article: these artists "require that all *workers* should become members [emphasis mine]" of their new association as they were hoping to represent all the "interests" of the artists, not their "systems" of preferences.[164]

The First Impressionist Exhibition, in 1874, held great hopes for its participants since it was the first time that they took their destinies in their hands. The point was no longer just to shock the system but to attempt to communicate to a larger public the message held by this new painting. Critics and artists worked hand in hand to transmit the message. Even the virulent Cézanne suddenly appeared much more diplomatic and pedagogic than one would have expected in the previous decade. A charming letter written to his mother openly refers to one of the raisons d'être of the Impressionist group, i.e., to establish a network of mutual peer support and critical feedback. Pissarro expressed a similar objective in his statement: "When we put all our soul into what we do, and pour our noblest intents into it,[165] we always end up finding a kindred spirit who understands us. They don't have to be many, but isn't that everything an artist must wish for!"[166]

Among the whole Impressionist group, however, Pissarro stood out for Cézanne. Pissarro's personal interest and admiration clearly meant a lot to Cézanne at the onset of the Impressionist era: "Pissarro isn't in Paris—he has been in Brittany for the

last month and a half—but I know that he has a very good opinion of me—and I have a very high opinion of myself, too."[167] In psychoanalysis, one could say that Pissarro's approval of Cézanne lifted the gate of his own self-approval. Cézanne goes on: "I am beginning to find myself stronger than all those who surround me, and, as you know, the high opinion I have of myself is not gratuitous."[168] This statement qualifies somewhat the commonly held view, stemming from Fry, that under Pissarro's influence, Cézanne would have had to "hold himself in." This statement is only partially true; but then, so is its opposite. Both artists obviously admired each other enough to want to gain the other's approbation; however, their relationship also liberated them and allowed them to explore new pictorial interests.

These interests were anchored by a common ideology and language, which gained in intensity and complexity throughout the 1870s. The two artists had already tested the ground on which they would continue to work and communicate with the world. "Language, when it *means*, is somebody talking to somebody else, even when that someone else is one's own inner addressee,"[169] wrote the critic Michael Holquist. The pictorial dialogues between Pissarro and Cézanne echoed this interpretation of verbal communication.

Throughout the Impressionist decade and a half, Cézanne and Pissarro both communicated and responded to each other, in paint and in words. Their output over this key period numbers several hundred works, among them about a dozen pairs of paintings of the same given motif, executed by each of the artists. Besides these very closely related works, the core of their exchange has to do with a constant give-and-take between them. What was essential was the relationship that tied each pictorial utterance to its response. This relationship had to do with their common aim: to keep searching for new modes of painting and exploring ways in which they could give a pictorial equivalent of their inner sensations. (They called this "*exécuter*.") Even the pairs of works produced at the same time, obviously very similar, are not alike. The relationship that binds one painting by one artist to another painting by the other artist is always different. As Holquist points out, the triangular nature of dialogues opens the present perspective to the future and to hope.

At the heart of all dialogues is the conviction that what is being exchanged is not worthless, but carries meaning. This becomes all the more poignant when the two interlocutors feel they are presently being misunderstood. It is always wise "to hope that outside the tyranny of the present there is a possible addressee who will understand them."[170] Pissarro refers to this addressee as a "*sosie*"[171] (a kindred spirit or a spitting image)—another self. It is highly likely that, in 1883, when he used that expression in a letter to his son, he was thinking about Cézanne. Pissarro states that this person had to be able to see something of interest in his own work, and be patient and compassionate.[172] Pissarro's reminiscence sounds nostalgic in 1883, when his relationship with Cézanne was becoming more and more strained. In fact, his letter seems to indicate that, by then, with Cézanne gradually moving away, he no longer seemed sure of finding such a "*sosie*." The joy inherent in an exchange seemed to have gradually been extinguished. Dialogues carry the hope of future resolution. They are necessarily oriented toward that future. At the same time, there is nothing that guarantees that resolution.

The tension inherent in all dialogues is what makes them both exciting and fragile. Philosopher Hannah Arendt described the fragile dynamic at work in any such interchange: "In judging these affects we can scarcely help raising the question of selflessness, or rather the question of openness to others, which in fact is the precondition for 'humanity' in every sense of that word. It seems evident that sharing joy is absolutely superior in this respect to sharing suffering. Gladness, not sadness, is talkative, and truly human dialogue differs from mere talk or even discussion in that it is entirely permeated by pleasure in the other person and what he says."[173]

There is no doubt that, beyond their common goal of establishing a new artistic language, Pissarro and Cézanne also wanted to use it, to live and experience their painting outside the sad, alienating context of solipsism. Yet, this dialogue can also occasion a more individual experience. Each painting by Cézanne or Pissarro can be read in terms of what Walter Benjamin declared, with a kind of self-referential intent: "No poem is intended for the reader, no picture for the beholder, no symphony for the listener."[174] Another way of expressing what Benjamin says is that ALL poems and pictures are, in fact, intended for a particular reader or beholder, who will be able

to reconstruct the full intent and message of the work of art. The problem is that this particular reader or beholder is almost impossible to find or might not even exist. "Super-addressees" are very scarce. Pissarro and Cézanne certainly knew this well, and it may ultimately be the cause of their intense and sustained relationship. It was deeply gratifying to both of them to have found a pair of eyes on which they could count for feedback and proper respectful criticism. At the same time, being someone's super-addressee can be a daunting job: integrity is a vital part of such a relationship. However, too much sincerity can sometimes be hurtful beyond repair. Such a relationship is, therefore, predicated on a fragile equilibrium between complementary and opposed psychological forces.

Pissarro and Cézanne remained each other's "super-addressees" for more than two decades: their mode of dialogue was to take the other's cue as a response to a previous message (work of art) and a provocation for another future message (work of art). Their artistic dialogue could (theoretically) have been endless, but it wasn't effortless. It involved constant attentiveness and consideration toward an ever uncertain future. We know Cézanne's "tempérament" (his character), his tendency to sudden mood swings. It is fair to say that this relationship required, at times, intense efforts on Pissarro's part. However, there is no question that this intersubjective exchange between the two was also supported and animated by a true, sincere friendship. Pissarro's wife, Julie ("Madame Pissarro," as Cézanne used to call her), also played an important role in this friendship. The rather touching pencil portrait by Cézanne of Julie Pissarro (fig. 28) testifies to the intimacy between not only Cézanne and Pissarro, but, in effect, their two families.

Julie was a woman with a deep-rooted practical sense. While her husband was often busy reflecting on the theoretical and political meaning of "autonomy" in anarchism or in art, she was busy making sure that their children had food to eat and their household was free of debt collectors or creditors. She too extended a warm welcome to Cézanne, his unwedded companion, Hortense Fiquet, and their six-month-old baby, Paul, when they decided to move near Pontoise so that the two male artists could work together with regularity. At that point, in 1872, the Pissarros already had three children, including a baby, Georges, who was born only a few months before the

fig. 28. Paul Cézanne
Portrait of Madame Pissarro (Portrait de Madame Pissarro). c. 1874
Pencil on paper, 15 × 11" (38.1 × 27.9 cm).
The William Woodward III Trust

fig. 29. Camille Pissarro
Study of Upper Norwood, London, with All Saints Church
(*Esquisse de Upper Norwood, London, avec All Saints Church*), 1871
Pen and brown ink over pencil, 5 × 4" (12.7 × 10.2 cm)
Ashmolean Museum, Oxford

Cézannes' baby. Julie certainly provided the Cézannes with what they did not have in the south: a friendly and hospitable family environment. Cézanne did not announce to his father the fact that he was living with Hortense, let alone that she had borne him a child. On the grounds of partly social and partly religious considerations, Julie herself had never been accepted by her mother-in-law, and had certainly suffered from the type of exclusive and elitist attitude that kept Cézanne and Hortense away from his own family. There is no doubt that these factors made the relationship between the Pissarros and the Cézannes all the more intense, and Cézanne, throughout his life, held Madame Pissarro in deep esteem for what she had done for him and his family.

Each artistic iteration provoked (to use a term echoing Emerson)[175] the other's next move. Pissarro, who left France during the Franco-Prussian War, realized, after he arrived in London (see fig. 29), what he was missing in France: the solidarity and comradeship of his friends, even though Monet and Daubigny were also there. "It is only when you're abroad that you realize how beautiful, great, and hospitable France is. What a difference from here [London], where all you gather is scorn, indifference, and crude behavior among colleagues. They are

all selfishly jealous and distrustful of each other: you see no art here. Everything is about money."[176]

The pleasure of finding a pair of benevolent and responsive eyes is all an artist needs, as Pissarro put it in another letter in which he describes the quintessential importance of a kindred soul. He mentioned that he sometimes felt scared to turn his canvases back from the wall and discover that he had created monsters,[177] those unrecognizable, incomprehensible creatures that can scare away the gazer and escape the grasp of language. The role of the kindred soul or the super-addressee, according to Pissarro, is to make it possible for the artist who has produced these monsters to face them and learn from them. It was also by using the metaphor of a monster that Pissarro referred to Cézanne trying to induce the art critic and collector Théodore Duret into buying one of Cézanne's works. Pissarro's sale argument was: "As long as you are looking for a five-legged lamb,[178] you will not be disappointed by Cézanne, for he has made some very strange works, conceived from a unique perspective [see fig. 30]."[179]

From the beginning of Impressionism (in the early 1870s) to the very end of Cézanne's life (1906), the attribute of "monstrosity" was attached to his work, whether it came from Pissarro's pen or from that of colleagues who visited him, or, eventually, from art historians themselves. Fry offers a prime example of this type of interpretation attached to Cézanne's early work: the Impressionist Cézanne, cured from this hallucination by the well-grounded Pissarro, would then have been able to mature. This is how Fry describes Cézanne's early "inner visions": "[They] show indeed extraordinary dramatic force, a reckless daring born of intense inner conviction and above all a strangeness and unfamiliarity, which suggests something like hallucination."[180]

Two artists, R. P. Rivière and Jacques-Félix-Simon Schnerb, who visited Cézanne at the end of his life, gave a very convincing account of the source of this "monstrosity" in the artist's later work. All his life Cézanne retained the same abhorrence for normalcy that he shared early on with Pissarro. What was called "the photographic eye" was not for them. "As for drawing per se, the element that can be arbitrarily separated from color, Cézanne vigorously declared his horror of the photographic eye that generates those accurate drawings, produced

by reflex, which they teach you at the École des Beaux-Arts."[181] Rivière and Schnerb then explained precisely what the main features of this "monstrous" art were about: "[Cézanne] was not defending the superficial incorrectness of his own drawing, this *awkwardness* [emphasis mine] which stems neither from negligence nor lack of talent, but which comes rather from excessive sincerity—if one can be permitted to use these words together—from an overzealous defiance of purely manual skill and a distrust of all movement in which the eye alone directs the hand without the intervention of reason."[182]

"Awkwardness" and "excessive sincerity," say Rivière and Schnerb; "disquieting" "want of proportion," "intoxication," or "romantic exaltations,"[183] says Fry about *The Orgy* (fig. 30). These are the terms that best characterize Cézanne's work. Interestingly, shortly after the penultimate Impressionist exhibition in 1882, Pissarro applied comparable terms to his own art: "Remember that I have a rough and somber mood, by character; my works look crude and wild. It will require a long time and a lot of tolerance before I can please anybody."[184] At various points in their careers, both artists saw their own works as coarse, crude, awkward—if not as plain "monsters," as Pissarro put it. It is almost certain that "excessive sincerity" was a factor that brought Pissarro and Cézanne closer together and led them to produce works that occasionally looked like monsters to them and others. They found in each other someone who would not only understand the monsters they produced, but would, in fact, support, encourage, and legitimize each other in their individual pursuits.

Yet, paradoxically, both artists wished to reach the same goal: harmony. What kind of harmony, then? "Art is a harmony parallel to nature" is perhaps Cézanne's most famous statement.[185] Only three weeks before the great Vollard retrospective of Cézanne's works, in 1895, and only a couple of years before this statement, Pissarro summed up what the Impressionist trajectory had been about: "Here is the true Impressionist way: nothing garish, but colors in harmony and value."[186] And Pissarro

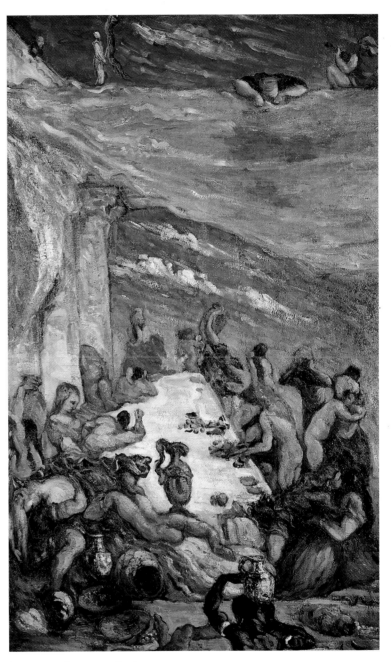

fig. 30. Paul Cézanne
The Orgy (Le Festin). c. 1867
Oil on canvas, 51¼ × 31⅞" (130 × 81 cm)
Private collection

fig. 31. Paul Cézanne
Cabaret Scene, and Head (*Scène de cabaret, et portrait*). c. 1856–61
Pencil on paper, 5⅞ × 9¼" (15 × 23.5 cm)
Musée du Louvre, Paris. Département des Arts graphiques,
under the Musée d'Orsay

fig. 32. Paul Cézanne
Portrait of Eugène Delacroix (*Portrait de Delacroix*). c. 1864–66
Lead pencil on paper, 5¼ × 5⅛" (14 × 13 cm)
Musée Calvet, Avignon, France. Gift of Joseph Rignault, 1947

concluded that this is highly noticeable, because it is very rare.[187] In his *Confidences*, Cézanne, in answer to the question: "What is your favorite color?" declares: "Overall harmony."[188]

Even though Pissarro and Cézanne shared the same vocabulary throughout the Impressionist decade, the balance between those polarized vectors ("harmony" versus "awkwardness") was very different in each case. Nothing tended to stand out in Pissarro's paintings; he was more interested than Cézanne in integrating the different tonal values into a unified whole. For Cézanne, however, if a particular patch of color stood out, or if a bottle ended up looking asymmetrical to him, it would be unapologetically the way it would be painted on his canvas or sheet of paper. This is how Rivière and Schnerb describe his method: "Cézanne fully recognized the asymmetry of his bottles and the defective perspective of his plates. Showing us one of his watercolors, he corrected with a fingernail a bottle which was not vertical, and he said, as if apologizing for himself, 'I am a primitive, I have a lazy eye. I applied twice to the École des Beaux-Arts, but I can't pull a composition together. If a head interests me, I make it too large.'"[189]

If one turns to both artists' works on paper, one can measure the closeness and dissimilarities in their approaches. A good number of these works illustrate the point made by Cézanne. They include *Cabaret Scene, and Head* (fig. 31),

fig. 33. Paul Cézanne
Portrait of Delacroix with various studies
(*Portrait de Delacroix, avec esquisses*). c. 1864–68
Pencil, pen, and wash on paper, 16¹⁵⁄₁₆ × 9⅜" (23.9 × 17.7 cm)
Kunstsammlung Basel. Kupferstichkabinett

fig. 34. Paul Cézanne
Portrait of a Man (*Portrait d'homme*). c. 1868-70
Pencil on paper, 5¼ × 5¼" (13.6 × 13.6 cm)
Private collection

fig. 35. Paul Cézanne
Head of Achille Emperaire (*Tête d'Achille Emperaire*). c. 1867-70
Charcoal on paper, 17 × 12¼" (43.2 × 31.9 cm)
Kunstsammlung Basel. Kupferstichkabinett

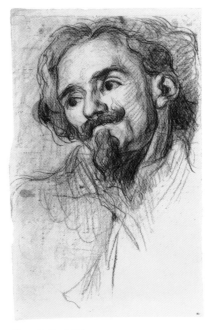

fig. 36. Paul Cézanne
Portrait of Achille Emperaire (*Portrait d'Achille Emperaire*). c. 1869-70
Charcoal and pencil on buff paper, 19¼ × 12¼" (49.6 × 31.8 cm)
Musée du Louvre, Paris. Département des Arts graphiques,
under the Musée d'Orsay

Portrait of Eugène Delacroix (fig. 32), and the *Portrait of Delacroix with various studies* (fig. 33), in which Delacroix's head is as large as any of the figures evoked on this sheet; and the quasi-caricatural *Portrait of a Man* (fig. 34), long thought to be a self-portrait. The most striking early examples are certainly the pair of pencil and charcoal portraits of his friend Achille Emperaire (figs. 35, 36) and the monumental painting (now in the collection of the Musée d'Orsay) depicting this friend, whose crippled body, frail and crumpled up, appears to be lost in a large armchair. The large head on top of this body contrasts forcefully with the rest of the full-length portrait.

At the other end of the Impressionist era, one finds portraits whose heads clearly interested Cézanne (as he put it), and ended up out of proportion: the portrait of Madame Cézanne (1886-87) or of Jules Peyron (c. 1885-87) offer perfect examples (figs. 37, 38). Cézanne made this declaration about the size of his portraits' heads to Rivière and Schnerb only a year before he died, and most likely he had in mind works he had recently executed, rather than earlier works. Indeed, his self-portraits from early to late offer other examples of this particular interest. *Self-Portrait* (1875; fig. 39) anticipates another *Self-Portrait* (c. 1902-06; fig. 40), a theme that finds its culmination in the artist's last painting, *The Gardener Vallier* (1906; fig. 41). One notices very analogous emphases and compositional procedures in many drawings by Pissarro. His *Three Studies of*

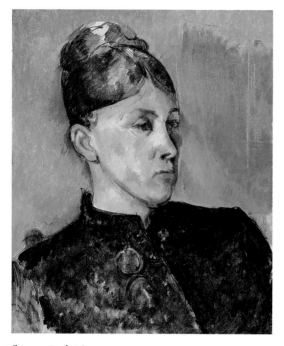

fig. 37. Paul Cézanne
Portrait of Madame Cézanne (Portrait de Madame Cézanne). 1886–87
Oil on canvas, 18⅞ × 15⁵⁄₁₆" (47.9 × 38.7 cm)
Philadelphia Museum of Art. The Samuel S. White 3rd and
Vera White Collection, 1967

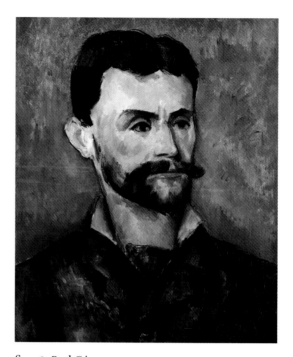

fig. 38. Paul Cézanne
Jules Peyron. c. 1885–87
Oil on canvas, 18¼ × 15" (46.4 × 38.1 cm)
Courtesy of the Fogg Art Museum, Harvard University Art Museums,
Cambridge, Mass. Gift of Mr. and Mrs. Joseph Pulitzer, Jr.

Lucien as a Baby (c. 1863; fig. 42) can be compared to Cézanne's studies of his son, for example.

Similarly, in the fascinating group of studies by Cézanne that Pissarro purchased (see fig. 43), one notes an obsession with repeating the same detail. This interest in repetition was exploited by both artists. Each of them could almost have stayed in the same place all their lives without ever getting bored. They both seemed focused and determined to mine a particular topic, or a particular model, once they had selected it. The repetitions of gestures in the Cézanne studies find an echo in numerous drawings by Pissarro spanning his entire life. See, for instance, the group of works showing female peasants either lying, bending, squatting on the ground, or working in the fields (figs. 44–47). As for the repetition of the same gesture on a given sheet of paper, the group of drawings of the 1860s by Cézanne must have struck Pissarro in the early 1880s because,

he too, at that particular point, was interested in testing how the same pose (caught in a snapshot) could vary ever so slightly and thus create a dynamic that is closer to cinematography than anything else (even though this art form had not yet been invented). Indeed, the relationship between Cézanne's drawings and Pissarro's drawings is rather striking. This strongly suggests, yet again, that Pissarro and Cézanne were constantly looking at each other's works and extends the chronology of their collaboration beyond the boundaries usually established.

As Jean-Claude Lebensztejn has pointed out, memory's part is enormously important in Cézanne's art.[190] It is no less important for Pissarro: "I am more than ever in favor of an impression evoked by memory."[191] In fact, each artist resorts to memory both as a creative mediation, and, as Pissarro puts it, as a mode of approach of "truth as glimpsed, as felt."[192] Besides, memory also offers knowledge of the other's work. Each artist constantly

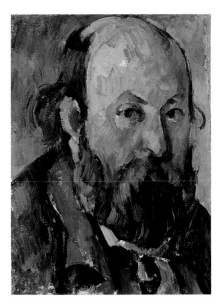

fig. 39. Paul Cézanne
Self-Portrait (Portrait de l'artiste). 1875
Oil on canvas, 10 × 7¼" (25.5 × 19 cm)
Foundation Hahnloser-Jaeggli. Villa Flora Winterthur

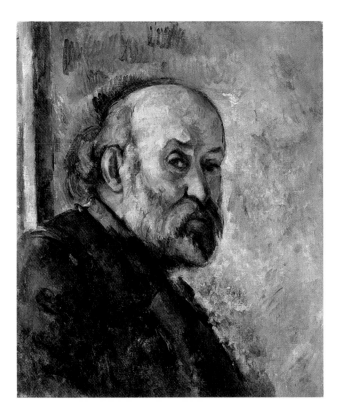

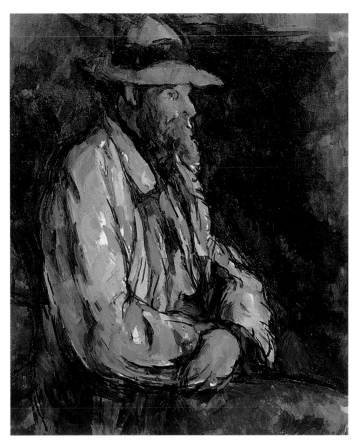

fig. 41. Paul Cézanne
The Gardener Vallier (Le Jardinier Vallier). 1906
Oil on canvas, 25⅜ × 21¼" (65 × 54 cm)
Private collection, New York

fig. 40. Paul Cézanne
Self-Portrait (Portrait de l'artiste). c. 1902–06
Oil on canvas, 21⅝ × 18⅛" (55 × 46 cm)
Private collection. Courtesy of Wildenstein & Co.

fig. 42. Camille Pissarro
Three Studies of Lucien as a Baby
(*Trois Études de Lucien comme bébé*). c. 1863
Pencil on paper, 8¼ × 13" (21.5 × 33.1 cm)
Ashmolean Museum, Oxford

fig. 43. Paul Cézanne
Arm Studies (Études de bras). 1867–69
Black crayon and pencil on blue paper, 6¹¹⁄₁₆ × 9⅞" (17 × 25.1 cm)
Collection Stephen Mazoh

refers to the other in three modes: through the present as a response to what the other is doing; through a future-oriented expectation of what the other's next move might be; and through looking back at, or thinking about, what the other used to do. Obviously, after 1885 (at the end of their last pictorial dialogue), the only mode of reference left to them would be through memory.

As we saw, during the time they worked together, both were profoundly attached to the principle of a division between art and mere skill—a division that would become part and parcel of any definition of modernism.[193] They repeated this all their lives. Pissarro used specific examples to compare Ingres to Hippolyte Flandrin: "The Flandrins are done much better, they are more correct than the Ingres! Yet what a great artist Ingres is!"[194] Who knows whether Cézanne's mother understood that important distinction between the "métier" (craft) involved in a painting that is "well done" (as Pissarro puts it) and a work of art per se that reflects the artist's inner truth (or sensation). Apparently, some of his close relatives—his wife, for instance—would have missed that subtle distinction, too. Hortense Fiquet, once seated at dinner next to Matisse, confided to him: "You know, Cézanne didn't know what he was doing. He didn't know how to finish his paintings. But take Renoir and Monet! They knew their painters' métier."[195]

fig. 44. Camille Pissarro
Study of a woman bending
(*Étude d'une femme pliante*).
c. 1875. Pencil on paper,
6 × 3⅝" (15 × 9.3 cm)
Ashmolean Museum, Oxford

fig. 45. Camille Pissarro
*Study of female peasant bending,
3/4 profile (Étude d'une paysanne
pliante, 3/4 profil)*. c. 1875
Pencil on paper, 5⅞ × 3⅝"
(14.9 × 9.3 cm)
Ashmolean Museum, Oxford

fig. 46. Camille Pissarro
Study of female peasants working in a field
(Paysannes travaillant aux champs). c. 1875
Pencil on paper, 6 × 3⅝" (15 × 9.3 cm)
Ashmolean Museum, Oxford

fig. 47. Camille Pissarro
Five studies of peasants harvesting (Cinq Études
des paysans faisant la moisson). c. 1875
Pencil on paper, 9 × 11⅞" (23 × 30.1 cm)
Ashmolean Museum, Oxford

Matisse was definitely not convinced by that much-rehearsed argument. To him, Cézanne knew exactly what he was doing. Matisse never met Cézanne, but he did know Pissarro. The two artists often discussed whether Cézanne "finished" his paintings or not. To Matisse, there was no doubt as far as Cézanne was concerned. As if in response to Fiquet's criticisms, he said:

I am very surprised that anyone can wonder whether the lesson of the painter of *The House of the Hanged Man* and the *Card Players* is good or bad. If you only knew the moral strength, the encouragement that his remarkable example gave me all my life! In moments of doubt, when I was still searching for myself, frightened sometimes by my discoveries, I thought: "If Cézanne is right, I am right" because I knew that Cézanne had made no mistake. There are, you see, constructional laws in the work of Cézanne which are useful to a young painter. He had, among his great virtues, this merit of wanting the tones to be forces in a painting, giving the highest mission to his painting.[196]

The terms used here by Matisse to characterize Cézanne would have easily applied to the relationship between Pissarro and Cézanne as well: each artist made what the other was doing seem right. Matisse was accurate on several issues regarding Cézanne. He was right to equate *The House of the Hanged Man* (1873; plate 36)–the major painting of Cézanne's Impressionist years–with *The Card Players* (1890-92; fig. 48) as examples of Cézanne's prime achievements that followed the same creative logic. The former painting was certainly the one Cézanne had in mind when writing to his mother, and it was indeed a critical part of Cézanne's and Pissarro's ongoing artistic dialogue at the time. *The House of the Hanged Man* was also a work that anchored Cézanne's presence in the public arena and in the incipient developments of modern art. Matisse also very shrewdly identifies the specific ingredients in the makeup of this work.

Indeed, *The House of the Hanged Man* is very structured and painstakingly worked out,[197] despite the lopsided and awkward configuration of the terrain that it depicts. Both Cézanne and Pissarro went on exploring the structural elements in their landscapes, throughout the 1870s. This is something they may partly owe to their knowledge of some of Corot's Italian pictures.[198] It offers a precise and close parallel with Pissarro's *The Climbing Path, L'Hermitage, Pontoise* or *L'Hermitage, seen from the Rue de la*

fig. 48. Paul Cézanne
The Card Players (Les Joueurs de Cartes). 1890–92
Oil on canvas, 53⅛ × 71½"
(135 × 181.6 cm)
© The Barnes Foundation, Merion, Pa.

Côte du Jalet, Pontoise (both 1875; plates 57, 58). Both artists seem to derive pleasure from constructing compositions based on solid and strict constructional laws, while the motifs of their compositions threaten to fall apart, or, at the least, are based on a very lopsided ground axis.

Beneath these careful constructional laws, the technical innovations of both artists during those years are truly fascinating. Research carried out in the laboratories of the French museums in the last twenty years,[199] supplemented by recent analyses by Jim Coddington at The Museum of Modern Art, have revealed, through radiographs taken of works by Cézanne and Pissarro, that both artists began to evolve a peculiar technique that consisted of delineating the contours of the objects depicted (houses, trees) "in reserve." The physical result, obvious through X-rays and observable by the naked eye, is that a millimeter-thin furrow of exposed canvas "draws" a line–a line of non-matter–around the contours of the objects (figs. 49, 51). This strange technique consists of painting the contours of

the objects "in reserve." The artist literally holds the brush all around tree trunks, walls, roofs, and thus creates a thin ridge that highlights the volumes of the objects depicted.[200] No one has given a pithier definition of what painting in reserve consists of than Rivière and Schnerb: "A form is created only by its neighboring form."[201] Or again: "Cézanne did not use lines to represent forms. Contour existed for him only as the place where one form ended and another began."[202]

This way of establishing a divide made out of a ridge between two blocks of paint sounds very modern. It goes back to the practices of Pissarro and Cézanne during the late 1860s and 1870s. Jean-Paul Sartre himself could have had Cézanne's or Pissarro's paintings in mind when he defined a painted image as a *"manque défini"* (a defined blank). Sartre coined this very apt phrase that perfectly applies to Pissarro and Cézanne in this specific instance of painting in reserve: the object *"se dessine en creux"* (the drawing of an object gets furrowed out in negative).[203] Naturally, this relatively recent discovery opens

fig. 49. Camille Pissarro
Orchard, Côte Saint-Denis, at Pontoise (*The Côte des Boeufs, Pontoise*)
(*Le Verger, côte Saint-Denis, à Pontoise* [*La côte des boeufs, Pontoise*])
(detail of plate 76)

fig. 50. Paul Cézanne
Orchard, Côte Saint-Denis, at Pontoise (*The Côte des Boeufs, Pontoise*)
(*Le Verger, côte Saint-Denis, à Pontoise* [*La côte des boeufs, Pontoise*])
(detail of plate 77)

fig. 51. X-ray photograph of Camille Pissarro's *Orchard,
Côte Saint-Denis, at Pontoise* (see plate 76)

up further avenues of research. For instance, before Pissarro and Cézanne, who else painted in this way? Courbet did, to a degree, in that he scraped his canvas with his palette knife, leaving thinly applied slabs of paint contiguous with each other, and he might have been a source for this peculiar technique. Before the nineteenth century, did any painter paint "in reserve"? These questions remain to be explored further.

The main result of this technique is that it establishes a discrete physical contrast of volumes between the objects and their contours, the objects and their backgrounds. It is as if the objects painted took off from the canvas: they are raised (almost like a soufflé) due to the accumulation of layer upon layer of dry paint. In an X-ray photograph, the radiation goes through the negative, unpainted contours, leaving a "black" delineation around painted objects where, in fact, there is no paint (see fig. 51). The result is that houses and trees look, in the X-ray, as if they had been drawn with a thick charcoal or a thick black line, whereas, in reality, this line corresponds literally to nothing, or more precisely, to the radiation going freely through the canvas, unimpeded by paint. These lines (indicating the thin ridges of unpainted canvas) designate the objects in absentia. They are especially visible in Pissarro's *Hill at L'Hermitage, Pontoise* (1873) and in Cézanne's *The House of Doctor Gachet, Auvers-sur-Oise* (c. 1872–74), and, later on, in Pissarro's

fig. 52. Camille Pissarro
Small Bridge, Pontoise (*Le Petit Pont, Pontoise*)
(detail of plate 64)

fig. 53. Paul Cézanne
L'Étang des Soeurs, Osny, near Pontoise
(*L'Étang des soeurs à Osny, près de Pontoise*)
(detail of plate 63)

Orchard, Côte Saint-Denis, at Pontoise[204] (1877; plates 40, 38, 76). This technical innovation can be read as a development of the method of building up a composition by patches (*taches*) and of eliminating drawing or carefully delineated contours. It will have vast repercussions throughout the course of modern art.

One should not conclude, however, that Cézanne and Pissarro were so enamored of their new technical discovery that they applied it to every one of their works. In fact, what is most characteristic of both artists throughout their careers is their careful avoidance of systematic formulae that could encapsulate their practice within a set of given parameters. Take the year 1875, for instance. Such paintings as Pissarro's *Small Bridge, Pontoise* and Cézanne's *L'Étang des Soeurs, Osny, near Pontoise*,[205] or Pissarro's *Rue de l'Hermitage, Pontoise* and Cézanne's *Road at Pontoise* (plates 64, 63, 55, 54) reveal yet another kind of technical innovation: both artists apply paint with a palette knife and juxtapose these flattened areas of paint, smoothly spread with a flexible metal blade on the canvas, with marks of their brush, loaded with wet paint (figs. 52, 53). The physical contrast between the painting in reserve method and this other method is often startling: it feels as if both artists made every effort to experiment with two polarized techniques of paint application. This latter method not only pulverizes the result of what painting by reserve had established; it also seems to push the pictorial game in opposite directions, just to see how far each artist can stretch his own *métier*. This peculiar juxtaposition of two methods lasted only about a year, around 1875. Then other pictorial problems arose that revolved around the question of how to deal with the massive, complex effervescence of a myriad of visual effects in nature. See, for instance, Pissarro's *Kitchen Garden, Trees in Flower, Spring, Pontoise* and Cézanne's *The Garden of Maubuisson, Pontoise* (both 1877; plates 68, 69). Finally, Cézanne's discovery of the so-called constructive stroke introduced yet another technical component that complicated the already multifaceted dialogue between the two artists.[206] (See "Pissarro, Cézanne, and the Crisis of Impressionism," pp. 59–64.)

Another observation that hinders any effort at defining what they were attempting to do during the Impressionist decade is that even while they were both sitting side by side before the same motif, they were not always necessarily applying the same technique synchronically, as it were. This became especially true for the works they presented to the Third Impressionist Exhibition, of 1877. See, for instance, the paintings by both artists titled *Orchard, Côte Saint-Denis, at Pontoise* (plates 76, 77 and figs. 49, 50). Both works represent the same plot of landscape, the same site. In each case, the technical solutions retained by each artist appear to be at the antipode

fig. 54. Camille Pissarro
Kitchen Garden, Trees in Flower, Spring, Pontoise (Potager, arbres en fleurs, printemps, Pontoise) (detail of plate 68)

fig. 55. Paul Cézanne
The Garden of Maubuisson, Pontoise (Le Jardin de Maubuisson, Pontoise) (detail of plate 69)

of what the other is doing. If one compares the *Orchard* paintings by both artists (plates 76, 77 and figs. 49, 50)—especially with the help of raking-light photographs and X-radiographs—one can see that Pissarro's work (plate 76) was executed essentially with a dry brush that slowly accumulated a thick crust of pigments, built up to a quarter-of-an-inch-thick layer of granular matter. This crust of oil pigment is clearly and dramatically created by painting in reserve (fig. 51): the ridges of unpainted matter that delineate the densely packed tree trunks, as well as the architectural units in the background, are so visible with raking light that one feels one could be looking at a three-dimensional map of a hilly landscape with valleys and meandering rivers.

In utter contrast, the painting of the same motif by Cézanne (plate 77) seems to present its viewers with an opposite set of problems. It is painted deliberately flat: the surface is built up with a palette knife that has thinly drawn the paint on the canvas, creating masses of smooth matter built up one on top of each other (fig. 50). Yet, it would be wrong to assume that Cézanne had decided to return to the 1875 mode of painting that he and Pissarro practiced assiduously (juxtaposing palette knife and brushwork in a most unusual way). Cézanne's painting, with its radically opposite method of paint applica-

tion, appears to be anti-Pissarro at this singular point. One could make similar observations (though perhaps not quite as dramatic) when comparing Pissarro's *Kitchen Garden* and Cézanne's *The Garden of Maubuisson* (figs. 54, 55).

The point is that it is absolutely impossible to identify *one* set of technical procedures for Pissarro, for Cézanne, and for Pissarro and Cézanne. Even if it appears fair to say, at this point in our research, that both artists paid a great deal of attention to the potentials of painting by reserve, it by no means exhausted their prodigious technical audacity and curiosity. Each artist seemed intent on one thing: constantly searching for new procedures or exploring new avenues of painting. Indeed, these artists were telling the truth when they claimed that their aims were to find ways of "rendering" (translating) their "sensations" in paint, but that this process was complex and difficult, because ceaselessly in flux and, therefore, almost impossible to achieve. Ultimately, their works challenge any attempt to categorize them in neat chronological sequences. Both artists seemed perfectly happy to return to the technique of painting without reserve after their discovery of the "painting in reserve" method; this did not stop them from resuming, independently or together, the same method again, when it suited them. And the same observations should be applied to

the "constructive stroke" method.[207] Their work executed in common adopted the form of a conversation: it took two to lead it; each person took his cue from the other; and, as in a conversation, there was absolutely no way to predict how their pictorial exchange would evolve or end when looking at it at the beginning. The beginning did not matter more than the end. The process of the exchange was what mattered most. They followed no other rules than to take into consideration what the other had just been uttering (in paint).

Some of the critics of the First Impressionist Exhibition, of 1874, searching for a common denominator among the members of this new group, found that these artists appeared to smear three-quarters of their canvas with black and white paint and, then, would randomly pick up patches (or stains) (*taches*) of red and blue.[208] Of all these "stain artists," Cézanne was singled out by one of the rare early collectors, who bought some of his works: the opera singer Jean-Baptiste Faure. The critic in question actually targeted Faure himself, as if he was responsible for Cézanne's own sins: "It is true that M. Faure has always been keen on doing things differently. To buy works by Cézanne is surely one way–as good as any–to draw attention to oneself and to produce self-promotion that is equal to none."[209] Faure was compared by the critic Émile Cardon to a precise equivalent of today's British advertising giant Charles Saatchi: buying works of art served to create a "sensation"[210] that in turn would be used as a tool of publicity.

Faure was indeed well known to both Pissarro and Cézanne. In 1873 he sold his collection of paintings by Corot, Delacroix, Jean-François Millet, and Théodore Rousseau, which enabled him to buy important works by Monet, Alfred Sisley, Pissarro, and Edgar Degas. He purchased Pissarro's largest painting ever, *L'Hermitage at Pontoise* (c. 1867; plate 92), now at the Guggenheim Museum, from Durand-Ruel. This painting, it is fair to say, retained a tremendous impact on Cézanne, so that, even during his last stay with the Pissarros in 1881, the painting continued to haunt him. Cézanne's famous *Mill on the Couleuvre near Pontoise* (c. 1881; plate 93)–executed about twenty years after their initial encounter–would be difficult to imagine without the presence of Pissarro's *L'Hermitage at Pontoise* of 1867, which Cézanne must have held in the back of, or even close to, the front of his artistic imagination. This example further compli-

cates the terms of the artists' exchange. In 1881, while painting with Pissarro, Cézanne seemed to be more interested in what Pissarro had been doing in 1867. This, of course, may have contributed to the beginning of the end of their relationship. Few comments hurt a living artist more than to be told that what is presently being done is not as good or interesting as what was done in the past.

Another reason for their gradual estrangement by the 1880s was that Cézanne did not succeed in persuading Pissarro to come to Provence and prolong their artistic exchange on his own turf. In one of the most beautiful letters written, in 1876, by Cézanne to Pissarro, the Provençal artist tried to lure his old friend to the south of France. Cézanne suggested that Pissarro should think of joining him because, there, he would find his happiness in painting. Pissarro would discover just what they had always been specializing in: "*impossible*" things. Cézanne knew what he was saying and to whom he was saying it. Their favorite artistic projects were those so hard to do that they would lose their minds in them: "I would gladly avoid speaking about *impossible* things, and yet I always end up tackling projects that are the least likely to be completed. I have figured out that the countryside where I am staying would suit you wonderfully [emphasis mine]."[211] Almost in direct echo to this, Pissarro, a few years later, wrote to his son to describe his first series of paintings in Rouen. He had begun a few sketches and "the next day, it was *impossible* to pursue. Everything was in shambles. The motifs were gone: it's just *impossible*, you have to do it all in one go [emphasis mine]."[212] In his search for the *impossible*, Pissarro had certainly found his match in Cézanne and vice versa.

The countryside near L'Estaque, described in Cézanne's letter, would have been a perfect fit for Pissarro because there he could tackle things that were just *impossible* to do. Cézanne's bait didn't work, however, and Pissarro–probably largely due to family reasons, but also because he felt a certain revulsion for the sea–never joined Cézanne in the south. Cézanne continued to write to Pissarro, describing what he was doing in L'Estaque and what Pissarro was missing in terms that he and Pissarro had coined together.[213] Cézanne referred specifically to *The Sea at L'Estaque* (1876)–one of the first paintings he executed in the south on the basis of the common experience of the artists (fig. 56). He explained to Pissarro that he had initi-

ated two sea motifs for the collector Victor Chocquet. The landscape, according to Cézanne, looked like a set of playing cards placed against a colored background. He described how he saw a red roof detaching itself from the background sea, and felt as if one could lift it off this background, just as one picks a card off a table. The problem with this description is that one is not absolutely sure to what this metaphor applies: what the artist is seeing in front of him or the painting he has just done. *The Sea at L'Estaque* is not a very large painting, and Cézanne explains that he will need to come back to it and "push it up to the end."[214] This expression, "pushing a painting up to the end," is also used by Pissarro. In one of his numerous maxims to his son Lucien, he said: "I recommend one thing, which is to do your utmost to push things to the very end of where you began. Yet, I know full well myself of the difficulty, or the difficulties—always unexpected—that come and assail you in the open air."[215]

Cézanne interestingly measures his project of painting in L'Estaque on the scale of the vast projects that Pissarro (and he) had tackled in Pontoise. He lays out his plan to spend at least a month in the countryside, "because one has to do here paintings that are at least two meters [over six feet] wide, just like the one you sold to Faure."[216] Indeed, the Faure painting (plate 92), massive as it is, can understandably have appeared to Cézanne as if it had been composed like a card game. One plane of solid color—whether it be a deeply saturated brown, or a slate blue color, as in the rooftops—was applied next to another plane of beige or creamy white color (to depict the walls' chalky surfaces). Each component (each "playing card") is its own unit and could almost be lifted off the rest of the canvas, one after the other (metaphorically). Naturally, the fact that these massive color planes were applied on the canvas while the artist had carefully left the delineating contours of the objects in reserve considerably enhanced this "playing card" effect described by Cézanne. The Faure painting was certainly one of Cézanne's favorite works by Pissarro. It had a great impact on him, and on his vision of L'Estaque. It sounds almost as if Cézanne was borrowing Pissarro's eyes to cast his own vision of L'Estaque.

Cézanne also suggested that the motifs in L'Estaque are so

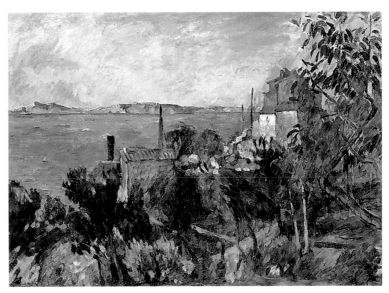

fig. 56. Paul Cézanne
The Sea at L'Estaque (*La Mer à l'Estaque*). 1876
Oil on canvas, 16⅛ × 23⅜" (42 × 59 cm)
Estate of Dr. Rau

big that they would demand much *work* and energy and, therefore, two people would not be too many to tackle such a challenge: "There are motifs we could find here that would require three or four months of work. These are olive trees and pine trees: they always keep their leaves."[217] Cézanne suggests that nature was even on their side. The trees, in the south, retain their leaves, so that Pissarro could come back and forth freely, without any detriment to his work. Nature is slow to move in the south and therefore provides an ideal setting for artists such as Pissarro and Cézanne, who were slow workers.

John Elderfield, chief curator of painting and sculpture at The Museum of Modern Art, pointed out in an unpublished lecture that Cézanne approached his motif almost as a lizard drinking up the sun—a metaphor borrowed from Pierre Bonnard: "According to Bonnard, Cézanne would sit motionless in the landscape, like a lizard in the sun, patiently waiting and watching the shifting scene for the appearance of what he wanted to catch in paint. This description is based on early eyewitness accounts of Cézanne not touching his brushes for a long time, both before starting to paint and between setting down individual brushstrokes—a length of time that kept increasing, as the stories were repeated, to an improbable

twenty minutes between each brushstroke."[218]

Another appeal of the south that Cézanne used in his "marketing" ploy to entice Pissarro to paint there was the quality of the light. Cézanne used to say that he preferred to paint in "pale gray light." In a letter written in 1874, Cézanne had referred to another painting by Pissarro, *Railway Crossing at Le Pâtis, near Pontoise* (1873–74; plate 82), in order to describe the spectacle that Cézanne was facing in the south. Here again, Cézanne's strategy consisted in suggesting that Pissarro should come down and see for himself the place where Cézanne worked because he would find that nature looked exactly like his own paintings: "Now that I have just reacquainted myself with this countryside [Aix], I believe that it would make you totally happy, for it is amazing how it reminds me of your study of a stop on a railroad track, in full sunlight, in the middle of summer."[219]

Already then, in 1874, Cézanne was quietly hoping that Pissarro would come south: the climate would be much better suited to the health of his children (who were often sick), and nothing would impede Pissarro from working steadily. All in all, Cézanne had lots of compelling arguments to draw Pissarro to his own home. In a letter to Pissarro of 1876, he wrote: "The sun is so startling that it makes it look as if objects could be lifted off in their outlines, which are cast not just in black or white, but in blue, red, brown, purple. I may be wrong, but it seems to me that this is the polar opposite of modeling."[220] In other words, nature, due to the light, looks as if it were to be painted in reserve,[221] the key technical innovation they had created together. As Cézanne suggests, the light in the south, in highlighting the elements of nature in the same way as they painted them in the north, seems to be imitating their work. In 1905, a year before his own death, and almost *thirty* years after this fascinating letter was written to Pissarro, Cézanne wrote to Bernard, drawing the ultimate consequences of this peculiar technique of applying planes of color, next to one another, without any kind of "modeling" (or shading) between them, nor any drawing. "Now that I am old, about seventy years old,[222] coloring sensations that provide light force me to produce abstract passages that stop me from covering my whole canvas, or from pushing to the full the delineation of objects when the points of contact between them are too fragile or delicate."[223]

Cézanne's description corresponds precisely to the definition of "painting in reserve," but pushed to its extreme conclusion, which Matisse will further explore at about that time. The artist leaves the lines of contact between objects open. "The result," Cézanne warns us, "is that my image or my painting is incomplete."[224] Each part, each component, can seemingly be lifted off the surface of the canvas, just as a playing card can be picked up from a table—or as a plane of color could seemingly be lifted off the canvas, as in the Faure painting (plate 92). The south, in Cézanne's eyes, offered a positively ideal laboratory for both artists to continue to make their own pictorial discoveries. Yet, Cézanne never managed to convince Pissarro to join him in painting the motifs around Mont Sainte-Victoire or in L'Estaque. Even though there is no document to support my conclusion, I am quite certain that Cézanne must have felt bitterly disappointed.

The two artists met again in Pontoise in 1881 and worked very closely for a few months. In all likelihood, they met again and worked together for a much shorter period during the summer of 1882. There they executed the last pair of paintings together, sitting side by side, twenty years after they first met (plates 96, 97). If Rewald's dating of the group of 1881 works is accurate, then some of Cézanne's paintings done then were based on the very motifs of paintings by Pissarro dating several years earlier. An example is *L'Hermitage at Pontoise* (plate 95), which resumes the motif of Pissarro's painting, *Gardens at L'Hermitage, Pontoise,* of 1867–69 (plate 94). Another example, *Turning Road, Auvers-sur-Oise* (plate 89), resumes the same motif that Pissarro had executed seven years earlier (plate 88). Unlike the work by Pissarro, which displays a smooth and unbroken surface, the painting by Cézanne has been covered with salvos of paint marks thrown at the canvas with amazing rapidity and no less impressive mastery. Infra-reflectographic examination of *Turning Road, Auvers-sur-Oise* provides evidence of some very loose, yet clearly observable, underdrawing—pencil lines that seem to have provided a rough indication of how to plot the bare essentials of his compositions.

At first glance, one might think that these are pairs, even though, in fact, in each of these cases, the painting by Cézanne and the painting by Pissarro were executed several years apart. Another painting by Cézanne corresponds to a painting of the same motif by Pissarro depicting a bridge and done several

years earlier (plates 86, 87). This group of works, when viewed together, were clearly executed using very different techniques, despite the proximity of the motifs. The textures of their surfaces, as well as their chromatic makeups, have relatively little to do with each other. This can be partly explained by the fact that from the early Impressionist years to the 1880s, both Pissarro and Cézanne had been experimenting with several different technical procedures. Therefore, one cannot be surprised that a painting of 1881 by either artist looks very different from an early Impressionist painting by the other artist. The surprising element here is that Cézanne would have decided, in 1881, to revisit some of the motifs that Pissarro had depicted in 1867 or 1873-74 (see plates 86, 90, 92). Cézanne seems to have been intent on re-engaging with the early Pissarro, by memory, but had little to gain from looking at, or working with, the Pissarro of 1881. The first signs of a crisis were in sight.

Pissarro, Cézanne, and the Crisis of Impressionism

The efforts to find ways of painting without modeling,[225] that is, without the subtle gradation of values (from light to dark), provoked the beginnings of a crisis between Cézanne and Pissarro. Instead of modeling, Cézanne and Pissarro preferred what Cézanne, in his late years, called "modulation," i.e., creating a sensation of depth or relief by merely juxtaposing contrasts of color next to each other. These innovations, however, inherently carried the germs of their own crisis. Indeed, at that point, in the mid- and late 1880s, Pissarro and Cézanne chose radically different pictorial solutions to further the point they had reached in their art. This, I believe, largely precipitated the end of their relationship.

 As we have seen, painting in reserve consists essentially in blocking out and juxtaposing planes of color with little or no modeling at all and without the auxiliary of drawing. This method consists in painting with no lines, that is, the lines of separation between the various blocks of paint (e.g., between the wall of a house and its roof) are effectively "no lines," or, more accurately stated, they are lines of no paint, slivers of non-matter. Well before Matisse would draw the ultimate consequences of this dichotomy,[226] Cézanne and Pissarro,

fig. 57. Camille Pissarro
View from Upper Norwood, London (Vue de Upper Norwood, London). 1871
Pen and brown ink over pencil, 4 × 5" (10.2 × 12.7 cm)
Ashmolean Museum, Oxford

fig. 58. Paul Cézanne
Still Life with Spirit Lamp (Nature morte: "pain sans mie"). 1887-90
Pencil on paper, 12¼ × 19⅜" (31.8 × 49.2 cm)
Private collection

throughout the Impressionist decade, put to the test and radically critiqued the traditional hierarchy between drawing and painting. In fact, for both artists, drawing became largely an autonomous activity that was in no way ancillary to painting (figs. 57, 58).[227] Conversely, painting produced its own drawing through the juxtaposition of areas of color. One could say that

once the traditional connections between drawing and color began to loosen, the whole system of tradition began to shake. The notion of "crisis" was locked, therefore, at the inner core of the Cézanne/Pissarro exchange from the beginning.

Once color began to become autonomous and contours (traditionally drawn in pencil or charcoal, or indicated with a brush and wash) could literally be pulverized, there was a consequent liberation that could essentially go in different directions. Color could be broken down into a myriad of fractured strokes of paint which, combined according to certain rules, would yield a greater sense of reality when reflected in the retina. This was the direction in which Seurat and Paul Signac were headed, and Pissarro adopted it shortly after his last contact with Cézanne in the mid-1880s. The other possible direction was to give color a freer status than ever, allowing it to dictate its own logic or its own system on the canvas. This was the direction followed by Cézanne. Art, then, became a system of harmonies parallel to the artist's sensations and to nature. "Art is a harmony parallel to nature," Cézanne famously declared, as one of his shibboleths.[228] "Parallel" here also means "equivalent," and it implies, by definition, that art is no longer subservient to nature, as Cézanne was quick to emphasize in the same letter in which he referred to those "imbeciles" who think that nature is superior to art.

Eventually, even though the directions they opted for were different technically and artistically, Pissarro and Cézanne continued to resort to the same language to explain their goals and intentions. Using a synonym of "harmony" to explain his technical goals, Pissarro favored the term *"accord"* in French, which describes the harmony between two musical notes: "When I start a painting, the first thing I strive to catch is its harmonic form [*'l'accord'*]. Between that sky and that ground and that water there is necessarily a link. It can only be a set of harmonies [*'relation d'accords'*], and this is the ultimate hardship with painting."[229]

By the mid-1880s, Cézanne and Pissarro had pushed their research to the point where their art could have moved in any number of directions. The last preserved stage of interaction between the two artists, in 1885, has remained almost uncharted by art historians because of the lack of documents that establish firmly that the two artists actually saw each other.

But given the frequency of Cézanne's visits to the north of France, his regular visits to Zola, and his trips to Paris, it would have been truly extraordinary if he had not seen his old friend. I therefore assume that the two artists saw each other, or, most importantly, had, at the very least, indirect knowledge of each other's work by 1885—either through Zola or through the handful of very close friends and dealers they both still shared. Skeptics would say that an event undocumented could not be an event. I would respond by saying that the extreme proximity of texture of Pissarro's canvases with Cézanne's offers a strong document of the fact that each knew full well what the other was doing (see plates 103, 104). Despite his very precarious finances, Pissarro still found a way to "buy himself" a handful of studies by Cézanne from the famous art dealer Père Tanguy. These consisted of a small oil study of the mid-1860s, with a subject vaguely inspired from mythology,[230] together with three preparatory drawings (see fig. 43).[231]

Through Père Tanguy alone, therefore, Cézanne and Pissarro continued to be aware of each other's work at that particular critical point in their careers. Pissarro, always supportive of Cézanne, even convinced Signac to buy a Cézanne (plate 103) at that point.[232] Pissarro wrote a letter to his son Lucien in 1884, in which he described a confusing political situation. He used the example of a painting by Cézanne as a metaphor: "This is just like a picture by Cézanne that you would stick under your own nose."[233] In order to get a proper understanding of the political situation, or to properly grasp a painting by Cézanne, you need to stand at the right distance: neither too far, nor too close. The details of several plates in this catalogue illustrate Pissarro's point very well (see pages 77, 147, and 204).

All this goes to prove that Pissarro and Cézanne were still closely aware of each other by the first half of the 1880s. Whether one is looking at Cézanne's *Village Framed by Trees* (c. 1881; plate 100), or at the exquisitely dry and fresh-looking oil sketch of a landscape at Osny by Pissarro (c. 1883; plate 102) or Pissarro's *Church and Farm at Eragny* (1884; plate 101), blocks of color are seen floating away on all three surfaces of the canvas, regardless of its author. Furthermore, all three paint surfaces are broken down in diagonally oriented flows of color touches. One cannot, therefore, imagine Pissarro's *Landscape at Osny* having been executed without his having seen Cézanne's works

of the mid-1880s. The parallels between the Pissarro painting and the Cézanne painting are striking. There is one small difference, though. By 1886 or 1887, Pissarro seems to have begun to introduce into his work a thin scaffolding of light wash drawing that held together these mosaics of color markings. Twenty years later, in a letter written to Bernard in 1905, Cézanne addresses, with amazing lucidity, the problems that marred the end of Impressionism and precipitated its crisis. Written exactly a year (to the day) before Cézanne died, this letter, in which the aging artist famously promises to tell Bernard "the truth in painting,"[234] carefully examines the method of his late work, in contrast to and in distinction from the Neo-Impressionist method. In other words, he is rehearsing mentally the point of his artistic separation from Pissarro. Cézanne had closed his previous letter to Bernard with a postscript in which he declared that studying modifies an artist's vision, and, therefore, Cézanne concluded, Pissarro was finally justified in his anarchistic theories.[235]

He resumes his next letter (almost as if he was teaching a seminar on "the truth in painting") by developing the same idea. Cézanne's "thesis" (as he calls it himself) is that, however strong or weak an artist's character ("*tempérament*") might be, an artist should try to forget all previous sensory perceptions before standing or sitting in front of a canvas. Forcing this mental block, the artist must simply "give an image of what we see"[236] totally detached from what might have been perceived before. This remained a hinge through the ideology of modern art: the myth of returning to some kind of detached looking that was to allow us to see reality afresh, and, by the same token, understand modern art. Half a century later, Jackson Pollock echoed this sentiment when he himself considered that "passive looking" was the best approach to his own paintings. Asked in an interview "how [the public] should look at a Pollock painting," he replied: "I think they should not look for, but *look passively*—and try to receive what the painting has to offer and not bring a subject matter or preconceived idea of what they are to be looking for."[237]

It was by looking at the art of the recent past—and especially at that of his then-deceased friend Pissarro—that Cézanne attempted to understand better the point of divergence that Pissarro and he had reached by the mid-1880s. In doing this,

he realized that it is hardly possible to "give an image of what [one] sees" in complete detachment. Cézanne is still heavily invested in the issue at hand. His resulting critique of Neo-Impressionism is fascinating, albeit hardly neutral. Near the end of his life, as quoted earlier, he wrote, "[C]oloring sensations that provide light force me to produce abstract passages that stop me from covering my whole canvas, or from pushing to the full the delineation of objects when the points of contact between them are too fragile or delicate. As a result, my image or picture remains incomplete."[238]

In this text, written in 1905, Cézanne describes in his own words what painting in reserve meant for both artists: to leave the delineations of objects incomplete and the points of contact between them, however thin, bare and empty. The old Cézanne logically infers from this very technique (which he explored with Pissarro some thirty or forty years earlier) that he came to paint "by abstractions" (i.e., by juxtaposing planes of solid color throughout his canvas), and that, as a result, he cannot possibly bring many of his canvases to completion. This is one of the most lucid and complete exercises of self-critique that one can read in the history of modern art. No wonder Bernard felt so completely riveted as Cézanne promised him *the truth in painting.*"

In the same letter, however, there is a very elliptical passage that is somewhat difficult to follow because (like Pissarro's epistolary style) Cézanne often assumes that his reader can fill in some of the mediations that he skips. Following the logical thread of "painting by abstractions" (or what he and Pissarro also called "painting by patches"), Cézanne produces a very pithy report of what happened in the mid- to late 1880s. As a counterpart to this technique of painting by abstractions, he wrote: "[O]n the other hand, the planes [of color] fall on top of each other—this was the source of Neo-Impressionism, which circumscribes the contours [of objects] with a black line: this is a downside that you have to fight with all your might."[239]

One notes Cézanne's virulent tone here. The letter was written almost twenty years after the incipient stage of Neo-Impressionism, the short-lived artistic movement that never directly affected Cézanne. Yet, he speaks about it in 1905 as if it were still a curse to watch out for. Why? Because Cézanne lost Pissarro, his best friend and ally, to its cause (for a while).

In this letter, Cézanne, with concise and synthetic intelligence, did not only teach Bernard the "truth in painting," he also offered him a summary of the history of early modern painting. Here is a brief reconstruction of the logical sequence and its ensuing dilemma that Cézanne poses to the younger Bernard: 1. *Coloring sensations* lead the artist to cover the canvas by "abstractions" (or by "patches"); 2. By definition, these patches or abstractions–like so many slabs of color–do not allow the artist to cover his canvas in the way Ingres or Flandrin applied paint solidly throughout their canvas; 3. This method of painting by patches or abstractions makes objects look like playing cards that can be lifted off the canvas; 4. The first possible option is to let these patches of color organize themselves on the canvas without overlapping: without delineated contours, or drawing, the patches float by themselves, and the painting cannot but look incomplete even though the colors (if the painting is successful) fall into some kind of organization almost by themselves.[240] (This is the real difference between Cézanne and Pissarro: Pissarro will use the same technical method of applying paint on the canvas as Cézanne does, but will never quite dare to "push" it to its ultimate conclusion.); 5. The second possible option is to let these patches of color overlap with each other: the planes of color then appear to fall on top of each other. There is no choice but to insert a structure and an organization within this mosaic of colors. This is what Cézanne sees as the Neo-Impressionist solution, which begins (for Pissarro) by reintroducing delineated contours drawn in black.

The first option (number 4) was the logical and ultimate consequence of painting in reserve for Cézanne. The second option (number 5) describes the system put in place by Pissarro's version of Neo-Impressionism to counterbalance the sense of "incompleteness" of the picture, and the autonomous status of patches of color. As Cézanne describes the situation to Bernard, Neo-Impressionism (in Cézanne's mind, Pissarro's version of Neo-Impressionism) begins from the same premises as his own: in both systems, color sensations led each artist to cover his canvas with patches of color. But whereas Cézanne took these premises to the point where these planes of color coexist (float) with each other on the canvas, according to their own logic, Pissarro's Neo-Impressionist solution allowed these

planes of color to "fall on top of each other." In order to counter the apparent randomness of colors looking as if they have been thrown one on top of another, the Neo-Impressionist Pissarro needed to reintroduce a classical and orderly device. This was the ominous "black contour," which held colors in check by stopping them from "falling on top of each other." By reintroducing these black lines (drawing into painting), Pissarro was seen by Cézanne as having betrayed what they had fought for since the 1860s (see figs. 61, 62).

Rewald added an interesting (but, in my opinion, partly inaccurate) comment to this most important letter-seminar addressed by Cézanne to Bernard on the history of modern painting. According to him, Cézanne was not targeting Seurat– and I think that he is absolutely right in this. Both Robert Herbert and Douglas Druick, who have spent more time than anyone else looking closely at Seurat's works, confirmed in recent conversations that they never saw a painting by Seurat in which the artist used black contours to delineate objects or figures (see fig. 59). Instead, however, Rewald suspected that Cézanne was referring to Cloisonism, i.e., a form of painting, practiced by Bernard himself, together with Louis Anquetin, in which

fig. 59. Georges-Pierre Seurat
Port-en-Bessin, Entrance to the Harbor
(*Port-en-Bessin, entrée de l'avant-port*). 1888
Oil on canvas, 21⅝ × 25⅝" (54.9 × 65.1 cm)
The Museum of Modern Art, New York. Lillie P. Bliss Collection

objects usually consisted of solid planes of vivid color sur-rounded by heavy black delineations (fig. 60). According to Rewald, therefore, Cézanne did not quite know what he was talking about and confused Neo-Impressionism with Cloisonism.

Here, I think, Rewald was wrong. Cézanne was not talking about Seurat's Neo-Impressionism, but about *Pissarro's* Neo-Impressionism. Cézanne's firsthand knowledge of Neo-Impressionism came not so much from Seurat as from his old friend, Pissarro. Indeed, Cézanne was right: as Pissarro suddenly embarked on his Neo-Impressionist adventure, black contours began to surface in his work, thus suddenly turning on its head the practice of painting in reserve. See, for instance, *Church and Farm at Eragny*, *Landscape at Osny* (plates 101, 102), and *Woman Hanging Laundry* (fig. 61), which is a preparatory study for *Woman Hanging Laundry* (fig. 62). The oil sketch of a woman hanging her laundry (fig. 61) is executed in a way that reminds us of the last interchange between the two artists. The flurries of diagonal strokes of paint covering the ground reveal visible segments of black contours all around the two figures. This was the exact opposite of painting in reserve and a sudden aban-donment of what Cézanne and Pissarro had established in the early 1870s.

Black contours around objects were, according to Cézanne, "what you have to fight against with all your might." Both Cézanne and Pissarro agreed with this statement in the 1870s. In 1886 Pissarro abandoned this principle and began to explore an altogether different idiom. Cézanne remained loyal to their earlier discoveries and tried to see how far he could push them. At this point, they no longer had much to say to each other. The irony, though, is that it was most certainly the lesson of the Cézannes of the mid-1880s and the first "floating" touches of paint that made it possible for Pissarro to turn to Seurat and Signac and adopt Neo-Impressionism while adding his own unique inflections (such as the introduction of light-black wash contours delineating painted objects). And it was after they had come so close again to painting exactly like each other (plates 103, 104) that they took different artistic paths that would never quite cross again. Had their art become too close for comfort? Was Cézanne afraid that he was falling under the grip of his old friend? (In his later years, one of Cézanne's favorite expressions centered on his fear that anyone

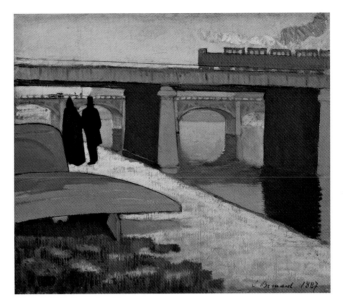

fig. 60. Émile Bernard
Iron Bridges at Asnières (*Le Pont de fer à Asnières*). 1887
Oil on canvas, 18⅛ × 21⅜" (45.9 × 54.2 cm)
The Museum of Modern Art, New York. Grace Rainey Rogers Fund

would "*mettre le grapin*" on him—a slang expression that means "hold someone in one's grip.") It is impossible to know the answer exactly.

The separation between Cézanne and Pissarro was sudden. There seems to have been no dialogues between the two lead-ing up to it, as if it were a natural and inevitable development of their more-than-twenty-year relationship. In characteristic fashion, Cézanne left the north abruptly and without explana-tion. Pissarro simply took note of it, as if it was business as usual, through somebody else: "I was told that Cézanne had gone back to Marseille."[241] The matter-of-fact tone of this statement in a letter sent by Pissarro to Monet implies that he found noth-ing unusual in this brief report.

From a pictorial point of view, they had begun taking very divergent paths. As suggested above, Pissarro's declination of Cézanne's repeated invitation to follow him to the south might have played a part in the dissolution of their relationship. Cézanne's decision to stay with Renoir at La Roche-Guyon in July 1885 rather than with the Pissarros may have been due to the fact that Renoir had visited him in 1882 and again in 1883, when Renoir and Monet were traveling along the French and Italian Rivieras.

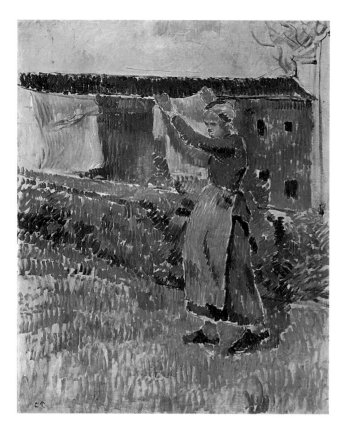

fig. 61. Camille Pissarro
Woman Hanging Laundry (Femme entendant du linge). c. 1887
Oil on board, 28⅞ × 23¼" (73.3 × 59.7 cm)
Galerie Adler, Paris

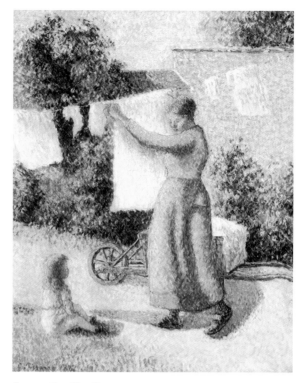

fig. 62. Camille Pissarro
Woman Hanging Laundry (Femme entendant du linge). 1887
Oil on canvas, 16⅛ × 12¾" (41 × 32.5 cm)
Musée d'Orsay, Paris

But even if Pissarro had stayed with Cézanne, it is doubtful that the aging Cézanne would have tolerated the sustained company of an artist—even a close friend like Pissarro—for very long. As Lebensztejn says very convincingly, Cézanne was ticklish about anything that touched his intimacy or his private space.[242] In 1885 Cézanne was indeed feeling very "ticklish" about his personal life, having begun an affair and asking Zola to accept letters sent to him by his lady friend.[243]

Edmond Jaloux has summed up our own conclusion on the subject: "It was difficult to keep his [Cézanne's] friendship for very long. Any pretexts would be good enough for him to get rid of someone. The slightest influence, the slightest intimacy seemed dangerous to him."[244] In the end, one of the most surprising features of this friendship between Pissarro and Cézanne was that it lasted so long and nurtured repercussions that largely shaped the rest of their artistic careers.

Reviewing the Past and Facing the End

History in the Making and the Vollard Exhibition: Pissarro's Review of Cézanne

THE LARGE-SCALE RETROSPECTIVE exhibition of Cézanne's works, organized by Vollard in his Paris gallery in November 1895, provided the first occasion for the public to become acquainted with Cézanne's career. This date also launched the entry of Cézanne in the history of modernism. Vollard's exhibition had a huge impact on Pissarro, who mentioned this show several times in his correspondence, unafraid of repeating himself. For him, it was a major artistic event that consecrated the importance of Cézanne, while bringing late validation to his unflagging admiration of Cézanne's work. He first acknowledged the exhibition in a letter to one of his nieces: "There is a very complete Cézanne exhibition at Vollard's: some still lifes that are surprisingly finished, and things left incomplete, but all of it is extraordinary in character and wildness."[245] Pissarro's closing phrase in his letter, however, was to be proven wrong: "I don't think many people will understand it."[246] About a week later, in a letter to his son, he introduced the subject again by saying how rare it is to find a "true painter," one who, according to Pissarro, knows "how to set two tones of color in harmony."[247] He mentions a list of artists, including Signac and Gauguin, who fail the test, in Pissarro's book. Only Cézanne makes it. Pissarro mentioned again the contrast between certain still lifes that are "flawless in their degree of finish" and those that, he tells us, were "left half-done." And, yet, Pissarro believed that the latter were even more beautiful than the former, thus agreeing (in anticipation) with the 1905 letter Cézanne will send to Bernard.

Pissarro's letter includes mention of Cézanne's landscapes, his nudes, some heads left unfinished—and, yet, all of these works were, to Pissarro's eye, "grandiose, so painterly, so easy and soft."[248] The ultimate cause for this resounding success was that in every single work, one could find Cézanne's *sensation*. This exhibition of his old friend's work was, for Pissarro, a revelation and a reaffirmation. He was in admiration of "the peculiar and disconcerting qualities of Cézanne, which [he] had been experiencing for many years."[249] Degas and Renoir profusely reinforced Pissarro's enthusiastic views and made him feel that he had been right about Cézanne all along. However, this feeling of certainty that Cézanne was one of the rare "true artists" would also come at a price: not everybody was prepared to credit Pissarro with recognizing, early on, the importance of this artist.

This reacquaintance with Cézanne and his art probably came as somewhat of a nice and heartening surprise to Pissarro, all the more so since the period that led from their separation, in 1885, to the Vollard show had been fraught with problems for Cézanne, whose emotional balance seemed to grow more and more precarious. It is most likely that Pissarro and Cézanne saw little of each other between 1885 and 1895. We know that Cézanne took a pied-à-terre in Paris, on the Quai d'Anjou (on the grand Île Saint-Louis), in 1888, funds from his father's estate allowing him to live more comfortably. But the fact that he had a second home in Paris did not bring him closer to his old friends. On the contrary, the reputation for complete isolation that surrounds Cézanne in the last twenty years of his career was witnessed by several of his closest friends. Renoir (who, among all the Impressionists, seemed to remain most loyal to Cézanne after he and Pissarro no longer saw each other) went to stay with Cézanne in Aix at the beginning of 1888. He soon departed, however, due to "the black stinginess that has taken hold of this place."[250] Guillaumin (with whom both Pissarro and Cézanne had worked in the late 1860s and early 1870s) told art dealer Eugène Murer that Cézanne had been institutionalized in a mental asylum.[251] Oller, his erstwhile friend and mentor at the Académie Suisse, was invited

by Cézanne to accompany him to Aix after the Vollard exhibition. Cézanne left Paris without telling him, and when Oller asked Cézanne what had happened, he was sent a letter of virtual insults, before Cézanne finally broke off all contacts with him a few weeks later.[252] Despite these growing difficulties, Cézanne was undoubtedly in contact with certain key individuals, such as Monet, the collector Chocquet (who died in 1891), and various dealers, including Tanguy, Paul Durand-Ruel, and, eventually, Vollard. Through all these contacts, it is certain that Cézanne saw the recent production of his old colleagues, including Pissarro.

Therefore, Cézanne's reemergence at the Vollard show was not so much of a break as has sometimes been claimed. He had not fallen into complete oblivion. Several critics, dealers, and collectors had, in fact, begun to pay serious attention to his work. Interestingly, though, the gradual recognition of Cézanne's place in history began to take place without Pissarro, and the latter felt frustrated and unjustly left out. Félix Fénéon, who had always been close to Pissarro, was the first author to refer to "the Cézanne tradition."[253] As early as 1891, he names those who are to be credited for this new tradition: Paul Sérusier, Jens Ferdinand Willumsen, Émile Bernard, Émile Schuffenecker, Charles Laval, Henri-Gabriel Ibels, Charles Filliger, and Maurice Denis. Not a word about Pissarro. In Fénéon's estimation, the Nabi generation was responsible for the dissemination of Cézanne's fame.

What truly angered Pissarro, however, was an article about Cézanne by Bernard, published in 1891.[254] Despite the fact that the cover of the journal features an etching of Cézanne by Pissarro (plate 18 and Chronology), the latter is barely mentioned. Even worse, Bernard took much pride in presenting an artist who, so far, had eluded fame: "Unknown, or rather unrecognized, he, Cézanne, has loved art to the point of giving up on the idea of becoming a celebrity through friendships or clubs and circles. Not out of contempt, but out of integrity, he has given up sharing his efforts with others."[255] Pissarro read this passage as a slap in the face and took it as a personal insult.

This pioneering essay by Bernard had a long shelf life among the early historians of modernism, and its author went on drawing much credit from it. A year after Cézanne's death, Bernard referred back to his original essay as "one of the first

homages to the master of that time."[256] Bernard was never one to choke on humility, and he declared that almost nobody before him had paid much attention to Cézanne. The one exception, according to Bernard, was not an artist but an art dealer, the much celebrated Père Tanguy,[257] who had seen in Cézanne's work, "the painting of the future." Pissarro died four years before this article was published.

Pissarro, however, was very much alive when Bernard's first essay was published. His well-known equanimity was most acutely put to the test when Bernard asserted that the principal influence on Cézanne had been Monet.[258] The wounded Pissarro wrote to his son: "That poor illiterate [Bernard] claims that Cézanne was for a while under Monet's influence: that tops it all! What do you think of this?"[259] Not just angry, Pissarro believed this was the effect of a conspiracy orchestrated by Gauguin. According to Pissarro, Gauguin was attempting to refute Pissarro's formative role in his, or anyone else's, artistic development.

One certainly can detect signs of paranoia on Pissarro's part, but the facts were more complex: Bernard, Fénéon (who could not be suspected of animosity against Pissarro), Georges Lecomte (the author of one of Pissarro's first monographs),[260] and Gustave Geoffroy—all of whom, with the exception of Bernard, were good friends of Pissarro's—saw Cézanne as having pioneered a different approach to painting. Pissarro found it difficult to reconcile his intimate knowledge of Cézanne with the way history was beginning to portray him as an outsider and a forerunner: someone who owed nothing to anyone, and who had invented a new form of art by himself. Geoffroy's introduction to Impressionism in 1893 pithily summed up the general perception. He focused on Monet, Pissarro, Renoir, Manet, Degas, and Jean-François Raffaëlli. He added, however, the following words: "In order to be absolutely exhaustive, one should add to the studies on these six artists a notice on Cézanne: he was a kind of precursor of a different kind of art."[261]

We know that Pissarro and Cézanne saw each other again in 1895 before the latter's retrospective opened, even though this is not often noted in the Impressionist literature. Pissarro wrote that he had run into Cézanne at the Durand-Ruel Gallery on May 25, 1895. One would imagine that this meeting—after close to ten years of mutual silence—was intense and charged.

Pissarro's account of that meeting is as unassuming as if they were still used to seeing each other frequently. Pissarro simply mentions Cézanne to his son in a very matter-of-fact way, only to emphasize that he and Cézanne saw eye to eye, and fully agreed with each other about Monet's monumental artistic accomplishment with his series of paintings of Rouen Cathedral.[262] Indeed, with the exception of Pissarro's Neo-Impressionist episode of 1886–90, the two artists continued to speak the same language and see eye to eye until their deaths, even through their prolonged silences.

This question of reciprocal influence also remained of paramount importance to the aging Pissarro even as he saw the phenomenon of Cézannism continue to take historic shape:

[Camille] Mauclair[263] published an article [on Cézanne] which I am sending you. You will see that he is ill-informed, like most of those critics who understand nothing. He simply doesn't know that Cézanne was influenced like all the rest of us, which detracts nothing from his qualities. They [the critics] forget that Cézanne was first influenced by Delacroix, Courbet, Manet, and even [Alphonse] Legros, like all of us; he was influenced by me at Pontoise, and I by him. You remember those remarks made by Zola and [Antoine-Ferdinand] Béliard on this issue. They imagined that you could invent painting from scratch, and that you could only be original if you looked like no one else. What is curious in that Cézanne exhibition at Vollard's is that you can see the kinship there between some works he did at Auvers or Pontoise, and mine. What do you expect! We were always together! What is certain, though, is that each of us kept the only thing that matters: "one's sensation!" This would be easy enough to demonstrate. . . . What cretins![264]

Two arguments are intertwined in this text, in which one senses Pissarro's frustration. The first is a philosophical argument about the antinomy between originality and influence. The second is a semantic argument: both he and Cézanne gave the concept of "influence" a new meaning. Pissarro refers back to discussions with Zola on this issue. We saw earlier the enormous value Zola put on originality. Pissarro now refers to earlier, and probably heated, discussions in which Zola would argue that the proof of originality was the fact that an artist would owe nothing of his originality to anyone, and would come out of nowhere. Pissarro argued on the contrary, that every artist was subject to various influences and that these influences, in no way, diminish an artist's originality. (In fact, here again, he and Cézanne are absolutely on the same page.) Pissarro's conception of the history of modern art is founded on this paradox: he defines modern art as "following the tradition of the old masters, without pillaging them."[265] He mentions as examples Manet, who "proceeds" from Francisco Goya but who introduces a "different vision" and "a very special and modern spirit" that Goya could have never conceived. He also mentions Corot, who "reflects" Claude Lorrain by also transforming him.[266] The second argument is very specific and consists in listing those who influenced Cézanne, culminating with Pissarro. This latter influence is almost unique, however, because Pissarro himself confesses that it was entirely reciprocal. What was essential was the fact that in this process, each artist's sensation (or his individuality) was preserved.

In the end, Pissarro's response to this sudden wave of interest in Cézanne was complex and ambivalent. His frustration with not being credited for his early impact on Cézanne is counterbalanced (somewhat) by the fact that he finds himself vindicated by history. He is jubilant, for instance, when he learns that Renoir and Degas fought over a drawing by Cézanne that they both wanted to buy from Vollard—and eventually decided on who would become the "felicitous owner" by tossing a coin.[267] And Pissarro concludes with these slightly self-congratulatory remarks: "Can you imagine Degas's enthusiasm for these sketches by Cézanne? . . . Wasn't I right back in 1861 when I and Oller went to see this peculiar Provençal at the Suisse art school, where he was doing life drawings that brought roars of laughter from all the impotents of that school. . . . Isn't it the funniest thing to see our old fights coming back to life!"[268]

"Peculiar" is Pissarro's favorite word when it comes to describing Cézanne or his œuvre. Ultimately, it is those peculiar qualities—at some point, Pissarro even uses the term "wild"—that the older artist recognizes in the works he discovers at Vollard's. These qualities constitute, for Pissarro, the thread that establishes a continuum from the early to the late Cézanne. Pissarro feels that he had been in a prime position, throughout his collaboration with Cézanne, to assess this continuum.

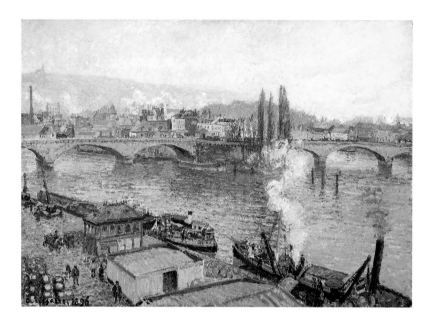

fig. 63. Camille Pissarro
The Stone Bridge at Rouen, Dull Weather
(*Le Pont de pierre à Rouen, temps gris*). 1896
Oil on canvas, 26 × 36" (66.1 × 91.5 cm)
National Gallery of Canada, Ottawa
Purchased 1923

Beyond Vollard–Into the Twentieth Century

*"Greetings to Madame Pissarro—everything seems so far
away and yet so close."*

<div align="right">PAUL CÉZANNE TO HIS SON, 1906[269]</div>

With the exception of Pissarro's Neo-Impressionist phase, the
two artists continued individually to articulate the same con-
cerns, issues, and obsessions as they had done from the incipi-
ent moment of their interaction. Their shared fascination for
the color gray offers one more example of this late commun-
ion beyond the point when they stopped seeing each other.
As he was ensconced in his hotel room, overlooking the roofs
of Rouen, Pissarro, only a few months after the Vollard show,
explained what his problem was: "I have been grappling here
for about two weeks with ceaselessly changing effects of gray
weather and fog: my work is going so slowly, it makes me feel
desperate. And, there is no snow in sight: I was counting on
some black-and-white effects. But still, the grays in Rouen are
truly beautiful [fig. 63]."[270] And again, the following year, when
he was in Paris, facing the Avenue de l'Opéra, Pissarro expressed
the same fascination for grappling with gray/silvery harmonies:
"It is so beautiful to do! It may not be very attractive aestheti-
cally, but I am thrilled to be able to try to do these streets of
Paris. People always say they are ugly, but they are so silvery,
so luminous, and so lively. . . . It is deeply modern!"[271]

In a strong echo of Pissarro's love of grays, Cézanne
declared to Gasquet the importance of gray in painting, using
the example of Talloires, where he worked: "For sure it is still
nature. . . . Not nature as I see it, you know. . . . Grays upon
grays. One is not a painter as long as one has not painted a gray.
Delacroix used to say that the enemy of all painting was gray.
Well, no! One is not a painter if one has not painted a gray."[272]

Cézanne was clearly thinking about Pissarro when he said
these words. As for Pissarro, he defined a "true painter" as
someone who is capable of setting two tones of color in har-
mony.[273] Each of them used the other's criteria to define what
true painting is about, and each of them referred to the other
as the ultimate painter. There is something very moving in this
mutual compliment, but there is also a certain oddity to it. By
declaring that the other's criteria are the ultimate criteria of
"true painting," do not both artists run the risk of excluding
themselves from the criteria they defend? If, in other words,
one is not a painter unless one is painting grays, can Cézanne
satisfy the definition of painting? If the criteria of true painting
is setting colors in harmony, can Pissarro satisfy those criteria?

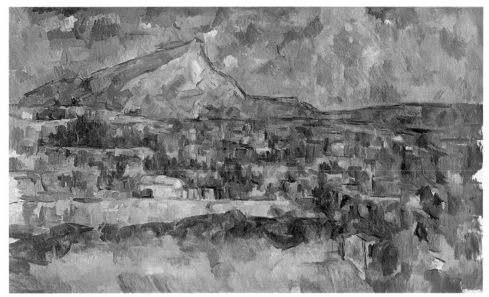

fig. 64. Paul Cézanne
Mont Sainte-Victoire. c. 1902–06
Oil on canvas, 22¼ × 38⅛" (56.5 × 96.8 cm)
The Metropolitan Museum of Art,
New York. The Walter H. and Leonore
Annenberg Collection, Partial Gift of
Walter H. and Leonore Annenberg,
1994 (1994.420)

In truth, however, both artists adhere to the very same fundamental concept. Whether Pissarro is talking about Cézanne's amazing sense of color, or Cézanne is quietly admiring the ability of Pissarro to paint grays, both men regard each other as artists who have performed well in creating forms of art based on *harmony*. Indeed, for both Pissarro and Cézanne, harmony prevails from beginning to end.

This harmony takes on a different appearance whether one looks at a painting by Pissarro or by Cézanne or whether one looks at an early or a later work by either artist. In any case, both always abided by their own rules of creating harmony within their work. In the end, the two forms of art these artists evolved complement each other, symmetrically—one mirror facing the other. Cézanne is the champion of color, one often hears, but these colors tend to strike us because they organize themselves (almost by fluke, *"au petit bonheur"*) into some form of harmony. To Gasquet, who didn't seem to understand why Cézanne should insist so much on gray, Cézanne replied that, indeed, nature in the south never looks gray; but he added that it does not look bright yellow, nor does it don any other specific garish colors either. In the end, Cézanne explains, what you observe is that "the ground is always quivering here, its sharp quality casts light back and has us blink our eyes. . . .

Everything becomes more intense, but blends into the sweetest harmony [emphasis mine] [fig. 64]."[274] As for Pissarro, his late works especially reveal the most prodigious palette of grays that any artist of his generation experimented with. But indeed, these grays, when one focuses on them, reveal myriads of color highlights suffused within his gray surfaces (see fig. 63).

Highlighting the continuous presence of certain themes or references throughout Cézanne's *entire* oeuvre, Lebensztejn concludes that it looks as if Cézanne had "anticipated his painter's destiny. Or, [it is] as if his destiny had found its own formula in the recollection of this anticipation."[275] Cézanne shared this "recollection of anticipation" with others, Pissarro first among them. The physical, visual, and artistic evidence examined in the present exhibition establishes that it is difficult—in some ways, prejudicial, even—to come to grips with the late Cézanne without referring to the early Cézanne. As Lebensztejn pointed out with potent examples, analyzing Cézanne's imagery of death, for instance, in his early and late works: "The intensity of Cézanne's late imagery appears to result from the inner concentration of all the violence that had been channeled out through these early drawings, in which one assaults a woman, one gets drunk, or feeds oneself from a human skull."[276] Nobody among Cézanne's contemporaries

had perceived or understood better the rich links between the youth and old age of Cézanne than Pissarro, as when he immersed himself in his recollections of their early days together, and as he continued to look for the same "curious and disconcerting qualities" in the late Cézanne that he had always known in the earlier Cézanne.

After the great Vollard exhibition, the two artists did not see much of each other before their deaths (Pissarro died in 1903; Cézanne in 1906). Having found this exhibition a reaffirmation, and, in a sense, a vindication of his own earlier convictions, tempered, indeed, by the lack of recognition of his pioneering interest in Cézanne among the critics of the 1890s, Pissarro went on producing his series of cityscapes, which he alternated with a considerable number of paintings depicting the same field, as it expanded outside his studio window in the countryside. Concurrently, Cézanne was also absorbed in painting the same sites again and again. Be it Mont Sainte-Victoire or the paths that took him from his studio to Sainte-Victoire, Cézanne focused on the same few square miles for the last twenty years of his life. There is an interesting parallel in the fact that these two artists never stopped searching for new sources of motifs as they worked together; in contrast, they both dedicated themselves solidly to depicting the same area (Eragny for one, Aix for the other), which absorbed them until their deaths.

The twenty-year period of their interaction had long-lasting repercussions on their lives and careers. One of the most moving testimonies of this is the fact that the aging Cézanne, after Pissarro's death, sent watercolors to a local exhibition under the name: "Paul Cézanne, pupil of Pissarro."[277] The anticipations of their early days, or anticipations of recollections, gradually turned into memories in their late days. They shared both anticipations and recollections until 1903. Afterwards, only Cézanne was alive. He became, in a sense, the repository of both of their capitals of memories. In 1906, during the last months of the artist's life, Cézanne wrote almost exclusively to his son—a total of fifteen letters. He also wrote one to Bernard and one to his color supplier. Memory and recollections had now taken over a large part of Cézanne's imaginary existence. When he asks his son to greet his mother for him, he also includes in the same phrase "all the people who still remember [him]" and specifically names one person: Madame Pissarro—Pissarro's widow.[278]

At this late stage of his life, Cézanne truly lived in isolation. In this last corpus of letters, he virtually mentions no artist. He reads a lot. Charles Baudelaire's writings continue to hold great interest for him, especially his *Art romantique* and his text on Delacroix. With the exception of Charles Camoin (who visits him) and Bernard (whom he mentions somewhat condescendingly),[279] Cézanne writes about no other artist than Pissarro, who (just like the Goncourt brothers) "had an inclination toward color, as a means of representation of air and light."[280] Finally, less than a month before his death, Cézanne mentions Pissarro for the last time almost in the same breath as he mentions "the unfortunate Bernard," who is "congested with his memories of museums."[281] The cure for the unfortunate Bernard's ailment—we can guess it by now—is what Pissarro himself would have prescribed: go outside into nature. But the problem lies with Bernard: he "doesn't see enough from nature."[282] All this goes to prove Pissarro right. According to Cézanne, "Pissarro was, therefore, not wrong. He may have gone a bit too far, you might say, when he claimed that we should burn all the necropolises of art."[283] A few weeks before his death, the Pissarro whom Cézanne remembers is his companion of the 1860s, the one who threatens to set fire to the Louvre. Likewise, at the end of their close collaboration, in the 1880s, Pissarro chose to remember the incipient stage of their friendship by buying a group of "peculiar studies" of the 1860s by his younger friend. From beginning to end, in both artists' careers, each mattered a great deal to the other.

Impressionism, Post-Impressionism: It's all Modern Painting

"It is absurd to look for perfection." With this statement, written in 1883, Pissarro was advocating a radically modern step. Sensations matter more than perfection; the former come naturally, the latter does not. Therefore, as an artist, one does not have to look for sensations: one cannot seek sensations, one can only find them. In this sense, Pissarro anticipates Picasso, who famously never sought, but found. Another formulation of this same problem for Pissarro was to find character. "In art, everything is good enough to do! The whole aim is to learn to see forms with one's own eyes, and one's own faults."[284] It was in the very faults inherent in Cézanne's works, which he rediscovered at Vollard's in 1895, that he found the secret of Cézanne's charm right from the beginning: what he called his "peculiar qualities."[285]

Throughout his career, Cézanne agreed with this principle. To seek perfection is pointless. In fact, the famous "sensation" that both artists proudly cultivated was inherently bound to their "faults." In this sense, "sensation" is an antonym of "perfection." Setting aside vain perfection, an artist has to mold himself to the demands of his motif. Both artists remained in full agreement with each other over this principle. "Nature!" Cézanne said to Gasquet, "I'd put my mind to copying it: I couldn't do it. With all my efforts to find a solution, to turn around it, to take it from all vantage points, it would escape me. From all vantage points."[286] Cézanne evoked his satisfaction, however, when he realized that the sun could only be represented through something else: color. And in one of the last letters to his son, he glorified Pissarro for being one of the very few who cultivated color as a means of representing light.

Around this same time, Pissarro admonished one of his sons and his brothers: "I hope that you've all gone back to *serious work*. Dig hard, work on your drawing and your color values. *Remain simple in front of nature* [emphasis mine]."[287] Even though by that time, Cézanne and Pissarro would seldom see each other, they continued to speak exactly the same language that they had elaborated in the 1860s and now articulated individually. The principles they had forged together remained: serious work was an obsession; a language of simplicity was the goal, attained through intense efforts; and a slavish humility in front of nature was believed to offer the possibility of defining their selves (or their sensations).

The following words by Matisse, reflecting on the influence Cézanne had on his own work, offer telling insight into the mutual impact one artist has on another:

Cézanne, you see, is a sort of god of painting. Dangerous, his influence? So what? Too bad for those without the strength to survive it. Not to be strong enough to withstand an influence without weakening is proof of impotence. I will repeat what I once said to Guillaume Apollinaire: *For my part, I have never avoided the influence of others, I would have considered it cowardice and lack of sincerity toward myself.* I believe that the artist's personality affirms itself by the struggle he has survived. One would have to be very foolish not to notice the direction in which others work. I am amazed that some people can be so lacking in anxiety as to imagine that they have grasped the truth of their art on the first try. I have accepted influences but I think I have always known how to dominate them [emphasis author's].[288]

Cézanne himself had referred to Pissarro in very similar terms: "As for the old Pissarro, he was a father to me. He was a man you could turn to for advice; he was something like God."[289] In effect, both artists had been playing the role of god for each other: each made it possible for the other to exist artistically; each justified the other's actions; each threatened retribution if the main line of conduct was violated; and each rewarded amply the other's accomplishments. Cézanne and Pissarro entered into the public arena of modern art together in the 1860s. The principles they forged provided them with guidelines for the rest of their careers, however diverse the visual results of their experiments happened to be.

While in close touch with each other—in actual fact or through memory—there was never a point when one became a master or a disciple to the other. This, of course, is contrary to what much art history has taught us about these artists. Fry, for instance, tells us that at Auvers, Cézanne became apprentice to Pissarro, "who was already master of his method and in full possession of his personal style. It was, one may say, his first and his only apprenticeship."[290] Oddly enough, the refutation to this analysis came from Cézanne himself, using the very same terms Fry would eventually use. When Cézanne listed himself in some of his last exhibitions as "pupil of Pissarro"—Pissarro being dead, and he being "around seventy"—he was actually refuting Fry (by anticipating this argument). What he meant by signaling that he was a pupil of Pissarro was that he was nobody's disciple but his own, nor could he be. For this was perhaps Pissarro's ultimate lesson for Cézanne: "This may be why we all come out of Pissarro. He had the fluke of being born in the West Indies, and there, he learned to draw without a master."[291]

PLATES

NOTE TO THE READER

Dates herein are largely based on John Rewald's *The Paintings of Paul Cézanne: A Catalogue Raisonné* and on Ludovic Rodo Pissarro and Lionello Venturi's *Camille Pissarro: Son art, son oeuvre*. A forthcoming catalogue raisonné of Pissarro's paintings, edited by Claire Durand-Ruel and Joachim Pissarro, under the aegis of the Wildenstein Institute, has provided a major source of information on the dating of this artist's work. Dates that differ from these published sources are the author's. Similarly, some titles have been changed in order to reflect new topographical data collected by Alain Mothe and in order to harmonize the titles of both artists' works of a given site.

Notes to the texts are on p. 223.

"Setting the Louvre on Fire": Radical Technique and Ideology in Early Works

The 1860s was a period of seminal importance for the development of Cézanne's and Pissarro's art and careers and served as a stepping-stone in the formation of the vocabulary of modern painting. This vocabulary manifested itself in practical and theoretical terms. In practice, Cézanne and Pissarro applied unprecedented, thick layers of paint on canvas that created a coarse, almost sculptural surface of pigment (see the still life and the landscape by Pissarro [plates 5 and 6], and the portraits of Uncle Dominique by Cézanne [plates 7-9]). In theory, both artists wrote and spoke a lot to each other as well as to others. Contrary to general belief, the Impressionists wrote extensively, expressing their artistic ideology either through letters or through articles (written by critics) that indirectly reflected their own positions and conceptions.[1] From both practical and theoretical viewpoints, Cézanne and Pissarro regarded themselves as revolutionaries who fostered a radical departure in art.

Cézanne boasted that his paintings would "send [the members of] the Institute up the wall with rage and despair,"[2] while Pissarro declared that the Louvre should be set on fire. They both established a kind of tabula rasa epitomized (figuratively and literally) by the flat, solid planes of earthy pigments slathered on the still lifes by each artist (plates 3-5), and by Pissarro's monumental *The Banks of the Marne in Winter* (plate 1). These works must be seen in the context of their artists' claim to be regarded as "serious workers"—a phrase used by Émile Zola and by Cézanne to describe the professional ambitions of these young newcomers who were about to transform the art world.

Seen in this context, Cézanne's portrait of his father reading *L'Événement* is a key work (plate 2). Louis-Auguste sits with his back to a recently painted, thickly impastoed still life by his son (see fig. 24) and holds in his hand a copy of the liberal newspaper in which Zola published his impassioned defense of what Cézanne and Pissarro's *work* stood for. In fact, Cézanne's father's situation in this painting is essentially modern: turning his attention to theoretical (or critical) discourse that functioned as a way to clarify and validate the claims made by a particular artist—here, his own son. In modern art, theory and practice (or discourse and painting) became inseparable. Indeed, Cézanne's father, as he perused Zola's articles in *L'Événement*, could read words that fittingly applied to many paintings by either artist seen in this section. For instance: "We must tell these judges [of the Salon] that the exhibitions were established in order to give ample publicity to serious workers."[3] Such words had a decisive ideological and practical impact on the following decades.

Joachim Pissarro

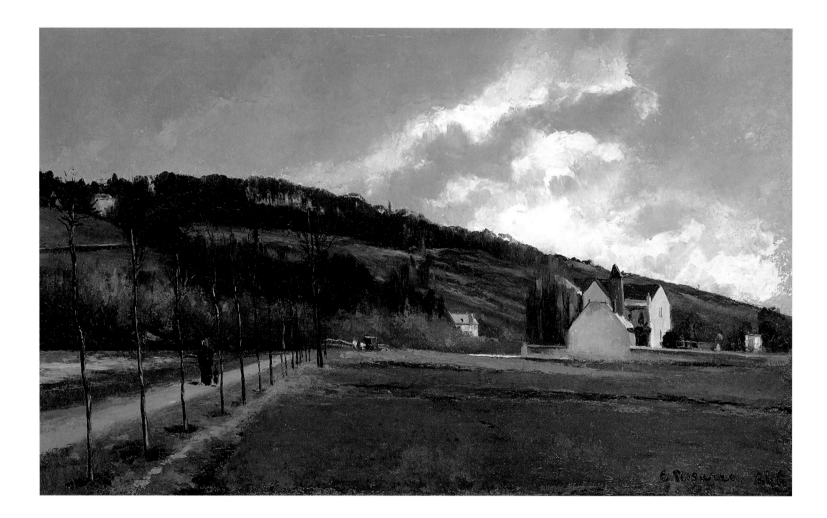

1. Camille Pissarro
The Banks of the Marne in Winter (*Bords de la Marne en hiver*). 1866
Oil on canvas, 36⅛ x 59⅛" (91.8 x 150.2 cm)
The Art Institute of Chicago. Mr. and Mrs. Lewis Larned Coburn Memorial Fund, 1957

78

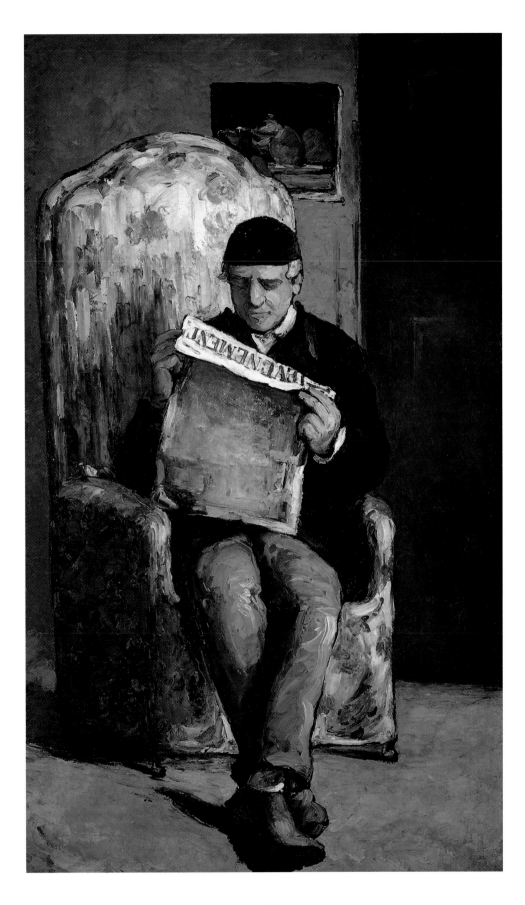

2. Paul Cézanne
The Artist's Father (Père de l'artiste). 1866
Oil on canvas, 6' 6⅛" × 47" (198.5 × 119.3 cm)
National Gallery of Art, Washington, D.C. Collection Mr. and Mrs. Paul Mellon

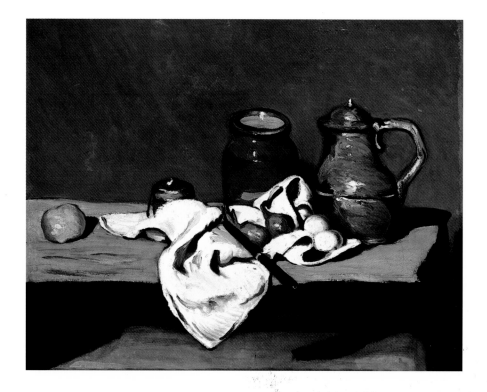

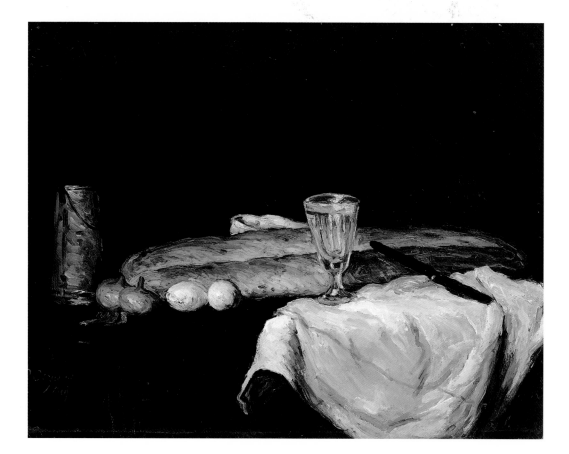

3. Paul Cézanne
Still Life with Kettle (Nature morte à la bouilloire). c. 1869
Oil on canvas, 25³⁄₁₆ x 31⅞" (64 x 81 cm)
Musée d'Orsay, Paris. Acquired with funds from an anonymous
Canadian donation, with the consent of the heirs of Gaston de Bernheim
de Villiers and the Society of Friends of the Louvre, 1963

4. Paul Cézanne
Still Life with Bread and Eggs (Nature morte: pain et oeufs). 1865
Oil on canvas, 23¼ x 30" (59 x 76 cm)
Cincinnati Art Museum. Gift of Mary E. Johnston

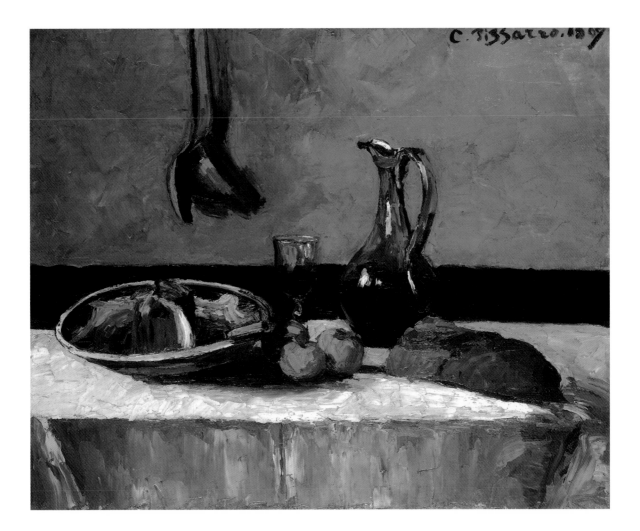

5. Camille Pissarro

Still Life (Nature morte). 1867

Oil on canvas, 31⅞ × 39¼" (81 × 99.6 cm)

Toledo Museum of Art. Purchased with funds from the Libbey Endowment.

Gift of Edward Drummond Libbey, 1949

6. Camille Pissarro
Square at La Roche-Guyon (*Une Place à la Roche-Guyon*), 1866–67
Oil on canvas, 19⅝ x 24″ (50 x 61 cm)
Nationalgalerie, Staatliche Museen zu Berlin, Germany

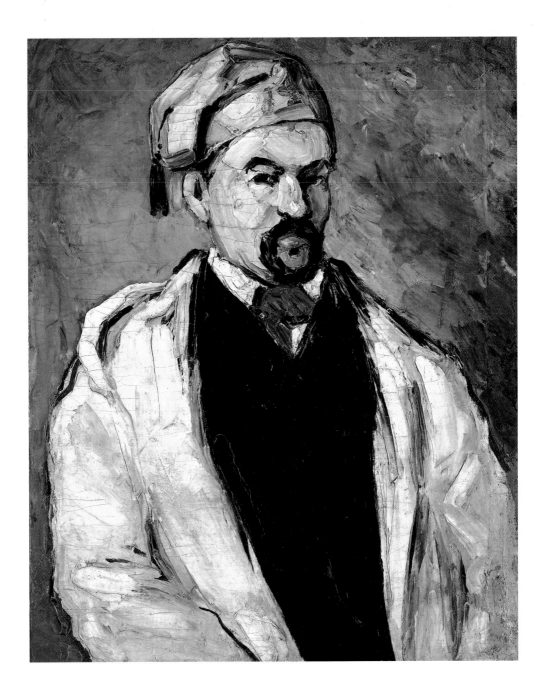

7. Paul Cézanne

Dominique Aubert, the Artist's Uncle (Homme au bonnet de coton [L'Oncle Dominique]). 1866

Oil on canvas, 31⅛ × 25¼" (79.7 × 64.1 cm)

The Metropolitan Museum of Art, New York. Wolfe Fund, 1951; acquired from The Museum of Modern Art, Lillie P. Bliss Collection (53.140.1)

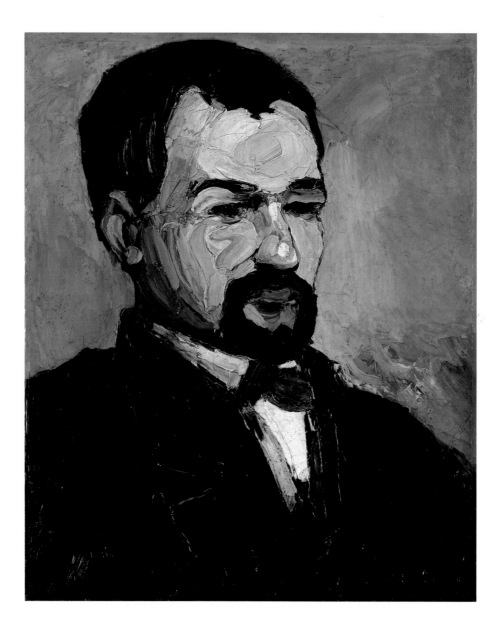

8. Paul Cézanne

Portrait of Uncle Dominique (L'Oncle Dominique). c. 1865–67

Oil on canvas, 18 x 15" (45.7 x 38.1 cm)

Norton Simon Art Foundation

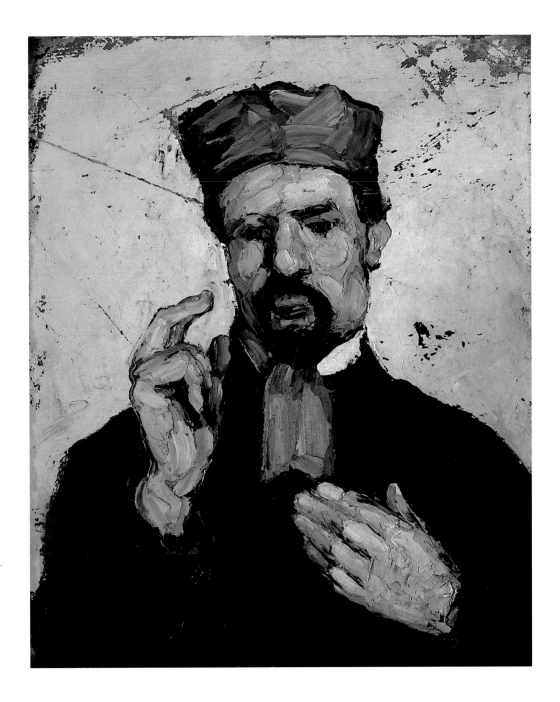

9. Paul Cézanne
The Lawyer (*Uncle Dominique*) (*L'Oncle Dominique en avocat*). 1866
Oil on canvas, 25½ × 21¼" (65 × 54 cm)
Musée d'Orsay, Paris. Gift in lieu of estate tax, 1991

Reciprocal Gazes: Portraits and Self-Portraits

Two self-portraits by Cézanne and Pissarro (plates 13, 14) speak eloquently about who these artists were. Pissarro's portrait, showing a bearded man, balding at age forty-five, evokes a gentle non-conformist as well as a biblical figure, a father, or a wise mentor. Cézanne's self-portrait, painted when he was in his thirties, also shows a balding and bearded figure who expresses a sense of rebelliousness.

Pissarro and Cézanne met in Paris in 1861, and by the 1870s they had forged an intimate friendship that is apparent in the cross references that tie Pissarro's *Portrait of Cézanne* of 1874 (plate 12) to Cézanne's *Still Life with Soup Tureen* of about 1874 (plate 11). Pissarro's painting of a rural scene, *Route de Gisors: The House of Père Galien, Pontoise* of 1873 (plate 10), partially visible in both pictures, is the most obvious link. His studio at Pontoise is the site where the portrait and the still life were painted. Pissarro settled in this town for a second time, from April 1872 to late 1882, and Cézanne joined him there frequently, especially after 1872.

Beyond location and ownership (Pissarro kept his portrait of Cézanne throughout his life and became the first owner of Cézanne's still life) as evidence of their close association, it is the pictures within the pictures that provide a glimpse into the camaraderie and mutual admiration that existed between the two artists. Theodore Reff's[1] investigations first shed light on this subject. Quoting other works—a practice revived by the Impressionists—allowed Pissarro to weave a complex narrative around Cézanne's presence. This device in turn helped Cézanne showcase his idiosyncratic subject matter against a backdrop of works by Pissarro, a master he admired, influenced, and was influenced by.

In his *Portrait of Cézanne* (plate 12), Pissarro frames the unkempt figure of his friend with a combination of "high" and "low" elements. He includes his own painting of the unpretentious Pontoise scenery at the lower right (plate 10), and brings in references to political newspapers. On the left the statesman Adolphe Thiers raises a newborn he has just delivered from the allegorical figure of France. The actual caricature, by André Gill, which was published in 1872 in the satirical weekly *L'Eclipse*, refers to the huge indemnity the newly installed Republic was forced to pay Prussia after the Franco-Prussian War. In its representation, this prominent politician seems to be offering his symbolic trophy, a bundle of money, to Cézanne, who remains oblivious to him. By including this image, Pissarro may have been expressing a veiled acknowledgment of France's indebtedness to Cézanne[2] and in the process turning a political figure, whose conservative views he vehemently opposed, into an adulator of Cézanne.

On the right, the figure of Gustave Courbet is shown toasting the seated painter with a glass of beer. The caricature, by Léonce Petit, illustrates an issue of the 1867 newspaper *Le Hanneton*. When Pissarro painted this portrait, Courbet had already fled to exile and Thiers had resigned. Yet these two giants, with opposing political views, are shown paying homage to Cézanne. Unassuming but massively present, Cézanne eclipses Thiers's figure[3] and reduces the imposing stature of Courbet to a miniature onlooker. With this humorous and laudatory work, Pissarro ties his own interest in politics and their shared admiration of Courbet into a tribute to his friend.

Fereshteh Daftari

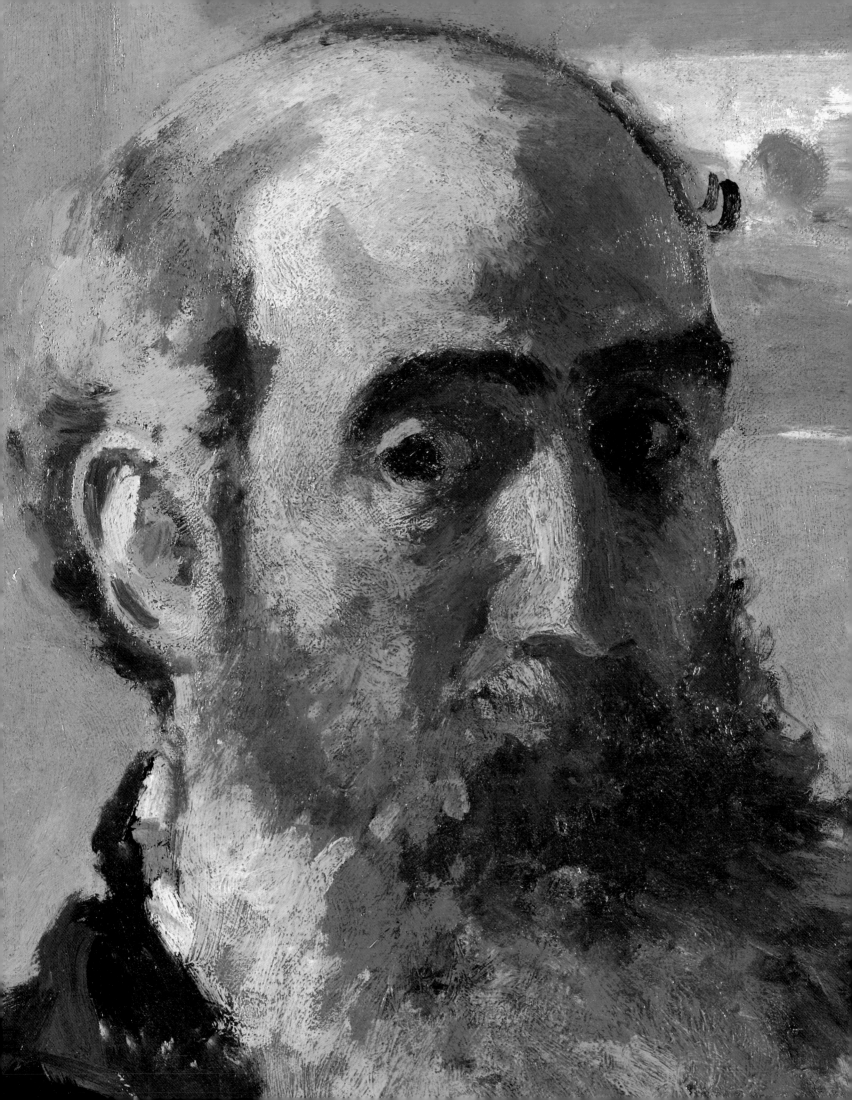

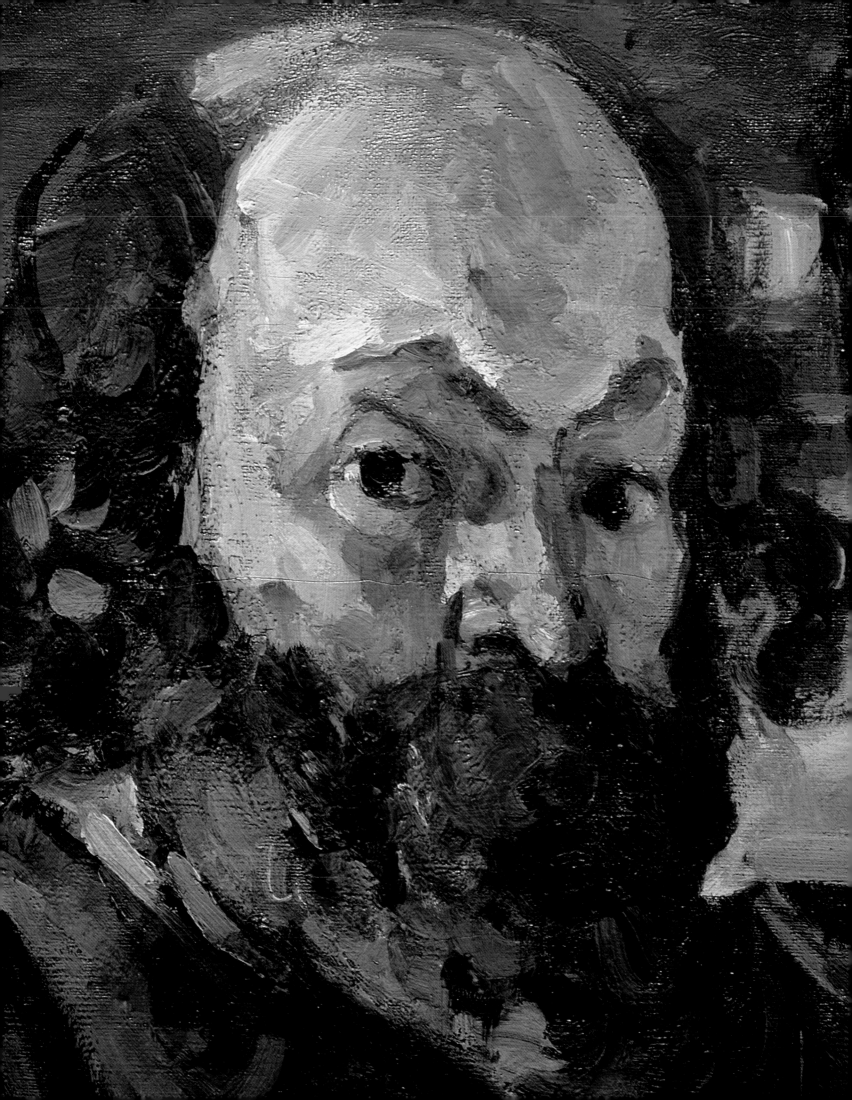

10. Camille Pissarro

Route de Gisors: The House of Père Galien, Pontoise (Route de Gisors: La Maison du Père Galien, Pontoise). 1873

Oil on canvas, 14¼ × 17⅞" (36.2 × 45.4 cm)

Private collection

11. Paul Cézanne

Still Life with Soup Tureen (Nature morte à la soupière). c. 1874

Oil on canvas, 25⁹⁄₁₆ × 32¹¹⁄₁₆" (65 × 81.5 cm)

Musée d'Orsay, Paris. Auguste Pellerin Bequest, 1929

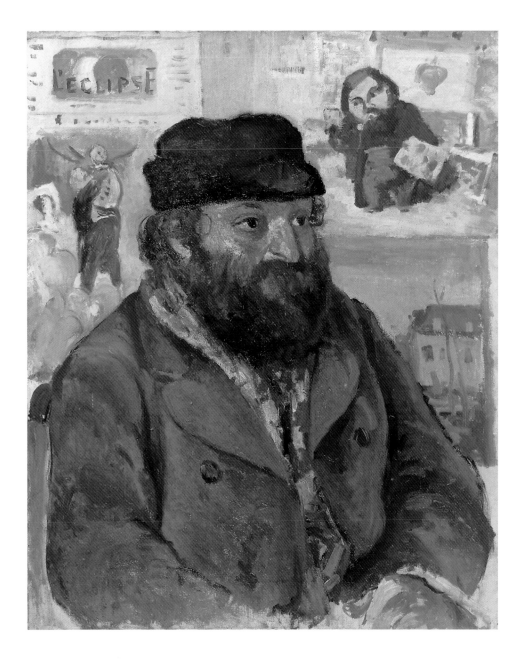

12. Camille Pissarro
Portrait of Cézanne (Portrait de Cézanne). 1874
Oil on canvas, 28¾ x 23⅜" (73 x 60 cm)
Collection Laurence Graff

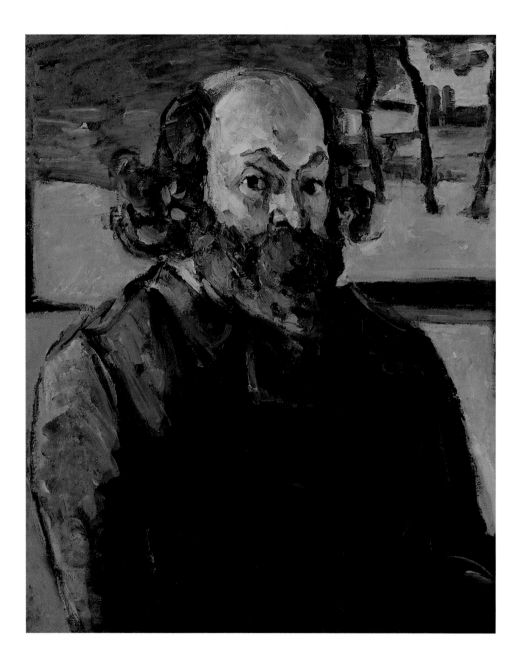

13. Paul Cézanne

Self-Portrait (Portrait de l'artiste). 1873-76

Oil on canvas, 25⅜₆ × 20⅞" (64 × 53 cm)

Musée d'Orsay, Paris. Gift of Jacques Laroche, 1947, the owner retaining life interest until 1969

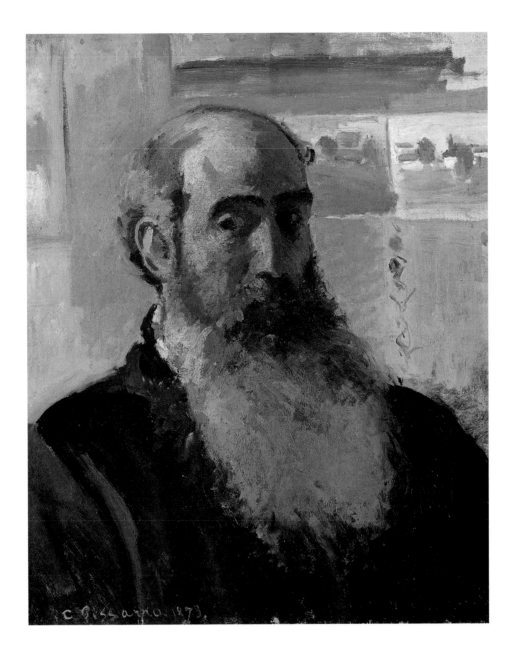

14. Camille Pissarro
Self-Portrait (Portrait de l'artiste). c. 1873
Oil on canvas, 22¹⁄₁₆ × 18³⁄₈" (56 × 46.7 cm)
Musée d'Orsay, Paris. Gift of Paul-Émile Pissarro, son of the artist, 1930, the owner retaining life interest

Portraits on Paper: Drawings

The works on paper in this section reveal the psychological investment Pissarro and Cézanne placed in each other throughout their long friendship, and serve as reminders of the intimacy these artists shared as they worked in and around Auvers and Pontoise, especially during their first years there together between 1872 and 1874. In Cézanne's drawing *Pissarro Going to Paint* (plate 21), the artist sketched Pissarro in quick and confident strokes. Although Pissarro's facial features are abstracted and there is little in the way of modeling, it is easy to identify his attire and age as the same as in a photograph from this period (see Chronology). In *Camille Pissarro, Seen from Behind* (plate 20), Cézanne goes further and employs minimal lines, rendering only those elements necessary to define the sitter. The tenderness with which Cézanne approached the subject of his colleague and friend is heightened by the vulnerability of Pissarro's position, seated with his back to the viewer.

Cézanne's portrait of Pissarro in profile (plate 17) captures the seriousness of the elder artist, who appears caught in a moment of contemplation. Here, Cézanne omitted any contextual reference, focusing instead on those elements that would most succinctly convey the personality of his subject. The strong angularity of Pissarro's lapel and hat reveal the constructional concerns that define Cézanne's mature works. By contrast, Cézanne's *Portrait of Pissarro, and sketches* (plate 19) depicts Pissarro in action, in front of his canvas. The unusual perspective reveals Cézanne's skill as a draftsman.

These works on paper also contribute revelatory information about the artists' views of themselves. Compared with Pissarro's *Portrait of Cézanne in a Hat* (c. 1874; plate 15), Cézanne's own self-portrait three years later (plate 16) depicts a much more existential version of himself. The round face, full beard, and cocked hat that define Cézanne in Pissarro's portrait lend him a warm and accessible quality. Pissarro took great care to render the delicate shading of Cézanne's face and the more abrupt shadow cast over his left shoulder. Cézanne's image of himself, on the other hand, is reduced to the features necessary to convey the personality of a serious and rebellious artist: fixed eyes, determined scowl, taut mouth, and gaunt cheeks. There is little trace of the beard or hat to distract the viewer from his gaze.

In his etching of Cézanne from 1874 (plate 18), Pissarro adhered more closely to Cézanne's version of himself. This portrait, later reproduced on the cover of the journal *Les Hommes d'aujourd'hui* in 1891 (see Chronology), depicts Cézanne with a hawkish gaze, peering out from under his cap. As in Auguste Rodin's famous monumental sculpture of Balzac,[1] also begun in 1891, Cézanne's personality is conveyed through his severe and contemplative expression, while his body is concealed by an abundance of garments that endow him with a grand and imposing presence. This impression is further enhanced by the dark lines of the print medium and the dramatic contours of Cézanne's overcoat, which fill the bottom half of the composition.

Jennifer Field

15. Camille Pissarro
Portrait of Cézanne in a Hat (Portrait de Cézanne coiffé d'un feutre). c. 1874
Lead pencil on paper, 9½ x 5⅛" (24.2 x 13 cm)
Musée du Louvre, Paris. Département des Arts graphiques, under the Musée d'Orsay

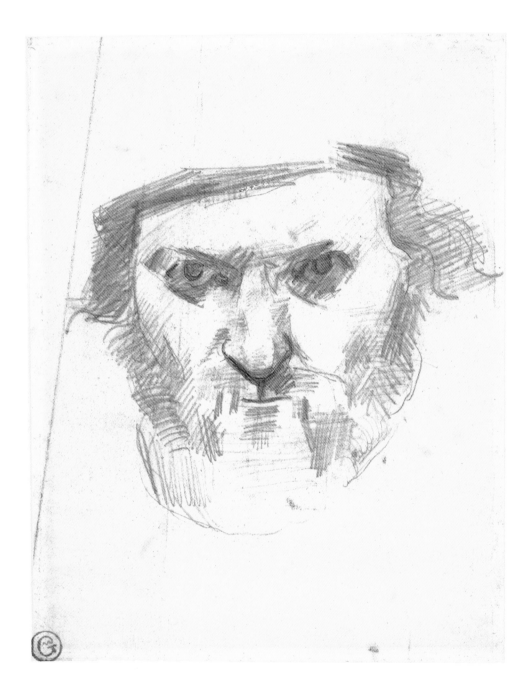

16. Paul Cézanne
Self-Portrait (Autoportrait). c. 1877
Pencil on paper, 7³⁄₁₆ × 5¹¹⁄₁₆" (18.5 × 14.5 cm)
Private collection, Paris

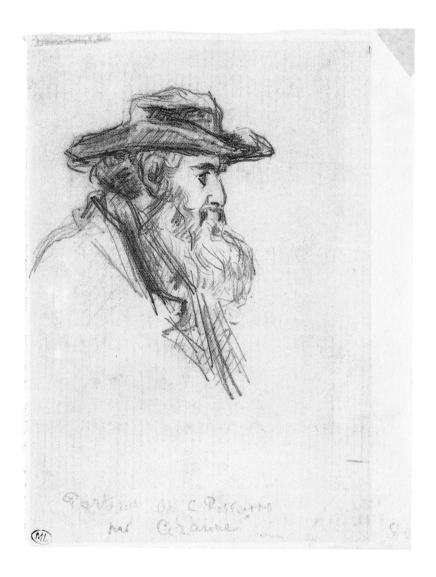

17. Paul Cézanne
Portrait of Camille Pissarro (Portrait de Camille Pissarro). c. 1873
Pencil on laid paper, 5¼ x 4¹⁄₁₆" (13.3 x 10.3 cm)
Musée du Louvre, Paris. Département des Arts graphiques, under the Musée d'Orsay. Gift of John Rewald, the owner retaining life interest until 1994

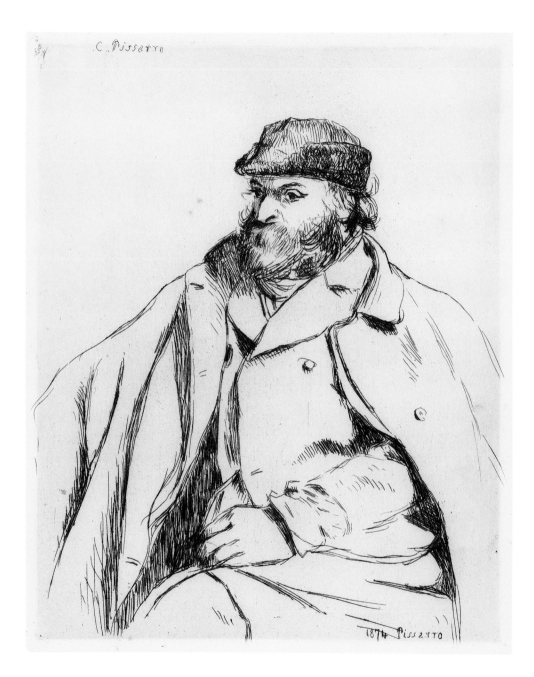

18. Camille Pissarro
Portrait of Paul Cézanne (Portrait de Paul Cézanne). 1874
Etching, plate: 10½ × 8⁷⁄₁₆" (26.6 × 21.5 cm); sheet: 17½ × 13⅝" (44.5 × 34.6 cm)
Museum of Fine Arts, Boston. Gift of Henri M. Petiet, confirmed by his estate

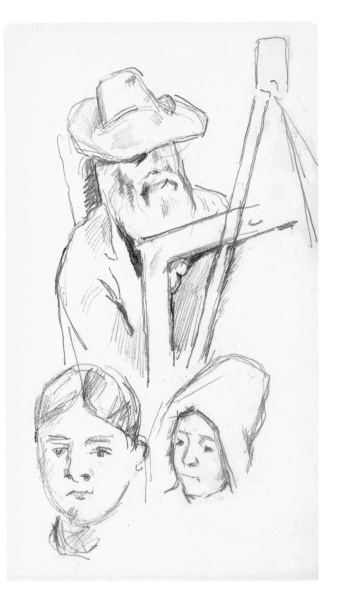

19. Paul Cézanne
Portrait of Pissarro, and sketches (Portrait de Pissarro, avec esquisses). 1874–78
Graphite on paper, from a sketchbook, approx. 8½ × 4¹⁵⁄₁₆" (21.6 × 12.6 cm)
The Pierpont Morgan Library, New York. Gift of the Eugene V. & Clare E. Thaw
Charitable Trust in honor of the 75th Anniversary of the Morgan Library and
the 50th Anniversary of the Association of Fellows

20. Paul Cézanne
*Camille Pissarro, Seen from Behind (Camille
Pissarro, vue de dos).* 1874–77
Pencil on paper, 5⅛ × 6¹⁄₁₆" (12.7 × 15.3 cm)
Kunstmuseum Basel, Kupferstichkabinett
Gift of Martha and Robert von Hirsch, 1977

21. Paul Cézanne
Pissarro Going to Paint (*Pissarro allant au motif*). 1877
Lead pencil on paper, 7¹¹⁄₁₆ × 4⁷⁄₁₆″ (19.5 × 11.3 cm)
Musée du Louvre, Paris. Département des Arts graphiques,
under the Musée d'Orsay.

Louveciennes/Louveciennes: "To Each His Own Sensation"

This pair of works by Pissarro and Cézanne (plates 22, 23) constitutes an apex in the history of Impressionism. Here Pissarro worked alone, creating his painting in 1871, a year earlier than Cézanne did. Cézanne borrowed his friend's painting to see what he could do with it. Lucien Pissarro, Pissarro's eldest son (who was about nine years old at the time), described his recollection of what happened: "To say who influenced the other is impossible. All I can say is that Cézanne borrowed one of father's pictures in 1870 to make a copy, probably to study how it was painted. Cézanne's copy still exists. . . . It is good to say this because one day it might be said that father copied Cézanne."[1]

Twenty-five years after this intense pictorial dialogue, Pissarro remarked on the Cézanne retrospective organized by Vollard in 1895: "What is curious in that Cézanne exhibition at Vollard's is that you can see the kinship there between some works he did at Auvers or Pontoise, and mine. What do you expect! We were always together! What is certain, though, is that each of us kept the only thing that matters: 'one's sensation!'"[2]

Indeed, these two works are strikingly similar and yet stand worlds apart. The Cézanne is slightly smaller than the Pissarro, but the layout of each composition is virtually identical: from the aqueduct (right) to the group of tall trees (left); from the foliage and twigs of the two saplings (central top) to the ruddy autumnal ground (bottom), every element, stone, roof, and figure occupies the same space and serves the same function in each composition. As a result, it was always difficult to tell the paintings apart when they were known from black-and-white photographs. However, when seen in actuality, each painting retains a staunch identity that makes us wonder how they could ever have been confused.

Several elements differentiate the Cézanne from the Pissarro: the composition, due to its lesser height, appears more densely compact than the Pissarro; the tonal contrasts are more pronounced (see, especially, the clouds, which are more clearly detached from the sky, or the shadows of the figures); and the hues are more intense, especially the reds (see, for instance, the bush of red leaves in the angle formed by the small wall and the tall, vertical tree trunk to the right). Specific details were given less attention by Cézanne. The group of three trees, to the left, are treated summarily, whereas Pissarro cared to represent the details (leaves, twigs, asperities) of each tree. Finally, the modes of paint application are different in each case: for every three or four brushstrokes by Pissarro, there appears to be one larger, broader, and bolder stroke by Cézanne. On the whole, Cézanne proceeds by simplification and intensification, whereas Pissarro proceeds by subtle gradations, building up fine chromatic scales and modulating soft contrast values in order to endow his painting with greater unity and finer shades. Pissarro's new way of painting after he returned from London in 1871, having looked at the great collection of works by Claude Lorrain and J.M.W. Turner at the National Gallery, prompted a response on Cézanne's behalf: their dialogue was on.

Joachim Pissarro

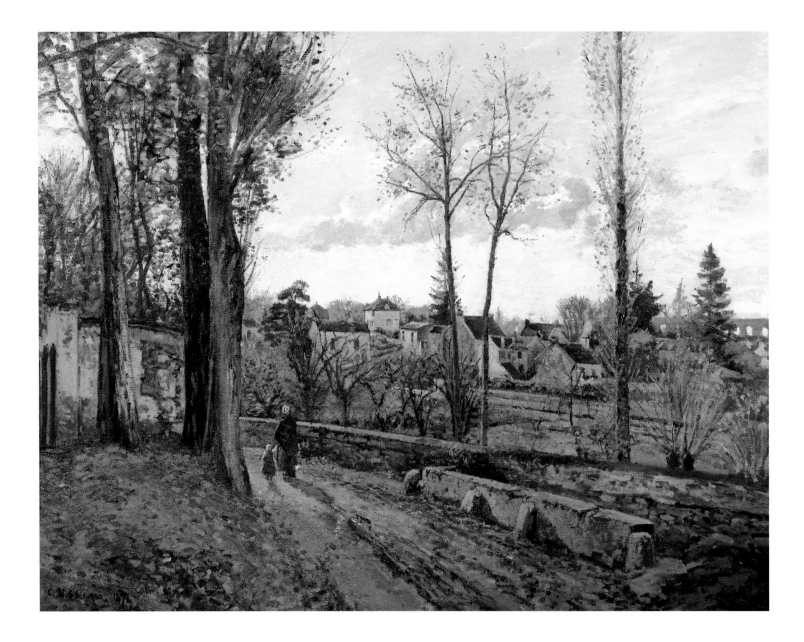

22. Camille Pissarro
Louveciennes. 1871
Oil on canvas, 35⁷⁄₁₆ x 45⁷⁄₈" (90 x 116.5 cm)
Private collection

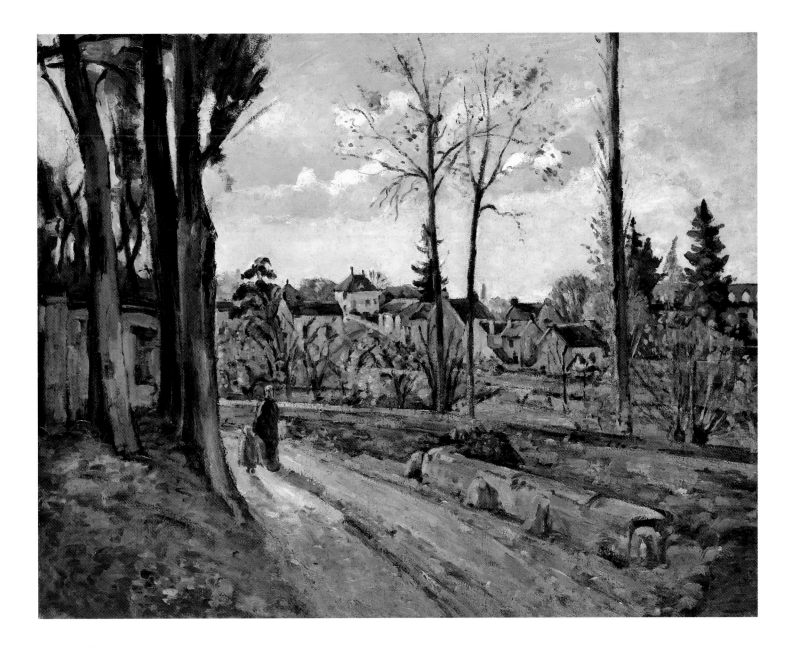

23. Paul Cézanne
Louveciennes. c. 1872
Oil on canvas, 28¾ × 36¼" (73 × 92 cm)
Private collection. Courtesy of Wildenstein & Co.

Still Lifes of the 1870s: A Classic Genre "Improperly" Painted

The still-life paintings shown in this section follow in the wake of the pivotal Salon des Refusés of 1863, when many works were rejected due to their contemporary realism. In the eyes of the Académie des Beaux-Arts, the still life was looked upon as a second-rate subject, easily saleable and left to those who had to sell their work to support themselves or who were not trained in figure drawing. In response to the criticism that avant-garde artists received from the Salon jury of 1863, many turned to the still-life genre as a form of rebellion, rejecting the conventional hierarchy of the jury.

For Pissarro and Cézanne, the still life provided a motif through which they could perpetuate the realism of Gustave Courbet and study the formal elements of painting, devoid of any allegorical content. The commonplace objects they depicted—such as apples, flasks, pottery, and knives, as seen in plates 26 and 27—allowed the artists to explore a variety of shapes and textures, while concentrating on their formal arrangements.

In plates 24 and 25, each artist reduced his composition to a centrally placed, round object set against a geometric background. Cézanne broke up the grid by introducing a strong diagonal on the right edge of his composition and setting the pattern of the wallpaper at a slight incline, thereby rejecting scientific perspective. Pissarro, on the other hand, relied on the essential shape of the pear to break up the geometry of his composition, a device that Cézanne would employ for the same reason throughout his career.

Both artists depicted the same blue-and-white Delft vase in two compositions of flowers (plates 28, 29), but the similarities between these paintings end there. In Pissarro's work, the artist employed a soft palette of warm pastels, while in Cézanne's painting there remain remnants of his heavy palette from the 1860s: black borders the bottom of the painting and is used to darken the shadows of the green leaves. The most striking feature of Cézanne's bouquets, however, is the bright yellows and mauves, which anticipate the palette used by the Fauve artists nearly thirty years later.

Pissarro's painting *Bouquet of Flowers with Chrysanthemums in a Chinese Vase* (plate 30) conveys the Impressionist concern for realism. As John McCoubrey has noted, a common feature among Impressionist still lifes was the inclusion of personal effects such as "expensive china, books, and statuettes presented in correct perspective." According to McCoubrey, "Cézanne thought the information such things provided about status and taste were distracting prettiness."[1] In Cézanne's *Flowers in a Blue Vase* (plate 34), the artist has omitted any decoration, and the background has been reduced to subtly modulated planes of neutral hues. The links and differences evident in the compositions shown in this section reveal how Cézanne and Pissarro explored the classic still-life genre by using an Impressionist vocabulary to develop their own unique styles.

Jennifer Field

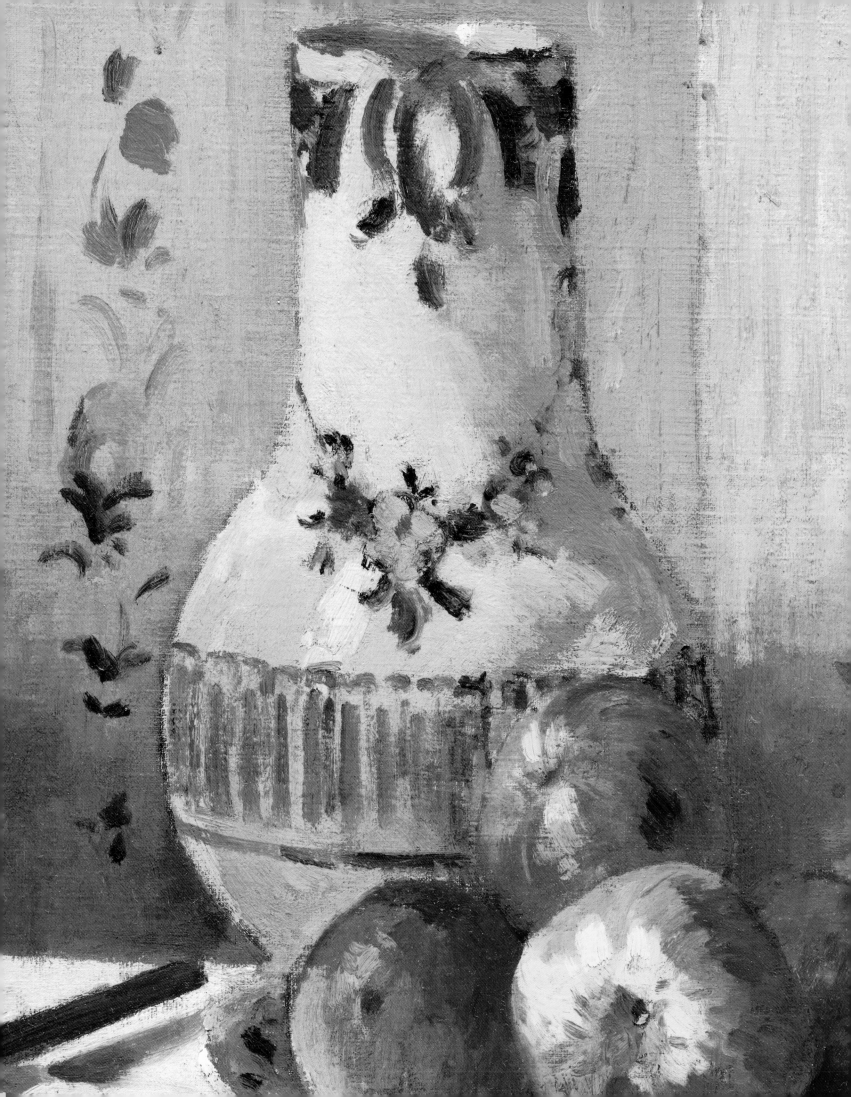

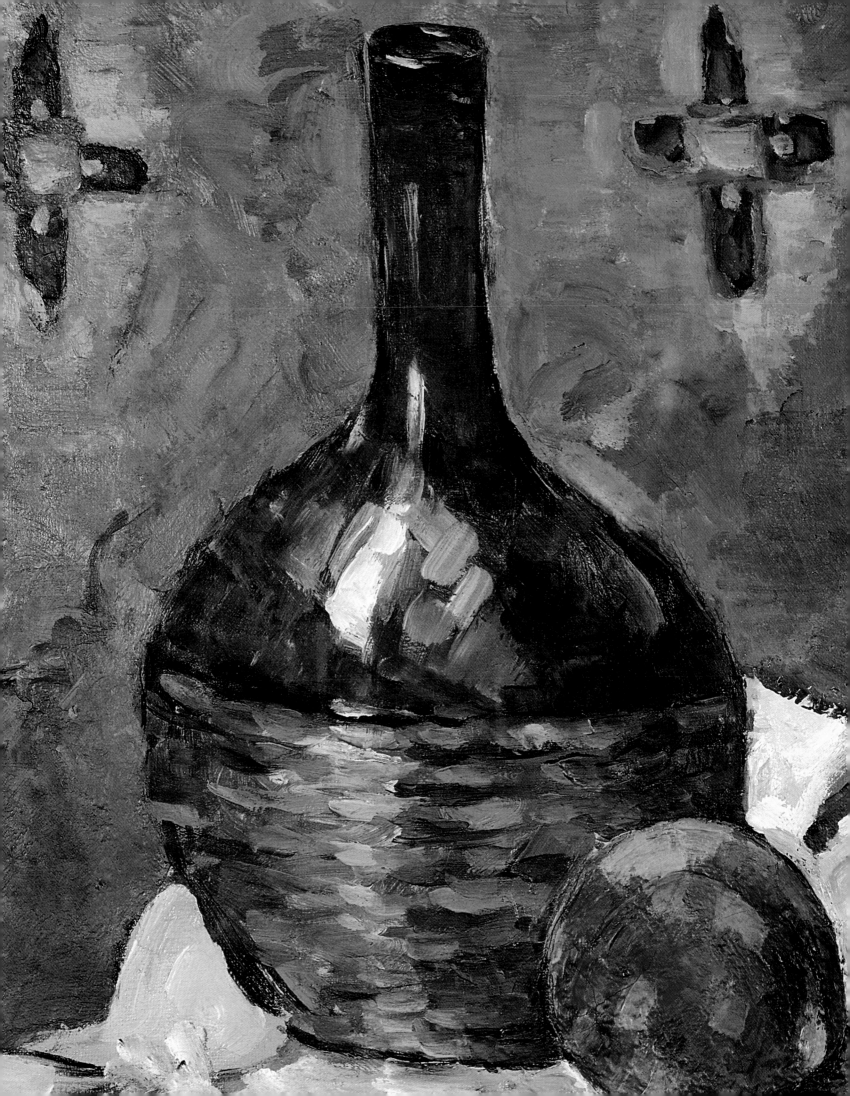

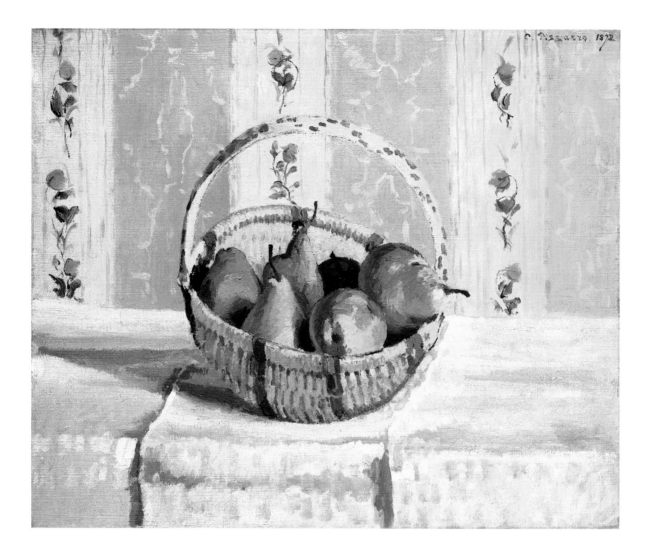

24. Camille Pissarro

Still Life: Apples and Pears in a Round Basket (Nature morte: Pommes et poires dans un panier rond). 1872

Oil on canvas, 18 x 21¾" (45.7 x 55.2 cm)

Lent by Mrs. Walter Scheuer

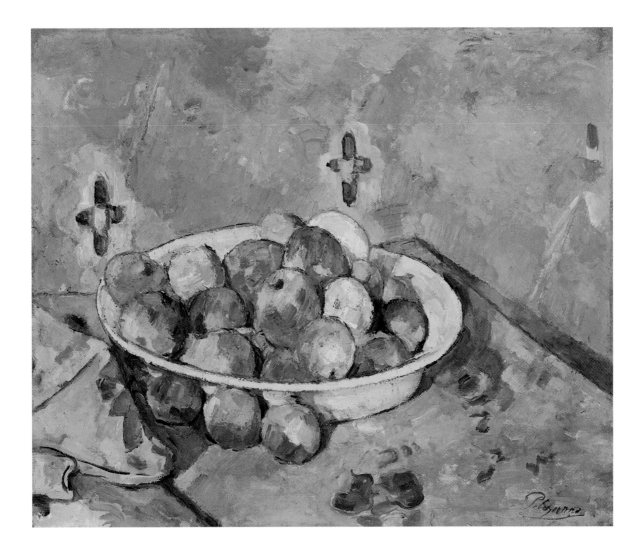

25. Paul Cézanne

The Plate of Apples (*Le Plat de pommes*). c. 1874

Oil on canvas, 18¹⁄₁₆ × 21⁹⁄₁₆" (45.8 × 54.7 cm)

The Art Institute of Chicago. Gift of Kate L. Brewster, 1949

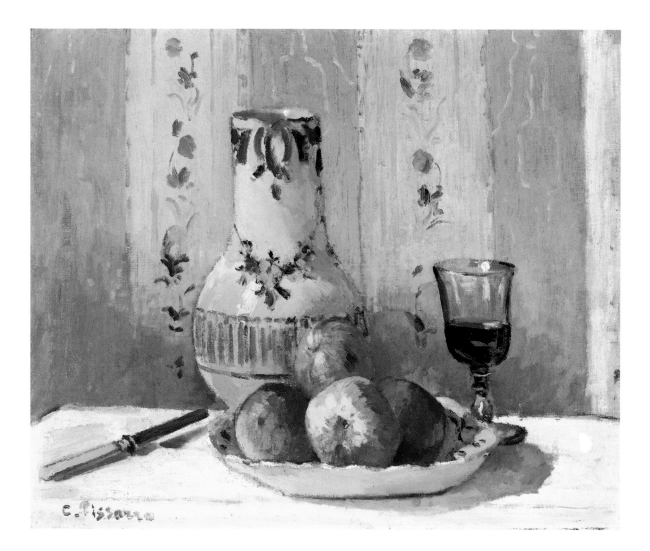

26. Camille Pissarro
Still Life with Apples and Pitcher (Nature morte: pommes et chataigniers et faience sur une table). 1872
Oil on canvas, 18¼ × 22¼" (46.4 × 56.5 cm)
The Metropolitan Museum of Art, New York. Purchase, Mr. and Mrs. Richard J. Bernhard Gift, by exchange, 1983 (1983.166)

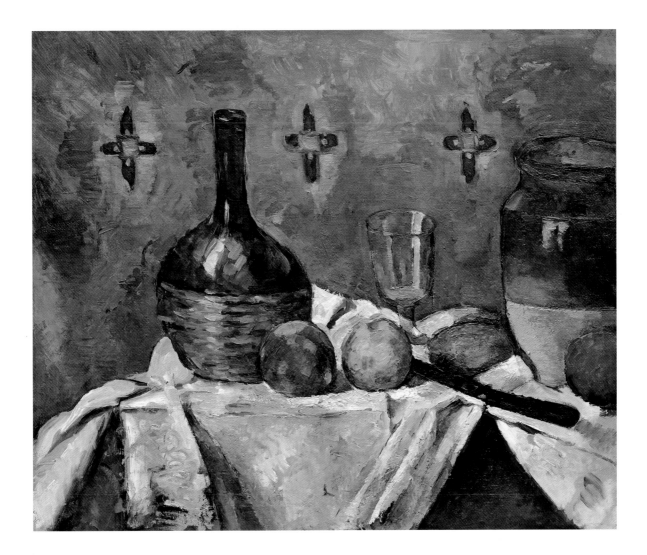

27. Paul Cézanne
Still Life: Flask, Glass, and Jug (Fiasque, verre et poterie). c. 1874
Oil on canvas, 18 × 21¾" (45.7 × 55.3 cm)
Solomon R. Guggenheim Museum, New York. Thannhauser Collection. Gift, Justin K. Thannhauser, 1978

28. Camille Pissarro
Bouquet of Pink Peonies (Bouquet de pivoines roses). 1873
Oil on canvas, 28¾ x 23⅝" (73 x 60 cm)
Ashmolean Museum, Oxford. Pissarro Family Gift, 1951

29. Paul Cézanne
Two Vases of Flowers (Deux Vases de fleurs). c. 1873-74
Oil on canvas, 22⅛ × 18⅜" (56.5 × 46.3 cm)
Collection Mr. and Mrs. Herbert Klapper

30. Camille Pissarro
Bouquet of Flowers with Chrysanthemums in a Chinese Vase (*Bouquet de fleurs, chrysanthèmes dans un vase chinois*). 1873
Oil on canvas, 24 x 19¹¹⁄₁₆" (61 x 50 cm)
National Gallery of Ireland, Dublin

31. Paul Cézanne
Dahlias. c. 1873
Oil on canvas, 28¾ × 21¼" (73 × 54 cm)
Musée d'Orsay, Paris. Count Isaac de Camondo Bequest, 1911

32. Paul Cézanne
Bouquet of Flowers in a Delft Vase (Bouquet de fleurs dans un vase Delft). c. 1873
Oil on canvas, 16⅛ x 10⅝" (41 x 27 cm)
Musée d'Orsay, Paris. Gift of Paul Gachet to the Musée du Jeu de Paume, 1951;
in the collection of the Musée d'Orsay since 1986

33. Paul Cézanne
Bouquet with Yellow Dahlias (Bouquet de dahlias jaunes). c. 1873
Oil on canvas, 21¼ x 25⅛" (54 x 64 cm)
Musée d'Orsay, Paris. Gift of Paul Gachet,
son of Doctor Paul Gachet, 1954

34. Paul Cézanne
Flowers in a Blue Vase (Fleurs dans un vase bleu). c. 1874
Oil on canvas, 21¾ x 18⅛" (55.2 x 46 cm)
The State Hermitage Museum, St. Petersburg, Russia

Building with Paint: Houses and Village Streets in Auvers-sur-Oise and Pontoise

Pontoise and Auvers-sur-Oise, the two neighboring small towns northwest of Paris where the artistic exchange and friendship between Pissarro and Cézanne took root, provide the unifying theme of the paintings in this section. According to Pissarro, Pontoise is where Cézanne "came under my influence and I his."[1] To compare Cézanne's *House and Tree, L'Hermitage* (plate 41) with the paintings he executed in the romantic vein in the 1860s is to realize how much closer he gets to Pissarro's naturalistic vision anchored in the direct observation of nature. Cézanne now leaves behind the mythological themes and turns his attention to an ordinary house for subject matter. The picture was painted outdoors, where Pissarro painted his own version. Their palettes have brightened and their sensitivity to light and atmosphere intensified. In *The House of the Hanged Man, Auvers-sur-Oise* (plate 36), the painting that is considered Cézanne's Impressionist masterpiece, instead of capitalizing on the morose connotations of the title, he remains in touch with the moment of daylight that envelops the architecture. In the company of Pissarro, Cézanne moves toward a vision of painting that is in synchrony with the external world.

The influence was mutually reinforcing. Pissarro, along with Cézanne, began to cultivate an abstract geometric order evident in what became very much integral to Cézanne's thinking. In several of Pissarro's scenes, where typically the architecture is unremarkable (plates 46, 49), geometry is accentuated. Already in the early 1870s this interest in order and structure translates into the way paint is applied on the canvas, with a regularity that eventually led Cézanne to his characteristic parallel strokes. At Auvers and Pontoise, the two artists explored their interest in the underlying geometry of their imagery, layering the surface of the canvas with a progression of geometric forms and systematic brushstrokes (see plates 43, 44, and 46).

While the two artists nudged each other in new directions, they mostly searched to define themselves. The flattening of the pictorial space, for instance, identifies Cézanne. Pissarro, on the contrary, allows the eye to wander into the spatial depth. Their individualities or differences become most evident in the paintings they executed side by side,[2] recurrently working on the same motifs. Cézanne's *Small Houses near Pontoise* (plate 44) and Pissarro's *The Potato Harvest* (plate 43), both of about 1874, are cases in point. The rigorous constructive or parallel strokes, a Cézanne trademark, inform both paintings. The houses that are so central to Cézanne's composition, however, retreat and fade into nature in Pissarro's painting, where the peasants and their activities occupy center stage. Indeed, with Pissarro, ties to humanity in the form of some human presence mark almost all his pictures in this section (see plates 35, 37, 40, 42, 47, and 52).

The common understanding of similarities and differences they came to develop in 1872 allowed the two artists to engage in the Impressionist project, starting with the 1874 First Impressionist Exhibition. Cézanne's *The House of the Hanged Man* could be seen there along with landscapes Pissarro painted at or near Pontoise.

Fereshteh Daftari

35. Camille Pissarro
The Conversation, chemin du chou, Pontoise (La Causette, chemin du chou à Pontoise). 1874
Oil on linen, 23⅝ x 28¾" (60 x 73 cm)
Private collection

36. Paul Cézanne
The House of the Hanged Man, Auvers-sur-Oise (La Maison du pendu, Auvers-sur-Oise). 1873
Oil on canvas, 21⅝ x 26" (55 x 66 cm)
Musée d'Orsay, Paris. Count Isaac de Camondo Bequest, 1911

37. Camille Pissarro
Village Street, Auvers-sur-Oise (Rue de village, Auvers-sur-Oise). 1873
Oil on canvas, 21½ x 25¾" (54.6 x 65.4 cm)
Collection Michael Vineberg

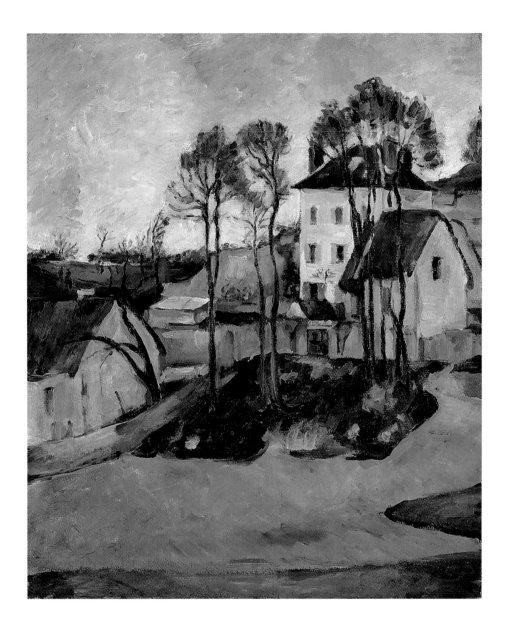

38. Paul Cézanne
The House of Doctor Gachet, Auvers-sur-Oise (La Maison du Docteur Gachet, Auvers-sur-Oise). c. 1872–74
Oil on canvas, 22¹⁄₁₆ x 18½" (56 x 47 cm)
Collection Rudolf Staechelin, on permanent loan to the Kunstmuseum Basel

39. Paul Cézanne
Crossroads of the Rue Rémy in Auvers-sur-Oise (*Carrefour de la rue Rémy à Auvers-sur-Oise*). c. 1872
Oil on canvas, 15 × 17⅞" (38 × 45.5 cm)
Musée d'Orsay, Paris. Gift of Paul Gachet to the Musée du Jeu de Paume, 1954; in the collection of the Musée d'Orsay since 1986

40. Camille Pissarro
Hill at L'Hermitage, Pontoise (Côteau de l'Hermitage, Pontoise). 1873
Oil on canvas, 24 x 28¼" (61 x 73 cm)
Musée d'Orsay, Paris. Gift in lieu of estate tax

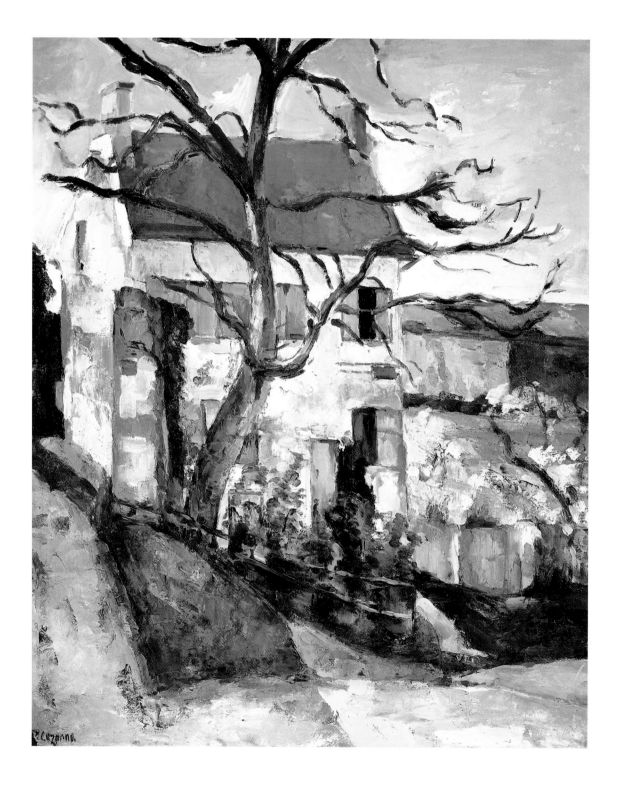

41. Paul Cézanne

House and Tree, L'Hermitage (Maison et arbre, quartier de l'Hermitage). c. 1874

Oil on canvas, 26 x 21⅞" (66 x 55.6 cm)

Private collection, California

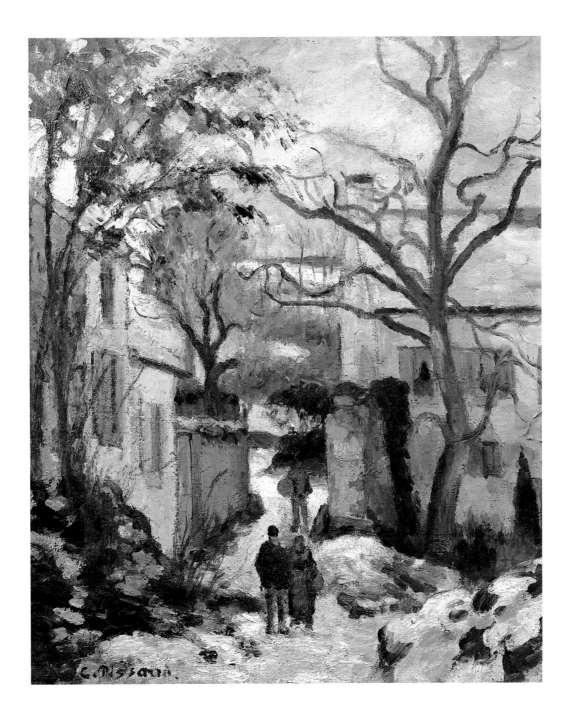

42. Camille Pissarro
L'Hermitage, Pontoise, Winter (L'Hermitage, Pontoise, en hiver). c. 1874
Oil on canvas, 18¼ × 15⅜" (46 × 40 cm)
Private collection, Cambridge, Mass.

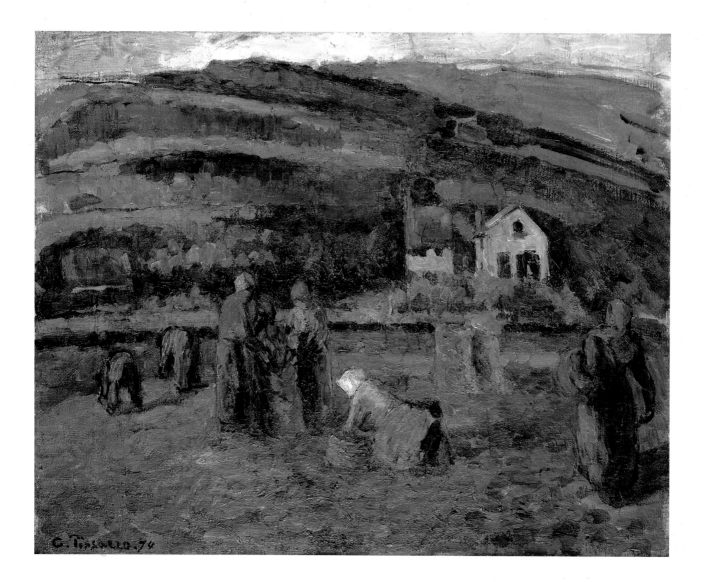

43. Camille Pissarro
The Potato Harvest (La Récolte des pommes de terre). 1874
Oil on canvas, 13³⁄₁₆ × 16⁵⁄₁₆" (33.5 × 41.5 cm)
Private collection, London

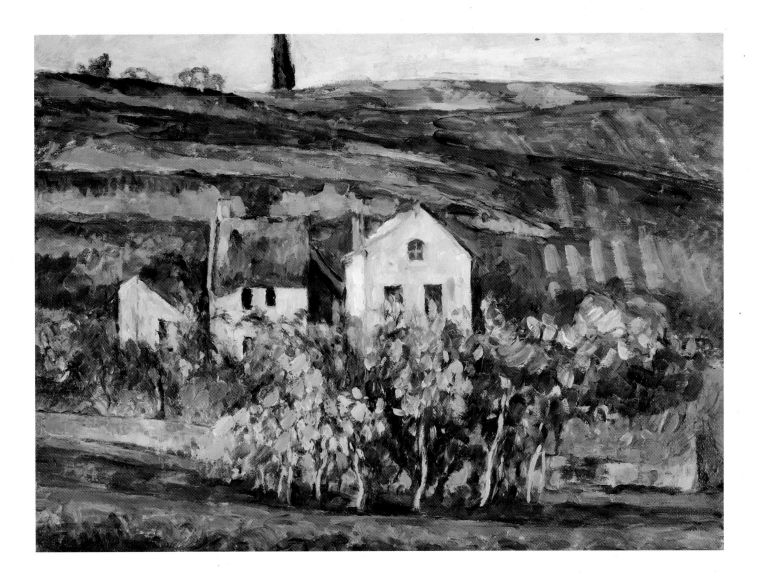

44. Paul Cézanne
Small Houses near Pontoise (Petites Maisons près de Pontoise). c. 1874
Oil on canvas, 15½ x 21" (39.4 x 53.3 cm)
Courtesy of the Fogg Art Museum, Harvard University Art Museums, Cambridge, Mass. Bequest of Annie Swan Coburn

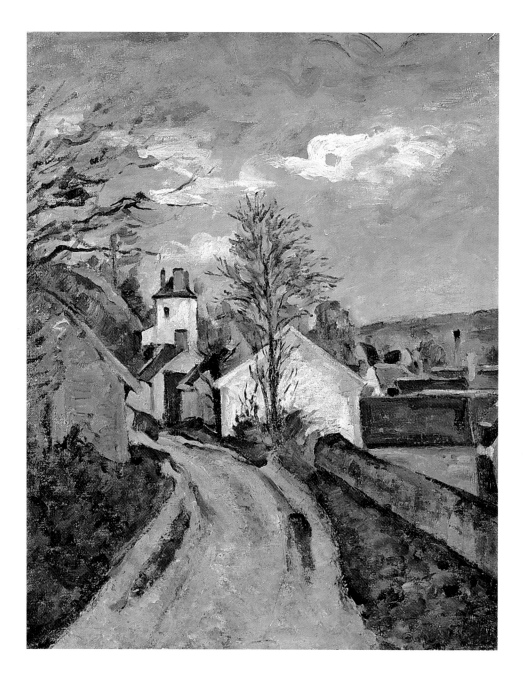

45. Paul Cézanne
The House of Doctor Gachet at Auvers-sur-Oise (La Maison du Docteur Gachet à Auvers-sur-Oise). c. 1872–74
Oil on canvas, 18⅛ x 15″ (46 x 38 cm)
Musée d'Orsay, Paris. Gift of Paul Gachet, 1951

46. Camille Pissarro
Rue de l'Hermitage, Pontoise. 1874
Oil on canvas, 16⅛ x 12⅜" (41 x 32 cm)
Estate of Dr. Rau

47. Camille Pissarro
Path at L'Hermitage, Pontoise (Chemin à l'Hermitage, Pontoise). 1874
Oil on canvas, 21¼ x 25¹⁵⁄₁₆" (54 x 65.5 cm)
Collection Museo Nacional de Bellas Artes, Buenos Aires

48. Paul Cézanne
Village Road, Auvers-sur-Oise (La Vieille Route à Auvers-sur-Oise). c. 1872–74
Oil on canvas, 18⅛ × 21⅝" (46 × 55 cm)
Musée d'Orsay, Paris. Gift of Max and Rosy Kaganovitch, 1973

49. Camille Pissarro
Farmyard, Pontoise (Cour de ferme à Pontoise). 1874
Oil on canvas, 15 × 18" (38.1 × 45.7 cm)
Collection Mr. and Mrs. Jeffrey Peek

50. Paul Cézanne

The House of Doctor Gachet at Auvers-sur-Oise (*La Maison du Docteur Gachet à Auvers-sur-Oise*). 1872–74

Oil on canvas, 24 x 20" (61.6 x 51.1 cm)

Yale University Art Gallery, New Haven, Conn. Collection Mary C. and James W. Fosburgh, B.A. 1933, M.A. 1935

51. Paul Cézanne
View from the Jas de Bouffan (*Vue prise du Jas de Bouffan*). 1875-76
Oil on canvas, 17½ × 23¼" (44.5 × 59 cm)
Anonymous gift to the French government in 2000, the owner retaining life interest

52. Camille Pissarro
Sunlight on the Road, Pontoise (Paysage, plein soleil, Pontoise). 1874
Oil on canvas, 20⅝ x 32⅛" (52.4 x 81.6 cm)
Museum of Fine Arts, Boston. Juliana Cheney Edwards Collection

A Turning Road: Experiments with Composition and the Palette Knife in 1875

The year 1875 can be regarded as the climactic point in the lengthy, if intermittent, working relationship between Pissarro and Cézanne. No letters of that year between the two artists have survived. However, the similarities of their works speak volumes about the intensity of their exchange. Two paintings of Pontoise (plates 54, 55) form a so-called pair that clearly indicates they were working in close proximity. On this particular point, it is interesting to note Cézanne's warm and humorous drawing of his older friend at work, seen from the back (plate 20). The drawing suggests that Cézanne might have favored sitting back slightly behind Pissarro, observing not only the landscape he was painting, but also his old friend as he was concentrating on his own task.

In the paintings mentioned above, the two artists were working at the same time, but not precisely at the same place. Cézanne's vantage point is closer to the group of houses across the road. The painting by Pissarro, executed in 1875, offers more technical and chromatic similarities to the painting by Cézanne than to a painting of the same site executed by Pissarro only two years earlier (plate 53)—a classical Impressionist landscape concerned with atmospheric nuances and subtle chromatic transitions. In the two 1875 paintings (plates 54, 55), Pissarro and Cézanne both are juggling between the palette knife and the brush. The surfaces of these works are harsher, the contrasts more brutal, than in their earlier paintings. Already in 1875, both artists are finding ways that will take them beyond Impressionism.

Another trio of paintings precisely illustrates this point: Cézanne's *L'Étang des Soeurs, Osny, near Pontoise* (plate 63), Pissarro's *Small Bridge, Pontoise* (plate 64), both of 1875, and Cézanne's *The Bridge at Maincy, near Melun* (plate 65), of 1879-80. The Pissarro painting gives us a clue that enables us to date and identify the location of Cézanne's work.[1] Both works seem distant from their earlier Impressionist paintings. At the same time, something rather unusual is happening: highlights of color, or a particular tonality, have acquired a certain autonomy and are detached on Pissarro's painted surface (see plate 64). This clearly anticipates Cézanne's way out of Impressionism—as can already be seen in his *The Bridge at Maincy* (plate 65), which, even though it was executed at the turn of the 1880s, owes a very clear debt to Pissarro's *Small Bridge* (plate 64) and can be read as a kind of homage by Cézanne to that climactic, shared moment in the story of their mutual pictorial discoveries.

Other sets of pictorial concerns then shared by the two artists include an exploration of the tension between receding spaces and foregrounds (see plates 56 and 57), and the visual tension that results from the opposition between a turning road or a lopsided vantage point and the plane surface of the painted canvas (see plates 58, 59, and 62). In all these works, the precepts of early Impressionism receive a new inflection. The turning road is not just one of their favored motifs at this particular juncture. It also offers an apt metaphor for the new directions of their art.

Joachim Pissarro

53. Camille Pissarro
Old Convent, Les Mathurins, Pontoise (Pontoise, Les Mathurins [ancien couvent]). 1873
Oil on canvas, 23½ x 28⅞" (59.7 x 73.3 cm)
Private collection

54. Paul Cézanne
Road at Pontoise (Le Clos des Mathurins à Pontoise). 1875
Oil on canvas, 22¹⁵⁄₁₆ x 27¹⁵⁄₁₆" (58 x 71 cm)
The State Pushkin Museum of Fine Arts, Moscow

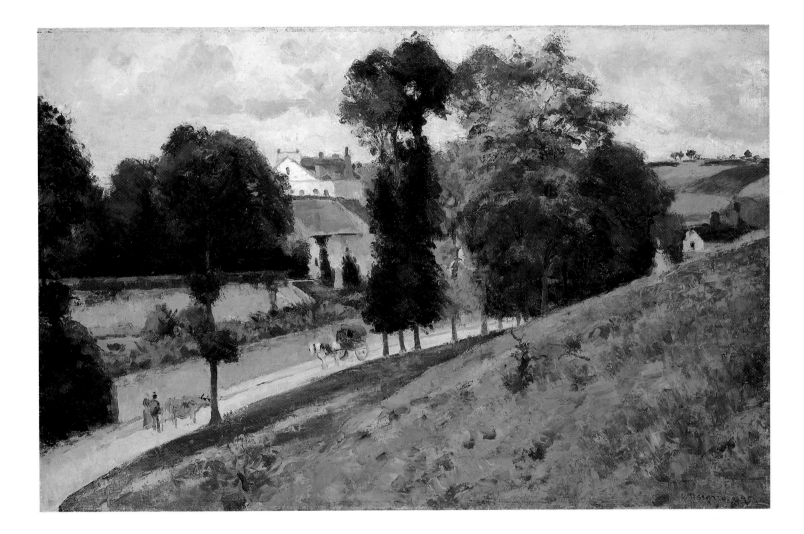

55. Camille Pissarro
Rue de l'Hermitage, Pontoise. 1875
Oil on canvas, 20⅝ x 31⅞" (52.5 x 81 cm)
Private collection, on permanent loan to the Kunstmuseum Basel

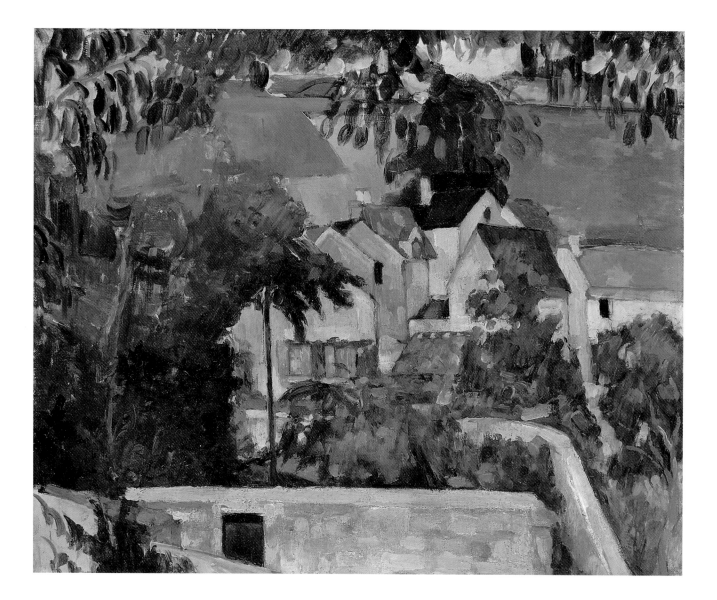

56. Paul Cézanne

Landscape, Auvers-sur-Oise (*Le Quartier du four à Auvers-sur-Oise*). c. 1874

Oil on canvas, 18½ × 20" (47 × 51 cm)

Philadelphia Museum of Art. The Samuel S. White 3rd, and Vera White Collection, 1967

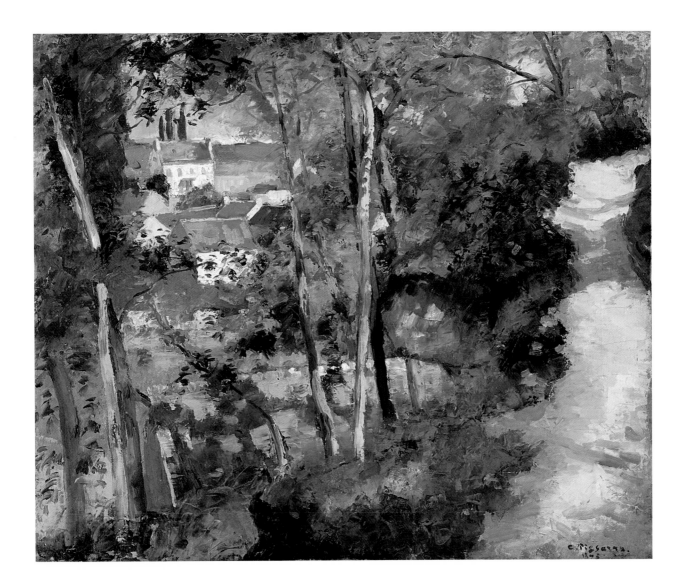

57. Camille Pissarro
The Climbing Path, L'Hermitage, Pontoise (Le Chemin montant l'Hermitage, Pontoise). 1875
Oil on canvas, 21⅛ × 25¾" (53.7 × 65.4 cm)
Brooklyn Museum, New York. Purchased with funds given by Dikran G. Kelekian

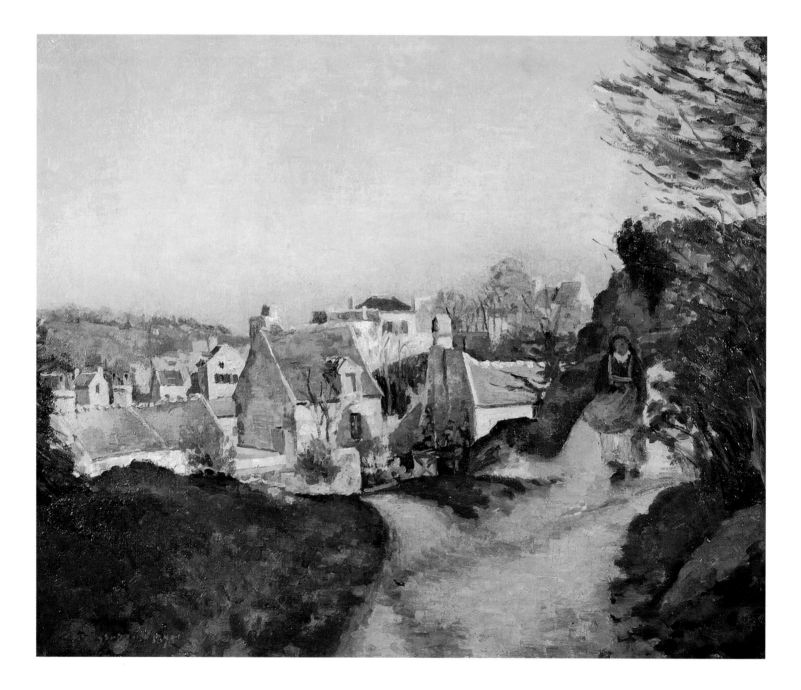

58. Camille Pissarro
L'Hermitage, seen from the Rue de la Côte du Jalet, Pontoise (L'Hermitage, vue de la rue de la Côte du Jalet, Pontoise). 1875
Oil on canvas, 24 x 28" (61 x 71.1 cm)
Private collection

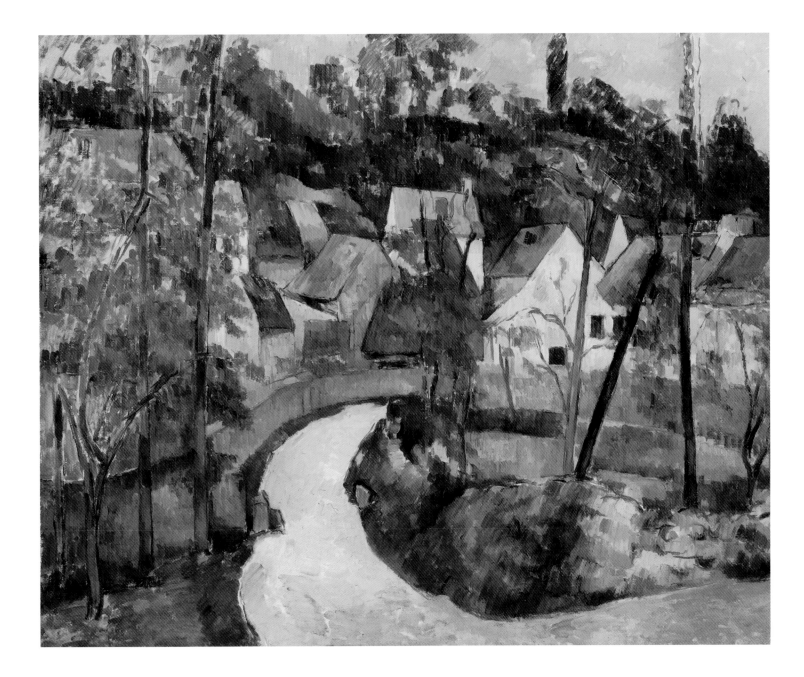

59. Paul Cézanne
Turn in the Road (*La Route tournante*). c. 1881
Oil on canvas, 23⅞ x 28⅞" (60.6 x 73.3 cm)
Museum of Fine Arts, Boston. Bequest of John T. Spaulding

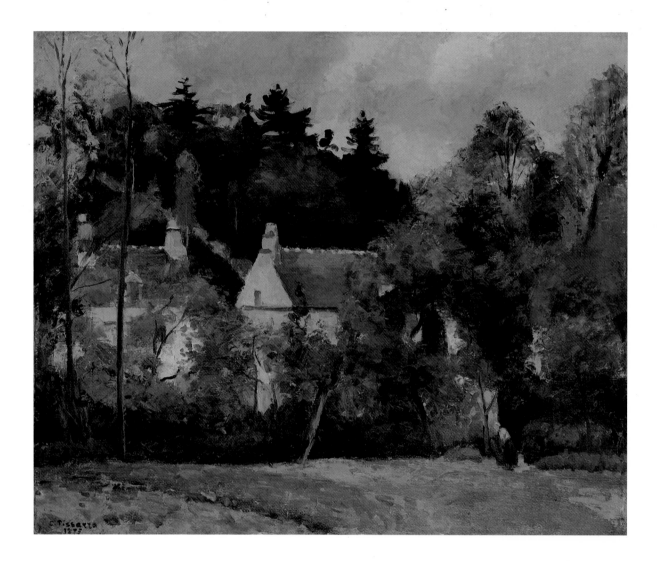

60. Camille Pissarro
Landscape at L'Hermitage, Pontoise (Paysage à l'Hermitage, Pontoise). 1875
Oil on canvas, 21¼ × 25⁵⁄₁₆" (54 × 65 cm)
Museo Cantonale d'Arte, Lugano

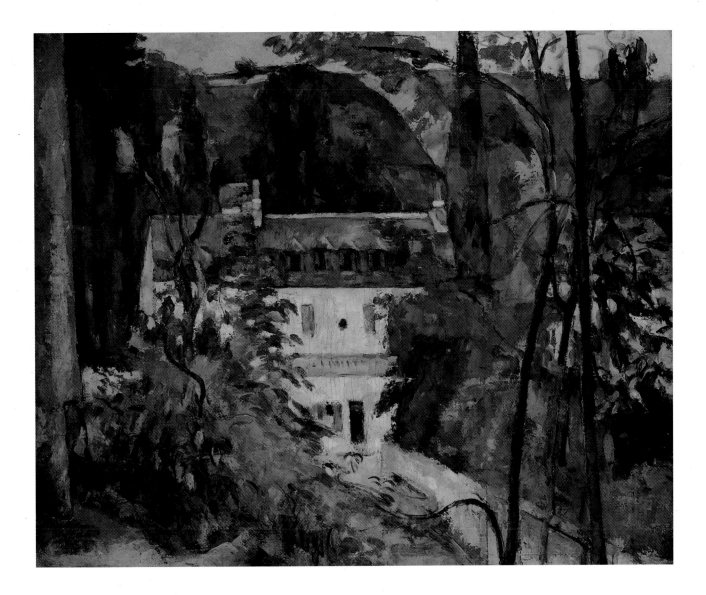

61. Paul Cézanne
Landscape around Pontoise (Paysage environs de Pontoise). c. 1875-77
Oil on canvas, 23⅝ x 28¾" (60 x 73 cm)
Museum Langmatt, Stiftung Langmatt Sidney und Jenny Brown, Baden, Switzerland

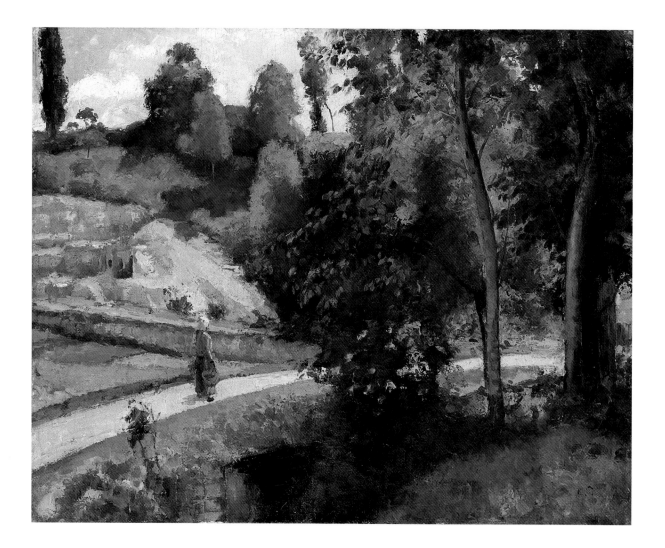

62. Camille Pissarro
Quarry, Pontoise (La Carrière, Pontoise). c. 1875
Oil on canvas, 22¹³⁄₁₆ x 28⁵⁄₁₆" (58 x 72.5 cm)
Collection Rudolf Staechelin, on permanent loan to the Kunstmuseum Basel

63. Paul Cézanne

L'Étang des Soeurs, Osny, near Pontoise (L'Étang des soeurs à Osny, près de Pontoise). c. 1875

Oil on canvas, 23⅝ x 28¹⁵⁄₁₆" (60 x 73.5 cm)

The Samuel Courtauld Trust, Courtauld Institute of Art Gallery, London

64. Camille Pissarro
Small Bridge, Pontoise (Le Petit Pont, Pontoise), 1875
Oil on canvas, 25¹³⁄₁₆ × 32¹⁄₁₆" (65.5 × 81.5 cm)
Stadtische Kunsthalle Mannheim

65. Paul Cézanne
The Bridge at Maincy, near Melun (*Le Pont de Maincy, près de Melun*). 1879-80
Oil on canvas, 23⅜ × 28¼" (58.5 × 72.5 cm)
Musée d'Orsay, Paris. Acquired with funds from the gift of an anonymous Canadian donor, 1955

Separate Paths Through a Shared Landscape: The Late 1870s and the Third Impressionist Exhibition

Early in 1877, Gustave Caillebotte held a dinner party to begin plans for a Third Impressionist Exhibition. To Pissarro, he wrote, "I count absolutely on you."[1] Pissarro had joined an alternative group to the Salon that year—the Union of artists founded by Alfred Meyer, who held political views similar to those of Pissarro. Although Cézanne was not invited to Caillebotte's dinner, it was he who convinced Pissarro to leave the Union and rejoin the Impressionists. Likewise, without Pissarro's support and involvement, Cézanne would probably not have been represented in the initial formation of this important movement in 1874.

Two paintings of the Orchard, Côte Saint-Denis, at Pontoise (plates 76, 77), exhibited at the Third Impressionist Exhibition, succinctly reflect Cézanne's and Pissarro's continous mutual respect. Both works reveal moments in the artists' careers when they looked to each other's works to inspire—but not to heavily influence—their own painting styles. In fact, these paintings are technically very different from one another. In his composition, Pissarro applied layer after layer of paint to the canvas with a dry brush, building up a rich and intricate network of granular brushstrokes that corresponds to the contours of the land. Cézanne, on the other hand, carved his landscape out of thick swathes of paint with a palette knife and highlighted the natural boundaries of the trees using strong, dark contours. He emphasized the inherent structure of the landscape, applying a kind of geometric formula to the natural world.

The same comparisons may be made between Pissarro's *Kitchen Garden, Trees in Flower, Spring, Pontoise* (plate 68) and Cézanne's *The Garden of Maubuisson, Pontoise* (plate 69), which depict the same site. Pissarro's composition is dominated by a vibrant, blossoming orchard. By contrast, Cézanne has inverted this hierarchy: the architectonic features of the houses dominate the gardens below, which have been abstracted to strict verticals and horizontals.

Pissarro's and Cézanne's artistic dialogue around the time of the Third Impressionist Exhibition was fostered by their shared experiences in the region of Auvers-sur-Oise and Pontoise. The compositional structure, heavy brushstrokes, and rich palette employed by Cézanne in paintings such as *Road at Auvers-sur-Oise* (plate 70) and *Turn in the Road* (plate 72) may also be found in Pissarro's *Crossroads at L'Hermitage, Pontoise* (plate 71). At the same time, their shared interest in the harmony of the landscape and the effects of light on the hillsides and meadows can be seen in Pissarro's *L'Hermitage in Summer, Pontoise* (plate 67) and in Cézanne's *Auvers-sur-Oise, Panoramic View* (plate 66).

Cézanne's paintings in this section reveal a new level of artistic maturity, when he adopted only certain elements from Pissarro's technique and incorporated them into a visual language that became uniquely his own. A later work (plate 81) reveals Cézanne's own heavily contoured forms, but the same directional brushstrokes, with which both Pissarro and Cézanne experimented during their years together in and around Pontoise, are still in evidence.

Jennifer Field

66. Paul Cézanne
Auvers-sur-Oise, Panoramic View (Vue panoramique d'Auvers-sur-Oise). c. 1875–76
Oil on canvas, 25¹¹⁄₁₆ x 32″ (65.2 x 81.3 cm)
The Art Institute of Chicago. Mr. and Mrs. Lewis Larned Coburn Memorial Collection, 1933

67. Camille Pissarro
L'Hermitage in Summer, Pontoise (L'Hermitage en été, Pontoise), 1877
Oil on canvas, 22⅜ × 36" (56.8 × 91.4 cm)
Helly Nahmad Gallery, New York

68. Camille Pissarro

Kitchen Garden, Trees in Flower, Spring, Pontoise (Potager, arbres en fleurs, printemps, Pontoise), 1877

Oil on canvas, 25¹⁵⁄₁₆ × 31⅞" (65.5 × 81 cm)

Musée d'Orsay, Paris. Gustave Caillebotte Bequest, 1894

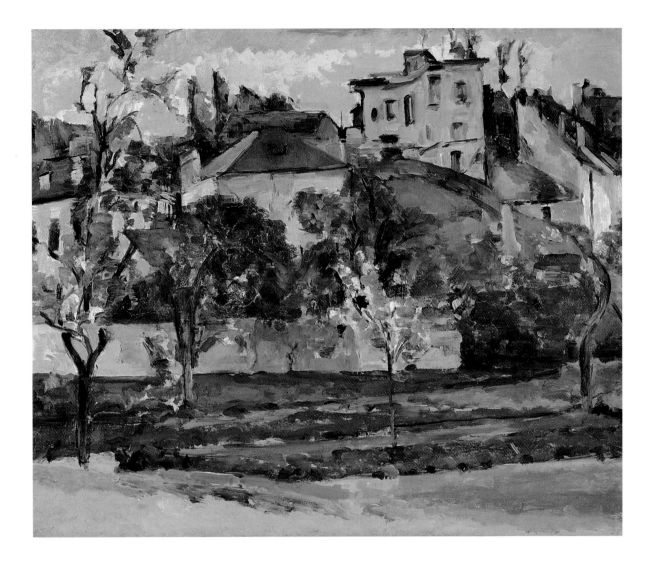

69. Paul Cézanne
The Garden of Maubuisson, Pontoise (Le Jardin de Maubuisson, Pontoise). 1877
Oil on canvas, 19¾ × 23⅝" (50.2 × 60 cm)
Collection Mr. and Mrs. Jay Pack, Dallas, Texas

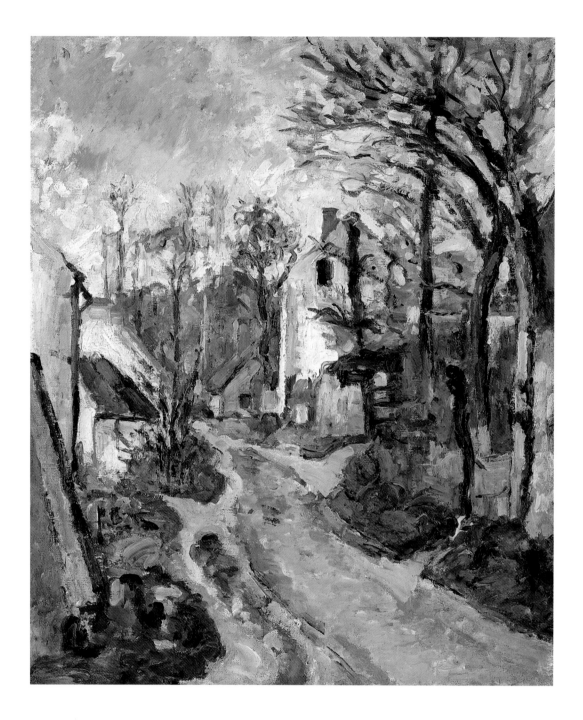

70. Paul Cézanne
Road at Auvers-sur-Oise (rue de Pilonnes) (*La Route à Auvers-sur-Oise [rue de Pilonnes]*). c. 1874–76
Oil on canvas, 21¾ x 18⅛" (55.2 x 46.2 cm)
National Gallery of Canada, Ottawa

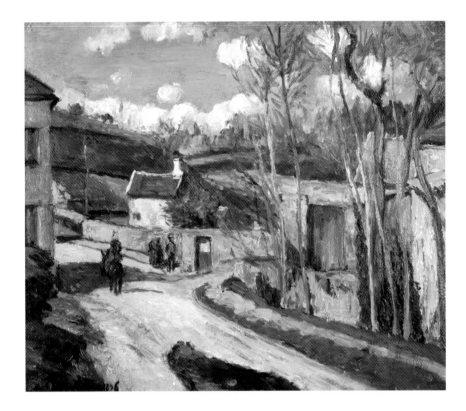

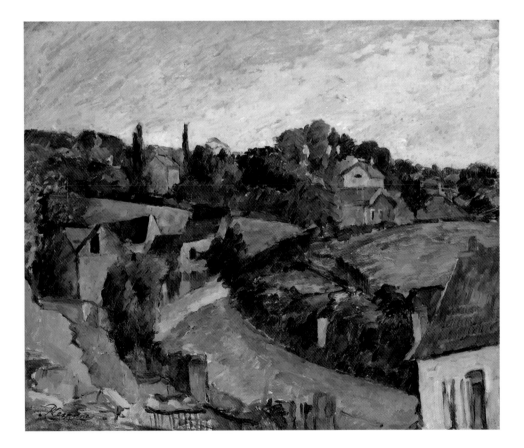

71. Camille Pissarro
Crossroads at L'Hermitage, Pontoise (Un Carrefour à l'Hermitage, Pontoise). 1876
Oil on canvas, 14¹⁵⁄₁₆ x 18⅛" (38 x 46 cm)
Musée Malraux, Le Havre. Collection Senn

72. Paul Cézanne
Turn in the Road (La Route tournante). c. 1875-77
Oil on canvas, 18⅞ x 23¼" (48 x 59 cm)
Collection Joe L. Allbritton

73. Camille Pissarro
The Laborer (*Le Laboureur*). 1876
Oil on canvas, 21¼ × 25⁹⁄₁₆" (54 × 65 cm)
Private collection

74. Paul Cézanne
The Hamlet of Valhermeil, near Pontoise (*Le Quartier de Valhermeil près de Pontoise*). c. 1876-81
Oil on canvas, 20⅞ × 33¹¹⁄₁₆" (53 × 85.5 cm)
Private collection, Tokyo

75. Camille Pissarro

Landscape at Chaponval, Oise Valley (Paysage à Chaponval, Val d'Oise). 1880

Oil on canvas, 21¼ × 25½" (54 × 65 cm)

Musée d'Orsay, Paris. Bequest of Antonin Personnaz to the Louvre, 1937; in the collection of the Musée d'Orsay since 1986

76. Camille Pissarro
Orchard, Côte Saint-Denis, at Pontoise (The Côte des Boeufs, Pontoise) (*Le Verger, côte Saint-Denis, à Pontoise* [*La côte des boeufs, Pontoise*]), 1877
Oil on canvas, 45¼ × 34⅛" (114.9 × 87.6 cm)
The National Gallery, London

77. Paul Cézanne

Orchard, Côte Saint-Denis, at Pontoise (*The Côte des Boeufs, Pontoise*) (*Le Verger, côte Saint-Denis, à Pontoise* [*La côte des boeufs, Pontoise*]). 1877
Oil on canvas, 26 × 22" (66 × 55.9 cm)
Museum of Fine Arts, St. Petersburg, Florida. Extended anonymous loan

78. Paul Cézanne

View of Auvers-sur-Oise, from a Distance (Auvers-sur-Oise, vu des environs). 1876-77

Oil on canvas, 23⅝ x 19¾" (60 x 50.2 cm)

Private collection, New York

79. Camille Pissarro
View of Côte des Grouettes, Pontoise (Vue prise de la côte des Grouettes, Pontoise). 1878
Oil on canvas, 21⅝ × 25⁹⁄₁₆" (55 × 65 cm)
The Museum of Modern Art, Ibaraki, Japan

80. Camille Pissarro
Red Roofs, a Corner in the Village, Winter (Les Toits rouges, coin de village, effet d'hiver), 1877
Oil on canvas, 21¼ × 25⅞" (54.5 × 65.6 cm)
Musée d'Orsay, Paris. Gustave Caillebotte Bequest, 1894

81. Paul Cézanne
Pines and Rocks (Fontainebleau?) (*Pins et Rochers [Fontainebleau?]*). c. 1897
Oil on canvas, 32 × 25¾" (81.3 × 65.4 cm)
The Museum of Modern Art, New York. Lillie P. Bliss Collection

Contrasts in Pure Colors:
L'Estaque and Pontoise

The paintings in this section (plates 82–85) testify to the fact that Cézanne and Pissarro thought about each other even when they were apart. In a letter dated June 24, 1874, Cézanne expresses his gratitude to Pissarro for simply "thinking about me while I am so far away [in Aix]."[1] Unfortunately, the exact terms Pissarro used to express his thoughts about Cézanne are not known, but Cézanne's letter tells us that the dialogue between them continued.

The constant and occasionally silent dynamics between these two artists are evident in Pissarro's painting of a railway crossing (plate 82), which can be seen as a quiet homage to Cézanne, who had this particular painting in mind when he facetiously discussed the pictorial accomplishments of "the great criminals of Paris" (i.e., the Impressionists) with the director of the museum in Aix-en-Provence. As Cézanne recounted in a letter to Pissarro: "When I told him [the director] that you have replaced modeling by the study of tones, and as I tried to explain this to him by looking at nature, he closed his eyes and turned his back to me."[2] The only painting by Pissarro that Cézanne mentions in his letter is indeed *Railway Crossing at Le Pâtis, near Pontoise*, which powerfully illustrates the point that Cézanne attempted to make in his discussion with the museum director.

In a sense, this painting could be read as a symbol of the Cézanne/Pissarro enterprise. The dramatic perspectival axis (that approximates the traditional way of depicting spatial depth) is brought to firm and solid closure with the horizontal railway fence that cuts through the road. Pissarro invites the viewer to focus on what Cézanne calls "pure color contrasts" that build up the surface of the canvas into an impressive, even monumental, chromatic construction that conjures up not only Cézanne, but, for us today, Mondrian, in some ways.

With this picture in mind, Cézanne tells Pissarro that he began painting as soon as he arrived in Aix. He uses this very painting to attempt to lure Pissarro to the south: "Now that I have just reacquainted myself with this countryside [Aix], I believe that it would make you totally happy, for it is amazing how it reminds me of your study of a stop on a railroad track, in full sunlight, in the middle of summer."[3] Two years later, in another letter addressed to Pissarro, Cézanne uses almost exactly the same terms he had used to describe his and Pissarro's venture to the museum director. Describing his very first paintings of L'Estaque, he wrote: "The sun is so startling that it makes it look as if objects could be lifted off in their outlines, which are cast not just in black or white, but in blue, red, brown, purple. I may be wrong, but it seems to me that this is the polar opposite of modeling."[4] In other words, the sun in L'Estaque appears to create pictorial effects in nature that are identical to what Pissarro was doing in *Railroad Crossing*. Indeed, Cézanne's expression would serve very well as a subtitle for this painting: "L'antipode du modelé" (the polar opposite of modeling). In many ways, it announces both artists' entire program for decades to come.

Joachim Pissarro

82. Camille Pissarro

Railway Crossing at Le Pâtis, near Pontoise (La Barrière du chemin de fer, au Pâtis près Pontoise). 1873-74

Oil on canvas, 25⁹⁄₁₆ × 31⅞" (65 × 81 cm)

The Phillips Family Collection

83. Paul Cézanne

L'Estaque. 1879-83

Oil on canvas, 31½ × 39″ (80.3 × 99.4 cm)

The Museum of Modern Art, New York. The William S. Paley Collection

84. Camille Pissarro
Rocky Landscape, Montfoucault (Paysage avec rochers, Montfoucault), 1874
Oil on canvas, 25¾ × 36⅜" (65.5 × 92.5 cm)
Private collection

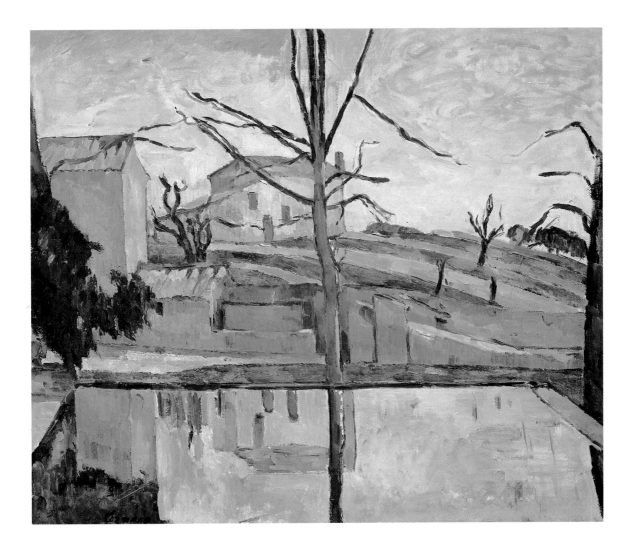

85. Paul Cézanne
The Pool at Jas de Bouffan (*Le Bassin du Jas de Bouffan*). c. 1878
Oil on canvas, 18½ × 22⅛" (47 × 56.2 cm)
Private collection. Courtesy Caratsch, de Pury & Luxembourg, Zürich

A Backward Glance: Cézanne Reconsiders Pissarro's Early Work

During Cézanne's last prolonged sojourn in Pontoise, from May to October 1881, he lived only a few blocks away from L'Hermitage, where the Pissarros resided. There Cézanne began to "formulate" his idea of an artistic truth or recipe, which he continued to develop until his death. This exasperated the young Paul Gauguin, who was then struggling to establish himself as an Impressionist. In a letter to his "professor," Gauguin (with a touch of cynicism) asked Pissarro if Cézanne had discovered the "formula" that would enable him to compress all his sensations into one unique procedure.[1]

The artistic results of the 1881 visit illustrate a statement made by Cézanne to the effect that "if Pissarro had always painted as in 1870, he would have been the strongest among all of us."[2] Cézanne's deference toward Pissarro's early works is evident in 1881. Every work produced by Cézanne at that point appears to refer to an earlier painting by Pissarro. Even though the motif of Cézanne's *Mill on the Couleuvre near Pontoise* (plate 93) is not the same as Pissarro's monumental canvas *L'Hermitage at Pontoise* (plate 92), the two paintings clearly belong to the same family. We know that Pissarro's painting impressed Cézanne, as he referred to it specifically in one of his letters from L'Estaque.[3] If the same serene grandeur presides over both paintings, the Cézanne, executed fourteen years after the Pissarro, displays a boundless energy through the staccato of parallel rows of brushstrokes of color, seen especially in the foliage.

Another parallel can be found in the "pair" of paintings, also executed about fourteen years apart: Pissarro's and Cézanne's *Jalais Hills, Pontoise* (plates 90, 91). The contrast here is even more pronounced. Pissarro proceeds by juxtaposing densely thick blocks of paint, smoothly and painstakingly applied on the canvas, that exude a deep sense of intense labor. Cézanne retains all the intensity of the Pissarro, but breaks down each plane into myriads of parallel brushstrokes that energize (almost electrify) the picture surface. One finds another instance of Cézanne's extraordinary, renewed interest in the pre-1870 Pissarro when he decided to resume the motif Pissarro had painted in 1867–69, *Gardens at L'Hermitage, Pontoise* (plate 94), and produced *L'Hermitage at Pontoise*, 1881 (plate 95). Besides looking at the Pissarros of the late 1860s, Cézanne also studied the early Impressionist production of his older friend: for instance, *Bridge and Dam, Pontoise* (1881; plate 87) depicts the same motif as Pissarro's *Railroad Bridge, Pontoise* (c. 1873; plate 86), and *Turning Road, Auvers-sur-Oise* (c. 1881; plate 89), draws on Pissarro's *Landscape at L'Hermitage, Pontoise* of 1874 (plate 88). At the end of their relationship, Cézanne bows to nostalgia and turns back to reexplore the beginnings of this extraordinary interrelationship. Finally, the last pair of works executed by both artists working side by side date from 1882 (plates 96, 97), during an undocumented stay by Cézanne with Pissarro in Pontoise.[4]

Joachim Pissarro

86. Camille Pissarro
Railroad Bridge, Pontoise (Le Pont du chemin de fer, Pontoise). c. 1873
Oil on canvas, 19⅝ x 25⅝" (50 x 65 cm)
Private collection

87. Paul Cézanne
Bridge and Dam, Pontoise (*Le Pont et le barrage, Pontoise*). 1881
Oil on canvas, 23¾ × 29¼" (60.3 × 74.3 cm)
Private collector

88. Camille Pissarro

Landscape at L'Hermitage, Pontoise (Paysage à l'Hermitage, Pontoise). 1874

Oil on canvas, 23¾ x 28⅜" (60.3 x 73 cm)

Private collection

89. Paul Cézanne
Turning Road, Auvers-sur-Oise (La Route tournante à Auvers-sur-Oise). c. 1881
Oil on canvas, 23¾ × 28¾″ (60.3 × 73 cm)
Quinque Foundation, Boston

90. Camille Pissarro
Jalais Hill, Pontoise (La Côte du Jalais à Pontoise). 1867
Oil on canvas, 34¼ × 45¼" (87 × 114.9 cm)
The Metropolitan Museum of Art, New York. Bequest of William Church Osborn, 1951 (51.30.2)

91. Paul Cézanne
Jalais Hill, Pontoise (La Côte du Jalais à Pontoise). 1879-81
Oil on canvas, 23⅝ × 29¾" (60 × 75.6 cm)
LVMH / Moët Hennessy. Louis Vuitton Collection

92. Camille Pissarro
L'Hermitage at Pontoise (*Les Côteaux de l'Hermitage*). c. 1867
Oil on canvas, 59⅜" × 6' 7" (151.4 x 200.6 cm)
Solomon R. Guggenheim Museum, New York. Thannhauser Collection. Gift, Justin K. Thannhauser, 1978

93. Paul Cézanne

Mill on the Couleuvre near Pontoise (Le Moulin sur le Couleuvre à Pontoise). c. 1881

Oil on canvas, 28¹⁵⁄₁₆ × 36" (73.5 × 91.5 cm)

Nationalgalerie, Staatliche Museen zu Berlin, Germany

94. Camille Pissarro
Gardens at L'Hermitage, Pontoise (Les Jardins de l'Hermitage, Pontoise), 1867-69
Oil on canvas, 31⅞ x 39⅜" (81 x 100 cm)
National Gallery, Prague

95. Paul Cézanne
L'Hermitage at Pontoise (L'Hermitage à Pontoise). 1881
Oil on canvas, 18⅜₆ × 22⅛₆" (46.5 × 56 cm)
Von der Heydt-Museum Wuppertal, Germany

96. Paul Cézanne
Houses at Pontoise, near Valhermeil (*Maisons à Pontoise, près de Valhermeil*). 1882
Oil on canvas, 28¾ × 36¼" (73 × 92 cm)
Private collection

97. Camille Pissarro
Path and Hills, Pontoise (Sente et côteaux de Pontoise). 1882
Oil on canvas, 23⅝ x 28¾" (60 x 73 cm)
Private collection, Mequon, Wisconsin

Salut and Farewell: A Final Interaction

Despite scant documentary evidence, Cézanne saw Pissarro during the summer of 1882. The last pair of paintings they produced together (*Houses at Pontoise, near Valhermeil* and *Path and Hills, Pontoise* (see plates 96, 97 in the previous section) offer a transition toward both artists' later development. While Cézanne had responded to Pissarro's early pictorial lesson, now Pissarro is responding to the lesson Cézanne absorbed from him ten or fifteen years earlier, and appears to be actually trying to outdo Cézanne. The surface of the painting in the Cézanne work seems to be divided into layers of parallel individual strokes; the Pissarro, however, reveals such a dense profusion of broken-down strokes as to say: "Let's see how far I can go with this new trick." The essential difference between the two paintings, besides their chromatic scales (Pissarro's palette is composed of brilliant or high-pitched hues, while Cézanne's is muted and monotonic), is the orientation of the strokes of paint given by each artist. While Cézanne's canvas is covered with rows of parallel strokes, in good order (either vertical, as in the foreground, or diagonal, as on the hillside to the left), Pissarro's hand seemed to have been under some kind of frenzy: flurries of brushstrokes flow in every direction, creating a complete impression of chaos as one looks closely at the paint surface.

The mid-1880s offer a denouement of a quarter of a century of reciprocal engagement between these artists. Despite the lack of much documentary evidence as to close contacts between them, it seems impossible to imagine that neither of them would have known what the other was doing in 1885. For one thing, that year Cézanne came to the north more frequently than he ever did, as he was staying in Médan, at Émile Zola's house. Even if no letters or written documents support the fact that they had contact by the mid-1880s, their works provide strong testimony to their ultimate contact. Pissarro's *Gisors, New Quarter* (1885; plate 104) is a direct response by the older artist to Cézanne's more and more systematic method of dividing and deconstructing his surfaces in rows of rhythmic and parallel strokes. It provides an exquisite final salute on Pissarro's part to Cézanne's *Oise Valley* (c. 1881–82, plate 103), which, given its densely worked surface, must have been reworked, possibly in the studio, after Cézanne's sojourn with Pissarro in 1881. The close parallels between these two works suggest that this was most likely the last intense moment of interaction and emulation between the two artists.

The final moment of this dialogue reveals the degree of mutual fascination that each artist held for the other's work. At the same time, the small group of works reproduced in this section is portentous of what modern painting holds in stock for the years and decades to come. These two works clearly no longer belong to Impressionism. At this particular point, Pissarro is about to jump from the Cézannian boat and catch the Neo-Impressionist boat, while Cézanne is about to launch his solitary experiment that will lead him to develop and expose his new "truth in painting."[1]

Joachim Pissarro

98. Paul Cézanne
The Pool at Jas de Bouffan (Le Bassin du Jas de Bouffan). c. 1878–79
Oil on canvas, 29 × 23¾" (73.7 × 60.3 cm)
Albright-Knox Art Gallery, Buffalo, New York. Fellows for Life Fund, 1927

99. Camille Pissarro
Washing House and Mill at Osny (Lavoir et moulin à Osny). 1884
Oil on canvas, 25¹¹⁄₁₆ x 21⅜" (65.3 x 54.3 cm)
Private collection

100. Paul Cézanne
Village Framed by Trees (Village encadré par des arbres). c. 1881
Oil on canvas, 28¾ x 36¼" (73 x 92 cm)
The National Museum of Fine Arts, Stockholm

101. Camille Pissarro
Church and Farm at Eragny (L'Eglise et la ferme d'Eragny). 1884
Oil on canvas, 21⁷⁄₁₆ × 24¹³⁄₁₆" (54.5 × 63 cm)
The Museum of Modern Art, Gunma, Japan

102. Camille Pissarro
Landscape at Osny (Paysage à Osny). c. 1883
Oil on canvas, 18⅛ × 21⅝" (46 × 55 cm)
Columbus Museum of Art, Ohio. Museum Purchase, Howald Fund, 1952

103. Paul Cézanne
Oise Valley (*La Vallée de l'Oise*). c. 1881–82
Oil on canvas, 28⅜ × 35⅞" (72 × 91 cm)
Private collection, Paris

104. Camille Pissarro
Gisors, New Quarter (*Gisors, Quartier neuf*). 1885
Oil on canvas, 23⅞ × 29" (60 × 74 cm)
Private collection

105. Camille Pissarro
Edge of the Woods near L'Hermitage, Pontoise (Le Fond de l'Hermitage, Pontoise). 1879
Oil on fabric, 49⁵⁄₁₆ × 63⁵⁄₁₆" (125 × 163 cm)
The Cleveland Museum of Art. Gift of the Hanna Fund, 1951

106. Paul Cézanne

Forest (Sous-Bois). c. 1894

Oil on canvas, 45¹³⁄₁₆ × 32" (116.2 × 81.3 cm)

Los Angeles County Museum of Art. Wallis Foundation Fund in memory of Hal B. Wallis

Notes

Abbreviated references herein are cited in full in the Bibliography. All translations are by this author, unless an English translation is specifically cited. Emendations to these published translations have occasionally been made, as noted.

1. George Sand, *Correspondance*, ed. Georges Lubin (Paris: Garnier, 1967), III, 327. Letter from George Sand, from Paris, April 2, 1836: "Je sens que je ne puis être ni soldat, ni prêtre, ni maître, ni disciple, ni prophète, ni apôtre. Je serai pour tous, un frère débile, mais dévoué: je ne sais rien, je ne puis rien enseigner, je n'ai pas de force, je ne puis rien accomplir."
2. As spelled by Ihab Hassan in an early manifesto of "postmodernism": "POSTmodernISM: A Paracritical Bibliography," *New Literary History: A Journal of Theory and Interpretation* 3, no. 1 (autumn 1971): 5-30.
3. Greenberg 1986, 85: "I identify Modernism with the intensification, almost the exacerbation, of this self-critical tendency that began with the philosopher Kant."
4. Lyotard 1979, 8. Lyotard is quoting Ludwig Wittgenstein from Wittgenstein, *Philosophical Investigations*, trans. by G. E. M. Anscombe, 2nd ed. (New York: Macmillan Company, 1958), 12.
5. Albrecht Wellmer, *The Persistence of Modernity: Essays on Aesthetics, Ethics, and Postmodernism* (Cambridge, Mass.: The MIT Press, 1991); William R. Everdell, *The First Moderns: Profiles in the Origins of Twentieth-Century Thought* (Chicago: The University of Chicago Press, 1997).
6. Modern*Starts* 1999, 18.
7. They also saw each other again in 1895, while viewing Claude Monet's paintings of Rouen Cathedral at Durand-Ruel's gallery. The same year Pissarro rediscovered his old friend's work at the first large-scale retrospective of Cézanne's work at Vollard's gallery.
8. Fry 1989 [1927], chaps. VIII-X.
9. Barr 1929, 19.
10. Ibid.
11. Castagnary, "L'Exposition du Boulevard des Capucines—Les Impressionnistes," *Le Siècle*, April 29, 1874. Quoted in Rewald 1985 [1946], 330.
12. Wechsler 1981, 6.
13. Barr 1929, 11.
14. Ibid., 20.
15. Ibid.
16. Fry 1989 [1927], 10.
17. Ibid., 30, 32.
18. Ibid., 33.
19. Barr 1929, 27.
20. See Shikes and Harper 1980, 17.
21. This union countermanded two Jewish laws. One specifically prohibits a man from marrying his uncle's wife: "Thou shalt not uncover the nakedness of thy father's brother, thou shalt not approach his wife: she is thine aunt" (Leviticus 18:14). The other forbids a man from marrying a nursing mother until her child is at least two years old. When young Frédéric proposed to Rachel, she was still nursing her last child from her deceased husband. See Pissarro 1994, 21-22, and *St. Thomas Tidende*, November 23, 1826, repr. p. 21.
22. St. Thomas then belonged to the Danish Crown.
23. This certainly may have been a strong factor in Pissarro's staunch atheism, to which he adhered throughout his life.
24. Venegas 1983, 124-25.
25. Letter from Antoine Guillemet to Oller, September 12, 1866. In Taylor 1983, 226: "Que ton élève a donc fait de chemin[,] il est méconnaissable."
26. The exact date and circumstances of the meeting between Pissarro and Cézanne is a point on which there is little agreement among art historians. I have chosen the date mentioned by Pissarro, although it remains undocumented and impossible to verify. John Rewald suggests that Pissarro met Cézanne through Guillaumin (Cézanne, *Correspondance*, 112).
27. Pissarro, *Correspondance*, IV, 128: "Voyais-je assez juste en 1861 quand moi et Oller nous avons été voir ce curieux provençal dans l'atelier Suisse où Cézanne faisait des académies à la risée de tous les impuissants de l'école, entre autres de ce fameux Jacquet effondré dans le joli depuis longtemps et dont les œuvres se payaient à prix d'or!!"
28. Lucien Pissarro, unpublished sketchbook, no. 52, 1912, Pissarro Family Archives, Ashmolean Museum, Oxford. ("Va te faire foutre . . . Le tout doit être dit avec un fort accent marseillais.") The same anecdote is told by Ambroise Vollard, who, therefore, must have heard it from Lucien or one of his brothers. Vollard

twists the context of the story and displaces it to Provence. See Vollard 1938, 60. On Cézanne's very strong Marseillais accent, see also Duranty 1880, 316.

29. See Rewald 1936, 7.

30. See, for instance, Shikes and Harper 1980, 18-19, and Vollard 1938, 11: "Elisabeth Aubert, la mère de Cézanne, née à Aix d'une famille qui avait de lointaines origines créoles, était vive et romanesque, avec un esprit primesautier mais en même temps d'une humeur inquiète, ombrageuse, emportée. C'est d'elle que 'Paul' tenait son imagination et sa vision de la vie." The term "Creole" in French can refer to persons of two different origins: one of European descent born in the French West Indies or in Latin America, or a descendant of French or Spanish settlers; or one of mixed Creole and black descent. It was presumably in the former sense that both Pissarro's and Cézanne's mothers were described as of Creole origins, although very little is known about the genealogy of either woman.

31. See Cahn 1995, 528.

32. Vollard 1938, 11. "Eh! quoi! Il s'appelle Paul, comme Véronèse et Rubens!"

33. Pissarro was nine years older than Cézanne; he arrived in Paris in 1855, Cézanne in 1861.

34. Bakhtin 1979, 323-35; quoted by Todorov 1984, 109-10.

35. For a lucid and useful explanation of the recent history of the concept of "patrie" (fatherland) within the French Academy, see Crow 1995, 31-45.

36. I am borrowing this apt metaphor from Richard Brettell, who, in 1992, used it to describe a late painting by Pissarro at the Dallas Museum of Art.

37. Pissarro, Correspondance, IV, 504. Letter to Lucien, August 19, 1898. Pissarro makes this manifesto-like declaration: "Nous avons aujourd'hui un type général que nos grands artistes modernes nous ont légué, nous avons donc une tradition d'art moderne; je suis d'avis de le suivre en le modifiant à notre point de vue individuel." (We have today a general culture—the legacy of our great modern artists. We, therefore, have a modern art tradition. In my opinion each of us should follow it while adjusting it according to our individual perspective.)

38. Pissarro, Correspondance, III, 100. Letter to Lucien, June 28, 1891: "Car l'art 1830, c'est

Corot, c'est Courbet, c'est Delacroix, c'est Ingres! . . . et c'est beau éternellement." (The art of 1830! That's Corot, that's Courbet, that's Delacroix, and that's Ingres! . . . And it is beautiful forever.)

39. Pissarro, Correspondance, I, 266. Letter to Lucien, December 28, 1883: "Une idée générale du movement qui emporte notre société moderne vers des idées nouvelles."

40. Pissarro, Correspondance, IV, 264. Letter to Lucien, September 30, 1896: "Nous sommes dans le vrai, suivons notre sensation." Quoted in Clement Greenberg, "Review of Camille Pissarro: Letters to His Son Lucien, edited by John Rewald," in Greenberg 1986, 214.

41. The concept of "sensation" would remain central to the theoretical scaffolding of Impressionism. Even though much has been written on this not easily definable notion, it seems likely that its source goes back to literature. Stendhal, in an early text (Filosophia Nova, II, 365), wrote: "Biran nomme sensation ce que l'on aperçoit lorsqu'on est passif dans l'impression. Lorsqu'on est actif, c'est-à-dire que l'on remarque ce que l'on sent, et cela au moyen de la disposition donnée à l'organe, il l'appelle perception." (Biran calls sensation what we perceive through a passive impression. When we are active, that is when we notice what we feel through the faculties of our organs, he calls that perception.) Quoted in Richard 1954, 128.

42. Flam 1994, 126. "Henri Matisse Speaks to You" (1950).

43. Pissarro, Correspondance, III, 102. Letter to Lucien, July 8, 1891: "Nous sommes dans la vraie voie, logique, qui nous conduira vers l'idéal, du moins il me semble." (We are on the way of truth and logic that will lead us to the ideal, at least it seems to me to be this way.)

44. Roos 1996, 182-220.

45. Cézanne, Correspondance, 332. Letter to his son, Paul, October 15, 1906: "Je continue à travailler avec difficulté, mais enfin, il y a quelque chose. C'est l'important, je crois. Les sensations faisant le fond de mon affaire, je crois être impénétrable. Je laisserai d'ailleurs le malheureux que tu sais me pasticher tout à son aise, ce n'est guère dangereux." (The artist who is "pastiching" his work is probably Émile Bernard, with whom Cézanne is corresponding, but whom he refers to as "l'infortuné Bernard" in a letter to his son. See Correspondance, 328.)

46. Cézanne, Correspondance, 332. "Mon cher Paul, pour te donner des nouvelles aussi satisfaisantes que tu le désires, il faudrait avoir vingt ans de moins. Je te le répète, je mange bien, et un peu de satisfaction morale—mais pour ça il n'y a que le travail qui puisse me le donner—ferait beaucoup pour moi. Tous mes compatriotes sont des culs à côté de moi."

47. In 1906 the only surviving artists who were his contemporaries were Edgar Degas, Auguste Renoir, and Claude Monet.

48. Cézanne, Correspondance, 332. "Je crois les jeunes peintres beaucoup plus intelligents que les autres, les vieux ne peuvent voir en moi qu'un rival désastreux."

49. Cézanne, Correspondance, 223. Letter to Zola, August 25, 1885. ". . . l'isolement le plus complet. Le bordel en ville, ou autre, mais rien de plus."

50. Zola, Manet 1867, in Zola, Écrits, 149: "Le beau n'est plus ici une chose absolue." (Beauty is no longer something absolute.)

51. In this. Zola is a direct heir of Immanuel Kant's Critique of the Power of Judgment, in which the principal thesis is that the site of production of aesthetic judgments ("this is beautiful" or "this is ugly") lays not so much in the object of contemplation itself (a painting, a landscape) as in the mind of the person who casts the judgment. More specifically, an aesthetic judgment (finding an object beautiful) occurs when the faculty of imagination matches the faculty of understanding as if per chance.

52. Zola, Manet 1867, in Zola, Écrits, 149. "C'est en nous que vit la beauté, et non en dehors de nous."

53. Zola's "Salon" was published in the form of seven successive articles in L'Événement between April 27 and May 20, 1866. The sociopolitical context of the 1866 Salon was comparable to the famous 1863 Salon (that generated the infamous Salon des Refusés, where works rejected by the jury of the Salon were given a chance to be seen by the public, even though this opportunity was interpreted by many as a form of humiliation and an admission of failure). The 1866 Salon opened with similar grounds for scandal: two of Manet's works (The Fifer and The Tragic Actor) had been "refusés." Jalos Holtzhapfel, an artist whose works had just been rejected, committed suicide. It is in this highly charged context that Zola published his polemical articles—all

dedicated to his friend Cézanne.

54. Zola, *Mon Salon*, in *Écrits*, 90.

55. Ibid., 90-91.

56. Pissarro 1994, 52 and 295, n. 20.

57. Examples of the use of the term "truth" abound in both Pissarro's and Cézanne's correspondence. Pissarro's definition of truth is that "one must only be oneself!—even though this is not an effortless goal!" (L'on doit [n']être que soi-même! Mais on ne l'est pas sans effort!). Pissarro, *Correspondance*, I, 264. Letter to Lucien, December 25, 1883. This truth to oneself (or one's sensations) remains a shibboleth in Pissarro's correspondence. To his second son, he sends the warning: "Mais méfie-toi, reste toi-même. Ah! Voilà où commence la difficulté!" (Beware! Stay yourself. Ah! That is where the difficulty begins!) Ibid., II, 324. Letter to Georges, January 9, 1890. Finally, in a pre-Greenbergian tone, Pissarro announces modernism by warning those artists who would lie, by "concealing" the inner components of their works (what Greenberg would have called the painterliness of their works). ("Gare à ceux qui cachent les dessous de l'œuvre.") Ibid., III, 151. Letter to Octave Mirbeau, November 23, 1891. To Cézanne, too, "Nothing is beautiful but truth, truth alone is pleasing." (Rien n'est beau que le vrai, le vrai seul est aimable.) Cézanne, *Conversations*, 114. But for him as well, truth is to be understood in terms of sincerity, or truth to oneself. This truth can only be reached through sensations, feelings, and simplicity: "Yes, I want to know. To know in order to feel better, and to feel in order to know. I want to be the best in my job: I want to be simple. Those who know are simple." (Oui, je veux savoir. Savoir pour mieux sentir, sentir pour mieux savoir. Tout en étant le premier dans mon métier, je veux être simple. Ceux qui savant sont simples.) Cézanne, *Conversations*, 115.

58. This article was first published under the title "L'esthétique professée à l'École des beaux-arts," in *Revue contemporaine*, February 15, 1866, and became the chapter titled "M. H. Taine, artiste" of his polemic set of essays, *Mes Haines, causeries littéraires et artistiques* (Paris: Achille Faure, 1866). See Zola, *Écrits*, 77: "J'ai dit que j'avais souci de vérité. Tout bien examiné, j'ai encore plus souci de personnalité et de vie. Je suis, en art, un curieux qui n'a pas grandes règles, et qui se penche volontiers sur toutes les œuvres, pourvu qu'elles soient l'expression forte d'un individu."

59. Zola, *Écrits*, 64: "On se sent le besoin de la vérité, et, comme on ne trouve la vérité entière nulle part, on s'en compose une pour son usage particulier, formée de morceaux choisis un peu partout. . . . La vérité n'est donc pas de ce monde, puisqu'elle n'est point universelle, absolue."

60. Zola, *Écrits*, 66: "Je préfère le poète, l'homme de chair et de nerfs, qui se révèle dans les peintures."

61. Ibid., 81: "J'exprimerai toute ma pensée en disant qu'une œuvre d'art est un coin de la création vu à travers un tempérament." This definition finds a strong echo in Jules Castagnary's early definition of Impressionism: "They are *impressionists* in the sense that they render not the landscape but the sensation produced by the landscape" (quoted by Shiff 1984, 2). It also has to be said that the same themes and concepts were already put in place a couple of years before Zola's incipient career as an art critic. In 1863 Castagnary thus laid out the problem: "The ideal is the free product of each person's consciousness put in contact with external realities, in consequence an individual conception which varies from artist to artist" (see Castagnary 1892, I, 102). For a more detailed and penetrating discussion of this early definition, see Shiff 1984, 45-52 and 245.

62. Zola, *Écrits*, 81.

63. Ibid.

64. Ibid.: "Il est bien convenu que l'artiste se place devant la nature, qu'il la copie en l'interprétant, qu'il est plus ou moins réel selon ses yeux; en un mot, qu'il a pour mission de nous rendre les objets tels qu'il les voit, appuyant sur tel détail, créant à nouveau."

65. Ibid., 72: "Meurent les écoles, si les maîtres nous restent. . . . Chaque grand artiste groupe autour de lui toute une génération d'imitateurs, de tempéraments semblables, mais affaiblis. Il est né un dictateur de l'esprit."

66. Cézanne, *Conversations*, 135: "C'est pourquoi les instituts, les pensions, les honneurs ne peuvent être faits que pour les crétins, les farceurs et les drôles. . . . Qu'ils aillent à l'École, qu'ils aient des professeurs à la pelle. Je m'en fous." Eng. trans. from Doran, ed., *Conversations with Cézanne*, 136.

67. Cézanne quoted by Vollard 1938, 48: "Les professeurs . . . ce sont tous des salauds, des châtrés, des j. f . . . ; ils n'ont rien dans le venntrrre! . . . Le grand point, comprenez, monsieur Vollard, c'est de sortir de l'École et de toutes les écoles!" Vollard transcribes the word *ventre* as pronounced by Cézanne with a Provençal accent.

68. Pissarro ended his career by constantly providing advice to younger generations of artists who came to consult him. Among the more notorious of these young artists were Henri Matisse and Francis Picabia. The interesting point about Matisse's visit was that one of Pissarro's first pieces of advice to him was to "encourage Matisse to study the master of Aix." See Barr 1951, 38. As for Cézanne, even during his lifetime, he was legendarily referred to as "le Maître d'Aix" or "der grosse Meister Cézanne." See for instance, Osthaus 1920-21.

69. Pissarro, *Correspondance*, II, 348. Letter to Esther Isaacson, May 5, 1890. "La défiance instinctive de ce qui pourrait lui être fatal!"

70. Ibid., 349: "Tu sais, c'est par atavisme qu'il est bâti ainsi. Je serai très heureux de causer de tout cela avec toi à Londres; tu sais que cette question de l'éducation est tout ce qu'il y a de plus compliqué; on ne peut poser des maximes, chaque personnalité ayant des sensations différentes. Dans toutes les écoles on apprend à faire de l'art: c'est une vaste erreur. On apprend à exécuter, mais faire de l'art, jamais!"

71. Courbet 1986 [1861], n.p.

72. An abundant amount of literature has appeared on this subject. For a succinct and clear summary of the main issues applied to contemporary art schools, see Michaud 1993.

73. Cézanne, *Conversations*, 121: "Ce qui fait que nous sortons peut-être tous de Pissarro. Il a eu la veine de naître aux Antilles, là il a appris le dessin sans maître. Il m'a raconté tout ça." Eng. trans. from Doran, ed., *Conversations with Cézanne*, 122.

74. In a letter announcing that he graduated with his baccalaureate, the nineteen-year-old Cézanne wrote a few alexandrine verses to Zola in which he declared: "Du Latin et du Grec je ne suis plus la proie!" (Of Latin and Greek I no longer am the prey!) See Cézanne, *Correspondance*, 37. Thus, Cézanne had at least between five and seven years of Latin and Greek behind him. On the importance of the humanities in Cézanne's formation, see Tuma 2000, 121-29. Rewald established the fact that

Cézanne was a star student in Latin and Greek in high school. See Rewald 1936, 9.

75. Denis 1907. Eng. trans. from Doran, ed., *Conversations with Cézanne*, 174.

76. Cézanne, *Correspondance*, 314, and Cézanne, *Conversations*, 45. Letter to Bernard, 1905.

77. Ibid. Note that this formula is a direct echo of Zola's statement published forty years earlier, quoted above. See Zola, *Écrits*, 81: "J'exprimerai toute ma pensée en disant qu'une œuvre d'art est un coin de la création vu à travers un tempérament."

78. "Chaque grand artiste . . . est né dictateur de l'esprit." (Every great artist . . . is born a dictator of the mind.) Zola, *Écrits*, 72.

79. Ibid.

80. In a conversation with Cézanne a couple of years before the artist's death, Francis Jourdain remarked that Cézanne apologized for not being informed of what was going on around him anymore. His excuse was that he "was living with the memories of his youth spent side by side with Zola." (Cézanne s'excusa de n'être au courant de rien, vivant avec les souvenirs de sa jeunesse, passée aux côtés de Zola.) Jourdain 1950, in Cézanne, *Conversations*, 83.

81. See Fry 1989 [1927], Rewald 1986 [1939], Schapiro 1952, Shiff 1984 (chap. 15: "Cézanne's Practice"), Brettell 1989, and Lloyd 1992, among others.

82. Pissarro, *Correspondance*, I, 220. Letter to his niece, Esther Isaacson, June 13, 1883. The artist refers there specifically to Renoir, Monet, and Manet.

83. In his emotive dedication of his "Salon" (1866) to "my friend Paul Cézanne," Zola asks Cézanne the following rhetorical question: "Sais-tu que nous étions révolutionnaires sans le savoir?" (Do you know that we were revolutionaries unbeknownst to us?) Zola, *Mon Salon*, in *Écrits*, 91.

84. Vollard 1920, 32-33: "Ce fut aussi cette année-là (1863) que je connus Cézanne. J'avais alors, aux Batignolles, rue de La Condamine, un petit atelier que je partageais avec Bazille. Celui-ci arriva, un jour, accompagné de deux jeunes gens: 'Je t'amène deux fameuses recrues!' C'étaient Cézanne et Pissarro.

Je devais les connaître, dans la suite, intimement tous les deux; mais c'est de Cézanne que j'ai gardé le souvenir le plus vif. Je ne crois pas que, dans toute l'histoire des peintres, on trouve un cas semblable à celui de Cézanne. Avoir vécu jusqu'à l'âge de soixante-dix ans, et, depuis le premier jour où l'on a tenu un pinceau, demeurer aussi isolé que si l'on était dans une île déserte! Et aussi, à côté de cet amour passionné de son art, une telle indifférence pour son œuvre une fois faite." See also Vollard 1938, 20, for a slightly different version of the same event, and Fry 1989 [1927], 30.

85. At this very same time, Zola was writing "Mon Salon" (1866) for *L'Événement*. In the preface to his series of articles, Zola refers to himself as "revolutionary" (révolutionnaire) in that he has expressed "the *audacious* idea of bringing the [Salon] jury to a trial before public opinion." (L'audacieuse pensée d'intenter un procès au jury devant l'opinion publique.) *Écrits*, 89.

86. Cézanne, *Correspondance*, 114-15. Letter to M. de Nieuwerkerke, Surintendant des Beaux-Arts, April 19, 1866.

87. One of them was his *Portrait of Antony Valabrègue*, now at the National Gallery of Art, Washington, D.C. (fig. 25).

88. Cézanne, *Correspondance*, 114-15. "Je ne puis accepter le jugement illégitime de confrères auxquels je n'ai pas donné moi-même mission de m'apprécier."

89. Ibid.: "Je désire en appeler au public et être exposé quand-même."

90. Ibid.: "Tous les peintres qui se trouvent dans ma position."

91. The virulent tone of Cézanne's assertion brings to mind Marx's political pamphlet. See Marx and Engels's triumphant motto at the end of *The Communist Manifesto*, in Marx 1994 [1848], 186: "Working men of all countries, unite!" If one supersedes the concept of "proletarian" by that of "serious worker" (in Cézanne's understanding), the concluding sentence of *The Communist Manifesto* can also apply to the situation evoked by Cézanne in his letter: "The proletarians have nothing to lose but their chains. They have a world to win." Needless to say, this analogy between Cézanne and Marx in no way implies that Cézanne had any Marxist leanings–quite the contrary. In fact, it is even doubtful that he had had a chance to read the *Manifesto* by 1866.

92. Cézanne, *Correspondance*, 114-15: "Ils vous répondraient tous qu'ils renient le Jury."

93. Ibid.: "Ils veulent participer d'une façon ou d'une autre à une exposition qui doit être forcément ouverte à tout travailleur sérieux."

94. Rewald 1986 [1955], 383-89. Rewald published three early versions of the charter drafted by Pissarro in the French translation of his *Histoire de l'impressionnisme*. See appendices. The founding charter was first published under the title "Société anonyme coopérative d'artistes-peintres, sculpteurs, etc., à Paris," in *La Chronique des arts et de la curiosité*, January 17, 1874, 19.

95. See Shikes and Harper 1980, 105-06.

96. See Rewald's comment in Cézanne, *Correspondance*, 115, n. 3.

97. Bernard 1907, in Cézanne, *Conversations*, 65.

98. Pissarro, *Correspondance*, II, 349. Letter to Esther Isaacson, May 5, 1890. First quoted by House 1986, 16.

99. Pissarro, *Correspondance*, I, 183. Letter to Lucien, March 15, 1883: "Les dimanches et jours de fête seraient des jours de bonheur, attendus avec impatience."

100. Flam 1994, 136. Quoted in Elderfield 1992, 56.

101. This is a reference to the 1870 Franco-Prussian War, a period after which Cézanne and Pissarro began to see each other much more regularly.

102. Gasquet 1926, in Cézanne, *Conversations*, 148.

103. Pissarro, *Correspondance*, I, 247. Letter to Eugène Murer, November 2, 1883: "Il compte par un travail acharné conquérir une place dans l'art."

104. Pissarro, *Correspondance*, I, 253. Letter to Lucien, November 20, 1883: "La peinture, l'art en général m'enchante, c'est ma vie, que me fait le reste!"

105. Pissarro, *Correspondance*, II, 30. Letter to Georges, October 7, 1889: "Il me faut rentrer en moi-même comme les moines des temps passés et tranquillement, patiemment, échafauder l'œuvre. . . . Je travaille beaucoup de tête, il s'agit d'exécuter." Note that this particular vocabulary and the reference to the "need to execute" were common to both artists.

106. Cézanne, *Correspondance*, 148. Letter to the artist's mother, September 26, 1874.

107. Pissarro, *Correspondance*, II, 341. Letter to Monet, March 14, 1890: "et dire que l'on nous reproche de ne pas finir!"

108. Cézanne, *Correspondance*, 311. Letter to Louis Aurenche, January 10, 1905.

109. Ibid., 200. Letter to Zola, May 20, 1881.

110. Ibid., 332. Letter to his son, October 15, 1906.

111. For a discussion of the subtle intricacies of

what the term "sensation" meant in the vocabulary of Impressionism, see Shiff 1984, 14–20; House 1986, 16–18; Lecomte-Hilmy 1993, 61 and 196; Smith 1995, 19–31; and Brettell 2001, 21–67. Also see two masterful essays by Meyer Schapiro: "The Concept of Impressionism," and "The Aesthetic and Method of Impressionism," in Schapiro 1997, 21–78.

112. Pissarro, *Correspondance*, I, 276: "Je me rappelle qu'à l'académie, il y en avait qui étaient joliment habiles, qui dessinaient cela avec une sûreté surprenante; plus tard, j'ai revu ces mêmes artistes à l'oeuvre: c'était toujours la même habileté, et rien de plus; mais rappelle-toi donc Bastien Lepage! et Carolus Duran! eh bien, non, ce n'est pas de l'art!"

113. LeWitt 1969, 5; reprinted in Alberro and Stimson 2000, 108.

114. The very same argument was central to Greenberg's seminal essay, "Avant-Garde and Kitsch," in Greenberg 1939, 5–22.

115. Zola, *Mon Salon*, in *Écrits*, 108.

116. Ibid. "Le mot 'art' me déplaît; il contient en lui je ne sais quelles idées d'arrangements nécessaires, d'idéal absolu. Faire de l'art, n'est-ce pas faire quelque chose qui est en dehors de l'homme et de la nature? Je veux qu'on fasse de la vie, moi; je veux qu'on soit vivant, qu'on crée à nouveau, en dehors de tout, selon ses propres yeux et son propre tempérament."

117. Cézanne, *Correspondance*, 249: "J'ai encore un brave ami de ce temps-là, eh bien, il n'est pas arrivé, n'empêche pas qu'il est bougrement plus peintre que tous les galvaudeux à médailles et décorations, que c'est à faire suer."

118. Zola, *Mon Salon*, in *Écrits*, 97: "Les artistes libres, ceux qui vivent en dehors, qui cherchent ailleurs et plus loin les réalités âpres et fortes de la nature."

119. Wallace Stevens, "The Auroras of Autumn," quoted by Clark 1999, i. For a complementary parallel between Stevens and Cézanne (specifically focusing on the "stubbornness of [the artist's] will"), see Tuma 2000, 97.

120. Crow 1995, i.

121. Cézanne, *Correspondance*, 112–13: "Samedi nous [Cézanne and Oller] irons à la baraque des Champs-Elysées [the Salon] porter nos toiles, qui feront rugir l'Institut de rage et de désespoir."

122. Ibid.: "J'espère que vous aurez fait quelque beau paysage."

123. *Dictionnaire de l'Académie des Beaux-Arts* (Paris), vol. 5 (1858), in Boime 1986, 169.

124. Delestre 1867, 94, in Boime 1986, 23.

125. Pissarro to Oller, December 14, 1865, in Taylor 1983, 224: "Tous les trois nous comptons sur un beau tableau de toi et surtout pas Jésuite."

126. The French expression is "La pituite règne dans la nature." "*Pituite*" is an old clinical term for vomit produced by excessive absorption of alcohol and an obvious reference to artists who congregated in painting outdoors after excessive libations.

127. Pissarro's painting was *The Banks of the Marne in Winter* (now at the Art Institute of Chicago; see plate 1).

128. Letter from Guillemet to Oller, September 12, 1866. In Taylor 1983, 226: "L'art est dans le marasme le plus profond, les couleurs coûtent cher. Crédit est mort tué par les peintres. Les commandes s'obstinent à ne point arriver et le jury lui-même, l'infâme, nous refuse l'entrée du sanctuaire!!! Le temps est atroce. La pituite règne dans la nature. Seul Pissarro continue à faire des chefs d'œuvre. Il aura cette année un salon superbe. Il a même l'audace d'envoyer une tartine réaliste à l'exposition universelle. L'innocent qui ne sait pas que la France ne veut montrer aux étrangers que les produits les moins hideux. Cézanne est à Aix où il a fait des études superbes d'audace: Manet ressemble à Ingres en comparaison. Que ton élève a donc fait de chemin: il est méconnaissable."

129. See Gowing et al. 1988. We are looking forward to the equivalent show on Pissarro's early years, *Camille Pissarro: The Evolution of an Impressionist 1864–1874*, being prepared by Kathy Rothkopf at the Baltimore Museum for 2007.

130. Waern 1892, 541: "There they were, piled up in stacks: violent or thrilling Van Goghes; dusky, heavy Cézannes that looked as if they were painted in mud, yet had curious felicities of interpretation of character." Quoted in Cahn 1995, 549.

131. Taylor 1983, 226: "Vois par taches; le métier n'est rien, pâte et justesse: tel doit être le but à poursuivre."

132. For a discussion of the term "*tache*" see Lecomte-Hilmy 1993, 66–68 and 199; Smith 1995, 19–31; Brettell 2001; and House 2004, 145–86.

133. Villehervé 1904, in Pissarro, *Correspondance*, V, 369. First quoted in House 1986, 26; also quoted and translated in Brettell and Pissarro 1992, xxxix.

134. Gasquet 1926, 196. Cézanne says: "Une touche après l'autre, une touche après l'autre." See Shiff 1991.

135. Maurice Merleau-Ponty, *L'Oeil et l'esprit* (Paris: Gallimard, 1964), 21–22.

136. Ibid.

137. Letter from Antony Valabrègue to Fortuné Marion, April 1866, in Barr 1937, trans. Scolari and Barr 1938. In Rewald 1986 [1939], 139 (translation modified).

138. Vollard 1938, 19.

139. A reference to Robespierre's radical grip on the French Revolution, which began in 1789 and reached a climactic and most radical development in 1793, under Robespierre's aegis. The year 1793 was also referred to as "la Terreur" because anybody suspected of having had ties with the previous regime was expeditiously executed. The year "1793" became the symbol of a complete and violent break with the past.

140. Letter from Guillemet to Oller, in Taylor 1983, 227: "Nous peignons sur un volcan; le 93 de la peinture va tinter son glas funèbre: le Louvre brûlera, les musées, les antiques disparaîtront, et, comme l'a dit Proudhon, des cendres de la vieille civilisation peut seul sortir l'art nouveau. La fièvre nous brûle; aujourd'hui est séparé d'un siècle de demain. Les dieux d'aujourd'hui ne seront pas ceux du lendemain, aux armes, saisissons d'une main fébrile le couteau de l'insurrection, démolissons et construisons (*et monumentum exegi aere perennius*). Courage frère. Serrons nos rangs: nous sommes trop peu pour ne pas faire cause commune—on nous fout à la porte; nous leur foutrons la porte au nez. Les classiques trébuchent. Nieu[wer]kerke chancèle sur son fondement. Montons à l'assaut et terrassons l'infâme . . . ne couper dans personne qu'en soi—construire, peindre en pleine pâte et danser sur le ventre des bourgeois terrifiés. . . . Travaille ma vieille, bon courage, de la pâte, les taches justes, nous finirons par imposer notre manière de voir. Pissarro te dit mille choses aimables et nous souhaitons tous avec Cézanne de te voir bientôt." (I have introduced punctuation when it was missing, without which this text is incomprehensible.)

141. Newman 1990, 303.

142. Ibid., 292. The artist was being interviewed by Pierre Schneider at the Louvre and compared Uccello's *Battle of San Romano* to Pissarro and

Courbet. My thanks to Richard Shiff for this reference.

143. Emerson 1838, in Emerson 1982, 112.

144. Habermas 1992, 168-69.

145. Rousseau 1866, 447, quoted by Loyrette and Tinterow 1994, 86, 89.

146. An artist about a generation younger than Cézanne who had worked alongside Cézanne and whom Rewald had met during the 1930s.

147. Rewald 1936, 120: "S'il avait continué à peindre comme il le faisait en 1870, il aurait été le plus fort de nous." In his footnote, Rewald credits this quote to Le Bail, who communicated it to him.

148. Cézanne, *Conversations*, 115: "Tout en étant le premier dans mon métier, je veux être simple. Ceux qui savent sont simples."

149. Pissarro, *Correspondance*, I, 285. Letter to Lucien, February 17, 1884.

150. Cézanne, *Correspondance*. The first letter (p. 112) is dated March 15, 1865; the second (p. 124), October 23, 1866; the third (p. 142), December 11, 1872; the fourth (p. 146), June 24, 1874; the fifth (p. 150), April 1876; the sixth (p. 152), July 2, 1876; and the seventh and last (p. 182), April 1, 1879.

151. Ibid., 112.

152. See p. 24 for the redefinition of the concept of "beauty" by Cézanne and Pissarro.

153. Cézanne, *Correspondance*, 124. Letter to Pissarro, October 23, 1866.

154. I wish to thank Jean-Claude Lebensztejn, who recently re-read as many of Cézanne's original letters as he could find, and pointed out to me that a few curses occasionally used by Cézanne are so extreme that Rewald decided to delete or edulcorate some of them out of his edition of the artist's correspondence.

155. Cézanne, *Correspondance*, 124.

156. Ibid., 125.

157. Ibid.

158. Guillemet, in Cézanne, *Correspondance*, 126: "Cézanne a fait des peintures très belles. Il refait blond et je suis sûr que vous serez content de trois ou quatre toiles qu'il va rapporter."

159. François Thiébault-Sisson, "Claude Monet: An Interview, 1900" (New York: Buskirk Press, 1900). Eng. trans. of article published in *Le Temps*, Paris, November 27, 1900. I am grateful here for an illuminating comment made by John Elderfield on this text. Elderfield explained that "seeing green" in Corot's words

probably referred to the fact that Pissarro's chromatic language was already (in the 1860s) based on hues (such as green). In contrast, Corot suggested that the right way to see is "gray and blond," i.e., by establishing color contrasts from cold (gray) to blond (warm). Corot here defines what modeling consists of. This was precisely what Pissarro and Cézanne rejected throughout their lives; both younger artists established early on that it was possible to represent spatial depth and physical volumes by juxtaposing "patches" of color of equal intensity. This practice goes radically against the grain of the more traditional approach advocated by Corot (i.e., of building up a composition around color values). Corot, therefore, was right; Pissarro and he were clearly speaking different artistic languages: one was based on tonal values (Corot); the other on hue contrasts (Pissarro).

160. Pissarro, *Correspondance*, I, 257. Letter to Lucien, December 1, 1883: "J'ai déballé mes études, mes peintures, tout me paraît très blond."

161. For a detailed account of this phase in the history of Impressionism and its critique of the French institutions of the moment, see Roos 1996.

162. Alexis 1873, quoted (with no source) in Shikes and Harper 1980, 104. See also Rewald 1985 [1946], chap. IX (309-40), and Rewald 1986 [1955], 197-220.

163. It has not been sufficiently pointed out that Cézanne and Pissarro (following Courbet's cue), by voicing their loud claims for opening the doors of the Salons to all, laid the ground for generations of avant-garde practices. The Twenty-sixth Exposition (1910), organized by the famous Société des Artistes Indépendants, offered all artists an opportunity "to present their works freely to the judgment of the public" without passing through the filter of any kind of jury. See Weiss 1994, 91. The members of the Société may not have been aware that they were using the same words Cézanne had used to claim his rights to exhibit independently almost half a century earlier.

164. Alexis 1873: "Leur association ne sera d'ailleurs pas une chapelle. Ils ne veulent unir que des interêts et non des systèmes; ils souhaitent l'adhésion de tous les travailleurs." This important term was translated in Rewald 1985 [1946], 309, as "serious artists" whereas here it should have been simply kept as "workers."

165. Cézanne echoes this feeling by using almost the same terms when he says: "La noblesse de la conception nous révèle l'âme de l'artiste." (The nobility of an artist's creation reveals his soul.) Cézanne, in Larguier 1925, reprinted in Cézanne, *Conversations*, 14; Eng. trans. from Doran, ed., *Conversations with Cézanne*, 16.

166. Pissarro, *Correspondance*, I, 253. Letter to Lucien, November 20, 1883: "Quand on fait une chose avec toute son âme et tout ce que l'on a de noble en soi, on trouve toujours un sosie qui vous comprend; point n'est besoin d'être legion. N'est-ce pas là tout ce que doit désirer l'artiste!"

167. Cézanne, *Correspondance*, 148. Letter to the artist's mother, September 26, 1874: "Pissarro n'est pas à Paris depuis environ un mois et demi, il se trouve en Bretagne, mais je sais qu'il a bonne opinion de moi, qui ai très bonne opinion de moi-même."

168. Ibid.: "Je commence à me trouver plus fort que tous ceux qui m'entourent, et vous savez que la bonne opinion que j'ai sur mon compte n'est venue qu'à bon escient."

169. Holquist, "Introduction," xxi, in Bakhtin 1981.

170. See Holquist 1990, 38-39.

171. Pissarro, *Correspondance*, I, 253. Letter to Lucien, November 20, 1883.

172. Pissarro, *Correspondance*, I, 252: "Ce n'est qu'à la longue que je puis plaire s'il y a dans celui qui me regarde un grain d'indulgence; mais pour le passant, le coup d'œil est trop prompt, il ne perçoit que la surface, n'ayant pas le temps, il passe!"

173. Arendt 1968, 15.

174. Benjamin, "The Task of the Translator: An Introduction to the Translation of Baudelaire's *Tableaux Parisiens*," in Benjamin, *Illuminations* (New York: Harcourt, Brace & World, 1955), quoted in Arendt 1968, 203.

175. See p. 38 for the Emerson quote.

176. Pissarro, *Correspondance*, I, 64. Letter to Théodore Duret, n.d. [early 1871]: "Ce n'est qu'à l'étranger que l'on sent combien la France est belle, grande, hospitalière, quelle différence ici, on ne recueille que le mépris, l'indifférence, et même la grossièreté, parmi les confrères, la jalousie et la défiance la plus égoïste—ici, il n'y a point d'art, tout est affaire de commerce."

177. Pissarro, *Correspondance*, I, 253.

178. Nowadays, it is difficult to think of Pissarro's metaphor of a five-legged lamb without associ-

ating it with Damien Hirst's piece with a five-legged calf, titled *In His Infinite Wisdom* (2003). Certainly the morbid curiosity and the horror of normality that Hirst conveys through his work might also suggest to us some affinities between Hirst and Cézanne, as well as Pissarro—the latter two having been interested throughout their lives in extending the practice of painting beyond its "normal" boundaries. Besides, Hirst is also very interested in the late-twentieth-century evolution of the concept of emotions, feelings, or indeed "sensations." He declared about his shark: *I like the idea of a thing to describe a feeling. A shark is frightening, bigger than you are, in an environment unknown to you. It looks alive when it's dead and dead when it's alive. And it can kill you and eat you, so there's a morbid curiosity in looking at them* (Hirst 1997, 285). Likewise, Lebensztejn describes the impact and function of Cézanne's female bathers: they are "ghosts, actualizations of Cézanne's obsessions, or maybe memories of his obsessions as a young man—obsessions that tracked him down all through his life, as if Cézanne's ghosts were to become all the more real, as they became mere memories" (Lebensztejn 1995, 61). See also Tuma 2000, 90.

179. Pissarro, *Correspondance*, I, 88. Letter to Duret, December 8, 1873: " Dès le moment que vous cherchez des moutons à cinq pattes, je crois que Cézanne pourra vous satisfaire, car il a des études fort étranges et vues d'une façon unique."

180. Fry 1989 [1927], 10 and 30.

181. Rivière and Schnerb 1907, in Cézanne, *Conversations*, 87; Eng. trans. from Doran, ed., *Conversations with Cézanne*, 86 (modified).

182. Ibid.

183. Fry 1989 [1927], 11.

184. Pissarro, *Correspondance*, I, 252. Letter to Lucien, November 20, 1883: "Rappelle-toi que je suis de tempérament rustique, mélancolique, d'aspect grossier et sauvage, ce n'est qu'à la longue que je puis plaire s'il y a dans celui qui me regarde un grain d'indulgence."

185. Cézanne, *Correspondance*, 262. Letter to Joachim Gasquet, September 26, 1897: "L'art est une harmonie parallèle à la nature."

186. Pissarro, *Correspondance*, IV, 105. Letter to Georges, October 21, 1895: "Voilà la vraie voie impressionniste, sans couleurs tapageuses, mais harmoniques et en valeur."

187. Ibid.: " Sûrement on se fait remarquer car c'est fort rare!"

188. Cézanne, *Mes Confidences*, in Cézanne, *Conversations*, 102. Q: "Quelle est la couleur que vous préférez?" A: "*L'harmonie generale.*" Eng. trans., from Doran, ed., *Conversations with Cézanne*, 101 (modified).

189. Rivière and Schnerb 1907, in Cézanne, *Conversations*, 87: "Cézanne ne faisait donc pas mine d'ignorer l'asymétrie de ses bouteilles, la perspective défectueuse de ses assiettes. Montrant une de ses aquarelles, il corrigeait de l'ongle une bouteille qui n'était pas verticale et il disait, comme en s'excusant: 'Je suis un primitif, j'ai l'oeil paresseux. Je me suis présenté deux fois à l'École, mais je ne fais pas l'ensemble: une tête m'intéresse, je la fais trop grosse.'" Eng. trans. from Doran, ed., *Conversations with Cézanne*, 86.

190. Lebensztejn 1995, 28: "Il y a dans sa peinture tardive, comme l'a montré Schapiro, une part non mesurable de souvenir."

191. Pissarro, *Correspondance*, III, 220. Letter to Lucien, April 26, 1892: "Je suis plus que jamais pour l'impression par le souvenir."

192. Ibid.: "La vérité entrevue, sentie."

193. This is an argument absolutely central to Clement Greenberg's "Avant-Garde and Kitsch." See Greenberg 1939.

194. Pissarro, *Correspondance*, I, 211. Letter to Joris-Karl Huysmans, May 20, 1883: "Les Flandrin sont bien mieux faits, plus corrects que Ingres! Cependant quel artiste que Ingres!"

195. Matisse 1993, 398: "Nice - En revenant de Vence, avec Matisse, il me raconte qu'à un dîner chez les enfants de Renoir (chez Jean) il était placé à côté de Mme Cézanne. Elle lui disait: 'Vous savez, Cézanne ne savait pas ce qu'il faisait. Il ne savait pas comment finir ses tableaux. Renoir, Monet, eux, savaient leur métier de peintre . . .'" My sincere thanks to Hilary Spurling for helping me locate the source of this conversation. The scene of this meeting is mentioned in her book: Spurling 1998, 146 and n. 85. Also quoted in Sollers 1995, 59.

196. Flam 1994, 55.

197. See Brettell 2001, 24-25.

198. Galassi 1991, 191-92, illus. nos. 242-44.

199. de Coüessin 1991, 81-97.

200. See the forthcoming study on the technical aspects of the artists' work by Jim Coddington, to be published by The Museum of Modern Art.

201. Rivière and Schnerb 1907, in Cézanne, *Conversations*, 87.

202. Ibid., 86.

203. Sartre 1940, 163. Quoted by Damisch 1995, 79. Damisch elaborates on this idea, using the same terms that Cézanne would use to discuss his own painting: "Le fond lui-même ne saurait prétendre à une autre manière d'être ou de présence que celle que lui confère la figure qui, sur lui, précisément *s'enlève*. Et s'y enlève éventuellement en négatif, avec toutes les apparences qui peuvent être celles du manque, ainsi qu'il en va d'une figure *en réserve* ou d'un tirage photographique lui-même *en négatif* [emphasis author's]."

204. de Coüessin 1991, 86, illus. nos. 3 and 4.

205. Rewald 1996 dates *L'Etang des Soeurs, Osny, near Pontoise* (plate 63) to 1877. I agree with John House: both paintings most certainly date to 1875 (see House 2004, 169).

206. See the seminal article on the subject in Reff 1962.

207. Reff was the first to point out the difficulty—not to say the impossibility—of dating Cézanne's works in chronological neat sequences, given the fact that he was prone to a kind of technical multitasking.

208. Cardon 1874, in Berson 1996, 13.

209. Ibid., 14: "Il est vrai que M. Faure a toujours aimé à se singulariser. Acheter des Cézanne, c'est un moyen comme un autre de se signaler et de se faire une réclame unique."

210. The term "sensation" as used by Pissarro and Cézanne never carried the "sensationalist" media-hype connotation at all. In fact, it meant quite the opposite.

211. Cézanne, *Correspondance*, 152. Letter to Pissarro, from L'Estaque, July 2, 1876: "Je voudrais bien ne pas parler de choses impossibles, et cependant je fais toujours les projets les plus improbables à réaliser. Je me figure que le pays où je suis vous serait à merveille."

212. Pissarro, *Correspondance*, I, 240. Letter to Lucien, October 19, 1883: "Le lendemain, impossible de continuer, tout était bousculé, les motifs n'existaient plus, c'est pas possible, on est obligé de les faire en une fois."

213. This reminds me of the last telephone conversation I had with Sir Lawrence Gowing a few weeks before his death. According to Gowing, Cézanne in this moving letter was reciting the lesson he had learned with Pissarro from afar. I agree with Gowing. I would just add, with all

great respect to his memory, that the lesson Cézanne learned, Pissarro learned too, and they both learned it together "without a master."

214. Cézanne, *Correspondance*, 152.

215. Pissarro, *Correspondance*, I, 240. Letter to Lucien, October 19, 1883: "Je te recommande une chose, c'est de faire toujours son possible de pousser jusqu'au bout ce que l'on a commencé. Cependant je constate, par moi-même, ici la difficulté, ou plutôt les difficultés, toujours inattendues qui viennent vous assaillir en plein air."

216. Ibid.: "Car il faut faire des toiles de deux mètres au moins, comme celle par vous vendue à Faure."

217. Ibid. "Il y a des motifs qui demanderaient trois ou quatre mois de travail, qu'on pourrait trouver, car la végétation n'y change pas. Ce sont des oliviers et des pins qui gardent toujours leurs feuilles." Cézanne uses the collective "on," which stands for "we" in spoken French.

218. Elderfield 2004. The fact that Cézanne was so slow in painting was held by some art historians as the main reason why he should not be regarded as an Impressionist. See Brion-Guerry 1966, 63: "Cézanne ne sera jamais un véritable impressionniste comme Pissarro. . . : Cézanne peint lentement, avec d'infinies hésitations, appliquant prudemment ses touches les unes à côté des autres, réfléchissant, comparant, reprenant."

219. Cézanne, *Correspondance*, 146. Letter to Pissarro, from Aix, June 24, 1874: "Maintenant que je viens de revoir ce pays-ci, je crois qu'il vous satisferait totalement, car il rappelle étonnamment votre étude en plein soleil et en plein été de la Barrière du Chemin de fer."

220. Cézanne, *Correspondance*, 152. Letter to Pissarro, July 2, 1876: "Le soleil y est si effrayant qu'il me semble que les objets s'enlèvent en silhouette non pas seulement en blanc ou noir, mais en bleu, en rouge, en brun, en violet. Je puis me tromper, mais il me semble que c'est l'antipode du modelé. Que nos paysagistes d'Auvers seraient heureux ici."

221. de Coüessin 1991.

222. Cézanne was actually sixty-six years old at the time this letter was written. He never was to reach the age of seventy.

223. Cézanne, *Correspondance*, 315. Letter to Bernard, October 23, 1905: "Or, vieux, soixante-dix ans environ, les sensations colorantes qui

donnent la lumière sont chez moi cause d'abstractions qui ne me permettent pas de couvrir ma toile, ni de poursuivre la délimitation des objets quand les points de contact sont ténus, délicats."

224. For a detailed discussion of the question of the "unfinished" in Cézanne's œuvre, see Baumann 2000, and especially Gottfried Boehm, "Precarious Balance: Cézanne and the Unfinished"; Evelyn Benesch, "From the Incomplete to the Unfinished: *Réalisation* in the Work of Paul Cézanne"; and Richard Shiff, "Mark, Motif, Materiality: The Cézanne Effect in the Twentieth Century."

225. See Cézanne, *Correspondance*, 152. Letter from Cézanne to Pissarro, July 2, 1876. Cézanne describes the landscape of the south, where he wants to invite Pissarro by telling him that what he would find in Aix "is the opposite of modeling." He concludes by saying: "How happy our painters from Auvers would be."

226. See Bois 1990, 17-29, especially his discussion of the Matissean concept of "compartmentalization" of areas of color, which can be understood in direct correlation to the concept of "painting in reserve."

227. On this issue regarding Matisse, see Bois 1990, 3-64, the chapter titled "Matisse and Arche-Drawing."

228. Cézanne, *Correspondance*, 262. Letter to Joachim Gasquet, September 26, 1897: "L'art est une harmonie parallèle à la nature."

229. Villehervé 1904, quoted in Pissarro, *Correspondance*, V, 369. Also quoted and translated in Brettell and Pissarro 1992, xxxi.

230. Rewald 1996, I, no. 123; II, illustrated p. 41. Also see Rewald et al. 1988, no. 28. The subject might be Diana after her bath, attended by maids.

231. Chappuis 1973, nos. 202-04.

232. Barr 1951, 38.

233. Pissarro, *Correspondance*, I, 294. Letter to Lucien, n.d. [c. March 1884]: "C'est comme un tableau de Cézanne que tu te fourrerais sous le nez."

234. See Derrida 1978, who wrote a book "about" this statement: *La Vérité en peinture*.

235. Cézanne, *Correspondance*, 314. Letter to Bernard, from Aix, 1905.

236. Cézanne, *Correspondance*, 315. Letter to Bernard, from Aix, October 23, 1905: "La thèse à développer est—quelque soit notre tempérament ou forme de puissance en présence de

la nature–de donner l'image de ce que nous voyons, oubliant tout ce qui apparut avant nous."

237. Pollock 1950: "Interview with William Wright," reprinted in Harrison and Wood 1992, 575.

238. Cézanne, *Correspondance*, 315. Letter to Bernard, October 23, 1905: "Or, vieux, soixante-dix ans environ, les sensations colorantes qui donnent la lumière sont chez moi cause d'abstractions qui ne me permettent pas de couvrir ma toile, ni de poursuivre la délimitation des objets quand les points de contact sont ténus, délicats; d'où il ressort que mon image ou tableau est incomplète."

239. Ibid.

240. Cézanne declared to Gasquet: "Au fond, je ne pense à rien, quand je peins. Je vois des couleurs. Je peine, je jouis à les transporter telles que je les vois sur ma toile. Elles s'arrangent au petit bonheur, comme elles veulent. Des fois, ça fait un tableau" (Cézanne, *Conversations*, 116).

241. Pissarro, *Correspondance*, I, 346. Letter to Monet, n. d. [c. Aug. 1885]: "On m'a dit que Cézanne était reparti pour Marseille."

242. Lebensztejn 1995, 45.

243. See Cézanne, *Correspondance*, 216-17. Letter to a lady (spring 1885), and letter to Zola (May 14, 1885).

244. Jaloux 1942, 76, quoted by Lebensztejn 1995, 45.

245. Pissarro, *Correspondance*, IV, 113. Letter to Esther Isaacson, November 13, 1895: "Chez Vollard il y a une exposition de Cézanne très complète. Des natures mortes d'un fini étonnant, des choses inachevées, mais vraiment extraordinaires de sauvagerie et de caractère, je crois que ce sera peu compris."

246. Ibid.

247. Pissarro, *Correspondance*, IV, 119. Letter to Lucien, November 21, 1895.

248. Ibid.: "Des paysages, des nus, des têtes inachevées et cependant vraiment grandioses, et si peintre, si souples."

249. Ibid.: "J'étais à admirer le côté curieux, déconcertant de Cézanne que je ressens depuis nombre d'années."

250. Letter from Renoir to Monet, from the Hôtel Rouget aux Martigues, February 1888: "Nous avons été obligés de quitter subitement la mère Cézanne à cause de l'avarice noire qui règne dans la maison." Reproduced in Augustin de Butler, *Écrits, entretiens et lettres sur l'art: Textes réunis, présentés et annotés* (Paris: Les Éditions de l'Amateur, 2002), 138.

251. Pissarro, *Correspondance*, II, 371. Letter to Lucien, December 3, 1890.

252. Pissarro, *Correspondance*, IV, 153. Letter to Lucien, January 20, 1896, and Cézanne, *Correspondance*, 245. Letter to Oller, July 5, 1895.

253. Fénéon 1891, 2.

254. Bernard 1891.

255. Bernard 1891, in Bernard 1994, 20: "Inconnu ou plutôt méconnu il a, lui, aimé l'art jusqu'à renoncer à se faire une notoriété par les amitiés et les cénacles. Non méprisant, mais entier, il a renoncé à faire part de ses efforts."

256. Bernard 1907, 386: "Un des premiers hommages à son maître d'alors."

257. Ibid., 385–86: "Tout ce que l'on en savait [de Cézanne] était raconté par le père Tanguy, le bon et généreux Breton dont la boutique était l'unique repaire, en ces temps si vite devenus passés, de la *peinture de l'avenir*."

258. Bernard, "Paul Cézanne," *Les Hommes d'aujourd'hui*, 8, no. 387 (1891): n.p. Bernard writes of Cézanne: "Il avait rencontré Monet qui ne rêvait que soleil et lumière et il succomba à son tour aux charmes des grandes clartés; mais il reprit peu à peu son calme et sa pondération, et il revint plus complet et plus savant à son point de départ."

259. Pissarro, *Correspondance*, III, 76. Letter to Lucien, May 7, 1891: "Ce pauvre ignorant [Bernard] prétend que Cézanne a été un moment sous l'influence de Monet, un comble, qu'en dis-tu?"

260. Lecomte 1900, 26, quoted in Cahn 1995, 549: "M. Cézanne qui fut l'un des premiers annonciateurs des tendances nouvelles et dont l'effort exerça une influence notable sur l'évolution impressionniste." (Mr. Cézanne was one of the first heralds of the new trends; his efforts exerted a notable impact on the Impressionists' evolution.)

261. Geoffroy 1893, 121, quoted in Cahn 1995, 550.

262. Pissarro, *Correspondance*, IV, 75. Letter to Georges, May 25, 1895.

263. It has proved difficult to identify the article mentioned by Pissarro. Janine Bailly-Herzberg cites a brief review by Mauclair on "Ebauches de Manet et de Cézanne" (*Mercure de France*, November 1895) in which there is no discussion of Cézanne's influences. See Pissarro, *Correspondance*, IV, 122.

264. Pissarro, *Correspondance*, IV, 121. Letter to Lucien, November 22, 1895: Ils [the critics] ne se doutent pas que Cézanne a subi des influences comme nous tous et que cela ne retire rien de ses qualités; ils ne savent pas que Cézanne a subi d'abord l'influence de Delacroix, Courbet, Manet et même Legros, comme nous tous; il a subi mon influence à Pontoise et moi la sienne. Tu te rappelles les sorties de Zola et Béliard à ce propos; ils croyaient qu'on inventait la peinture de toute pièce et que l'on était original quand on ne ressemblait à personne. Ce qu'il y a de curieux c'est que dans cette exposition de Cézanne chez Vollard on voit la parenté qu'il y a dans certains paysages d'Auvers, Pontoise et les miens. Parbleu, nous étions toujours ensemble! mais ce qu'il y a de certain, chacun gardait la seule chose qui compte, 'sa sensation' . . . ce serait facile à démontrer. . . . Sont-ils assez niais!"

265. Pissarro, *Correspondance*, IV, 462–63. Letter to Lucien, March 23, 1898: "La tradition des maîtres, sans les piller."

266. Ibid.

267. Pissarro, *Correspondance*, IV, 128. Letter to Lucien, December 5, 1895.

268. Ibid.: "Degas si passionné des croquis de Cézanne, qu'en dis-tu? . . . voyais-je assez juste en 1861 quand moi et Oller nous avons été voir ce curieux provençal dans l'atelier Suisse où Cézanne faisait des académies à la risée de tous les impuissants de l'école. . . . Amusant comme tout, ce réveil des anciens combats."

269. Cézanne, *Correspondance*, 316. Letter to his son, July 20, 1906. "Bonjour à Madame Pissarro—comme tout est déjà lointain et pourtant si rapproché."

270. Pissarro, *Correspondance*, IV, 168. Letter to Paul Durand-Ruel, February 12, 1896: "Voilà une quinzaine de jours que je me débats ici avec les effets si changeants de temps gris et de brouillard, je me désespère des lenteurs de mon travail, et pas de neige, moi qui comptais faire des effets de blanc et noir. Tout de même les gris sont bien beaux à Rouen."

271. Pissarro, *Correspondance*, IV, 417. Letter to Lucien, December 15, 1897: "C'est très beau à faire! C'est peut-être pas très esthétique, mais je suis enchanté de pouvoir essayer de faire ces rues de Paris que l'on a l'habitude de dire laides, mais qui sont si argentées, si lumineuses et si vivantes . . . —c'est le moderne en plein!!!"

272. Cézanne to Gasquet, in Cézanne, *Conversations*, 116–17: "Tant qu'on n'a pas peint un gris, on n'est pas un peintre." . . . "Assurément, c'est toujours la nature. . . . Mais pas comme je la vois. Comprenez-vous? . . . Gris sur gris. On n'est pas un peintre, tant qu'on n'a pas peint un gris. L'ennemi de toute peinture est le gris, dit Delacroix. Non, on n'est pas un peintre tant qu'on n'a pas peint un gris."

273. Pissarro, *Correspondance*, IV, 119. Letter to Lucien, November 21, 1895.

274. Cézanne to Gasquet, in Cézanne, *Conversations*, 117. "Oui, le sol ici est toujours vibrant, il a une âpreté qui réverbère la lumière et qui fait clignoter les paupières . . . Tout s'intensifie, mais dans la plus suave harmonie."

275. Lebensztejn 1995, 51.

276. Ibid.

277. Cézanne, *Correspondance*, 316. Letter to his son, July 20, 1906.

278. Cézanne, *Correspondance*, 333. Letter to his son, October 15, 1906: "Je le dirai encore une fois: Émile Bernard me paraît digne d'une grande compassion, puisqu'il a charge d'âmes." (I will say it again: Émile Bernard is worthy of compassion because he is in charge of many souls.)

279. Cézanne, *Correspondance*, 318–19. Letter to his son, August 3, 1906.

280. Cézanne, *Correspondance*, 328. Letter to his son, September 26, 1906: "L'infortuné Bernard . . . c'est un intellectuel, congestionné par les souvenirs des musées."

281. Ibid.

282. Ibid.: "Pissarro ne se trompait donc pas, il allait un peu loin cependant, lorsqu'il disait qu'il fallait brûler les nécropoles de l'art."

283. Pissarro, *Correspondance*, I, 220. Letter to Esther Isaacson, June 13, 1883.

284. Pissarro, *Correspondance*, IV, 119. Letter to Lucien, November 21, 1895.

285. Cézanne, *Conversations*, 119: "La nature, j'ai voulu la copier, je n'arrivais pas. J'avais beau chercher, tourner, la prendre dans tous les sens. Irréductible. De tous les côtés."

286. Pissarro, *Correspondance*. Letter to Georges, June 8, 1896: "J'espère que vous vous êtes mis au travail sérieusement, bûchez ferme votre dessin et les valeurs, soyez très simples vis-à-vis de la nature."

287. Flam 1994, 55: "Interview with Jacques Guenne" (1925).

288. Borély 1911, in Cézanne, *Conversations*, 21. "Quant au vieux Pissarro, ce fut un père pour moi. C'était un homme à consulter et quelque chose comme le bon Dieu."

289. Fry 1989 [1927], 33.
290. Cézanne to Gasquet, in Cézanne, *Conversations*, 121.

Notes to the Plate texts

"Setting the Louvre on Fire" (p. 75)

1. See "A Yardstick of Modernity: The Importance of Émile Zola," pp. 24-28.
2. Cézanne, *Correspondance*, 113: "Samedi nous [Cézanne and Oller] irons à la baraque des Champs-Élysées [the Salon] porter nos toiles, qui feront rougir l'Institut de rage et de désespoir."
3. Zola, *Écrits*, 97.

Reciprocal Gazes (p. 87)

1. See Reff 1967, 627-33, and Reff, "The Pictures within Cézanne's Pictures," *Arts Magazine* 53, no. 10 (June 1979): 90-104.
2. White 1996 points to "France toasting Cézanne," 145.
3. This could have been a subtle pun and a reference to the newspaper *L'Eclipse*.

Portraits on Paper (p. 95)

1. One cast is in the collection of The Museum of Modern Art, New York.

Louveciennes/Louveciennes (p. 103)

1. W. S. Meadmore, *Lucien Pissarro* (London: Constable & Co., 1962), 26-27.
2. Pissarro, *Correspondance*, IV, 121. Letter to Lucien, November 22, 1895.

Still Lifes of the 1870s (p. 109)

1. John McCoubrey, "Cézanne's Difference," in Eliza E. Rathbone and George T. M. Shackelford, *Impressionist Still Life* (New York: The Phillips Collection in association with Harry N. Abrams, 2001), 34.

Building with Paint (p. 123)

1. Pissarro, *Correspondance*, IV, 1211.
2. See White 1996, 118-35.

A Turning Road (p. 145)

1. See Reidemeister 1963, 74, who identifies the motif of the Pissarro painting as being in the Parc of Osny. On both stylistic and historic evidence, it is highly probable that the Cézanne painting was executed in the same park, along-side Pissarro. I agree with House 2004, 169 and 232: these two paintings should be regarded as a pair.

Separate Paths Through a Shared Landscape (p. 163)

1. See Brettell in Moffett 1986, 189.

Contrasts in Pure Colors (p. 181)

1. Cézanne, *Correspondance*, 146. Letter to Pissarro, from Aix, June 24, 1874: "Je vous remercie d'avoir pensé à moi pendant que je suis si loin."
2. Ibid., 147: "Lorsque je lui disais par exemple que vous remplaciez par l'étude des tons le modèle, et que je tâchais de lui faire comprendre sur nature, il fermait les yeux et tournait le dos."
3. Ibid., 146: "Maintenant que je viens de revoir ce pays-ci, je crois qu'il vous satisferait totalement, car il rappelle étonamment votre étude en plein soleil et en plein été de la Barrière du Chemin de fer."
4. Cézanne, *Correspondance*, 152. Letter to Pissarro, from L'Estaque, July 2, 1876: "Le soleil y est si effrayant qu'il me semble que les objets s'enlèvent en silhouette non pas seulement en blanc ou noir, mais en bleu, en rouge, en brun, en violet. Je peux me tromper, mais il me semble que c'est l'antipode du modelé."

A Backward Glance (p. 187)

1. Victor Merlhès, ed., *Correspondance de Paul Gauguin* (Paris: Fondation Singer-Polignac, 1984), 21.
2. Rewald 1936, 120: "S'il avait continué à peindre comme il le faisait en 1870, il aurait été le plus fort de nous."
3. Cézanne, *Correspondance*, 152. "Car il faut faire des toiles de deux mètres au moins, comme celle par vous vendue à Faure."
3. See Rewald 1996, 331. During the summer of 1882, "external evidence points to [Cézanne's] fairly prolonged stay in Hattenville with Chocquet . . . and to [his] reappearance in Pontoise, where Cézanne must have executed this landscape at Pissarro's side. . . . It is, of course, a moot question whether he went first to Chocquet's or to Pontoise."

Salut and Farewell (p. 203)

1. Cézanne, *Correspondance*, 314. Letter to Bernard, from Aix, 1905.

Bibliography

Alberro and Stimson 2000
Alberro, Alexander, and Blake Stimson, eds. *Conceptual Art: A Critical Anthology*. Cambridge, Mass., and London: The MIT Press, 2000.

Alexis 1873
Alexis, Paul. "Paris qui travaille, III, 'Aux peintres et sculpteurs.'" *L'Avenir national*, May 5, 1873.

Anderson 2003
Anderson, Wayne. *The Youth of Cézanne and Zola: Notoriety at Its Source—Art and Literature in Paris*. Geneva and Boston: Éditions Fabriart, 2003.

Arendt 1968
Arendt, Hannah. *Men in Dark Times*. New York: Harcourt, Brace & World, 1968.

Athanassoglou-Kallmyer 2003
Athanassoglou-Kallmyer, Nina Maria. *Cézanne and Provence: The Painter in His Culture*. Chicago: The University of Chicago Press, 2003.

Bakhtin 1979
Bakhtin, Mikhail. *Estetika slovesnogo tvorchestva* [The aesthetics of verbal creation]. Moscow: S. G. Bocharov, 1979; Eng. ed., Caryl Emerson and Michael Holquist, eds. *Speech Genres and Other Late Essays*. Translated by Vern W. McGee. Austin: University of Texas Press, 1986.

Bakhtin 1981
Bakhtin, Mikhail. *The Dialogic Imagination*. Edited by Michael Holquist, translated by Caryl Emerson and Michael Holquist. Austin: University of Texas Press, 1981.

Bakhtin 1984
Bakhtin, Mikhail. *Problems of Dostoevsky's Poetics*. Appendix II. Edited and translated by Caryl Emerson. Minneapolis: University of Minnesota Press, 1984.

Barr 1929
Barr, Alfred H., Jr. "Foreword." In *First Loan Exhibition: Cézanne, Gauguin, Seurat, van Gogh*. New York: The Museum of Modern Art, 1929.

Barr 1937–38
Barr, Alfred H., Jr. "Cézanne d'après les lettres de Marion à Morstatt, 1865–68." *Gazette des Beaux-Arts*, ser. 6, 17 (January 1937): 37–58; Eng. trans., Margaret Scolari and Alfred H. Barr, Jr. "Cézanne in the Letters of Marion to Morstatt, 1865–1868." *Magazine of Art* 31, no. 2 (February 1938): 84–89; no. 4 (April 1938): 220–25; no. 5 (May 1938): 288–91.

Barr 1951
Barr, Alfred H., Jr. *Matisse: His Art and His Public*. New York: The Museum of Modern Art, 1951.

Baumann 2000
Baumann, Felix, et al. *Cézanne: Finished—Unfinished*. Ostfildern-Ruit: Hatje Cantz Publishers, 2000.

Bernard 1891
Bernard, Émile. "Paul Cézanne." *Les Hommes d'aujourd'hui* 8, no. 387. Paris: Librairie Vanier, 1891; reprinted in Bernard 1994, 20–22.

Bernard 1907
Bernard, Émile. "Souvenirs sur Paul Cézanne." *Mercure de France* (October 1, 1907): 385–404, and (October 16, 1907): 606–27; reprinted in Cézanne, *Conversations*, 49–80.

Bernard 1994
Bernard, Émile. *Propos sur l'art*. Edited by Anne Rivière. Paris: Séguier, 1994.

Berson 1996
Berson, Ruth. *The New Painting—Impressionism 1874–1886: Documentation*. Vol. I: *Reviews*. San Francisco: The Fine Arts Museums of San Francisco, 1996.

Boime 1986
Boime, Albert. *The Academy and French Painting in the Nineteenth Century*. New Haven and London: Yale University Press, 1986.

Bois 1990
Bois, Yve-Alain. *Painting as Model*. Cambridge, Mass., and London: The MIT Press, 1990.

Borély 1911
Borély, Jules. "Cézanne à Aix." *Vers et Prose* 27 (1911): 109-13; also published in *L'Art Vivant*, no. 2 (1926): 491-93; reprinted in Cézanne, *Conversations*, 18-22.

Brettell 1989
Brettell, Richard R. *Pissarro and Pontoise: The Painter in a Landscape*. New Haven and London: Yale University Press, 1989.

Brettell 2001
Brettell, Richard R. *Impression: Painting Quickly in France, 1860–1890*. New Haven and London: Yale University Press, 2001.

Brettell and Lloyd 1980
Brettell, Richard R., and Christopher Lloyd. *A Catalogue of the Drawings by Camille Pissarro in the Ashmolean Museum, Oxford*. Oxford: The Clarendon Press, 1980.

Brettell and Pissarro 1992
Brettell, Richard R., and Joachim Pissarro. *The Impressionist and the City: Pissarro's Series Paintings*. Exh. cat. New Haven and London: Yale University Press, 1992.

Brion-Guerry 1966
Brion-Guerry, Liliane. *Cézanne et l'expression de l'espace*. Paris: Albin Michel, 1966.

Cachin, Loyrette, and Guégan 1997
Cachin, Françoise; Henri Loyrette; and Stéphane Guégan, eds. *Cézanne aujourd'hui*. Paris: Réunion des musées nationaux, 1997.

Cahn 1995
Cahn, Isabelle. "Chronology." In Françoise Cachin et al. *Cézanne*. Exh. cat. Philadelphia: Philadelphia Museum of Art, 1995, 527-69.

Cardon 1874
Cardon, Émile. "Avant le Salon: L'Exposition des révoltés." *La Presse*, April 29, 1874, 2-3; reprinted in Berson 1996, 12-14.

Castagnary 1892
Castagnary, Jules-Antoine. "Salon de 1863." *Nord* (Brussels), May 14-September 12, 1863; reprinted posthumously in *Salons*. 2 vols. Paris: Bibliothèque Charpentier, 1892. Eng. trans., Harrison and Wood 1998, 411.

Cézanne 1995
Cachin, Françoise, et al. *Cézanne*. Exh. cat. Paris: Réunion des musées nationaux, 1995. Eng. ed., *Cézanne*. Philadelphia: Philadelphia Museum of Art, 1995.

Cézanne, Conversations
Conversations avec Cézanne. Edited by P. M. Doran. Paris: Macula, 1978. Eng. ed., Michael Doran, ed. *Conversations with Cézanne*. Translated by Julie Lawrence Cochran. Berkeley: University of California Press, 2001.

Cézanne, Correspondance
Cézanne, Paul. *Correspondance*. Edited by John Rewald. Rev. ed. Paris: Bernard Grasset Editeur, 1978.

Cézanne, Mes Confidences
Cézanne, Paul. *Mes Confidences*. Unpublished biographical document. 1899. Printed in Chappuis 1973, I, 25-28, and in Cézanne, *Conversations*, 102-04; Eng. trans. in Doran, ed., *Conversations with Cézanne*, 101-03. Also printed in Bernard 1994, 11-17.

Chappuis 1973
Chappuis, Adrien. *The Drawings of Paul Cézanne: A Catalogue Raisonné*. 2 vols. Greenwich, Conn.: New York Graphic Society, 1973.

Clark 1999
Clark, T. J. *Farewell to an Idea: Episodes from a History of Modernism*. New Haven and London: Yale University Press, 1999.

de Coüessin 1991
de Coüessin, Charles. "Le Synthétisme de Paul Gauguin, hypothèses." In *Gauguin: Actes du colloque Gauguin, Musée d'Orsay, 11-13 janvier 1989*. Paris: La Documentation Française, 1991.

Courbet 1986 [1861]
Courbet, Gustave. "Peut-on enseigner l'art?" [letter to his students]. *Courrier du Dimanche*, December 25, 1861. Reprinted as Gustave Courbet. *Peut-on enseigner l'art?* Paris: L'Échoppe, 1986.

Crow 1995
Crow, Thomas. *Emulation: Making Artists for Revolutionary France*. New Haven and London: Yale University Press, 1995.

Damisch 1995
Damisch, Hubert. *Traité du trait: Tractatus tractus*. Paris: Éditions de la Réunion des musées nationaux, 1995.

Delestre 1867
Delestre, Jean-Baptiste. *Gros, sa vie et ses ouvrages*. Paris: J. Renouard, 1867.

Denis 1907
Denis, Maurice. "Cézanne." *L'Occident* 12 (September 1907): 118-33; reprinted in *Théories: 1890-1910: Du symbolisme et de Gauguin vers un nouvel ordre classique*. Paris: Bibliothèque que l'Occident, 1912. Rev. ed., Paris: Rouart et Watelin, 1920, 245-61; Eng. trans. in Doran, ed., *Conversations with Cézanne*, 166-79.

Derrida 1978
Derrida, Jacques. *La Vérité en peinture*. Paris: Flammarion, 1978.

Duranty 1880
Duranty, Edmond. *Le Pays des arts*. Paris: Charpentier, 1880.

Elderfield 1971
Elderfield, John. "Drawing in Cézanne." *Artforum* 9 (June 1971): 51-57.

Elderfield 1978
Elderfield, John. "The World Whole: Color in Cézanne." *Arts Magazine* 52 no. 8 (April 1978): 148-53.

Elderfield 1985
Elderfield, John. "Cézanne: The Lesson of the Master." *Art in America* 78 no. 6 (June 1985): 86-93.

Elderfield 1992
Elderfield, John. "Describing Matisse." In *Henri Matisse: A Retrospective*. Exh. cat. New York: The Museum of Modern Art, 1992.

Elderfield 2004
Elderfield, John. "The Lizard in the Landscape: From *The Bottom of the Ravine* to *The Turning Road*." Unpublished lecture presented at the Museum of Fine Arts, Houston, June 20, 2004.

Emerson 1838
Emerson, Ralph Waldo. "An Address Delivered Before the Senior Class in Divinity College, Cambridge 1838"; reprinted in Emerson 1982, 107-29.

Emerson 1982
Emerson, Ralph Waldo. *Selected Essays*. Edited by Larzer Ziff. New York: The Penguin American Library, 1982.

Everdell 1997
Everdell, William R. *The First Moderns: Profiles in the Origins of Twentieth-Century Thought*. Chicago: The University of Chicago Press, 1997.

Fénéon 1891
Fénéon, Félix. "M. Gauguin.–M. Dujardin," *Le Chat noir*, May 23, 1891.

Flam 1994
Flam, Jack D., ed. *Matisse on Art*. London: Phaidon Press, 1973. Rev. ed., Berkeley and Los Angeles: University of California Press, 1994.

Fry 1989 [1927]
Fry, Roger. *Cézanne: A Study of His Development*. New York: Macmillan, 1927. New ed., Chicago: The University of Chicago Press, 1989.

Galassi 1991
Galassi, Peter. *Corot in Italy: Open-Air Painting and the Classical-Landscape Tradition*. New Haven: Yale University Press, 1991.

Gasquet 1926
Gasquet, Joachim. *Cézanne*. New ed. Paris: Bernheim-Jeune, 1926; partially reprinted in Cézanne, *Conversations*, 106-61.

Geoffroy 1893
Geoffroy, Gustave. "L'Impressionnisme." *La Revue encyclopédique*, no. 73 (December 15, 1893): 1223.

Goldberg 1903
Goldberg, Mecislas. "Les Peintres du Salon d'Automne, suite." *La Plume* 16, no. 352 (December 15, 1903); reprinted in *Cézanne* 1995, 36.

Gowing et al. 1988
Gowing, Lawrence, et al. *Cézanne: The Early Years 1859–1872*. Exh. cat. Edited by MaryAnne Stevens. London: Royal Academy of Arts, in association with Weidenfeld and Nicolson, 1988.

Greenberg 1939
Greenberg, Clement. "Avant-Garde and Kitsch." *Partisan Review* 6, no. 5 (fall 1939): 34-49; reprinted in Greenberg 1986, 5-22.

Greenberg 1986
Greenberg, Clement. *Clement Greenberg: The Collected Essays and Criticism*. Vol. I: *Perceptions and Judgments, 1939-1944*. Edited by John O'Brian. Chicago: The University of Chicago Press, 1986.

Habermas 1992
Habermas, Jürgen. *Postmetaphysical Thinking: Philosophical Essays*. Translated by William Mark Hohengarten. Cambridge, Mass.: The MIT Press, 1992.

Harrison and Wood 1992
Harrison, Charles, and Paul Wood, eds. *Art in Theory 1900–1990: An Anthology of Changing Ideas*. Oxford: Blackwell Publishers, 1992.

Harrison and Wood 1998
Harrison, Charles, and Paul Wood, eds., with Jason Gaiger. *Art in Theory 1815–1900: An Anthology of Changing Ideas*. Oxford: Blackwell Publishers, 1998.

Hayashi 1999
Hayashi, Michio. "Paul Cézanne: The Resistance of Painting." Ph.D. diss., Columbia University, New York, 1999.

Hirst 1997
Hirst, Damien. *i want to spend the rest of my life everywhere, with everyone, one to one, always, forever, now*. New York: The Monacelli Press, 1997.

Holquist 1990
Holquist, Michael. *Dialogism: Bakhtin and His World*. London: Routledge, 1990.

House 1986
House, John. "Camille Pissarro's Idea of Unity." In Lloyd 1986, 15-34.

House 2004
House, John. *Impressionism: Paint and Politics*. New Haven and London: Yale University Press, 2004.

Isaacson 1986
Isaacson, Joel. "The Seventh Exhibition 1882: The Painters Called Impressionists." In Moffett 1986, 375-420.

Jaloux 1942
Jaloux, Edmond. *Les Salons littéraires, 1896-1903*. Fribourg: Éditions de la Librairie de l'Université, 1942.

Jourdain 1950
Jourdain, Francis. *Cézanne*. Paris: Braun/Collection Palettes, 1950. Extracts reprinted in Cézanne, *Conversations*, 82-84.

Kyle 1995
Kyle, Jill Anderson. "Cézanne and American Painting 1900 to 1920." Ph.D. diss., University of Texas at Austin, 1995.

Larguier 1925
Larguier, Léo. *Le Dimanche avec Paul Cézanne: Souvenirs*. Paris: L'Édition, 1925. Extracts published in Cézanne, *Conversations*, 10-17; Eng. trans. in Doran, ed., *Conversations with Cézanne*, 12-18.

Lebensztejn 1995
Lebensztejn, Jean-Claude. *Les Couilles de Cézanne [et] Persistance de la mémoire*. Paris: Nouvelles Éditions Séguier, 1995.

Lecomte 1900
Lecomte, Georges. "Paul Cézanne." In *Vente de la collection E. Blot*. Sale cat., Paris, May 9 and 10, 1900.

Lecomte-Hilmy 1993
Lecomte-Hilmy, Anne. *La Formation du vocabulaire de la peinture impressionniste*. Toronto: Canadian Scholars' Press, 1993.

LeWitt 1969
LeWitt, Sol. "Sentences on Conceptual Art." *0-9*, no. 5 (January 1969): 3-5; reprinted in Alberro and Stimson 2000, 106-08.

Lloyd 1986
Lloyd, Christopher, ed. *Studies on Camille Pissarro*. London and New York: Routledge & Kegan Paul, 1986.

Lloyd 1992
Lloyd, Christopher. "'Paul Cézanne, pupil of Pissarro: An Artistic Friendship." *Apollo* 136, no. 369 (November 1992): 284-90.

Loyrette and Tinterow 1994
Loyrette, Henri, and Gary Tinterow. *Impressionnisme: Les Origines 1859-1869*. Exh. cat. Paris: Réunion des musées nationaux, 1994. Eng. ed., *Origins of Impressionism*. New York: The Metropolitan Museum of Art, 1994.

Lyotard 1979
Lyotard, Jean-François. *La Condition postmoderne: Rapport sur le savoir*. Paris: Éditions de minuit, 1979. Eng. trans., *The Postmodern Condition: A Report on Knowledge*. Translated by Geoff Bennington and Brian Massumi. Minneapolis: University of Minnesota Press, 1984.

Marx 1994 [1848]
Marx, Karl, and Friedrich Engels. *The Communist Manifesto*. London: J. E. Burghard, 1848; reprinted in *Karl Marx: Selected Writings*. Edited by Lawrence H. Simon. Indianapolis and Cambridge: Hackett, 1994, 157-86.

Matisse 1993
Matisse, Henri; Marie-Alain Couturier; and Louis-Bertrand Rayssiguier. *La Chapelle de Vence: Journal d'une création*. Paris: Éditions du Cerf; Houston: Menil Foundation; and Geneva: Skira, 1993. Eng. trans., *The Vence Chapel: The Archive of a Creation*. Milan: Skira, and Houston: Menil Foundation, 1999.

Michaud 1993
Michaud, Yves. *Enseigner l'art? Analyses et réflexions sur les écoles d'art*. Nîmes: Éditions Jacqueline Chambon, 1993.

Modern*Starts* 1999
Modern*Starts: People—Places—Things*. Exh. cat. Edited by John Elderfield, Peter Reed, Mary Chan, and Maria del Carmen González. New York: The Museum of Modern Art, 1999.

Moffett 1986
Moffett, Charles S., et al. *The New Painting: Impressionism 1874-1886*. Exh. cat. Geneva: Richard Burton, S.A., and San Francisco: The Fine Arts Museums of San Francisco, 1986.

Newman 1990
Newman, Barnett. *Selected Writings and Interviews*. New York: Knopf, 1990.

Nozick 1974
Nozick, Robert. *Anarchy, State and Utopia*. Oxford: Basil Blackwell, 1974.

O'Connor 1967
O'Connor, Francis V. *Jackson Pollock*. Exh. cat. New York: The Museum of Modern Art, 1967, 79-81.

Osthaus 1920-21
Osthaus, Karl Ernst. "Cézanne." In *Feuer: Monatsschrift für Kunst und künstlerische Kultur*. Saarbrücken: Gebrüder Hofer, and Weimar: Feuer Verlag, 1920-21, 81-85; reprinted in Doran, ed., *Conversations with Cézanne*, 95-99.

Pissarro, *Correspondance*
Correspondance de Camille Pissarro. Edited by Janine Bailly-Herzberg. Vol. I. Paris: Presses universitaires de France, 1980; Vols. II-V. Paris: Éditions du Valhermeil, 1986-91.

Pissarro 1993
Pissarro, Joachim. *Pissarro*. New York: Harry N. Abrams, 1993.

Pissarro 1994
Pissarro, Joachim. "Pissarro's Memory." In Joachim Pissarro and Stephanie Rachum. *Camille Pissarro: Impressionist Innovator*. Exh. cat. Jerusalem: The Israel Museum, 1994.

Pissarro and Venturi 1939 (also PV)
Pissarro, Ludovic Rodo, and Lionello Venturi. *Camille Pissarro: Son art, son œuvre*. 2 vols. Paris: Paul Rosenberg Editeur, 1939.

Pollock 1950
Pollock, Jackson. "Interview with William Wright." Taped in summer 1950 for the Sag Harbor radio station (not broadcast); first transcribed and published in Francis V. O'Connor. *Jackson Pollock*. Exh. cat. New York: The Museum of Modern Art, 1967; reprinted in Harrison and Wood 1992, 575-78.

Reff 1962
Reff, Theodore. "Cézanne's Constructive Stroke." *Art Quarterly* 25, no. 3 (fall 1962): 214-27.

Reff 1967
Reff, Theodore. "Pissarro's Portrait of Cézanne." *The Burlington Magazine* 109, no. 776 (November 1967): 627-33.

Reidemeister 1963
Reidemeister, Leopold. *Auf den Spuren der Maler der Île-de-France*. Berlin: Propyläen, 1963.

Rewald 1936
Rewald, John. *Cézanne et Zola—Thèse pour le Doctorat d'Université présentée à la Faculté des Lettres de l'Université de Paris*. Paris: Edition A. Sedrowski, 1936.

Rewald 1963
Rewald, John. *Camille Pissarro*. New York: Harry N. Abrams, 1963.

Rewald 1985 [1946]
Rewald, John. *History of Impressionism*. New York: The Museum of Modern Art, 1946; 4th rev. ed., London: Secker & Warburg, 1985.

Rewald 1986 [1939]
Rewald, John. *Cézanne*. Paris: Flammarion,

1939; Eng. ed., New York: Harry N. Abrams, 1986.

Rewald 1986 [1955]
Rewald, John. *Histoire de l'impressionnisme.* Paris: Albin Michel, 1955. Rev. ed., Paris: Albin Michel, 1986.

Rewald 1996 (also R)
Rewald, John. *The Paintings of Paul Cézanne: A Catalogue Raisonné.* 2 vols. New York: Harry N. Abrams, 1996.

Rewald et al. 1988
Rewald, John, et al. *Cézanne: The Early Years 1859–1872.* Exh. cat. London: Royal Academy of Arts, 1988.

Richard 1954
Richard, Jean-Pierre. *Stendhal et Flaubert: Littérature et sensation.* Paris: Éditions du Seuil, 1954.

Rivière and Schnerb 1907
Rivière, R.-P., and Jacques-Félix Schnerb. "L'Atelier de Cézanne." *La Grande Revue,* December 25, 1907, 811-17; reprinted in Cézanne, *Conversations,* 85-91.

Roos 1996
Roos, Jane Mayo. *Early Impressionism and the French State (1866–1874).* Cambridge and New York: Cambridge University Press, 1996.

Rousseau 1866
Rousseau, Jean. "Le Salon de 1866, IV." *L'Univers illustré* 9 (July 14, 1866): 447-48.

Rubin 1977
Rubin, William, ed. *Cézanne: The Late Work.* Exh. cat. New York: The Museum of Modern Art, 1977.

Sartre 1940
Sartre, Jean-Paul. *L'Imaginaire.* Paris: Gallimard, 1940.

Schapiro 1952
Schapiro, Meyer. *Cézanne.* New York: Harry N. Abrams, 1952.

Schapiro 1997
Schapiro, Meyer. *Impressionism: Reflections and Perceptions.* New York: George Braziller, 1997.

Schmidt 2004
Schmidt, Bertram. *Cézannes Lehre.* Kiel: Verlag Ludwig, 2004.

Shiff 1978
Shiff, Richard. "Seeing Cézanne." *Critical Inquiry* 4 (summer 1978): 769-808.

Shiff 1984
Shiff, Richard. *Cézanne and the End of Impressionism: A Study of the Theory, Technique, and Critical Evaluation of Modern Art.* Chicago and London: The University of Chicago Press, 1984.

Shiff 1984 (2)
Shiff, Richard. Review of five books on Pissarro. *Art Bulletin* 66 (December 1984): 681-90.

Shiff 1991
Shiff, Richard. "Cézanne's Physicality: The Politics of Touch." In Salim Kemal and Ivan Gaskell, eds. *The Language of Art History.* Cambridge, Eng.: Cambridge University Press, 1991, 129-80.

Shiff 1992
Shiff, Richard. "The Work of Painting: Camille Pissarro and Symbolism." *Apollo* 136 (November 1992): 307-10.

Shiff 1993
Shiff, Richard. "Cézanne and Poussin: How the Modern Claims the Classic." In Richard Kendall, ed. *Cézanne & Poussin: A Symposium.* Sheffield: Sheffield Academic Press, 1993, 51-68.

Shiff 1994
Shiff, Richard. *Paul Cézanne.* New York: Rizzoli, 1994.

Shiff 1997
Shiff, Richard. "La touche de Cézanne: Entre vision impressionniste et vision sym-

boliste." In Cachin, Loyrette, and Guégan 1997, 117-24.

Shiff 1998
Shiff, Richard. "Cézanne's Blur, Approximating Cézanne." In Richard Thomson, ed. *Framing France: Essays on the Representation of Landscape in France, 1870-1914.* Manchester: Manchester University Press, 1998, 59-80.

Shiff 2000
Shiff, Richard. "Mark, Motif, Materiality: The Cézanne Effect in the Twentieth Century." In Baumann 2000, 99-123.

Shiff 2003
Shiff, Richard. "Unfinished and Abstracted: Paul Cézanne, Twentieth-Century Painter in Spite of Himself" ["Inacabado y Abstraído: Paul Cézanne, pintor del siglo veinte a pesar de sí mismo"]. *Cuaderno 7.* Translated by Juan Luis Delmont. Caracas: Fundación Cisneros, 2003, 5-43.

Shikes and Harper 1980
Shikes, Ralph E., and Paula Harper. *Pissarro: His Life and Work.* New York: Horizon Press, 1980.

Simms 1998
Simms, Matthew Thomas. "The Impression to Excess: Color and Drawing in Cézanne." Ph.D. diss., Harvard University, Cambridge, Mass., 1998.

Smith 1995
Smith, Paul. *Impressionism Beneath the Surface.* New York: Harry N. Abrams, 1995.

Smith 1996
Smith, Paul. *Interpreting Cézanne.* London: Tate Publishing, 1996.

Sollers 1995
Sollers, Philippe. *Le Paradis de Cézanne.* Paris: Gallimard, 1995.

Spurling 1998
Spurling, Hilary. *The Unknown Matisse, A Life of Henri Matisse: The Early Years, 1869–1908.* New York: Knopf, 1998.

Taylor 1983
Taylor, René, et al. *Francisco Oller: Un realista del impressionismo*. Exh. cat. Puerto Rico: Museo de Arte de Ponce, 1983, 226-27.

Todorov 1984
Todorov, Tzvetan. *Mikhail Bakhtin: The Dialogical Principle*. Translated by Wlad Godzich. Minneapolis: University of Minnesota Press, 1984.

Tucker 1986
Tucker, Paul. "The First Exhibition 1874: The First Impressionist Exhibition in Context." In Moffett 1986, 93-144.

Tuma 2000
Tuma, Kathryn Anne. "Cézanne, Lucretius and the Late Nineteenth-Century Crisis in Science." Ph.D. diss., University of California, Berkeley, 2000.

Venegas 1983
Venegas, Haydee. "Francisco Oller: Perfil de un pintor puertorriqueño/Francisco Oller: Profile of a Puerto Rican Painter." In Taylor 1983, 121-54.

Villehervé 1904
de la Villehervé, Robert. "Camille Pissarro," *Le Havre éclair*, September 25, 1904; reprinted in Pissarro, *Correspondance*, V, 369-70.

Vollard 1920
Vollard, Ambroise. *Auguste Renoir (1841–1919)*. Paris: Éditions G. Crès, 1920.

Vollard 1938
Vollard, Ambroise. *En écoutant Cézanne, Degas, Renoir*. Paris: Grasset, 1938.

Waern 1892
Waern, Cecilia. "Some Notes on French Impressionism." *Atlantic Monthly* 69, no. 414 (April 1892): 535-41.

Wechsler 1981
Wechsler, Judith. *The Interpretation of Cézanne*. Ann Arbor: UMI Research Press, 1981.

Weiss 1994
Weiss, Jeffrey. *The Popular Culture of Modern Art: Picasso, Duchamp, and Avant-Gardism*. New Haven and London: Yale University Press, 1994.

Wellmer 1991
Wellmer, Albrecht. *The Persistence of Modernity: Essays on Aesthetics, Ethics, and Postmodernism*. Cambridge, Mass.: The MIT Press, 1991.

White 1996
White, Barbara Ehrlich. *Impressionists Side by Side: Their Friendships, Rivalries and Artistic Exchanges*. New York: Knopf, 1996.

Zola, *Écrits*
Zola, Émile. *Écrits sur l'art*. Edited by Jean-Pierre Leduc-Adine. Paris: Gallimard, 1991.

Zola, *Manet* 1867
Zola, Émile. *Édouard Manet: Étude biographique et critique, accompagnée d'un portrait d'Édouard Manet par Bracquemond et d'une eauforte d'Édouard Manet d'après Olympia*. Paris: E. Dentu, 1867; reprinted in Zola, *Écrits*, 137-69.

Zola, *Mon Salon*
Zola, Émile. *Mon Salon*. Paris: Librairie centrale, 1866; reprinted in Zola, *Écrits*, 85-136.

Zola, "Taine"
Zola, Émile. "M. H. Taine, artiste." First published as "L'Esthétique professée à l'École des beaux-arts." *La Revue contemporaine*, February 15, 1866; reprinted in Zola, *Mes Haines*. Paris: Achille Faure, 1866, and in Zola, *Écrits*, 63-83.

Comparative Chronology

By Alain Mothe

NOTE: Dates that could not be definitively determined have been placed between brackets and are based on letters left undated or dated incorrectly. Occasionally, no documents or sources survive to establish the precise dates of some of Pissarro's and Cézanne's close artistic interactions, which are evidenced through their works only.

Camille Pissarro as a gaucho. 1860. Photograph. L&S Pissarro Archives

1861

Cézanne visits Paris from April to September. According to Pissarro, he and Francisco Oller go to the Académie Suisse to see Cézanne, "that peculiar Provençal . . . [who] was doing life studies that provoked roars of laughter from all the impotents of the school."[1]

1863

FEBRUARY 20
Birth of Lucien Pissarro, the artist's first child.

MAY 15
Opening of the Salon des Refusés. Among the artists exhibiting are Pissarro, Édouard Manet, and Cézanne.[2]

1865

DURING THE YEAR
Pissarro, Auguste Renoir, Alfred Sisley, and sometimes Cézanne frequent the studio that Frédéric Bazille and Claude Monet rent together in Paris at 6, rue de Furstenberg.[3] Cézanne introduces Émile Zola to Pissarro.[4]

MARCH 15
Cézanne tells Pissarro that he and Oller will bring their paintings to the Salon on Saturday, March 18.[5]

MAY 1–JUNE 20
Pissarro exhibits two paintings at the Salon.[6]

JUNE
Birth of Jeanne Rachel Pissarro, the artist's second child.

[AUGUST 26]
The painter Antoine Guillemet asks Pissarro for news of Cézanne and Oller.[7]

[SEPTEMBER 13]
Guillemet wants Pissarro to join him at La Roche-Guyon in October, as well as Cézanne, who is in Aix-en-Provence.[8]

Portrait of Paul Cézanne. c. 1875. Musée Granet, Aix-en-Provence. Photographer: Bernard Terlay, after an old photograph

Émile Zola. c. 1865. Photograph. National Gallery of Art, Washington, D.C. John Rewald Papers, Gallery Archives

DECEMBER 14
Pissarro informs Oller, who is in Puerto Rico, that Cézanne, still in Aix, will return to Paris in a month and a half.[9]

1866

[FEBRUARY]
Cézanne, back in Paris, participates in Zola's "Thursday night receptions."[10]

MARCH 28
Cézanne "hopes" he will not be accepted at the Salon.[11]

[APRIL?]
Pissarro, his companion, Julie Vellay, and their two children, Lucien and Jeanne Rachel, come to live in Pontoise, on rue du Fond de l'Hermitage (now rue Maria-Deraismes), the address listed in the Salon catalogue.

APRIL 12
Cézanne goes to visit Manet, who saw his still lifes at Guillemet's. Manet also pays him a visit.[12]

APRIL 19
Cézanne protests his rejection from the Salon and demands the reestablishment of a Salon des Refusés.[13]

APRIL 27
Article by Zola appears, also demanding the reestablishment of the Salon des Refusés.[14]

LA ROCHE GUYON. — La Fontaine.

Square at La Roche-Guyon (see plate 6). Postcard. Collection Alain Mothe

MAY 1-JUNE 20

Pissarro exhibits *The Banks of the Marne in Winter* (plate 1) at the Salon.

MAY 20

Zola gives Pissarro a favorable review.[15]

JUNE 14

Zola announces that Cézanne has been rejected by the Salon.[16]

JULY

Cézanne visits the village of Bennecourt, as he has several times in May and June. According to Zola, who joins him for a few days, he plans to leave for Aix, perhaps in August or September, to spend at most two months there.[17]

[JULY 31 OR AUGUST 1]

Guillemet, in Brittany, asks Zola for news of Cézanne and Pissarro.[18]

[AUGUST 17]

Guillemet tells Pissarro that he will return to Paris at the end of August and will come by to see him, as well as Cézanne, before going to Aix or somewhere else in the south, perhaps with Pissarro.[19]

AUGUST 18

Cézanne returns to Aix.[20]

SEPTEMBER 12

Guillemet informs Oller that "Cézanne is in Aix and has made a good picture. He says so, and he is very tough on himself."[21]

[OCTOBER?]

Pissarro and his family move to Paris.[22]

[STARTING IN OCTOBER?]

Pissarro begins to frequent Café Guerbois, in the Batignolles, where artists and writers meet.[23]

[OCTOBER 17]

Cézanne informs Zola that Guillemet has joined him in Aix. He asks for news of Pissarro and declares: "I am seeing wonderful things, and I must get into the firm habit of only working in the open air."[24]

OCTOBER 23

Cézanne writes to Pissarro: "You are perfectly right to speak of gray; it alone reigns in nature, but it's terribly difficult to capture."[25]

END OF THE YEAR

Pissarro participates in Zola's "Thursday night receptions" every week.[26]

1867

FEBRUARY 19

Zola writes that Cézanne is working a lot and dreaming of huge paintings.[27]
Cézanne seems to have remained in the Aix region until early February.

MARCH 30

Bazille composes a petition demanding the reestablishment of the Salon des Refusés. Among the signatories are Monet, Renoir,

397 PONTOISE. — *Vue sur les Quartiers Victor-Hugo et de l'Ermitage*

Le Fond de L'Hermitage, Pontoise (see plate 90). Postcard. Collection Alain Mothe

Pissarro, Sisley, Guillemet, and Oller, but not Cézanne.[28]

[APRIL?]

Pissarro and his family return to Pontoise. Ludovic Rodo Pissarro recorded this information: "1867—Pontoise, house of père Colomban (Lucien)."[29] The reference is to Colomban Delaplace's house in Pontoise at 1, rue du Fond de l'Hermitage (now 5, rue Maria-Deraismes).[30]

APRIL 8

Article in *Le Figaro* critiquing the two paintings by Pissarro rejected from the Salon.[31]

APRIL 12

An excerpt from Zola's letter defending Cézanne and supporting the painters' petition for a reestablishment of the Salon des Refusés is published in *Le Figaro*.[32]

APRIL 13

A new petition, signed notably by Bazille, Pissarro, Monet, Guillemet, and Renoir, demands the "right to appeal to public opinion."[33]

[JUNE 8]

Cézanne leaves for Aix.[34]

[EARLY SUMMER]

Cézanne spends time painting in Aix, determined to succeed as soon as possible.[35]

[FALL]

Pissarro and his family go to live in Paris, at 108, boulevard Rochechouart.[36]

[SHORTLY AFTER OCTOBER 9]

Cézanne returns to Paris.[37]

1868

[DURING THE YEAR]

With Armand Guillaumin, Pissarro paints window blinds and shop signs. Guillaumin paints a picture of Pissarro.[38]

[JANUARY 20 TO ABOUT JANUARY 29]

Pissarro stays in London for the funeral of his half-sister, Emma Isaacson.[39]

[FEBRUARY 13]

Cézanne signs up as a copyist at

the Musée du Louvre. His card, no. 278, specifies his address in Paris as 22, rue Beautreillis.[40]

[APRIL 2]
A friend of Zola's tells him he has met Pissarro, Guillemet, and all the "Batignolles" at the Salon (before the exhibition), and they think Cézanne's painting is very good.[41]

[FROM APRIL TO OCTOBER]
The Pissarro family lives in Pontoise.[42]

MAY 1–JUNE 20
Pissarro exhibits two works at the Salon–*Jalais Hill, Pontoise* (plate 90) and *Gardens at L'Hermitage, Pontoise* (plate 94).

[FROM MAY 16 TO ABOUT MID-DECEMBER]
Cézanne stays in Aix.[43]

MAY 19
Zola publishes a long, admiring critique of Pissarro.[44]

[AUGUST 7]
Guillemet, having arrived in Pontoise the night before, invites Zola to join him there.[45]

[SHORTLY AFTER OCTOBER 11]
Pissarro and his family live in Paris, at 23, rue Chappe.[46]

1869

[BEGINNING OF THE YEAR?]
Cézanne meets a young model, Hortense Fiquet, nineteen years old, who becomes his companion.[47]

DURING THE YEAR
Meetings at Café Guerbois continue (they are suspended during the Franco-Prussian War of 1870-71). Pissarro, Cézanne, Guillemet, Edgar Degas, Manet, Bazille, Monet, Renoir, and Sisley are notable participants.[48]

APRIL
Cézanne is at L'Estaque, as evidenced by the inscription on the watercolor *Factories at L'Estaque*.[49]

[SPRING, BEFORE MAY 3]
Pissarro and his family move to Louveciennes, to Maison Retrou, route de Versailles. The house, which still exists, is now at no. 22.[50]

MAY 1–JUNE 20
Pissarro exhibits at the Salon.

AUGUST 28
Guillemet informs Zola that Pissarro has made a moralistic painting and that Cézanne is attempting painting that is only rarely successful.[51]

SEPTEMBER 4
Zola says Cézanne would be ready to leave for Paris immediately if he had 200 francs.[52]

1870

Pissarro and his family continue to live in Louveciennes, at Maison Retrou. Pissarro depicts Julie in front of the house, in *Route de Versailles at Louveciennes*.[53]

MID-MARCH
Cézanne returns to Paris to bring his entry to the Salon.[54]

MAY 1–JUNE 20
Pissarro exhibits two paintings at the Salon.[55]

MAY 30
Théodore Duret asks Zola for a letter of recommendation to visit Cézanne.[56] Zola replies the same day that he cannot give out Cézanne's address because Cézanne has locked himself away and finds himself in a period of trial and error with his work.[57]

MAY 31
Cézanne is one of Zola's witnesses at his wedding in Paris.[58]

JULY 19
France declares war on Prussia.

[SHORTLY BEFORE SEPTEMBER 13]
Faced with the advance of the Prussians, the Pissarro family leaves Louveciennes precipitously to find refuge at the home of painter Ludovic Piette in Montfoucault. They abandon artworks and furniture, including a few canvases that Monet entrusted to them.[59]

OCTOBER 21
Birth of Adèle Emma Pissarro in Montfoucault.

NOVEMBER 5
Death of the young Adèle Emma Pissarro in Montfoucault.

[UNTIL FALL 1871]
Cézanne lives in the south, first in Aix, then, until about March 1871 in L'Estaque, where he hides from his father, while living with Hortense Fiquet. They probably return later to Aix.[60] He tells Ambroise Vollard that during the war he worked assiduously on painting motifs of L'Estaque.[61]

[SHORTLY AFTER DECEMBER 3]
The Pissarro family takes refuge in London.[62]

1871

JANUARY 21
In London, Charles-François Daubigny introduces Pissarro to the art dealer Paul Durand-Ruel.[63] Shortly after this initial contact, Durand-Ruel buys two paintings from Pissarro.[64]

FEBRUARY 12
Zola learns that Cézanne is in the south.[65]

FEBRUARY 22
The painter Édouard Béliard also informs Pissarro that Cézanne is in the south.[66]

[MARCH 10]
Félicie Estruc, in Louveciennes, informs her sister, Julie Vellay, that the Pissarros' house has been destroyed by the Prussians. A neighbor was able to save about forty of the paintings and some of the furniture.[67]

[LATE MAY]
Pissarro tells Duret that he has lost everything in Louveciennes except for about forty paintings.[68]

JUNE 14
Camille Pissarro and Julie Vellay marry in Croydon, near London.[69]

[SHORTLY BEFORE JUNE 23]
The Pissarros return to Louveciennes, not to the Maison Retrou, which has been destroyed, but next door to Eugène Ollivon's house (now 24, route de Versailles).[70]

[FROM FALL TO EARLY DECEMBER]
Cézanne, returning to Paris, lives at 5, rue de Chevreuse.[71]

Auvers-sur-Oise (see plate 48). Postcard. Collection Alain Mothe

NOVEMBER 22
Birth of Georges Henri Pissarro in Louveciennes.

DECEMBER 21
Monet, living in Argenteuil, suggests that Pissarro come to his Paris studio and bring him the few remaining canvases that he left in storage in Louveciennes.[72]

1872

JANUARY 4
Birth of Paul Cézanne, son of the painter and Hortense Fiquet, in the apartment they occupied since early December 1871 at 45, rue Jussieu, in Paris.

[FEBRUARY]
Pissarro stops by the Paris gallery of Durand-Ruel, which wants to buy paintings from him.[73] Starting in March, the dealer buys Pissarro's works that total 5,900 francs.[74]

[AROUND APRIL 8]
The Pissarros return to live in Pontoise, at 16, rue Mallebranche, in a house owned by Gateau that corresponds to the current 18, rue Revert.[75]

APRIL 28
The sculptor A. Rossi and the painter L. Authiès ask Pissarro to sign a petition favoring the reinstating of the Salon des Refusés.[76]

JUNE 18
The petition has twenty-six signatories, among whom are Pissarro (by proxy) and Cézanne.[77]

[JULY OR AUGUST]
Cézanne stays with his family at the Hôtel du Grand-Cerf, in Saint-Ouen-l'Aumône, near Pontoise.[78]

SEPTEMBER 3
Pissarro invites Guillemet to Pontoise. He writes: "He [Cézanne] will surprise a lot of artists who were too quick to condemn him."[79]

DECEMBER 11
Because he missed the train back to Paris, Cézanne spends the night at the Pissarros' house in Pontoise.[80] That evening Pissarro, Cézanne, Sisley, Monet, and Manet invite Zola to dine at Café Anglais.[81]

[END OF THE YEAR]
Cézanne and his family go to live on rue Rémy in Auvers-sur-Oise, near the home of Dr. Paul Gachet. A painting by Louis Van Ryssel (pseudonym of Paul Gachet, the doctor's son), *House Inhabited by Cézanne in Auvers in 1873*,[82] executed in

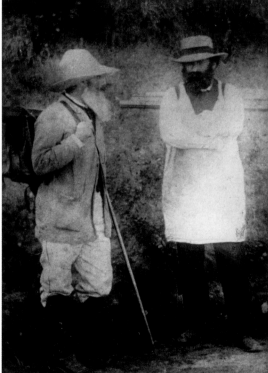

Camille Pissarro and Paul Cézanne. Photograph. L&S Pissarro Archives

1905, depicts Cézanne's house. The house still exists, at 66, rue Rémy.

That year, Cézanne borrows a painting from Pissarro entitled *Louveciennes* (plate 22) in order to copy it (plate 23).[83]

1873

BEGINNING OF THE YEAR
Cézanne, Guillaumin, and Dr. Gachet take a walk in the valley of La Bièvre. Cézanne and the doctor make an etching printed on Dr, Gachet's own printing press in Auvers.[84] Pissarro will also print his etchings on the same press.

DURING THE YEAR
Durand-Ruel buys eight paintings from Pissarro for 5,400 francs, but in the middle of the year, in a period of recession, financial difficulties force him to reduce his acquisitions.[85]

Like Pissarro, Cézanne purchases food and supplies from a grocer named Armand Rondest, who accepts paintings as payment. At least four Pissarros and three Cézannes are included in his collection.[86] Cézanne works in Dr. Gachet's house painting still lifes there.[87]

STARTING IN 1873
Pissarro rents a studio in Paris at 21, rue Berthe, which he will keep at least until 1876, for a monthly rent of 115 francs.[88]

Pissarro and Cézanne and the color supplier and dealer Père Tanguy have become good friends.[89]

Between 1874 and 1880, Pissarro buys 3,313.10 francs worth of paints from him. During the same period, Tanguy is able to sell only three of Pissarro's paintings. They are bought by Albert André for 100 francs, Eugène Murer for 50 francs, and Théodore Duret for 50 francs.[90]

Cézanne also buys supplies from Tanguy.[91] Between August 5, 1873, and February 15, 1880, he pays him 842.50 francs. Tanguy sells paintings by Cézanne on October

Rondest's house, Pontoise (see plate 36). Photograph.
Photographer: Alain Mothe

25, November 1, and December 30, 1875, for 50
francs each; on March 30 and September 20,
1876, for 50 francs each; and in 1884 and 1885,
for 200 and 150 francs, respectively.[92]

Painters and writers meet at Café de la Nouvelle
Athènes, at 9, place Pigalle, in Paris. Their meet-
ings cease in 1883, shortly after the death of
Manet.[93] Cézanne makes only rare appearances.[94]

MAY 5
Echoing Bazille's, Cézanne's, and Pissarro's
discontent, an article by Paul Alexis suggests
joining forces to advocate remedying the
injustices of the Salon.[95]

JULY
Date inscribed by Gachet on the proof of an
etching by Cézanne, *Entrée de ferme rue Rémy*,
engraved after the painting *Chaumière dans les
arbres, à Auvers* that Pissarro came to own.[96]

SEPTEMBER
Date of an etching by Cézanne, *Head of a
Woman*, engraved at the home of Dr. Gachet.[97]

SEPTEMBER 6
Guillaumin writes Dr. Gachet that he hopes to
visit him soon in Auvers. He would like to have
Pissarro's and Cézanne's opinion of his recent
studies.[98]

SEPTEMBER 12
Monet invites Pissarro to come to his house
the following day, so that they can work on the
statutes of their future artists' society. He men-
tions that Renoir will not be present.[99]

OCTOBER 13
The Pissarros move to 26, rue de l'Hermitage.[100]
The house, owned by Nicolas Cassard, cur-
rently occupies 54-54 bis, rue de l'Hermitage.
It appears in many paintings.[101]

[OCTOBER 28]
Pissarro asks Dr. Gachet to return a snowscape
(possibly plate 42) that he lent him through
the intermediary of Cézanne.[102]

OCTOBER 30
Pissarro asks Dr. Gachet to bring him a large
copperplate.[103] Thanks to Dr. Gachet, Pissarro
begins engraving again. At the doctor's sugges-
tion, each adopts a particular monogram: a
small flower for Pissarro; a hanged figure for
Cézanne; and a cat for Guillaumin.[104]

DECEMBER 5
Monet informs Pissarro that he scoured Paris
all day, trying unsuccessfully to find five extra
members to add to the fifteen who have

The Mathurins property at l'Hermitage, Pontoise
(see plate 53). Postcard. Collection Alain Mothe

already agreed to form their artists' society.[105]
A handwritten list of twenty numbered names
was found in Pissarro's papers, among which
are Pissarro (at 26, rue de l'Hermitage in
Pontoise), Cézanne (at rue Rémy in Auvers-sur-
Oise), and Guillaumin (at 13, quai d'Anjou in
Paris).[106] John Rewald was told by Lucien
Pissarro that Pissarro had to plead the case
of Cézanne and Guillaumin in order to get
them accepted into the group.[107]

DECEMBER 8
Pissarro responds to Duret's request: "As long as
you are looking for a five-legged lamb, you will
not be disappointed by Cézanne, for he has
made some very strange works, conceived
from a unique perspective."[108]

DECEMBER 27
Date of the statutes of the Société anonyme
des artistes peintres, dessinateurs, graveurs,
etc., drafted by Pissarro.[109]

1874

[BEGINNING OF THE YEAR]
Pissarro executes two portraits of Cézanne,
at age thirty-five, wearing the same cap and
winter coat each time. One is an etching (see
plate 18), the other a painting.[110]

Cézanne informs an art collector, probably
Rondest, that he will soon be leaving Auvers.
"If you would like me to sign the painting you
spoke of, please bring
it to Mr. Pissarro's, and
I will put my name
on it."[111]

In a letter, the date of
which has not been
established, Cézanne
explains to his parents
that he is not return-
ing to Aix, because he
would not feel free to
leave again if he did.
He asks his father to
increase his allowance
to 200 francs a month, which will allow him
["to have a full stay in Aix"].[112]

Cézanne lives at 120, rue de Vaugirard (according to the exhibition catalogue of the Société anonyme).

[DURING THE YEAR]

Durand-Ruel again buys paintings from Pissarro, four in all, for 5,035 francs.[113]

JANUARY

Durand-Ruel pays Pissarro 1,835 francs, in three installments.[114]

[JANUARY]

Piette writes to Pissarro to inform him that he failed to see Cézanne: "Your friend, Mr. Cézanne, must have gone off and made camp on the legendary shores of the blue Mediterranean."[115] He was thought to be in Auvers, then in Paris, during the entire winter of 1873–74.

JANUARY 17

The statutes of the Société anonyme are published, but they are, in fact, only excerpts.[116] For example, the rules of exhibition, printed on the last page of the 1874 exhibition catalogue, are not mentioned.

APRIL

New residence for the Pissarros in Pontoise at 18 or 18 bis, rue de l'Hermitage, owned by Berlioz. The house still exists, its current address 36, rue de l'Hermitage.[117]

APRIL 6

Death of Jeanne Rachel Pissarro, in Pontoise, at 26, rue de l'Hermitage, at the age of eight years and ten months.[118]

APRIL 15–MAY 15

First exhibition of the Société anonyme des artistes peintres, etc. [later referred to as the First Impressionist Exhibition]. There are 167 items inscribed in the catalogue, five of which are listed twice, and three are unattributed. Thirty artists exhibit, among them Pissarro, Cézanne, Guillaumin, Degas, Monet, Berthe Morisot, Renoir, and Sisley.[119]

APRIL 26

The dealer Louis Latouche guards Cézanne's *A Modern Olympia* at the exhibition, fearing someone will puncture it out of outrage.[120]

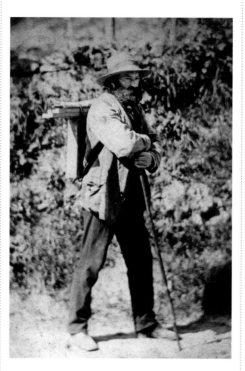

Paul Cézanne. Photograph. L&S Pissarro Archives

[MAY 29]

Cézanne returns to Aix, according to his letter of June 24.

JUNE 24

Cézanne, back in Aix, sends news of himself to Pissarro.[121]

JULY 16

The painter Auguste de Molins encourages Gustave Arosa to buy Pissarro's works: "He is being completely stepped on by G., only acts on his advice. G. thinks more of himself than his friends."[122] Arosa's artistic mentor is certainly Paul Gauguin, which suggests that Pissarro already knew him.

JULY 24

Birth of Félix Camille Pissarro in Pontoise.

[AUGUST]

The painter Alfred Meyer, one of the exhibitors of the Société anonyme, confirms his intention to found a new society of artists with Pissarro. Among the other prospective members are Cézanne and Guillaumin.[123]

[OCTOBER 22?]

Pissarro, in great financial difficulty, leaves with his family for Montfoucault.[124]

NOVEMBER 26

Dr. Gachet writes that Cézanne came by to see him.[125]

[NOVEMBER 26]

Cézanne, back in Paris, at 120, rue de Vaugirard, writes to his mother: "Pissarro isn't in Paris–he has been in Brittany for the last month and a half–but I know that he has a very good opinion of me, and I have a very high opinion of myself too. I am beginning to find myself stronger than all those who surround me, and, as you know, the high opinion I have of myself is not gratuitous."[126] This letter is known only through the transcription of it that Gustave Coquiot published.[127]

DECEMBER 17

A general meeting takes place to dissolve the Société anonyme. Members find they each owe a sum of 184.50 francs.[128]

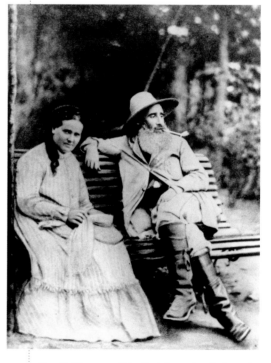

Camille Pissarro and his wife, Julie. c. 1875. Photograph. L&S Pissarro Archives

The House of the Hanged Man, Auvers-sur-Oise (see plate 36). c. 1950. Postcard. Collection Alain Mothe

1875

JANUARY 3

In anticipation of his return to Pontoise, Pissarro writes a will in which he designates his wife as sole legatee and asks his "friends," Piette, Guillaumin, and Cézanne, to be his executors.[129]

Alfonso (medical student and painter, left), Paul Cézanne (center), Camille Pissarro (right), and an unidentified person in the back. c. 1875. Photograph. National Gallery of Art, Washington, D.C. John Rewald Papers, Gallery Archives

[FEBRUARY]

The Pissarros leave Montfoucault for Pontoise, where they live at 18, rue de l'Hermitage.[130]

MARCH 24

Auction at the Hôtel Drouot of seventy-three works by Monet, Morisot, Renoir, and Sisley. Prices are low: 160 francs on average. Renoir relays his account of the auction to his son Jean: "The public protested. A man called Berthe Morisot a 'hussy.' Pissarro threw a punch at the insolent fellow. A fight ensued. The police intervened."[131]

AUGUST 18

Constitution of the Union des Artistes [a new artists' organization that rivaled the Société anonyme]. It comprised nineteen members, among them Alfred Meyer; Pissarro, at 10 bis, rue de l'Ermitage, Pontoise; Béliard, at quai du Pothuis, Pontoise; and Cézanne, at 67, rue de l'Ouest, Paris.[132]

NOVEMBER–DECEMBER

Pissarro and his family spend part of the fall at Piette's in Montfoucault.

[LATE DECEMBER]

Piette asks Pissarro if Cézanne has "returned from his trip to the land of sun."[133]

1876

The Pissarro family is included in a census in Pontoise, 18, rue de l'Hermitage, with a maid, Marie Grandin, nineteen.[134]

FEBRUARY 5

Cézanne brings the collector Victor Chocquet to Argenteuil to introduce him to Monet.[135]

MARCH 22

Guillaumin tells Pissarro that neither he nor Cézanne will participate in the next exhibition.[136]

MARCH 30–APRIL 30

Second Impressionist Exhibition. There are 280 works listed in the catalogue; the nineteen exhibitors include Gustave Caillebotte, Degas, Monet, Morisot (now Mrs. Eugène Manet), Pissarro, Renoir, and Sysley [sic]. Neither Cézanne nor Guillaumin exhibit work.[137]

[SHORTLY AFTER APRIL 15]

Cézanne returns to Aix for at least two weeks.[138]

JULY 2

Cézanne, in L'Estaque, having left Aix a month before, wants a new Impressionist Exhibition to take place and the Union des Artistes to be a "flop." He will return to Paris, perhaps at the end of the month.[139]

Martinès (the photographer), Alfonso, Paul Cézanne, Lucien Pissarro, Aguiar (Cuban painter), and Camille Pissarro. c. 1875. Photograph. L&S Pissarro Archives

[JULY 23]

Guillaumin also proves reticent to exhibiting with the Union. He tries to retain faith in Pissarro again, who is staying at Piette's in Montfoucault.[140]

[SEPTEMBER 2]

Cézanne returns to Paris for three or four days, but ends up staying much longer.[141]

Julie Pissarro and the maid, Marie Grandin. c. 1875.
Photograph. L&S Pissarro Archives

[SEPTEMBER 9]

Cézanne tells his parents he went to see Guillaumin in Issy on Wednesday (September 6). He has not yet been able to see Pissarro. At the closing of the April exhibition, each artist receives 300 francs.[142]

OCTOBER 4

Cézanne spends the day with Guillaumin in Issy.[143]

NOVEMBER 3

At the age of twenty-eight, Caillebotte writes a will. He wants the necessary sum to be taken from his estate for an exhibition in 1878 that would include Pissarro and Cézanne. He gives the paintings he owns to the State.[144] Caillebotte confirms this will on November 20, 1883, with a few adjustments.

1877

DURING THE YEAR

Cézanne returns at various times to Pontoise and Auvers.[145]

Pissarro and, more rarely, Cézanne participate on Tuesdays in dinners at the home of the pastry chef and collector/dealer Eugène Murer, 95, boulevard Voltaire.[146]

Pissarro buys 264.25 francs worth of supplies from Tanguy.[147]

FEBRUARY 15–MARCH 17

The Union exhibition, at the Grand-Hôtel, 37, boulevard des Capucines, takes place without Pissarro, Cézanne, or Guillaumin.[148]

FEBRUARY 24

Cézanne works a lot in his apartment in Paris.[149]

APRIL 4–30

Third Impressionist Exhibition. There are 241 works listed in the catalogue; the eighteen exhibitors include Caillebotte, Cézanne, Degas, Guillaumin, Monet, Morisot, Piette, Pissarro, Sisley, and Renoir.[150] Profits increase to about sixty francs for each artist.[151]

APRIL 5

Dinner for about twenty "Impressionists" at Café Riche, presided over by Zola, "an Impressionist of the pen." The group includes Pissarro, Cézanne, Caillebotte, Monet, and Piette.[152]

MAY 28

Auction of paintings by Pissarro (fourteen), Caillebotte, Renoir, and Sisley at the Hôtel Drouot, which is not a great success.

AUGUST 24

Cézanne tells Zola that he goes to the park in Issy every day to paint.[153]

[TOWARD LATE SEPTEMBER]

Cézanne makes an appearance at the Café de la Nouvelle Athènes.[154]

1878

DURING THE YEAR

Pissarro rents a studio in Montmartre, 18, rue des Trois-Frères.[155]

FEBRUARY 22

Murer tells Pissarro that "Sézanne" [sic] plans to leave for the south in early March.[156]

[AROUND MARCH]

Pissarro informs Caillebotte that Cézanne intends to participate in their next exhibition.[157]

MARCH 4

Cézanne, "still residing in Paris, rue de l'Ouest, 67," acknowledges a debt to M. and Mme Tanguy, for 2,174.80 francs worth of painting supplies.[158]

Tanguy mentions this debt in a letter to Cézanne of August 31, 1885, his account having increased in the meantime to 4,015.40 francs, after the deduction of 1,442.50 francs in payments and income from the sale of paintings.[159]

MARCH 23

Cézanne, in L'Estaque before returning to Aix in the evening, tells Zola that his father has found out about his companion, Hortense Fiquet, and their son, Paul, who is now six years old.[160]

[MARCH 28]

Cézanne asks Zola to lend him one of his still lifes for the next Impressionist Exhibition.[161]

APRIL 4

After his father decides to allocate only 100 francs for living expenses, Cézanne asks Zola to send 60 francs to Hortense Fiquet on a regular basis, which he does until August.[162]

APRIL 14

Death of Ludovic Piette in Montfoucault.

MAY

Publication of Théodore Duret's *Les Peintres Impressionnistes: Claude Monet, Sisley, C. Pissarro, Renoir, Berthe Morisot.*

JUNE 6

Auction, by order of the court, at the Hôtel

L'Hermitage, Pontoise (see plate 67). Postcard. Collection Alain Mothe

Drouot of the Ernest Hoschedé collection, comprising nine paintings by Pissarro.

JULY 16

Cézanne has been at L'Estaque for about a week.[163]

[AROUND JULY]

Pissarro confides to Murer: "What I'm suffering through right now is terrible, even more so than when I was young, full of enthusiasm and ardor, convinced as I am that I am lost, as is the future. Yet if I had to do it all over again, it seems to me I wouldn't hesitate to follow the same path."[164]

JULY 29

Cézanne, in L'Estaque, seeks a place in Marseille to spend the winter. He intends to go to Paris around March of the next year. As he had done in Auvers, he plans to move to the Médan area for one or two years, where Zola has just bought property.[165]

AUGUST 24

Pissarro returns to Pontoise, after two weeks of fruitless attempts at finding a buyer for his work.[166]

AUGUST 27

Cézanne still seeks inexpensive lodging in Marseille.[167]

[LATE AUGUST]

Pissarro returns to Paris, after, he says ironically, a *"long stay* in Pontoise, where I engaged in an orgy of painting." His financial troubles continue.[168]

[SEPTEMBER 13 OR 14]

Julie expresses her great lassitude to Camille.[169]

SEPTEMBER 14

Cézanne is still in L'Estaque. His father sends him 300 francs this month, probably the same amount allocated earlier.[170]

[SEPTEMBER 14]

Pissarro returns to Pontoise immediately, because he senses his wife is in despair.[171]

SEPTEMBER 24

Cézanne decides to spend the winter in L'Estaque. In the evening, he will return to Marseille to spend the night.[172]

NOVEMBER 5

The entire Pissarro family leaves Pontoise to move into a Paris studio that Camille has occupied since the beginning of the year, at 18, rue des Trois-Frères. They will stay there until May 1879.[173]

Garden of Maubuisson, Pontoise (see plate 69). Photograph. Photographer: Alain Mothe

NOVEMBER 13

It has been about nine months since Cézanne left Paris.[174]

NOVEMBER 21

Birth of Ludovic Rodolphe Pissarro, at 18, rue des Trois-Frères, Paris.

DECEMBER 19

Cézanne is still in L'Estaque. He thinks he will return to Paris in early March.[175]

[LATE DECEMBER]

Pissarro sells two recent fall scenes to Murer, for 50 francs each, one of which depicts the "red house."[176] The house, which was actually white, is the one the Pissarro family inhabited in Pontoise, 18, rue de l'Hermitage (currently, 36, rue de l'Hermitage).[177]

1879

FEBRUARY

Cézanne informs Zola that he will stay in L'Estaque another two weeks, then go to Aix, and from there to Paris.[178]

[MARCH 16]

Degas takes stock of the possible participants in their future exposition: "Sisley has declined. I saw Pissarro this morning, Cézanne will be here in a few days, Guillaumin will see him right away. Monet only knows one thing right now and that is that he won't be sending anything to the Salon. . . . Miss Cassatt will see Miss Morisot tomorrow and will know what she's decided."[179]

APRIL I

Cézanne explains to Pissarro that because of the difficulties raised by his shipment to the Salon, he has decided not to participate in the Impressionist exhibition. He must leave Paris in a few days, for Melun.[180]

Camille Pissarro. c. 1880. Collection Sirot-Angel, Paris

[AROUND APRIL]
Pissarro, Degas, Félix Bracquemond, and Cassatt plan to publish a journal of engravings. According to Degas, "Pissarro is *beaming* with energy and confidence."[181]

APRIL 10–MAY 11
Fourth Impressionist Exhibition. There are 246 items listed in the catalogue; the fifteen exhibiting artists include Caillebotte, Cassatt, Degas, Monet, and Pissarro. Twelve works by Piette are not mentioned, and at least one sculpture by Gauguin is also not mentioned.[182]

[LATE MAY, BEFORE THE 26TH]
The Pissarro family returns to live in Pontoise, 18, rue de l'Hermitage.[183]

[LATE MAY]
Caillebotte informs Monet that profits from the exhibition, the result of some 15,400 admission fees, have increased to 439.50 francs per person.[184]

JUNE 3
Cézanne, who has lived in Melun since early April, tells Zola he came through Paris on May 10.[185]

JUNE 5
Cézanne writes Zola to confirm their appointment in Paris on June 10. He plans to arrive the night before.[186]

SECOND HALF OF SEPTEMBER
Pissarro receives Gauguin in Pontoise.[187]

SEPTEMBER 24
Cézanne confides to Zola: "I'm trying hard to find my pictorial path. Nature offers me the greatest challenges."[188]

[AROUND DECEMBER]
Degas sends Pissarro the proofs of his engravings and compliments him on them.[189]

DECEMBER 18
From Melun, Cézanne warns Zola he might have to seek refuge in Paris on Saturday (December 20), because he will have no more coal.[190]

DECEMBER 26
Oller asks Pissarro to send one of his works to Madrid so that it can be exhibited alongside one of his. He makes the same request of Cézanne.[191]

1880

DURING THE YEAR
Renoir executes a portrait of Cézanne in pastels, which the latter will copy, probably in 1881.[192] Pissarro acquires Cézanne's painting.

JANUARY 24
An article in *Le Gaulois*, signed Tout-Paris, announces the publication on February 1 of the journal of engravings *Le Jour et la nuit*. It also mentions the loss, for the Impressionists, of Monet, whose funeral will coincide with the opening of the Salon.[193]

FEBRUARY 2
Monet [who is very much alive] questions Pissarro to see who was the instigator of this article.[194]

[FEBRUARY 5]
Pissarro conveys his indignation against these sorts of writings to Monet.[195] The author of the article is probably Octave Mirbeau.[196]

APRIL 1
Cézanne tells Zola he is back in Paris, after his year-long stay in Melun. He resides at 32, rue de l'Ouest.[197]

APRIL 1–30
Fifth Impressionist Exhibition. There are 232 items listed in the catalogue. The eighteen exhibitors include Pissarro, Caillebotte, Miss Cassatt, Degas, Gauguin, Guillaumin, and Miss Morisot.[198]

APRIL 9
Cassatt's mother regrets that the publication of *Le Jour et la nuit* was postponed.[199] The magazine never sees the light of day.

JULY 15
Cézanne, staying with Zola in Médan, spends the day with Guillemet, who arrived the night before.[200]

STARTING IN NOVEMBER
Pissarro stays in Paris in his studio, 18, rue des Trois-Frères.[201]

END OF THE YEAR
Thanks to the support of the director of the Union Générale bank, Durand-Ruel is able to begin buying again from the Impressionists.[202] In late December, he pays Pissarro 1,750 francs and offers to buy whatever he paints.[203]

The hamlet of Valhermeil, Pontoise (see plate 59). Postcard. Collection Alain Mothe

1881

DURING THE YEAR
Durand-Ruel pays Pissarro 14,450 francs, in several installments.[204]

FEBRUARY 27
In Aix, Cézanne attends the wedding of his sister Rose.[205]

APRIL 2–MAY 1
Sixth Impressionist Exhibition. There are 170 works listed in the catalogue;[206] the thirteen exhibiting artists include Cassatt, Degas, Gauguin, Guillaumin, Morisot, Pissarro, but not Caillebotte.

MAY 7
Cézanne tells Zola he and his family have been in Pontoise for two days, residing at 31, quai du Pothuis, not far from Pissarro's house.[207]

MAY 14
Auction at the Hôtel Drouot to benefit the musician François Cabaner. Thirty-eight items, including two watercolors by Pissarro and two paintings by Cézanne, are offered for sale.[208]

MAY 16
Cézanne, having arrived in Pontoise, writes to Chocquet that he saw Pissarro the night before.[209] He will stay in Pontoise until October.

MAY 20
Cézanne tells Zola that he sees Pissarro often.[210]

[JULY]
Gauguin asks Pissarro: "Has Mr. Césanne [*sic*] found the exact *formula* for his work that is accepted by everyone? If he has found the recipe to compress the extravagant expression of all his feelings in a single method, please try to have him talk."[211]

BEGINNING ABOUT AUGUST 27
The Pissarro family moves a few houses away from where Cézanne stays, to 85, quai du Pothuis in Pontoise, a house owned by M. F. Jeanne; the rent is 175 francs a month.[212] The house still exists, greatly transformed (its current address 21, quai Eugène-Turpin). In 1881, the Pissarro family, Joséphine Daudon, a sister of Julie's, and her son are listed in a census as living at

Les Pâtis, Pontoise (see plate 100). Postcard. Collection Alain Mothe

The mill on the Couleuvre, Pontoise (see plate 93). Postcard. Collection Alain Mothe

85, quai du Pothuis. Cézanne is not included in the census.[213]

AUGUST 27
Birth of Jeanne Marguerite Éva Pissarro, quai du Pothuis.

OCTOBER 15
Cézanne tells Zola he is preparing to leave Pontoise for Aix.[214]

NOVEMBER 5
Zola says that he played host to Cézanne in Médan for eight days and that he has left again for Aix.[215]

1882

[AROUND FEBRUARY 24]
Letter from Pissarro to Monet: "Cézanne wrote me that he had nothing [for the exhibition that year]!"[216]

MAY 1–JUNE 20
One painting by Cézanne is exhibited at the

Osny (see plate 102). Photograph. Photographer: Alain Mothe

Salon des Champs-Élysées, thanks to Guillemet, a member of the jury.

SUMMER

Cézanne's painting *Houses at Pontoise, near Valhermeil* (plate 96) represents the same site as that chosen by Pissarro for his *Path and Hills, Pontoise* (plate 97). Even though the whereabouts of Cézanne during the summer of 1882 is not known, this evidence suggested to Rewald that the two paintings were done working side by side when Cézanne visited Pissarro at that time.[217]

1883

MAY 13

Letter from Pissarro to Joris-Karl Huysmans: "How is it that you have not said a word about Cézanne? There is not a single one of us who doesn't regard him as one of the most astonishing and curious personalities of our era and he has had an enormous influence on modern art."[218]

1884

[EARLY MARCH]

Letter from Pissarro to Lucien: "When you're too close, you see nothing, as in a picture by Cézanne that you would stick under your own nose. Speaking of Cézanne, I just bought myself four of his studies. They're very peculiar."[219]

1885

Pissarro persuades Signac to buy a Cézanne landscape.[220]

JUNE 14

Back from Aix, Cézanne has dinner at Zola's home in Paris.[221]

JUNE 15–JULY 10

Cézanne and his family stay with Renoir in La Roche-Guyon.[222]

JULY 11

Cézanne moves to Vernon.[223]

JULY 22

He arrives at Zola's home in Médan, where he spends a few days; then leaves again for Aix.[224]

[LATE AUGUST]

Letter from Pissarro to Monet: "I've been told that Cézanne has left again for Marseille."[225]

OCTOBER 27

Letter from Monet to Pissarro: "I cannot join you for the next dinner. Please make my excuses to friends and give them my regards. And you, what are you doing, and Renoir, Cézanne, Sisley, and Durand [*sic?*]. How is business and all that? It would be kind of you to keep me informed."[226] The letter suggests that Pissarro is still in touch with Cézanne.

1888–90

After receiving his father's inheritance, Cézanne rents an apartment in Paris at 15, quai d'Anjou.[227]

1891

MAY 7

Pissarro sends his son a copy of Emile Bernard's article on Cézanne. Pissarro's etching, *Paul Cézanne*, illustrates the cover (see opposite).[228]

1895

MAY 25

Cézanne and Pissarro meet at the Durand-Ruel Gallery to see Monet's exhibition of the Rouen Cathedral series, which they are both enthusiastic about.[229]

NOVEMBER

Pissarro visits the first large Cézanne retrospective at Vollard's, an event he will evoke frequently.[230]

NOVEMBER 22

Pissarro makes this remark to his son Lucien: "They [the critics] simply don't know that Cézanne was influenced like all the rest of us, which detracts nothing from his qualities. They forget that Cézanne was first influenced by

3 — Éragny (Oise) - La Ferme

The church and farm of Éragny-sur-Epte (see plate 101). Postcard. Collection Alain Mothe

Camille Pissarro. *Portrait of Cézanne.* Cover page of *Les Hommes d'aujourd'hui,* 1891. Art & Architecture Collection, Miriam and Ira D. Wallach Division of Art, Prints and Photographs, The New York Public Library, Astor, Lenox and Tilden Foundations

Delacroix, Courbet, Manet, and even Legros, like all of us; he was influenced by me at Pontoise, and I by him. . . . What is curious in that Cézanne exhibition at Vollard's is that you can see the kinship there between some works he did at Auvers or Pontoise, and mine."[231]

NOVEMBER 29

Letter from Pissarro to Lucien: "I've made an exchange for some small things by Cézanne."[232]

DECEMBER 12

Pissarro buys a painting by Cézanne from Vollard: "One painting naked woman standing full length by Cézanne, 200 francs."[233] Pissarro begins painting nudes the same year.

1896

JANUARY 20

Letter from Pissarro to Lucien: "It seems he [Cézanne] is furious at us all: 'Pissarro is an old fool, Monet a sly fox, they have no guts. . . . I'm the only one who has personality, I'm the only one who can make a red!!' "[234]

JANUARY 31

Letter from Pissarro to Lucien: "[Georges] Lecomte told me, speaking of Cézanne, that he started to run me into the ground hard in front of [Gustave] Geffroy, whose portrait he is doing at the moment. How nice: I, who for thirty years, defended him with so much energy and conviction, besides. It would take too long to tell you everything, but that's where this sort of silence and doubt comes from. . . . Oh bah! Let's work hard and try to make splendid grays! That would be better than running others into the ground."[235]

1902

In the catalogue of the Fourth Exhibition of the Société des amis des arts d'Aix-en-Provence, one of the exhibitors is listed as "CÉZANNE (Paul), élève [pupil] de Pissarro, Rue Boulegon, Aix."

[1905]

Letter from Cézanne to Émile Bernard: "Studying modifies our vision to such a degree that the humble and colossal Pissarro has proved to be justified in his anarchist theories."[236]

1906

JULY [20]

Letter from Cézanne to his son, Paul: "Greetings to Madame Pissarro—everything seems so far away and yet so close."[237]

[SUMMER ?]

Supplement to the catalogue of the Fifth Exhibition of the Société des amis des arts d'Aix-en-Provence lists: "Paul Cézanne, élève [pupil] of Pissarro."

SEPTEMBER

Cézanne continues to refer to Pissarro.[238]

NO DATE

Reportedly said by Cézanne: "As for the old Pissarro, he was a father to me. He was a man you could turn to for advice; he was something like God."[239]

Notes

Abbreviations:
The following abbreviations refer to the main bibliographical sources.

Archives Pissarro
Archives de Camille Pissarro, auction, November 21, 1975, Hôtel Drouot, Paris; microfilm conserved in the Cabinet des Estampes, Bibliothèque nationale, Paris.

BL
Richard R. Brettell and Christopher Lloyd. *A Catalogue of the Drawings by Camille Pissarro in the Ashmolean Museum, Oxford.* Oxford: Oxford University Press, 1980.

C
Adrien Chappuis. *The Drawings of Paul Cézanne: A Catalogue Raisonné.* 2 vols. Greenwich, Conn.: New York Graphic Society, 1973.

Cézanne, *Correspondance*
Paul Cézanne. *Correspondance.* Edited by John Rewald. Rev. ed. Paris: Bernard Grasset Editeur, 1978.

CV
Ludovic Rodo Pissarro. *Curriculum vitae.* Unpublished manuscript, Musée Pissarro, Pontoise.

JBH
Janine Bailly-Herzberg, ed. *Correspondance de Camille Pissarro.* Vol. I: Paris: Presses universitaires de France, 1980; vols. II-V: Paris: Éditions du Valhermeil, 1986-91.

LD
Loys Delteil. *Camille Pissarro, Alfred Sisley, Auguste Renoir.* Le Peintre-Graveur illustré, vol. 17. Paris: Chez l'auteur, 1923.

LM
Jean Leymarie and Michel Melot. *Les Gravures des impressionnistes: Manet, Pissarro, Renoir, Cézanne, Sisley.* Paris: Arts et métiers graphiques, 1971.

MB
Marie Berhaut. *Gustave Caillebotte: Catalogue raisonné des peintures et pastels.* New ed. Paris: Wildenstein Institute, La Bibliothèque des arts, 1994.

MPP
Musée Pissarro, Pontoise.

Piette
Janine Bailly-Herzberg, ed. *Mon cher Pissarro: Lettres de Ludovic Piette à Camille Pissarro*. Paris: Éditions du Valhermeil, 1985.

PV
Ludovic Rodo Pissarro and Lionello Venturi. *Camille Pissarro: Son art, son œuvre*. 2 vols. Paris: Paul Rosenberg Editeur, 1939.

R
John Rewald, in collaboration with Walter Feilchenfeldt and Jayne Warman. *The Paintings of Paul Cézanne: A Catalogue Raisonné*. 2 vols. New York: Harry N. Abrams, 1996.

Rwc
John Rewald. *Les Aquarelles de Cézanne: Catalogue raisonné*. Paris: Arts et métiers graphiques, 1984.

VM
Victor Merlhès. *Correspondance de Paul Gauguin, 1873–1888*. Paris: Fondation Singer-Polignac, 1984.

W
Daniel Wildenstein. *Claude Monet, biographie et catalogue raisonné*. 2 vols. Lausanne-Paris: Bibliothèque des arts, 1974 and 1979.

Zola, Correspondance
Émile Zola. *Correspondance*. Edited by B. H. Bakker. 4 vols. Montreal and Paris: Les Presses de l'Université de Montréal and Éditions du centre national de la recherche scientifique, 1978–83.

Other bibliographic references are cited in their entirety at first mention and abbreviated thereafter.

1. "Ce curieux Provençal . . . [qui] faisait des académies à la risée de tous les impuissants de l'école." Letter from Pissarro to his son Lucien, dated December 4, 1895. JBH 1181.

2. The participation of "Cézame" [sic] is mentioned in an article by Arnold Mortier in *Le Nain jaune*, reprinted by F[rancis] M[agnard] in *Le Figaro*, April 8, 1867; Jacques Lethève, *Impressionnistes et symbolistes devant la presse* (Paris: Armand Colin, 1959), 44–45, and 279, n. 9.

3. Gaston Poulain, *Bazille et ses amis* (Paris: La Renaissance du livre, 1932), 48–49.

4. Paul Alexis, *Émile Zola, notes d'un ami* (Paris: G. Charpentier Editeur, 1882), 71.

5. Letter from Cézanne, from Paris, to Pissarro, dated; *Archives Pissarro*, no. 10; Cézanne, *Correspondance*, 112–13.

6. One of these paintings is PV 46.

7. Letter from Guillemet, from Yport, to Pissarro, dated Saturday, August 26; *Archives Pissarro*, no. 79.

8. Letter from Guillemet to Pissarro, dated Tuesday, September 13; *Archives Pissarro*, no. 79.

9. Letter from Pissarro, in the Batignolles, to Oller, dated. JBH 1090.

10. Letter from Zola to Antony Valabrègue, undated; *Autographes, livres*, auction, Hôtel Drouot, September 27, 2002, no. 26; Zola, *Correspondance*, I, no. 145.

11. Letter from Fortuné Marion to Heinrich Morstatt, dated; Alfred Barr, "Cézanne d'après les lettres de Marion à Morstatt, 1865–68," *Gazette des Beaux-Arts* 17, no. 883 (January 1937): 45.

12. Ibid., 46.

13. Letter from Cézanne, from 22, rue Beautreillis, Paris, to M. de Nieuwerkerke; Archives du Musée au Louvre, Salon de 1866; Cézanne, *Correspondance*, 114–15.

14. Émile Zola, "Le Jury," *L'Événement*, April 27, 1866; reprinted in July in *Mon Salon, augmenté d'une Dédicace* ["A mon ami Paul Cézanne"] *et d'un Appendice* (Paris: Librairie centrale, 1866).

15. Émile Zola, "Salon de 1866, Adieux d'un critique d'art," *L'Événement*, May 20, 1866; reprinted in *Mon Salon*, July 1866.

16. Letter from Zola, from Paris, to Numa Coste, dated; Zola, *Correspondance*, I, no. 150.

17. Letter from Zola, from Paris, to Coste, July 26, 1866; Zola, *Correspondance*, I, no. 151.

18. Letter from Guillemet, in Guildo-en-Crehen, to Zola, Wednesday, July 31 [in fact, Tuesday the 31st or Wednesday, August 1st]; Renée Baligand, "Lettres inédites d'Antoine Guillemet à Émile Zola (1866–1870)," *Les Cahiers naturalistes* (Paris), no. 52, 23e année (1978): 184–85.

19. Letter from Guillemet, at M. Dagorne's in Guildo-en-Crehen, to Pissarro, dated Friday, August 17; *Archives Pissarro*, no. 79.

20. Letter from Marion, from Aix, to Morstatt, dated; "Cézanne, d'après les lettres de Marion à Morstatt, 1865–68," 57–58.

21. Letter from Guillemet to Oller, dated; copy in MPP.

22. Letter from Guillemet to Pissarro, undated; *Archives Pissarro*, no. 11; Cézanne, *Correspondance*, 126.

23. Théodore Duret, *Histoire des peintres impressionnistes* (Paris: Floury, 1906).

24. "Je vois des choses superbes, et il faut que je me résolve à ne faire que des choses en plein air." Letter from Cézanne to Zola, undated, written on a Wednesday; Cézanne, *Correspondance*, 124.

25. "Vous avez parfaitement raison de parler du gris, cela seul règne dans la nature, mais c'est d'un dur effrayant à attraper." Letter from Cézanne, dated "this 23rd day of October 1866, year of grace." Cézanne, *Correspondance*, 124–26.

26. Letter from Zola to Valabrègue, dated December 10, 1866; Zola, *Correspondance*, I, no. 159.

27. Letter from Zola, from Paris, to Valabrègue; Zola, *Correspondance*, I, no. 162.

28. Petition from F. Bazille, 20, rue Visconti, to the Superintendent des Beaux-Arts, dated; Archives du Louvre, Salon de 1867.

29. Ludovic Rodo Pissarro, *Notes recueillies d'après les documents, catalogues, lettres, peintures, etc.*; unpublished; MPP.

30. Map of rue du Fond de l'Hermitage, Archives départementales du Val-d'Oise.

31. F. M., *Le Figaro*, April 8, 1867, which quotes an article by Arnold Mortier published in *Le Nain jaune*; Jacques Lethève, *Impressionnistes et symbolistes devant la presse* (Paris: Armand Colin, 1959), 45.

32. Letter from Zola to Francis Magnard, undated; Zola, *Correspondance*, I, no. 172.

33. Petition, signed by twenty-five people, undated, received on April 13, 1867; Archives du Louvre, Salon de 1867.

34. Letter from Zola to Philippe Solari, dated June 6, 1867; Zola, *Correspondance*, I, no. 186.

35. Letter from Marion, from Aix, to Morstatt, undated; "Cézanne, d'après les lettres de Marion à Morstatt, 1865–68," 41.

36. Address listed in the catalogue of the Salon of 1868 and date given in letter JBH 5 of October 11, 1868.

37. Letter from Marion to Morstatt, dated October 9, 1867; "Cézanne, d'après les lettres de Marion à Morstatt, 1865–68," 50.

38. Guillaumin, *Camille Pissarro en train de peindre des volets*. Undated. Musée municipal de l'Évêché, Limoges.

39. Testament JBH 3, dated January 19, 1868; letter from Alfred Pissarro to Camille Pissarro, at P. Isaacson, 23 Norfolk St., Strand, London, dated January 28; *Archives Pissarro*, addendum no. 4.

40. Theodore Reff, "Copyists in the Louvre, 1850–1870," *The Art Bulletin* 46 (December

1964): 555 and n. 37.

41. Letter from Solari to Zola, dated April 2; John Rewald, *Cézanne et Zola* (Paris: Éditions A. Sedrowski, 1936), 62.

42. Letter JBH 5, dated October 11, 1868.

43. Letters from Cézanne to Coste, one dated Wednesday, May 13, 1868, the other "Aix, toward the end of November. It's Monday evening." Cézanne, *Correspondance*, 129 and 132; Letter from Zola, from Paris, to Marius Roux, dated December 4, 1868; Zola, *Correspondance*, II, no. 48.

44. Émile Zola, "Mon Salon: les Naturalistes," *L'Événement illustré*, May 19, 1868.

45. Letter from Guillemet, "Hôtel du Gd Cerf, Pontoise" [actually Saint-Ouen-l'Aumône] to Zola, dated Friday, August 7; Baligand, "Lettres inédites . . . ," 189-90.

46. Letter JBH 5, from Pissarro, from Pontoise, to the sub-prefect, dated October 11, 1868.

47. Birth certificate of Emélie Hortense Fiquet, April 22, 1850, city hall of Saligney, Jura; Rewald, *Cézanne et Zola*, 67.

48. François Thiébault-Sisson, "Claude Monet: Les Années d'épreuves," *Le Temps*, November 26, 1900; Ambroise Vollard, *Paul Cézanne* (Paris: Vollard, 1914).

49. Rwc 24; *Vente après décès de la Succession de Madame Émile Zola, en exécution du testament de la défunte*, Hôtel Drouot, November 9-10, 1925, lot no. 48.

50. Letters JBH 7 and 12.

51. Letter from Guillemet to Zola, dated; Baligand, "Lettres inédites . . . ," 194-95.

52. Letter from Zola to Valabrègue, dated; Zola, *Correspondance*, II, letter no. 80, 205.

53. PV 96.

54. Letter from Zola to Solari, dated February 13, 1870; Zola, *Correspondance*, II, no. 84.

55. One of these is PV 87.

56. Letter from Duret to Zola, dated; Zola, *Correspondance*, II, 219, n. 1.

57. Letter from Zola to Duret, dated; Zola, *Correspondance*, II, letter no. 89, 219.

58. Marriage certificate, Archives de Paris.

59. Letter from Monet, from Argenteuil, to Pissarro, dated October 21, 1871; W, I, letter no. 61.

60. Letter from Zola, from Paris, to Cézanne, dated July 4, 1871; Zola, *Correspondance*, II, no. 134; John Rewald, *Cézanne* (New York: Harry N. Abrams, 1986), 268.

61. Vollard, *Paul Cézanne*.

62. CV.

63. Letter from Durand-Ruel, on letterhead from the Society of French Artists, 168, New Bond Street, London W., to Pissarro, dated; *Archives Pissarro*, no. 21-1.

64. Letter JBH 9, from Pissarro to Duret, undated.

65. Letter from Zola, from Bordeaux, to Solari, dated; Zola, *Correspondance*, II, letter no. 125, 278.

66. Letter from Béliard to Pissarro, dated; *Archives Pissarro*, no. 6.

67. Letter from Estruc to Vellay, dated Friday the 10th; MPP.

68. Letter JBH 9, from Pissarro, from 2, Chatham Terrace, Palace Road, Upper Norwood, Surrey, to Duret, undated.

69. Marriage certificate no. 29, District of Croydon, County of Surrey; General Register Office, London.

70. CV.

71. Unpublished letter from Solari to Zola; Rewald, *Cézanne et Zola*, 78.

72. Letter from Monet, from Argenteuil, to Pissarro, dated; *Archives Pissarro*, no. 91; W, I, letter no. 61.

73. Letter JBH 14, from Pissarro, from Paris, to Julie, dated Monday evening.

74. Ralph E. Shikes and Paula Harper, *Pissarro* (Paris: Flammarion, 1981), 118.

75. CV. Map of the building line of rue Mallebranche, c. 1860; Archives départementales du Val-d'Oise.

76. Letter from Rossi and Authiès, from Paris, dated; *Archives Pissarro*, no. 162; Bibliothèque d'art et d'archéologie, Paris.

77. Archives nationales.

78. Information communicated to John Rewald by Paul Gachet; Rewald, *Cézanne et Zola*, 79.

79. "Il étonnera bien des artistes qui se sont hâtés trop tôt de le condamner." Letter JBH 18, from Pissarro, from Paris, to Guillemet, dated.

80. Letter from Cézanne to Pissarro, dated "En la ville de Pontoise, 11 décembre 1872." *Archives Pissarro*, no. 12; Cézanne, *Correspondance*, 142.

81. Letter from Manet to Zola, dated Wednesday, December 4; Colette Becker, "Lettres de Manet à Zola," in *Manet*, exh. cat., Galeries nationales du Grand Palais, Paris, 1983, letter no. 22, p. 524.

82. Paul Gachet, *Deux Amis des Impressionnistes, le docteur Gachet et Murer* (Paris: Editions des musées nationaux, 1956), fig. 33.

83. Letter from Lucien Pissarro to Paul-Émile Pissarro, undated [1912]; Anne Thorold, compiler, *Artists, Writers, Politics: Camille Pissarro and His Friends* (Oxford: Ashmolean Museum,

1980), 8.

84. LM 3; Paul Gachet, *Cézanne à Auvers, Cézanne graveur* (Paris: Les Beaux-Arts, 1953), n. p.

85. Anne Distel, "Some Pissarro Collectors in 1874," in *Studies on Camille Pissarro*, edited by Christopher Lloyd (London and New York: Routledge & Kegan Paul, 1986), 67-68, 72. "Memoires de Paul Durand-Ruel." *Les Archives de L'Impressionisme*, II, 197-98.

86. *Succession de Monsieur Rondest, L'Isle-Adam, Vente de très beaux meubles, objets d'art, tableaux anciens et modernes*, September 8 and 15, 1929. Gachet, *Deux Amis des Impressionnistes*, 59.

87. Notably R 203-05, 214, 223, 226, 227, and 318. Gachet, *Deux Amis des Impressionnistes*, 61; Paul Gachet, *Souvenirs de Cézanne et de Van Gogh, Auvers 1873-1890* (Paris: Les Beaux-Arts, 1953), n. p.

88. JBH 22. CV.

89. Adolphe Tabarant, *Pissarro* (Paris: Rieder, 1924), 21.

90. Invoice from Tanguy to Pissarro, on Tanguy's letterhead, 14, rue Clauzel, undated [c. late 1880]; *Archives Pissarro*, addendum no. 7.

91. "Avoir à M. Cézanne" [Credit to M. Cézanne] on Tanguy's letterhead, 14, rue Clauzel, undated [August 31, 1885].

92. Wayne V. Andersen, "Cézanne, Tanguy, Chocquet," *The Art Bulletin* 49, no. 2 (June 1967): 137.

93. Duret, *Histoire des peintres impressionnistes*.

94. Georges Rivière, *Renoir et ses amis* (Paris: Floury, 1921), 32; Georges Rivière, *Le Maître Paul Cézanne* (Paris: Floury, 1923), 78-79.

95. Paul Alexis, "Aux peintres et sculpteurs," *L'Avenir national*, May 5, 1873, p. 2.

96. The etching is LM 5, the painting R 196; Paul Gachet, *Cézanne à Auvers, Cézanne graveur*, 1953, n. p.

97. The etching is LM 4; Ibid.

98. Letter from Guillaumin to Dr. Gachet, dated; Paul Gachet, *Lettres impressionnistes* (Paris: Grasset, 1957), 65-68.

99. Letter from Monet, from Argenteuil, to Pissarro, dated; *Archives Pissarro*, no. 95; W, I, letter no. 69.

100. JBH 23, 26, and 27.

101. Map of the building line of rue de l'Hermitage, about 1860; Archives départementales du Val-d'Oise. These paintings include PV 56, 242, 337, 495, and one, not in PV, in the Folkwang Museum in Essen.

102. Letter JBH 25, from Pissarro, from Pontoise, to Dr. Gachet, dated Tuesday.

103. Letter JBH 26, from Pissarro, from Pontoise, 26,

rue de l'Hermitage, to Dr. Gachet, dated. The small flower is seen in LD 8-10, and 12; the hanged figure is seen in Cézanne's portrait of Guillaumin (LM 2).

104. Gachet, *Cézanne à Auvers, Cézanne graveur*, n. p.

105. Letter from Monet, from Argenteuil, to Pissarro, dated; *Archives Pissarro*, no. 98; W, I, letter no. 74.

106. John Rewald, *Histoire de l'Impressionnisme* (Paris: Albin Michel, 1986), 385.

107. Rewald, *Cézanne et Zola*, 85, n. 2.

108. "Dès le moment que vous cherchez des moutons à cinq pattes, je crois que Cézanne pourra vous satisfaire, car il a des études fort étranges et vues d'une façon unique." Letter JBH 29, from Pissarro, from Pontoise, to Duret, dated.

109. *La Chronique des arts et de la curiosité*, no. 3, January 17, 1874, pp. 19-20.

110. The etching is LD 13; the painting PV 293.

111. "Si vous désirez que je signe la toile dont vous m'avez parlé, veuillez la remettre chez M. Pissarro, où j'y mettrai mon nom." Letter from Cézanne, undated; Cézanne, *Correspondance*, 144.

112. "Faire un plein séjour à Aix." Letter from Cézanne to his parents, undated; Cézanne, *Correspondance*, 145.

113. Distel, "Some Pissarro Collectors in 1874," 67.

114. Shikes and Harper, *Pissarro*, 128.

115. "Votre copain, Monsieur Cézanne, doit avoir porté sa tente sur les bords tant chantés de la mer bleue." Letter from Piette to Lucien and to Pissarro, undated; *Archives Pissarro*, no. 139; *Piette*, 100-104.

116. *La Chronique des arts et de la curiosité*, 19-20.

117. *CV*.

118. Death certificate no. 77, city hall of Pontoise.

119. There are five works by Pissarro listed: nos. 136-40 (PV 230, 203, 236, 231, 224); three works by Cézanne: nos. 42-44 (R 161, 225, 201?).

120. Letter from Latouche, from Paris, to Dr. Gachet, dated; Gachet, *Deux Amis des Impressionnistes*, 58. The work is R 225.

121. Letter from Cézanne to Pissarro, dated; *Archives Pissarro*, no. 13; Cézanne, *Correspondance*, 146-47.

122. "Il est entièrement sous la pantoufle de G.– n'agit que d'après son avis? G. pense beaucoup plus à lui même qu'à ses amis." Letter from Molins, 17, route du Calvaire, Saint-Cloud, to Pissarro, dated; *Archives Pissarro*, no. 137.3; Bibliothèque d'Art et d'Archéologie Jacques Doucet, Paris.

123. Letter from Meyer to "Pissaro [sic]," undated [prior to September 3]; *Archives Pissarro*, no, 82.2, partly unpublished. Bibliothèque d'Art et d'Archéologie Jacques Doucet, Paris.

124. *CV*. Letter JBH 37, from Pissarro, from Pontoise, to Duret.

125. Letter from Dr. Gachet to his wife, under treatment in Pau, dated; Gachet, *Deux Amis des Impressionnistes*, 60-61.

126. Letter from Cézanne to his mother, dated September 26, 1874, probably incorrectly; Gustave Coquiot, *Paul Cézanne* (Paris: Albin Michel, 1919), 70-72.

127. Œuvres PV 268-71, 274-79, 281-88, 294.

128. Minutes of the meeting of December 17, 1874; *Archives Pissarro*, no. 82.1.

129. JBH 39, testament of Camille Pissarro, Montfoucault, dated.

130. Tabarant, *Pissarro*, 27.

131. "Le public manifesta. Un monsieur traita Berthe Morisot de 'gourgandine.' Pissarro donna un coup de poing à l'insolent. Une bagarre s'ensuivit. La police intervint." Jean Renoir, *Pierre-Auguste Renoir, mon père*. New ed. (Paris: Gallimard, 1981), 170.

132. *Statuts de l'Union, société anonyme à personnel et capital variables des artistes peintres, sculpteurs, graveurs, architectes, lithographes, céramistes, etc.* Paris, August 18, 1875; MPP.

133. Letter from Piette to Pissarro, undated; *Archives Pissarro*, no. 139; *Piette*, 122, n. 1. Another letter from Piette to Pissarro of February 1876 suggests that Cézanne was in the south at the end of 1875 and the beginning of 1876. He returned to Paris in early February 1876, according to Monet's letter to Chocquet of February 4, 1876.

134. Census of the population of Pontoise, 1876, taken by Mayor Germain, December 31, 1877; Archives départementales du Val-d'Oise.

135. Letter from Claude Monet, from Argenteuil, to Chocquet, dated February 4, 1876; W, I, letter no. 86.

136. Letter from Guillaumin to Pissarro, dated March 22; *Archives Pissarro*, no. 78; Unpublished. Bibliothèque d'Art et d'Archéologie Jacques Doucet, Paris.

137. There are twelve catalogued works by Pissarro and one uncatalogued *Dessous de bois*. These include nos. 197-203, 205, and 206 (PV 336? 268? 246, 238, 274, 370? 366, 205, and 209.

138. Letter from Cézanne to Pissarro, dated April 1876; *Archives Pissarro*, no. 14; Cézanne, *Correspondance*, 150-51.

139. Letter from Cézanne, from "maison Girard (dit Belle), place de l'Église à l'Estaque, banlieue de Marseille" to Pissarro, dated; *Archives Pissarro*, no. 15; Cézanne, *Correspondance*, 152-54.

140. Letter from Guillaumin, from Paris, to Pissarro, dated July 23; *Archives Pissarro*, no. 78, partly published. Bibliothèque d'Art et d'Archéologie Jacques Doucet, Paris.

141. Letter from Guillaumin to Dr. Gachet, dated "Samedi, 2 7bre" ["Saturday, September 2"]; private collection; cited in Gachet, *Lettres impressionnistes*, 69-71, under the incorrect date "Saturday, July 2, 1876."

142. Letter from Cézanne to his parents, mistakenly dated "Saturday, September 10, 1876"; Cézanne, *Correspondance*, 154-56.

143. Letter from Cézanne to Dr. Gachet, dated Thursday morning, October 5; Gachet, *Lettres impressionnistes*, 62.

144. Testament of Gustave Caillebotte, Paris, dated; Marie Berhaut, *Caillebotte, sa vie et son œuvre: Catalogue raisonné des peintures et pastels* (Paris: Fondation Wildenstein, La Bibliothèque des Arts, 1978), 251.

145. Georges Rivière, *Cézanne, le peintre solitaire* (Paris: Floury, 1936), 127.

146. Notes de Murer [Murer's notes], cited by Tabarant, *Pissarro*, 34-35.

147. Invoice from Tanguy to Pissarro, c. late 1880; *Archives Pissarro*, addendum no. 7, feuillets no. 3-4.

148. *Catalogue de la première exposition du 15 février au 17 mars, au Grand-Hôtel, faite par l'Union des artistes, peintres, sculpteurs, graveurs, céramistes, etc.* (Paris: Imprimerie de Pillet et Demoulin, 1877).

149. Letter from Guillaumin, from Paris, to Dr. Gachet, dated; Gachet, *Lettres impressionnistes*, 71-73.

150. Georges Rivière, "A M. le Rédacteur du *Figaro*," *L'Impressioniste*, no. 1 (April 6, 1877): 1, and no. 4 (April 28, 1877): 7. There are sixteen catalogued works by Cézanne and one uncatalogued work, *Scène au bord de la mer* (according to the article by Georges Rivière, "L'Exposition des Impressionnistes," *L'Impressionniste* [April 14, 1877]).

151. Letter from Degas to Mme de Nittis, dated May 21, 1877; Mary Pittaluga and Enrico Piceni, *De Nittis* (Milan: Bramante Editrice, 1963), 368-69.

152. Un vieux Parisien, "L'indiscret: le dîner des impressionnistes," *L'Événement*, April 8, 1877, 1. Letter from Monet to Zola, undated; W, I, letter

no. 105.

153. Letter from Cézanne to Zola, dated; Cézanne, *Correspondance*, 158.

154. Letter from Louis-Edmond Duranty to Zola, undated; Auriant, "Duranty et Zola (lettres inédites)," *La Nef*, no. 20, 3ᵉ année (July 1946): 50-51.

155. *CV.*

156. Letter from Murer to Pissarro, dated. Private collection.

157. Letter JBH 53, from Pissarro, from Pontoise, to Caillebotte, dated Saturday.

158. Cézanne, from Paris, to M. and Mme Tanguy, dated; Cézanne, *Correspondance*, 160.

159. Letter from Julien Tanguy, Paris, to "Cézanne," dated; Cézanne, *Correspondance*, 224. Cézanne's bill of credit for 1442.50 francs on Tanguy's letterhead, undated; reproduced in Andersen, "Cézanne, Tanguy, Chocquet," 137.

160. Letter from Cézanne to Zola, dated; Cézanne, *Correspondance*, 161-62.

161. Letter from Cézanne to Zola, dated March 28; Cézanne, *Correspondance*, 162-63.

162. Letter from Cézanne to Zola, dated; Cézanne, *Correspondance*, 164.

163. Letter from Cézanne to Zola, dated; Cézanne, *Correspondance*, 166.

164. "Ce que je souffre actuellement est terrible, encore bien plus qu'étant jeune, plein d'enthousiasme et d'ardeur, convaincu que je suis d'être perdu comme avenir. Cependant il me semble que je n'hésiterais pas, s'il fallait recommencer, suivre la même voie." Letter JBH 66, from Pissarro to Murer, dated Monday morning.

165. Letter from Cézanne to Zola, dated; Cézanne, *Correspondance*, 169-70.

166. Letter JBH 71, from Pissarro, from Paris, to Duret.

167. Letter from Cézanne to Zola, dated; Cézanne, *Correspondance*, 170.

168. Letter JBH 70, from Pissarro, from Paris, to Murer, dated Saturday.

169. Letter from Julie to Camille, written on the back of a letter from Duret dated September 9, 1878; *Archives Pissarro*, no. 22; Frits Lugt collection, Institut néerlandais, Paris, inv. 1978-A.18.

170. Letter from Cézanne to Zola, dated; Cézanne, *Correspondance*, 172-73.

171. Letter JBH 65, from Pissarro, from Paris, to Murer, dated Saturday.

172. Letter from Cézanne to Zola, dated; Cézanne, *Correspondance*, 173-74.

173. Letter JBH 74, from Pissarro, from Pontoise, [to] Duret, undated.

174. Letter from Cézanne, from L'Estaque, to Zola, dated; Cézanne, *Correspondance*, 172-73.

175. Letter from Cézanne to Zola, dated; Cézanne, *Correspondance*, 177-78.

176. Letter JBH 52, from Pissarro, from Paris, to Murer, dated Sunday. The painting is PV 426.

177. The house is depicted in PV 347, 390, 427, 429-32, as well as in a work not in PV (see auction, Sotheby's, London, July 1, 1980, lot no. 37).

178. Letter from Cézanne, from L'Estaque, to Zola, dated February 1879; Cézanne, *Correspondance*, 182.

179. Letter from Degas to Caillebotte, dated Sunday; MB 16.

180. Letter from Cézanne to Pissarro, dated; *Archives Pissarro*, no. 16; Cézanne, *Correspondance*, 182-83.

181. Letter from Degas to Bracquemond, undated; Marcel Guérin, ed., *Lettres de Degas* (Paris: B. Grasset, 1945), letter XIX, 46-47.

182. Thirty-eight works by Pissarro catalogued and *Saules inondés en hiver* uncatalogued. Uncatalogued work according to Armand Silvestre, "Les Expositions des Indépendants," *L'Estafette*, April 16, 1879, p. 3.

183. Letter JBH 77, from Pissarro, from Pontoise, to Murer, dated. *CV.*

184. Letter from Caillebotte to Monet, undated; MB 20.

185. Letter from Cézanne, from Melun, to Zola, dated; Cézanne, *Correspondance*, 183-84.

186. Letter from Cézanne to Zola, dated; Cézanne, *Correspondance*, 184.

187. Visit attested by Gauguin's letter, from Paris, to Pissarro, dated 7 26 1879; *Archives Pissarro*, no. 30; VM 11; and by Gauguin's works: Daniel Wildenstein, *Gauguin, premier itinéraire d'un sauvage, catalogue de l'œuvre peint (1873-1888)*, I (Milan: Skira/Seuil, and Paris: Wildenstein Institute, 2001), nos. 51-52 and 53 dated 1879.

188. "Je m'ingénie toujours à trouver ma voie picturale. La nature m'offre les plus grandes difficultés." Letter from Cézanne to Zola, dated; Cézanne, *Correspondance*, 184-85.

189. Letter from Degas to Pissarro, undated; Guérin, *Lettres de Degas*, letter no. XXV, 52-55.

190. Letter from Cézanne, from Melun, to Zola, dated; Cézanne, *Correspondance*, 187-88.

191. Letter from Oller, from Madrid, to Pissarro, dated; *Archives Pissarro*, no. 137.4.

192. The pastel is in the Graff Collection, London. The Cézanne copy is R 446.

193. Tout-Paris, "La journée parisienne Impressions d'un impressionniste," *Le Gaulois*, January 24, 1880, p. 2.

194. Letter from Monet, from Vétheuil, to Pissarro, dated; W, I, letter no. 172.

195. Letter from Pissarro, from Paris, to Monet, dated Thursday; *Lettres et manuscrits autographes, Mᵉ Laurin, Guilloux, Buffetaud*, auction, Drouot Richelieu, Paris, November 12 and 13, 1998, lot no. 359.

196. Pierre Michel, *Octave Mirbeau: Premières chroniques esthétiques* (Angers: Société Octave Mirbeau et Presses de l'Université d'Angers, 1996), 11-13.

197. Letter from Cézanne to Zola, dated; Cézanne, *Correspondance*, 190-91.

198. Twenty-eight works by Pissarro are shown.

199. Letter from Katherine Cassatt (Mary's mother), from 13, avenue Trudaine, to her son Aleck (Alexander), dated April 9; Nancy Mowll Mathews, ed., *Cassatt and Her Circle: Selected Letters* (New York: Abbeville Press, 1984), 150-51.

200. Letter from Guillemet, from Trouville, to Zola, dated August 18, 1880; Zola, *Correspondance*, IV, 94, nn. 1-2.

201. Letter JBH 83, from Pissarro, from "Paris, 18, rue des 3 Frères," to Duret, dated December 23, 1880.

202. "Mémoires de Paul Durand-Ruel," in Lionello Venturi, *Les Archives de l'Impressionnisme*, II (Paris: Durand-Ruel, 1939), 210.

203. Shikes and Harper, *Pissarro*, 186. Letter JBH 84, from Pissarro, from Paris, 18, rue des 3 Frères," to Esther, dated January 4, 1881.

204. Shikes and Harper, *Pissarro*, 186.

205. Registry of Sainte-Madeleine Church, Archives de l'archevêché d' Aix-en-Provence.

206. Twenty-eight works by Pissarro are shown.

207. Letter from Cézanne, Pontoise, to Zola, dated; Cézanne, *Correspondance*, p. 198.

208. *Tableaux, études, aquarelles et dessins, marbres, bronzes offerts en partie par les artistes à M. C.*, auction, Hôtel Drouot, May 14, 1881.

209. Letter from Cézanne, from Pontoise, to Chocquet, dated; Cézanne, *Correspondance*, 199.

210. Letter from Cézanne, from Pontoise, to Zola, dated; Cézanne, *Correspondance*, 199-200.

211. "Mʳ Césanne a-t-il trouvé la *formule* exacte d'une œuvre admise par tout le monde? S'il trouvait la recette pour comprimer l'expression outrée de toutes ses sensations dans un seul et unique procédé je vous en prie tâchez

de le faire causer." Letter from Gauguin to Pissarro, undated; *Archives Pissarro*, no. 35; VM 16.

212. *CV*. Rent receipts dated April 10, July 11, and October 2, 1882, private collection.

213. Population count of Pontoise, 1881, taken January 31, 1882; Archives départementales du Val-d'Oise.

214. Letter from Cézanne, from Pontoise, to Zola, dated; Cézanne, *Correspondance*, 203.

215. Letter from Zola, Médan, to Coste, dated November 5, 1881; Zola, *Correspondance*, IV, no. 171.

216. "Cézanne m'a écrit qu'il n'avait rien [pour l'exposition de cette année-là]!" Letter JBH 98, from Pissarro, from Paris, to Monet, dated Friday.

217. R 493, I, 331.

218. "D'où vient que vous ne dites pas un mot de Cézanne, que pas un de nous n'admette comme un des tempéraments les plus étonnants et le plus curieux de notre époque et qui a eu une influence très grande sur l'art moderne?... " Letter JBH 149, from Pissarro, from Osny près Pontoise, to Huysmans.

219. "Quand on est trop près, on ne voit rien, c'est comme un tableau de Cézanne que tu te fourrerais sous le nez. A propos de Cézanne, je me suis payé quatre de ses études, très curieuses." Letter JBH 224, from Pissarro, from Paris, to Lucien, undated.

220. Alfred H. Barr, Jr., *Matisse: His Art and His Public*. Reprint ed. (New York: The Museum of Modern Art, 1951), 38.

221. Letter from Cézanne, from La Roche, to Zola, dated June 15, 1885; Cézanne, *Correspondance*, 218.

222. Letters from Cézanne, from La Roche, to Zola, dated June 15, 1885 and July 6, 1885. Cézanne, *Correspondance*, 218, 220.

223. Letters from Cézanne to Zola, dated July 11, 13, 1, 1885, Cézanne, *Correspondance*, 220-22.

224. Letter from Cézanne to Zola, dated July 1, 1885, Cézanne, *Correspondance*, 222.

225. "On m'a dit que Cézanne était reparti pour Marseille." Letter JBH 286, from Pissarro, from Éragny-sur-Epte (Eure), to Monet, undated.

226. "Je ne serai pas des vôtres pour le prochain dîner. Vous voudrez bien m'en excuser près des amis et leur faire mes amitiés. Et vous, que faites-vous, et Renoir, Cézanne, Sisley, et Durand, les affaires, où tout cela en est-il? Vous serez bien aimable de me mettre un peu au courant." Letter from Monet, from Etretat,

to Pissarro, dated October 27; *Archives Pissarro*, no. 118; W, II, letter no. 595.

227. Calepins cadastraux [Registry notebooks] D1P432, Archives de Paris. *Annuaire-Almanach du commerce* [Business Directory], Didot-Bottin, Paris, 1889, 1890.

228. Letter JBH 659, from Pissarro, from Paris, dated. *Les Hommes d'Aujourd'hui*, 8, no. 387 [May 1891].

229. Letter JBH 1138, from Pissarro, from 111, rue Saint-Lazare, Paris, to Lucien, dated May 26, 1895.

230. Rewald, *Cézanne*, 1986, 207. Letters JBH 1169, 1171, 1174.

231. "Ils [les critiques] ne se doutent pas que Cézanne a subi des influences comme nous tous et que cela en sommes ne retire rien de ses qualités; ils ne savent pas que Cézanne a subi d'abord l'influence de Delacroix, Courbet, Manet et même Legros, comme nous tous; il a subi mon influence à Pontoise et moi la sienne... Ce qu'il y a de curieux c'est que dans cette exposition de Cézanne chez Vollard on voit la parenté qu'il y a dans certains paysages d'Auvers, Pontoise et les miens." Letter JBH 1175, from Pissarro, from Paris, to Lucien, dated.

232. "J'ai fait un échange pour des petites choses de Cézanne." Letter JBH 1175, from Pissarro, from Paris, to Lucien, dated.

233. "Une peinture femme nue debout en hauteur de Cézanne, 200 francs" (V 114?). *Agenda commercial 1895* [Business Diary 1895], Vollard Archives, Bibliothèque centrale et archives des musées nationaux, Musée du Louvre, Paris.

234. "Il paraît qu'il [Cézanne] est furieux contre nous tous: 'Pissarro est une vieille bête, Monet un finaud, ils n'ont rien dans le ventre.... il n'y a que moi qui ai du tempérament, il n'y a que moi qui sais faire un rouge! !...'" Letter JBH 1203, from Pissarro, from Rouen, to Lucien, dated.

235. "Lecomte m'a dit à propos de Cézanne qu'il s'était mis à me bêcher ferme auprès de Geffroy, dont il fait le portrait, en ce moment, comme c'est gentil; moi, qui depuis trente ans le défend avec tant d'énergie et conviction d'ailleurs, ce serait trop long à te raconter, mais c'est de là que vient cette espèce de silence et de doute... ah bah!... Travaillons ferme et tâchons de faire des gris épatants! Ce sera mieux que de bêcher les autres... " Letter JBH 1175, from Pissarro, from Rouen, to Lucien, dated.

236. "L'étude modifie notre vision à tel point que

l'humble et colossal Pissarro se trouve justifié de ses théories anarchistes." Letter from Cézanne to Bernard, undated; Émile Bernard, "Souvenirs sur Paul Cézanne et lettres inédites," *Mercure de France*, 69, no. 248 (October 16, 1907): 623.

237. "Bonjour à Madame Pissarro,—comme tout est déjà lointain et pourtant si rapproché." Letter from Cézanne to his son, Paul, dated Friday, July 1906; Cézanne, *Correspondance*, 316.

238. Letters from Cézanne, from Aix, to his son, Paul, dated; Cézanne, *Correspondance*, 318-19, 328-29.

239. "Quant au vieux Pissarro, ce fut un père pour moi. C'était un homme à consulter et quelque chose comme le bon Dieu." Jules Borély, "Cézanne à Aix," *L'Art vivant*, no. 37, 2ᵉ année (July 1, 1926): 432.

Works by Cézanne owned by Pissarro include: oil paintings: V 56, 93, 114?, 115, 139, 140, 170, 174, 176, 217?, 239, 272, 285, 303?, 322, 371, 372, 379, 494, 1607? R, I, p. 577-578; Watercolors: Rwc 20, 38; Rwc, p. 483; Drawings: C 143, 159, 181, 201, 202, 203, 204, 298, 300, 301, 758.

Cézanne's collection was not documented. We do not know what works by Pissarro he owned.

Index

This index references the texts, the illustrations, and some of the notes. Titles of works by both artists have been established on the basis of topographical evidence and archival research conducted by Alain Mothe. The bracketed number that follows the title of each painting by Camille Pissarro refers to the forthcoming catalogue raisonné number assigned to it in *Camille Pissarro: Catalogue critique*, to be published by the Wildenstein Institute in 2005.

Photograph Credits

Photographs of works of art reproduced in this volume have been provided in most cases by the owners or custodians of the works, who are identified in the captions. Individual works of art appearing here may be protected by copyright in the United States of America or elsewhere, and may thus not be reproduced in any form without the permission of the copyright owners. The following copyright and/or other photo credits appear at the request of the owners of individual works.

David Allison: fig. 41; © The Art Institute of Chicago: plates 1, 25, 66, 87, page 188; Art Resource, NY: fig. 15; © 2005 Artists Rights Society (ARS), New York/ADAGP, Paris (photo Kate Keller, Department of Imaging Services, The Museum of Modern Art): fig. 2; (photo Mali Olatunji, Department of Imaging Services, The Museum of Modern Art): fig. 60; Jeff Bates: plate 104, page 205; Dean Beasom: plate 10; Bildarchiv Preussischer Kulturbesitz/Art Resource, NY (photo Joerg P. Anders): plate 6; (photo Klaus Goeker): plate 93; Jeremy Butler: plate 43, page 124; © Stiftung Langmatt Sidney und Jenny Brown, Baden (photo SIK [Jean-Pierre Kuhn], Zurich): plate 61; © 2005 Christie's Images Inc.: figs. 7, 34, plates 37, 97; © 2005 Christie's Images Limited: plate 96; © The Cleveland Museum of Art: plate 105; © The Samuel Courtauld Trust, Courtauld Institute of Art Gallery, London: fig. 53, plate 63; Teresa Diehl: plate 88; Brad Flowers: fig. 55, plate 69, page 165; Thomas U. Gessler: fig. 50, plate 77; Photography courtesy of Richard Green, London: plate 99; André Guerrand: fig. 32; © The Solomon R. Guggenheim Foundation, New York: plates 27, 92; © 2004 President and Fellows of Harvard College: page 125; (photo Katya Kallsen): plate 44; (photo David Mathews): fig. 38; Florian Kleinefenn: plate 71; Kunsthalle Mannheim (photo Margita Wickenhäuser): fig. 52, plate 64; Kunstmuseum Basel (photo Martin Bühler): figs. 33, 35, plates 20, 38, 55, 62; © L & M Services B.V., Amsterdam (photo Kate Keller, Depart-

ment of Imaging Services, The Museum of Modern Art: figs. 4, 5; Erich Lessing/Art Resource, NY: figs. 8, 10-14, 16, 19, plates 9, 80; © 2005 Succession H. Matisse, Paris/Artists Rights Society (ARS), New York: fig. 20; © 1983 The Metropolitan Museum of Art: plate 26; © 1988 The Metropolitan Museum of Art: fig. 21; © 1993 The Metropolitan Museum of Art: plate 7; ©1994 The Metropolitan Museum of Art: fig. 64; © 1997 The Metropolitan Museum of Art: plate 90; © 2004 The Metropolitan Museum of Art: pages 77, 110; © 2005 The Pierpont Morgan Library: plate 19; © 2004 Musée d'Orsay, Paris (photo Patrice Schmidt): plate 91; © 2004 Museum Associates/ LACMA: plate 106; © 2004 Museum of Fine Arts, Boston: plates 18, 52, 59; © 2005 Museum of Fine Arts, Boston: fig. 1; The Museum of Modern Art, New York, Department of Imaging Services (photo Kate Keller): 59; (photo Paige Knight): plate 81; (photo Mali Olatunji): plate 83; © 2004 Board of Trustees, National Gallery of Art, Washington, D.C.: fig. 25; © 2005 Board of Trustees, National Gallery of Art, Washington, D.C. (photo Bob Grove): fig. 23, plate 2; National Gallery of Ireland: plate 30; © The National Gallery, London: figs. 9, 49, 51, plate 76; © 2004 National Gallery, Prague: plate 94; The National Museum of Fine Arts, Stockholm: plate 100; © Board of Trustees of the National Museums and Galleries on Merseyside (Walker Art Gallery): fig. 27; Courtesy of Pace/MacGill Gallery: plate 89; © 2005 Estate of Pablo Picasso/Artists Rights Society (ARS), New York (photo Kate Keller, Department of Imaging Services, The Museum of Modern Art): fig. 3; © 2000 Trustees of Princeton University (photo Bruce M. White): plate 24; © The State Pushkin Museum of Fine Arts, Moscow: plate 54; Rheinisches Bildarchiv Koln: fig. 26; Réunion des musées nationaux/Art Resource, NY: figs. 17, 18, 22, 24, 31, 36, 62; (photo Michèle Bellot): plates 15, 21, 51; (photo J. G. Berizzi): plate 17; (photo Gérard Blot): plates 31, 39; (photo: Hervé Lewandowski): plates 3, 11, 13, 14, 32, 33, 36, 40, 45, 48, 65, 75; © RMN/Hervé Lewandowski: pages 88, 147, 164, 204; (photo Pascale Néri): fig. 54, plate 68; John Sargent: plate 70; Scala /Art Resource, NY: fig. 6; Photo courtesy of Sotheby's, New York: fig. 61, plates 49, 78, 84; Glenn Steigelman: plate 82; Richard Valencia: plate 58, page 189.

Lenders to the Exhibition

Albright-Knox Art Gallery,
Buffalo, New York

Joe L. Allbritton

The Art Institute of Chicago

Ashmolean Museum, Oxford

Brooklyn Museum, New York

Cincinnati Art Museum

The Cleveland Museum of Art

Columbus Museum of Art

The Samuel Courtauld Trust, Courtauld
Institute of Art Gallery, London

Fogg Art Museum, Harvard University
Art Museums, Cambridge, Mass.

Laurence Graff

Solomon R. Guggenheim Museum,
New York

Mr. and Mrs. Herbert Klapper

Kunstmuseum Basel, Kupferstichkabinett

Los Angeles County Museum of Art

LVMH/Moët Hennessy. Louis Vuitton
Collection

The Metropolitan Museum of Art,
New York

Musée Malraux, Le Havre

Musée d'Orsay, Paris

Museo Cantonale d'Arte, Lugano

Museo Nacional de Bellas Artes,
Buenos Aires

Museum of Fine Arts, Boston

Museum of Fine Arts, St. Petersburg, Fla.

Museum Langmatt, Stiftung Langmatt
Sidney und Jenny Brown, Baden,
Switzerland

The Museum of Modern Art, Gunma,
Japan

The Museum of Modern Art, Ibaraki,
Japan

The Museum of Modern Art, New York

Helly Nahmad Gallery, New York

National Gallery of Art, Washington, D.C.

National Gallery of Canada, Ottawa

National Gallery of Ireland, Dublin

The National Gallery, London

National Gallery, Prague

Nationalgalerie, Staatliche Museen
zu Berlin

Mr. and Mrs. Jay Pack

Mr. and Mrs. Jeffrey Peek

Philadelphia Museum of Art

The Phillips Family Collection

The Pierpont Morgan Library, New York

Private collection

Private collection, California

Private collection, Cambridge, Mass.

Private collection. Courtesy Caratsch,
de Pury & Luxembourg, Zürich

Private collection. Courtesy of
Wildenstein & Co.

Private collection, London

Private collection, Mequon, Wisconsin

Private collection, New York

Private collection, Paris

Private collection, Tokyo

Private collector

Quinque Foundation, Boston

Estate of Dr. Rau

Mrs. Walter Scheuer

Stadtische Kunsthalle Mannheim

Rudolf Staechelin

The State Hermitage Museum,
St. Petersburg, Russia

The State Pushkin Museum of Fine Arts,
Moscow

Toledo Museum of Art

Michael Vineberg

Von der Heydt-Museum Wuppertal

Yale University Art Gallery, New Haven,
Conn.